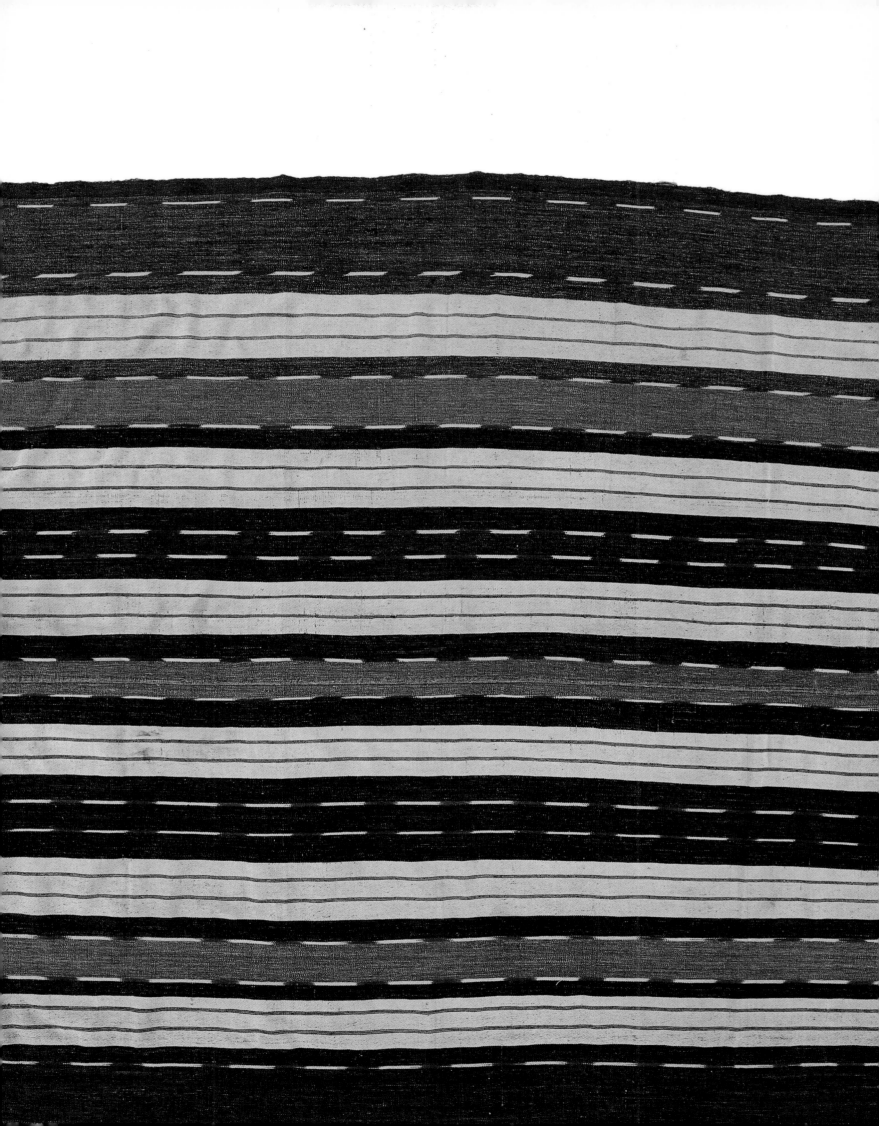

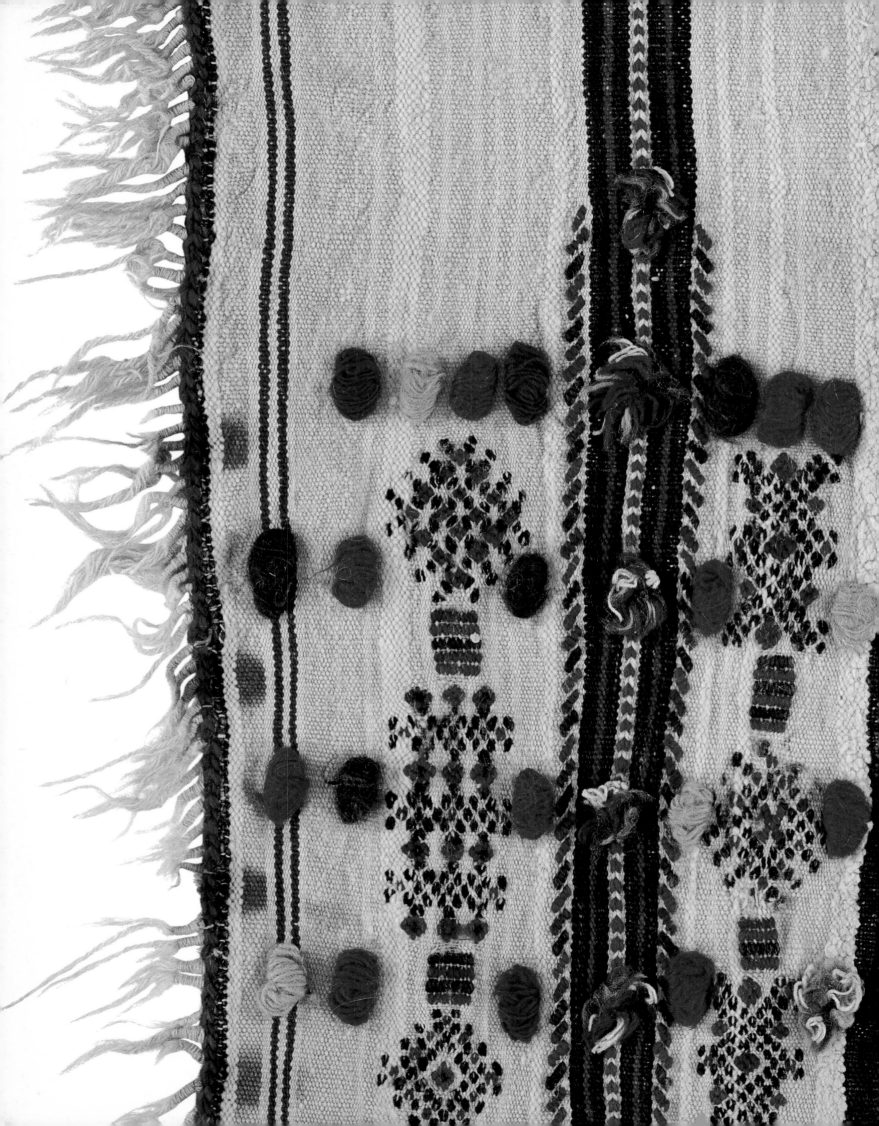

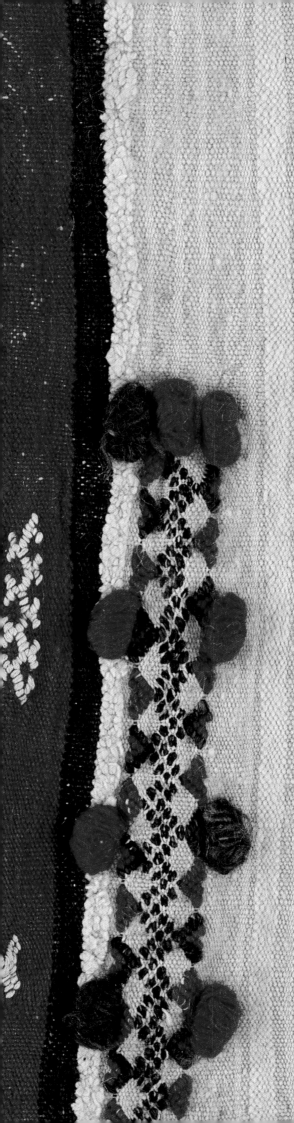

african textiles

by John Gillow

CHRONICLE BOOKS

SAN FRANCISCO

For Rosie and to the memory of my beloved mother, Yvonne

ACKNOWLEDGMENTS

There are so many who have helped with this
book, it seems invidious to single certain
people out for special mention. However, firstly
I should like to pay an unstinting tribute to the
pioneering efforts of Venice and Alastair Lamb.
Their seminal books on West African textiles
have been both an inspiration and an invaluable
guide to my own researches. Having travelled
a little of their long dusty road, I much
appreciate their tenacity and dedication.

Many have lent me textiles and photos, given
me information and helped me on my travels.
To all of them I give my thanks and gratefully
acknowledge them below. I am of course
indebted to the many unnamed African textile
practitioners that I met in the course of my
researches. I should like to give special thanks
to the following, on whose textile collections
I drew heavily to illustrate this book:
Karun Thakar of Tanoti Textiles, Molly Hogg,
Clive Loveless, Sheila Paine, Joyce Doel,
Sue Ubagu, Robert Clyne, Barbie Rich,
Esther FitzGerald, David Bennie, Liz Hunter,
Junnaa and Thomi Wroblewski, and
Francesca Galloway and Simon Peers.

I should also like to thank for their advice
and help: Duncan Clarke, Robert Clyne,
Harvey Derrien and Noëmi Speiser on
West Africa; Julia Bassett, Barry Dawson,
Janet Hotine, Alastair Hull and Caroline Stone
on North Africa; Anchy Desalegh on Ethiopia;
Steven Long, Phindi Mabuza, Robert Papini
and Pam Stallebrass on South Africa; and
Simon Peers on Madagascar.

They corrected many, but perhaps not all,
of my mis-apprehensions, which are of course
all my own responsibility.

A general and heartfelt thanks to the following,
for all the various ways they have so generously
helped in the making of this book:

African Image
Judith Akappo-Whyte
Emmanuel Amoako-Gyan
Janet Anderson
Angelina de Antonis
Jenny Balfour-Paul
Nicholas Barnard
John and Pauline Bassill
Ave and Beryl Behrendt
Lenore Blackwood
Rosie Bose
George Burrill
Barbie Campbell-Cole
Peter Collingwood
Caroline Crabtree
Anna Crutchley
André de Vries
Bryan Eberhardy
Bert Flint
Jenny Foley
Valerie Foley
Elizabeth Gibbons
Peter Gillow
Polly Gillow
Mr and Mrs John Grainger
Jackie Guille
Phil Hague
Margaret Hall-Townley
Owen Hargreaves
Janet Harvey
Trish and Richard Hewlings
Sally Hirons
Stephany Hornblow
Julie Hudson
Ben Hunter
Alec and Jenny Hutchison
Hiroko Iwatate
Mie Iwatsubo
Carole Kaufmann
Kelvingrove Art Gallery and Museum, Glasgow
Venice and Alastair Lamb
Leicester Museum
Diane Lelupe
Mike Leslie
Gusti Lina
Steven Long
Mary Lowry
Paul Lunde
Alistair McAlpine
John Mack
McGregor Museum, Kimberley, South Africa
Rosie McMurray
Jane May
Peter and Pam May
Odon Mbembe
Anne Morrell
Carole Morris
Joan Morris
Haj Moussa
Ruth Philo
Benonia Puplampu
Clive Rogers
Bryan Sentance
Roddy Taylor
Barbara Tyrell
Charles Vernon-Hunt
Ingrid Wagner
Patrick Watson
Sandra Wellington

SOURCES OF ILLUSTRATIONS

The following abbreviations have been used:
a above; b below; i inset; l left;
m middle; mn main picture; r right.

All studio photography is by James Austin
unless otherwise stated.

All drawings are by Bryan Sentance except those
on p. 152 by Anne Morrell and p. 221 by Stephany
Hornblow.

Lenore Blackwood 93al, 93ml; Rosie Bose 106bl,
107r, 110bm, 145al, 154al, 154bl, 155r; Barry
Dawson 131al, 133, 134, 237; Anchy Desalegh 165b,
165i; Francesca Galloway 230a, 230b, 231mn;
Elizabeth Gibbons 145r; John Gillow 16al, 16ar,
20al, 20bl, 20r, 21bc, 21br, 30b, 34a, 57r, 58al, 65bm,
65br, 83ml, 93bl, 100bm, 100br, 106al, 106ar, 106br,
107l, 110bl, 110br, 111bl, 117al, 117am, 117ab, 124a,
132al, 145bl, 154ar, 154br, 155l, 161al, 161cl, 167br,
172bl, 172bm, 172br, 178ar, 182l, 182r, 183br,
187bm, 187br, 210b, 211al, 211ar, 212r, 224br;
Richard Heeps 18br, 53b, 59, 70m, 103b, 146br,
147a, 147b, 148a, 148b, 149a, 149b, 180ar, 192l, 192r;
Ken Karner 204r; Kelvingrove Art Gallery and
Museum, Glasgow 156am; Horst Kohlo 126br,
150bl; Longevity Studio, London 11, 14l, 14r, 28r,
118br, 120, 121, 122, 123, 142al, 142ar, 142b, 143, 249;
McGregor Museum, Kimberley, South Africa,
Photo Alfred Duggan-Cronin 215al; Sheila Paine
178al, 178b, 179l, 179r, 183bl, 187bl, 238b; Pam
Stallebrass 204br, 211l; Sue Ubagu 16b, 17l, 21bl,
43br, 47b, 50bl, 62m, 83al, 100ml, 100mr, 182r, 240.

PAGE 1
Igarra stripwoven woman's wrap from Nigeria
with warp-ikat details in some of the warp stripes.

PAGES 2–3
Embroidered woollen details on the corner of
a Berber woman's *haik*, Anti-Atlas mountains,
Morocco.

OPPOSITE
Bakhnug, Berber woman's everyday shawl from
Gourmessa, south Tunisia. Woven of sheep's
wool with supplementary cotton details, it has
been dyed blue over red, while the ends have
been tie-dyed.

PAGE 6
Limbe hunter's shirt dyed with an infusion of
tree roots and printed with a leaf and mud-based
dye. This type of work is known as *huronko*.

PAGE 7
TOP LEFT Pokot woman's collar of vegetable
fibre strung on stiff wire, north Kenya.
BOTTOM LEFT *Tahendirt*, woman's cloak, High Atlas,
Morocco.
TOP RIGHT Bamileke elephant society mask
adorned with beads and buttons.
BOTTOM RIGHT *Ijogolo* beaded apron of a married
Ndebele woman with children. The imported
seed beads are worked in herringbone stitch
on a goatskin base.

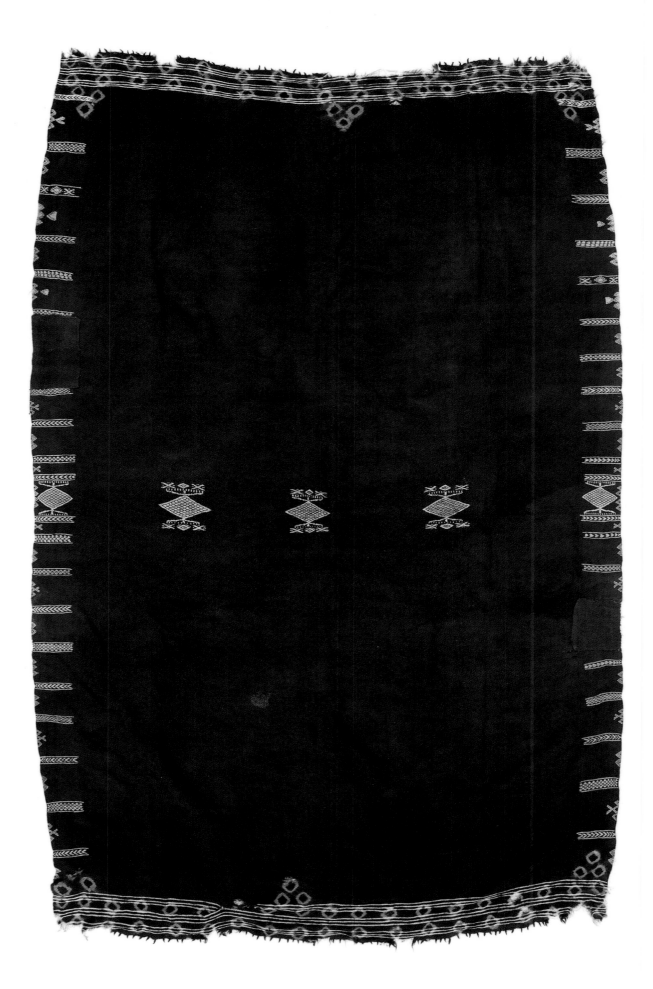

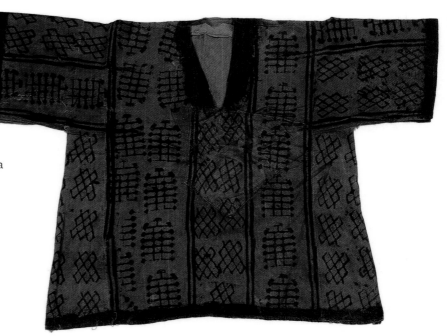

CONTENTS

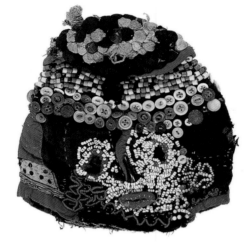

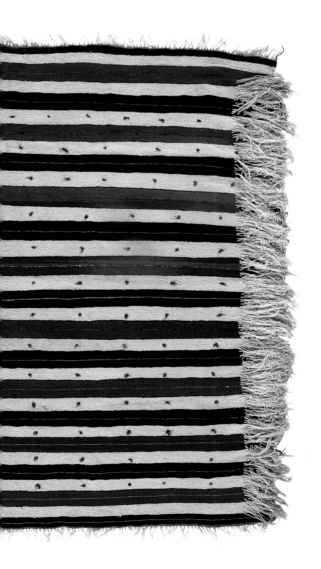

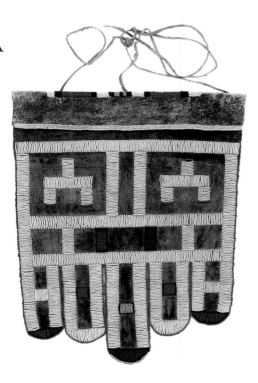

African textiles have been the subject of much study over the last few decades. Some students have concentrated on the aesthetics of African design, some have taken an anthropological approach, many have naturally just responded to the visual stimulus and excitement of seeing patterns, designs and combinations of colours for the first time, while others have been fascinated by the particular techniques of making and decorating African cloth. There have been many studies in depth of particular regions, but, with a few honourable exceptions, no attempts to provide an illustrated general survey of the textiles of the whole African continent.

This book aims to do just that, to present, region by region, the handmade textiles of West, North, East, Central and Southern Africa and to outline the techniques used to make them, some of which – such as stripweaving and cut-pile raphia embroidery – are virtually unique to the continent. The trade links established and the accompanying cultural and religious implications and their profound influence on textile production are also examined. Traditional textile techniques and uses have been maintained in many areas, while they have died out in others.

Strict job demarcation has been the norm. Usually men dominate commercial – and women domestic – production, but there have always been exceptions to this general rule. Indeed, in recent times, women in such countries as Egypt and Nigeria have become commercial weavers on looms hitherto the domain of men.

A visit to any African marketplace provides an assault on one's senses. Market women dressed in brightly coloured machine prints bustle through, carrying baskets of vegetables or bales of cloth. Villagers come to market wearing either the same colourful garb or more sober handwoven cloth, and very often a mixture of the two. It is these traditional, handcrafted, indigenous cloths that are the focus of this book.

Africa is a vast and varied continent that has long fascinated those born outside its bounds. Attracted by its wealth of minerals, animal products and manpower, traders and colonists, slavers and missionaries have, over the centuries, flocked to its shores by land and, especially, by sea. Traders had to overcome the difficult barriers of vast desert and dense forest that separated the populated areas.

Africa's peoples are of varied origin, from Arab and Berber descent in the north to Khoisan speakers and European colonists in the extreme south. There are Nilotic speakers in the north-east, but the vast majority of the population south of the Sahara belong to the Bantu language group.

All of Africa's population have the same basic clothing needs as the rest of humanity. They have to have some form of flexible material to protect themselves against the elements and usually a piece of fabric to cover the genitalia of both sexes and to ensure their modesty. Special garments are required for different stages of life, such as birth, circumcision, first menstruation, marriage, birth of a child, or death. Even those African cultures that do not mark any

INTRODUCTION
The Diversity of African Textiles

of the other rites of passage with a special ceremony often provide a traditional shroud for a burial.

North Africa is part of the Mediterranean world. Though inhabited for millennia by Berbers, it has been influenced by invasions of the Maghreb by Arabs and Turks. Egypt, which has always been the gateway for Asian cultural and religious influences to enter the continent, has experienced the same invasions, but, due to geographical proximity, has adopted Levantine ways. The Maghreb has a great tradition of weaving, with the Berbers and Arabs using horizontal, ground and vertical looms. Abundant sheep's, goat's and camel's wool is woven into lengths of cloth that is designed for men's and women's clothing, either tailored or simply draped and pinned. Embroidery is used for decoration in those areas subject to Arab, Turkish or European immigration or influence.

Historically, North Africa was cut off from the inhabited regions to the south by the vast Sahara desert. Though it is inhospitable, it is nevertheless home to nomads like the Tuareg and some groups of Arab pastoralists. Crossed by caravan routes such as those linking Timbuktu in modern Mali to Gabes in Tunisia, North Africa experienced heavy trading in such highly saleable products as precious metals, spices, dyes, salt, leather, ivory, beads and, sadly, humanity, in the form of slaves.

Islam came to West and Central Africa, largely by these caravan routes. It was brought to East Africa, relatively close to Arabia, by sea, but trade was again the primary force. It was very much to the advantage of newly arrived Muslim merchants to convert the locals, who would be working with the same code of ethics, a fact that was not lost on later Christian missionaries.

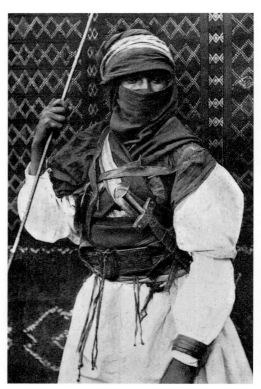

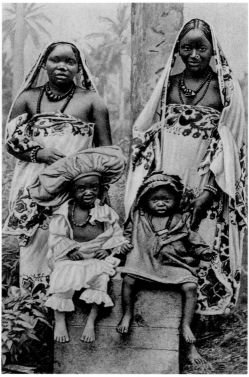

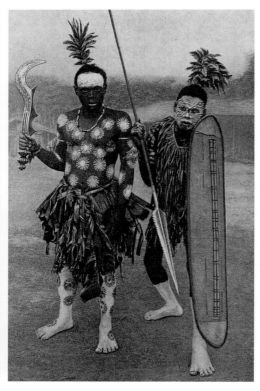

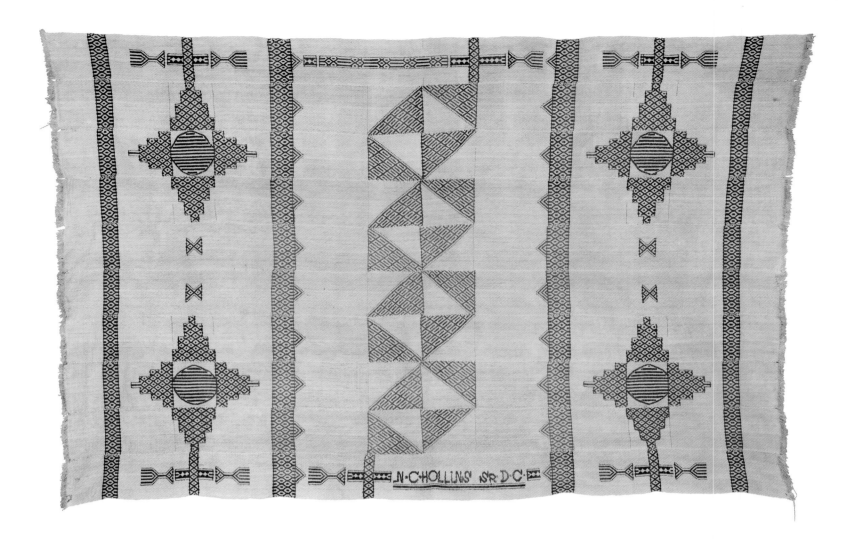

Conversion to Islam or Christianity had a profound effect on the clothing of sub-Saharan Africa. The Muslim faith has strict requirements of modesty for men and, especially, women. People whose clothing needs in a warm and humid climate had been minimal before the arrival of Islam – perhaps a breech-clout of bark cloth, often nothing at all – were, if converted, obliged to adopt clothing that covered the body in a modest fashion. Men who converted to the Islamic faith were often rich traders or political leaders within their own societies, and they in turn inspired imitation by others who may have not wished to adhere to the new religion, but who wanted to be associated with its prestige. So began the fashion for men of gown-like shirts, turbans and baggy trousers that can be seen in modern Nigeria, both in the Muslim north and in the predominantly Christian south. Conversion and the imitation of prestigious converts by others was a terrific stimulus to textile production. Weavers, dyers, tailors and embroiderers were now required.

PAGE 8
LEFT TO RIGHT Textiles from:
FIRST ROW Ghana, Mali, Mali, Mauritania. SECOND ROW Tunisia, Morocco, Egypt, Tunisia. THIRD ROW Ethiopia, Uganda, Ethiopia, Tanzania. FOURTH ROW The Congo, the Congo, the Congo, Cameroon. FIFTH ROW South Africa, Zambia, Madagascar, Madagascar.

OPPOSITE
TOP LEFT Warrior from Biskra, Algeria.
TOP CENTRE Swahili family group, East African coast. The women are wearing machine-printed *kangas* in pairs.
TOP RIGHT Warriors adorned with body paint parading before a battle, the Congo.
BOTTOM *Hizam* bridal girdle, woven on drawlooms in Fez, using the highly complex lampas technique.

ABOVE Prestige cloth consisting of tripod-loom woven cotton strips made for a British official in Sierra Leone.

The need for cloth to make this kind of clothing had increased manifold over traditional requirements and could not nearly be satisfied by expensive imports from North Africa, Asia or Europe. Neither bark cloth, nor skins nor furs were adequate for the job; woven cloth had to be provided. Locally made stripwoven cloth dating back to the 11th century has been found in the burial caves of the Tellem people in the Dogon area of Mali. Even though it is known that it was woven out of a local variety of cotton, the question of the exact type of loom used is still unanswered.

Though found to a very limited extent in other parts of the world, stripweaving as a method of manufacturing cloth is most characteristic of West Africa. Whole cloths are made up of very long and narrow strips that are cut into appropriate lengths and then sewn together, selvedge to selvedge. Recent research indicates that the Mande weavers of the Sierra Leone area were probably the first to master the art of incorporating complex supplementary-weft patterning into strips. In the city of Kano, indigo-dyed veils made up of the narrowest strips are beaten to give a metallic sheen, and are so highly prized by Tuareg men that, weight for weight, they are some of the most expensive textiles in the world.

The influence of the Europeans trading on the west coast of Africa from the mid-15th century on was also of great importance in encouraging demand for textiles, which was partially satisfied by foreign imports. There was also a market for African woven cloth from a different region, which could be bought from the sea-borne traders. In many places this demand encouraged the weaving of 'country cloths' in the West African interior. They were taken up to the coast to sell to the Europeans, who would trade them along the coast.

The European traders bought slaves and gold in exchange for a range of European industrial products, such as alcohol and even dried fish. The Portuguese, Dutch, British and other northern Europeans built forts along the Gold Coast (modern Ghana). In the mid-18th century the Dutch recruited troops there to fight their colonial wars in Java, and on their return they are reputed to have introduced into West Africa a taste for Javanese wax-resist textiles. Modern-day Ghanaian women swathe themselves in brightly patterned wraps, usually wax-printed factory-made batiks of Dutch or local origin.

In Central Africa and parts of East Africa, bark cloth is still worn for prestigious ceremonial occasions both in

Uganda and amongst the Pygmies and the Kuba of the Congo. The Baganda people of Uganda were reputed to have made almost fifty different types of bark cloth, which was used as clothing and bedding.

In East and Southern Africa, the weaving tradition was much less developed than in the rest of the continent and was in many places wholly absent. Throughout these regions there was a heavy reliance on animal skins, leather and bark cloth to fulfil the often minimal clothing requirements. Clothing made from imported textiles, or at least woven locally with imported technology, allowed local inhabitants to comply, for the most part, with concepts of modesty adopted from conversion to either Christianity or Islam. For instance, there was always a large market for Asian textiles in East Africa, particularly Indian block-prints, and anything that was woven locally was produced on Asian-style looms. In the 20th century, machine-woven and printed women's wraps called *kangas* became popular,

featuring bold colours and designs that often sported Swahili proverbs.

There was also a good market for mill cloth in Southern Africa, particularly the English 'Manchester' prints. As in East Africa, beadwork was extremely popular. Both areas had a long tradition of decorating belts, aprons and cloaks with little discs cut from materials such as ostrich eggshells, so the use of imported beads to decorate the same garments seems like a natural progression. Beads came from sources such as Indian merchants in Zanzibar or from Christian missionaries.

The Zulu and Basotho peoples were famous for their beadwork belts and aprons, while the Ndebele started a fashion for complex beadwork aprons and collars in the 1920s, perhaps as a reaffirmation of their cultural identity after their land was taken from them.

Traditionally made textiles have in many parts of Africa been superseded by factory-made cloth, which is often

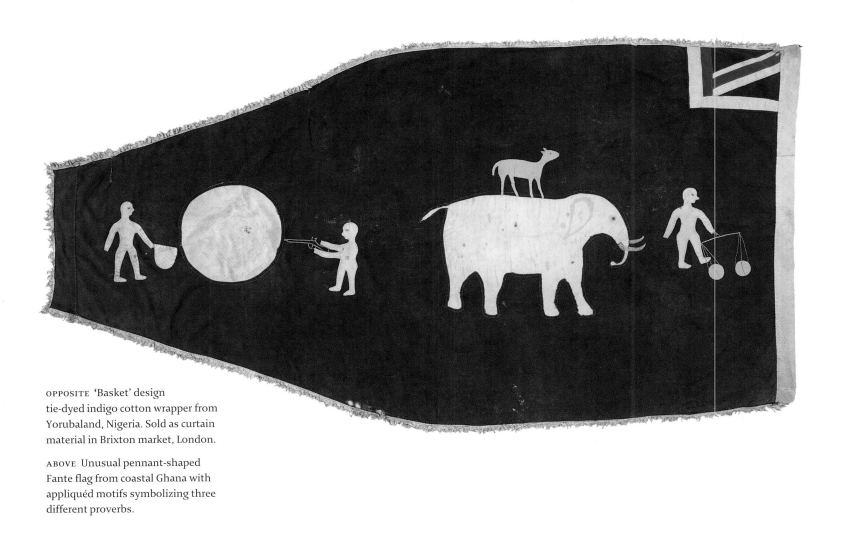

OPPOSITE 'Basket' design tie-dyed indigo cotton wrapper from Yorubaland, Nigeria. Sold as curtain material in Brixton market, London.

ABOVE Unusual pennant-shaped Fante flag from coastal Ghana with appliquéd motifs symbolizing three different proverbs.

preferred for its brightness of colour and ease of washing. It is considered fashionable and modern, and can be tailored easily to create clothes on the Western model.

Nevertheless, there are two main factors in preserving the African handcrafted clothmaking tradition. First, it is still considered essential that traditional cloths are worn at change-of-life ceremonies in general and at funerals in particular.

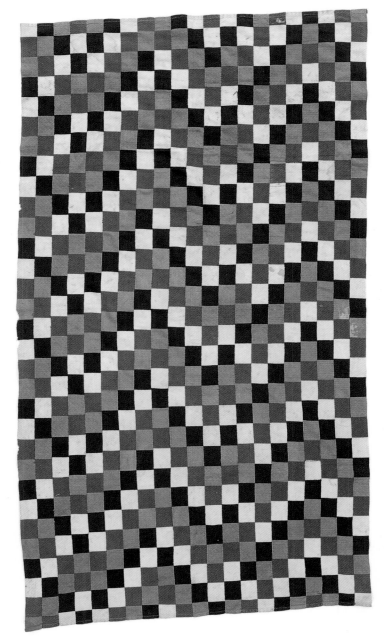

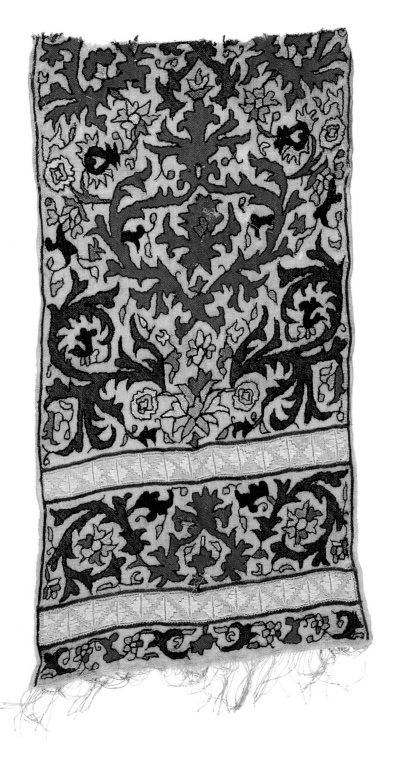

Second, fashion has an important role to play. When textiles such as *bogolanfini* mud cloths from Mali become fashionable in the West, this trend influences the clothing habits of the local urban élite. Fine fabrics will continue to be produced by African weavers, dyers and embroiderers as long as there is a local market for them. Although export orders and tourist-orientated production help to keep these craftspeople in work, it is essential, if standards are to be maintained, for there to be local demand for their products. However, traditional beliefs are still very strong in many places. It is hoped that traditional textile producers will be kept in work for the foreseeable future.

OPPOSITE

LEFT *Tanshifa* 18th-century Algiers counted thread embroidered scarf with motifs of wild flowers. Worked in silk on linen.

RIGHT Chequerboard Ewe man's cloth woven at Keta or Agbozume, Ghana.

RIGHT Woven raphia woman's wrap of the Bunda people, Idiofa region, the Congo.

BELOW *Arid* chest or bed cover embroidered in silk on linen from Chefchaouen, northern Morocco. Both this urban style and examples in a more free-form rural design were, by the beginning of the 20th century, but a distant memory in their place of origin.

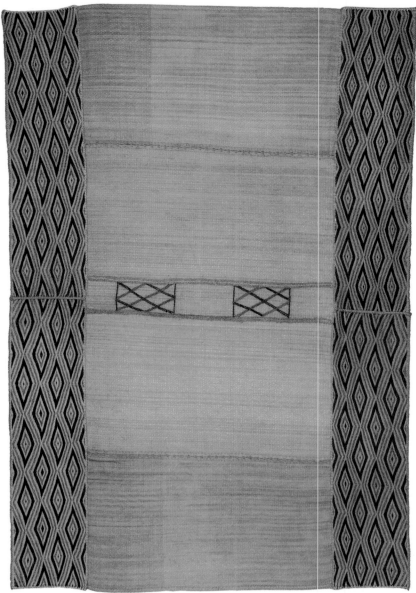

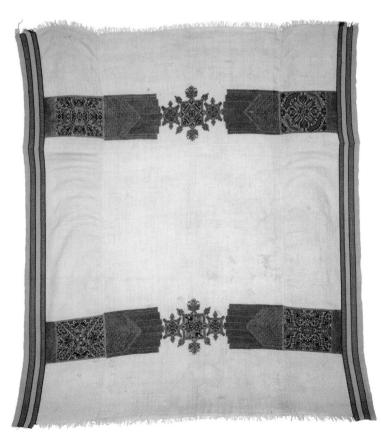

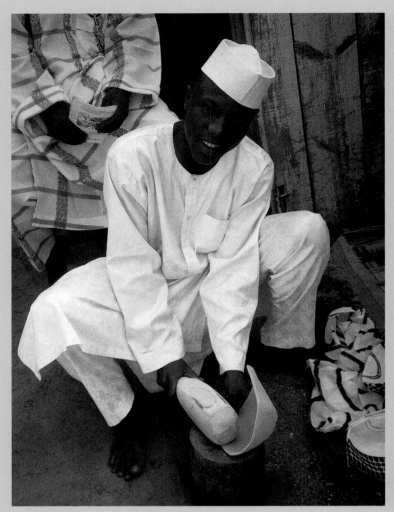

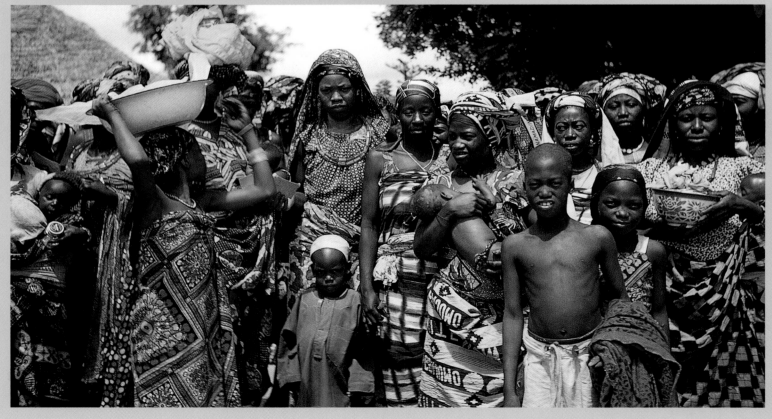

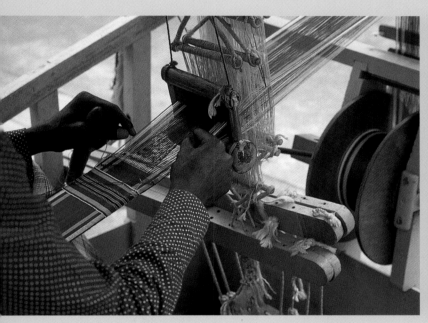

WEST AFRICA

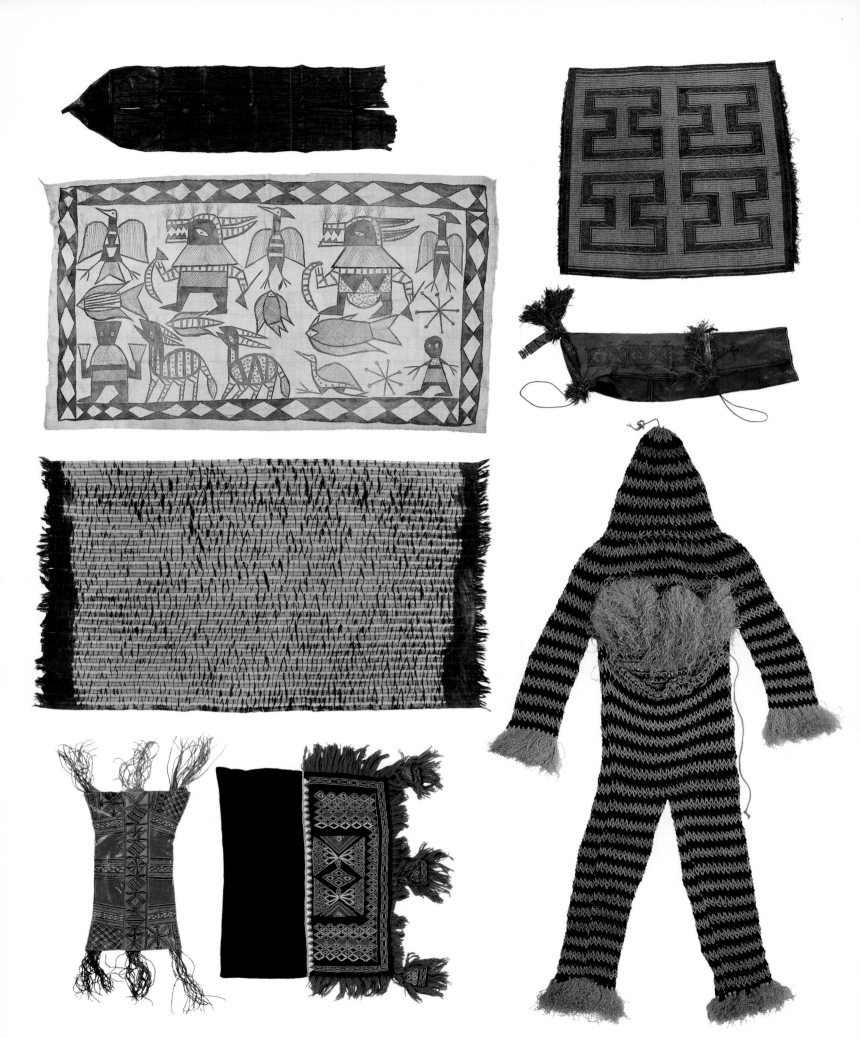

Introduction

WEST AFRICA

PAGE 16
TOP LEFT A cap-maker from Kano, northern Nigeria.
TOP RIGHT A young tailor sewing finely woven Ewe cloth, Ghana.
BOTTOM Nigerian women wearing a variety of body wraps, some hand-made, others machine-printed.

PAGE 17
LEFT An Ashanti weaver weaving strips for *kente* cloth.
RIGHT Spindles of handspun cotton, Mali.

ABOVE Wodaabe woman's embroidered cotton blouse, Niger.

OPPOSITE, CLOCKWISE FROM TOP LEFT
TOP LEFT Glazed, indigo-dyed Tuareg veil from Kano, Nigeria.
TOP RIGHT Tuareg mat of leather-bound reeds, Mauritania.
SECOND RIGHT Tuareg leather grain bag with painted 'lucky' designs.
BELOW RIGHT Masquerade costume of grass-netting, Cross River, Nigeria.
BELOW CENTRE Tuareg embroidered panel, central Sahara.
BELOW LEFT Tuareg painted leather cushion, Mali. THIRD LEFT Strip-weave from Burkina-Faso. SECOND LEFT Painted Senufo stripwoven cotton cloth from the Ivory Coast.

West Africa, stretching southwards from Mauritania to Sierra Leone and then eastwards along the Bight of Benin to the Nigerian border with Cameroon, is, in many respects, the heartland of African textile production. Indigo dyeing is practised to a greater or lesser extent both in the coastal regions and further inland. Resist techniques – tie-dye, stitched and folded resist, wax batik and starch resist – are common modes of surface decoration. Narrow strips from 2.5 cm (1 in.) to 45.70 cm (18 in.) wide are woven by men throughout the region to be sewn together, selvedge to selvedge, to form garments for men and women.

Cotton is the main textile, though in the not too distant past raphia (the dried stripped leaves of the raphia palm) was in widespread use. Undyed wild silk is spun in Nigeria, both for embroidery and weaving. A broad, upright loom is used by women to weave plain or warp-striped cotton cloth in southern Nigeria.

West Africa is by no means cut off from external influences. Kano, the ancient trading city of northern Nigeria, was visited by the noted Arab traveller Ibn Battutah in the 14th century. He remarked upon the indigo dye-pits of Kofor Mata, which, nearly seven hundred years later, are still in use. The whole region is greatly influenced by two major 'world' religions, Islam and Christianity. From the 11th century on, Islam was adopted via merchants from the caravan routes from North Africa, often for the practical reason that it made trade easier if both parties conformed to the same moral, religious and ethical code. Christianity was a relative newcomer, arriving in coastal districts with the Portuguese caravels that sailed around Cape Verde in the 1450s and landed by the Gambia river. Over the next five centuries Christianity spread along the coast and, at the end of the 19th century, inland, as British and French colonial power extended into the hinterland.

It is well known that the European traders – the Portuguese, soon followed by the British, Dutch, French and even the Brandenburgers and Danes – were attracted by gold, ivory and slaves. A vast trade arose, often based on the classic triangular pattern of consumer goods going from Europe to the West African coast, slaves to the Americas and rum and sugar back to Europe. There were many variations on this trade, with products often coming direct from North America to West

Africa, but the essentials remained the same. European and North African fabrics were major trading items on the coast. In addition, locally woven cloth was bought to be traded further along the littoral. It is important to mention specially made cloths, such as the *Pano d'Obra*, woven by enslaved weavers on the Cape Verde islands, which were so desirable and standardized that they functioned as monetary units.

Local cloth production on the coast and in the near interior was stimulated by external trade, but, in the hinterland, the adoption of Islam by the courts, rich merchants and others of influence had a more profound and long-lasting effect. On the humid coast and in the hot dry interior, there is little need for protective clothing. However, the introduction of Islam – with its requirements for male and, particularly, female modesty – engendered a vast market for woven cotton cloth. The wide shirts, trousers and head-dresses – normal Muslim attire of Middle Eastern influence – were worn not only by men who converted to Islam, but also by non-converts wishing to emulate the prestige of the Muslim community, who simply adopted their attire, but not necessarily their religion. Women conformed to the strictures of the new religion by adopting a range of voluminous wraps.

Similar requirements of modesty were demanded by Christianity, but, as the religion arrived comparatively late, they were often met from imported, rather than locally woven, cloth, though most local needs came from local sources. The requirements of the two 'world' religions stimulated local production, mainly of stripwoven cloth.

The origins of creating a cloth by means of sewing strips together, selvedge to selvedge, are obscure, though there are both Asian (Uzbek Gudgeri) and North African (Berber flat weaves) precedents. Whether stripweaving is an adaptation of a technique that crossed the Sahara or is indigenous to West Africa is a matter of speculation, though evidence from the caves of the Bandiagara escarpment in Mali suggests it was practised in West Africa as early as the 11th century.

It is not known how long the Fulani of the Niger Bend have been weaving their woollen stripweaves, but, as they are of Berber origin, it is highly likely that they absorbed influences and weaving technology from North Africa. By the 18th century, complex stripweaves were being created in Kong in the present-day Ivory Coast. The neighbouring Ashanti were at the same time creating a powerful kingdom based on gold around the city of Kumasi. The wealth afforded by the gold

RIGHT
TOP LEFT Picking indigo leaves for dyeing, Oshogbo, Nigeria.
BOTTOM LEFT Skeins of wild silk for sale in Kano market, Nigeria.
RIGHT Spindles of handspun cotton and indigo-dyed veils wrapped ready for sale in Kano market, Nigeria.

OPPOSITE
TOP Early 20th-century meeting of a 'secret society', Cross River, Nigeria.
BOTTOM LEFT A Nigerian village trader selling handwoven cloth.
BOTTOM CENTRE A Hausa shopkeeper selling synthetic indigo balls, Kano, Nigeria.
BOTTOM RIGHT A Hausa trader selling indigo-dyed veils in Kano market.

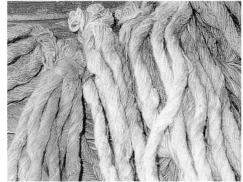
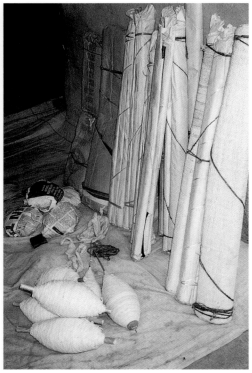

trade enabled the Ashantahene (the king) and the Ashanti court to commission sumptuous and densely patterned stripweaves from the main source for royal textiles, the weaving village of Bonwire. The Ewe, located in south-eastern Ghana and Togo, and also the Yoruba of Nigeria, are very sophisticated stripweavers. Nigeria is also home to the vertical loom, on which women weave.

Indigo dyeing is one of the main means of colouring cloth in West Africa. The deep-blue hue is esteemed from the Senegal river down to the Cameroon border. *Lonchocarpus cyanescens* is the main plant for indigo dyeing. Various methods are used to prepare the indigo: either fresh leaves are steeped in a wood-ash lye in vats or in deep pits, covered with lids, that are set into the ground; or balls of dried leaves kept back from harvest or acquired through trade are used. Indigo-dyed cloths and clothing are still very popular, whether dyed in natural or synthetic indigo. However, it is mill-woven cloth, either locally made or imported, that provides the bulk of everyday wear. Western models of clothing, often with regional modifications, are in vogue, for both women and, particularly, men.

Two factors help to preserve the African handcrafted clothmaking tradition. First, traditional cloths are still

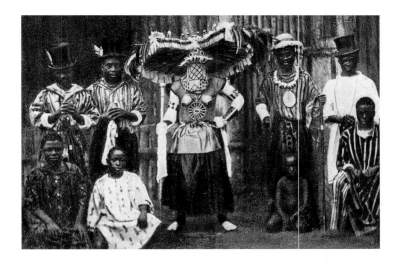

deemed essential for change-of-life ceremonies in general and for funerals in particular. Second, cloths such as the *bogolanfini* mud cloths of Mali became fashionable in the West, which in turn influences the local urban élite. African weavers, dyers and embroiderers will continue to produce fine cloths as long as there is a local market for them. Standards will decline if craftspeople have to rely only on export orders and tourist-orientated production. The textiles required for traditional, change-of-life ceremonies will, it is hoped, keep traditional textile producers in steady work for many years.

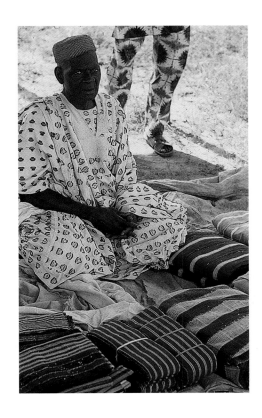

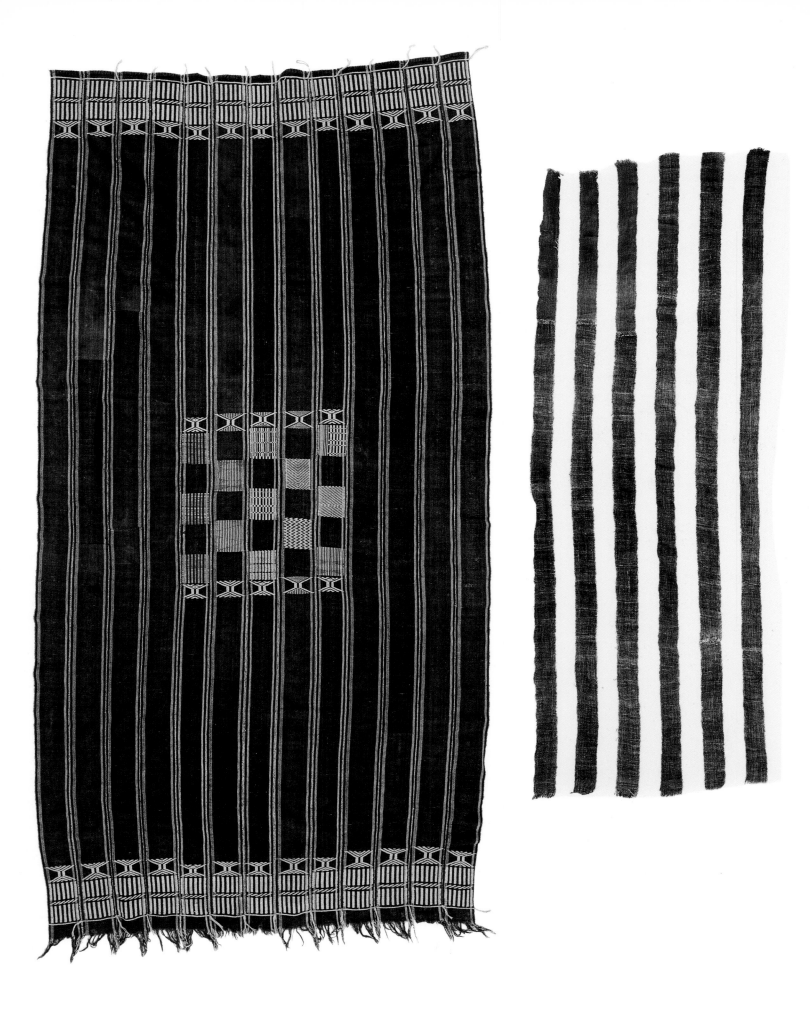

Stripweaves

Cloths made up by sewing two or more widths together, selvedge to selvedge, are found in many parts of the world, reflecting the ease with which cloth the width of a weaver's cubit can be woven on a narrow loom. However, it is only in West Africa that cloth is assembled by weaving on double-heddle looms in very long strips from 2.5 to 45.70 cm (1 to 18 in.) wide. They are then cut into requisite shorter length strips and sewn together to form a large rectangular wrap. Evidence of 11th-century garments made up of cotton stripweaves by the Tellem people has been found in Mali.

Woollen blankets are woven in Mali, but in other parts of West Africa cotton, silk or rayon strips are usually woven to form a voluminous toga-like garment or a tailored robe for men and a smaller cloth for women. The stripweave *kente* cloths of the Ashanti and *adanudo* cloths of the Ewe tribes of Ghana have a distinctive chequered appearance, which is achieved by alternately weaving a warp-faced section (showing the longitudinal stripes of the variously coloured warp threads) and then a weft-faced section (appearing as a horizontal band). An extra pair of heddles is used with the warp threads grouped in sixes so different sheds can be opened for weaving the weft-faced sections. Supplementary weft floats introduce motifs depicting animals, combs, hands and geometric devices into the warp-faced sections.

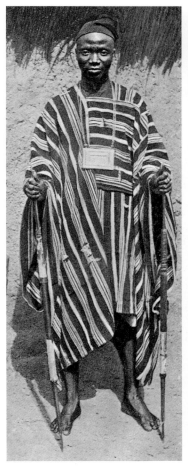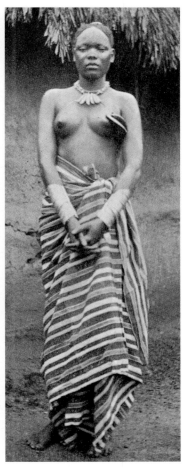

OPPOSITE
LEFT Stripwoven man's cloth woven from indigo-dyed cotton thread with white cotton decorative details, Ivory Coast.
RIGHT Simple stripwoven cloth from north-east Nigeria that alternates white and indigo-dyed cotton strips.

ABOVE LEFT AND RIGHT A Mende chief and his wife from Sierra Leone wearing warp-striped cloth.
LEFT Reed-beaters from Ewe looms, Ghana.

23

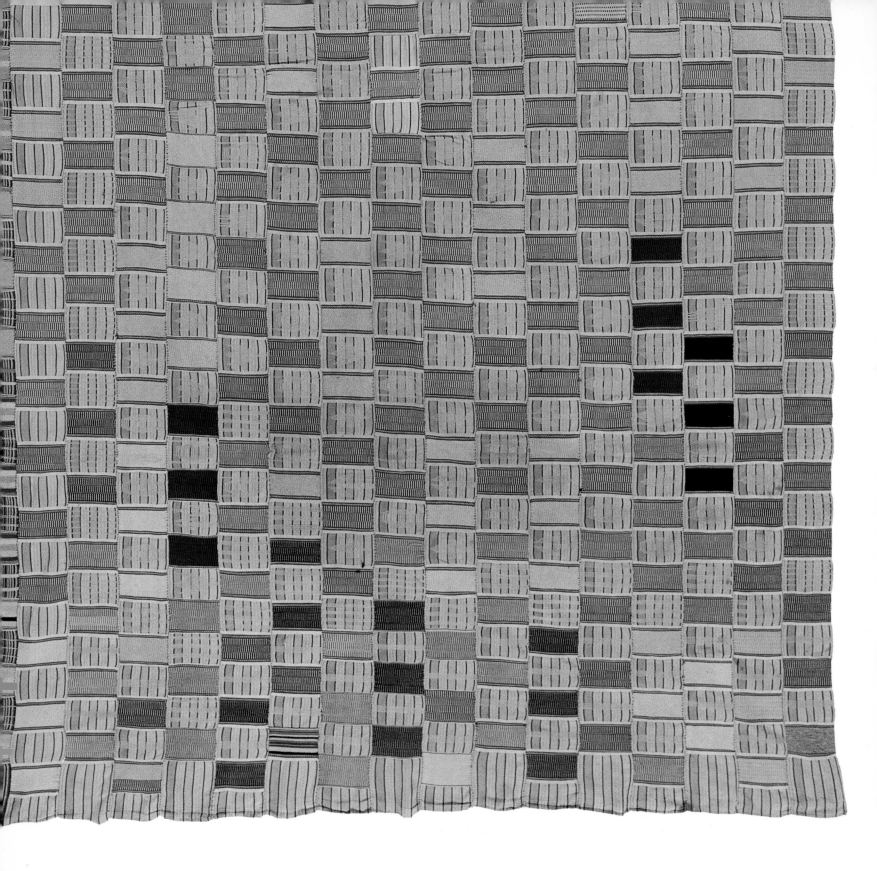

ABOVE Ewe man's cloth with fine
weft insert patterns stripwoven
in the Kpetoe district, Ghana.

OPPOSITE
TOP Prestigious Ewe chief's cloth
stripwoven in south-east Ghana.
BOTTOM Country cloth of
handspun, stripwoven cotton,
Sierra Leone.

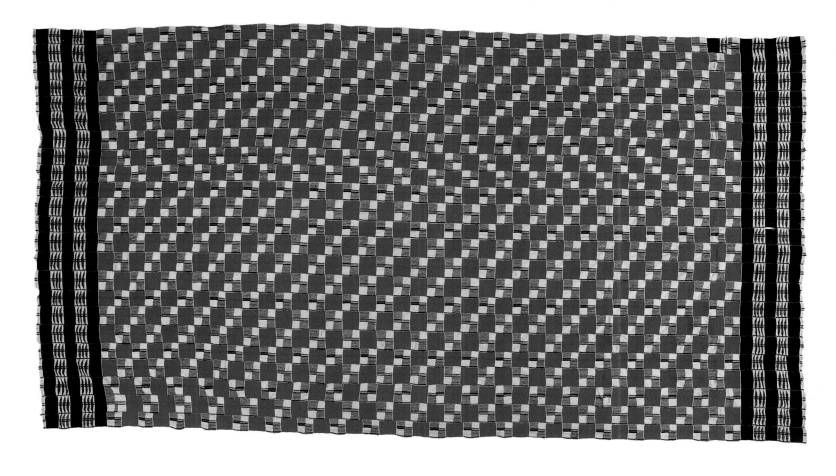

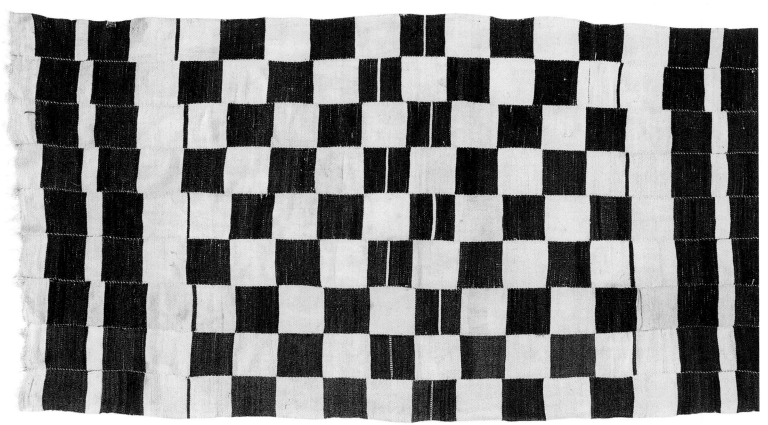

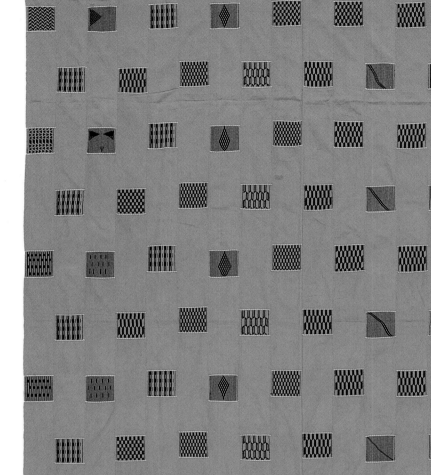

ABOVE Drawing showing alternating warp-faced and weft-faced weaves.
RIGHT Baulé stripwoven man's cloth, Ivory Coast.

OPPOSITE *Kente* cloth woven out of rayon on a narrow loom at Bonwire village, Ghana. Very long strips are woven and then cut to size and sewn, selvedge to selvedge, to make up the cloth. Both the weavers and sewers are men.

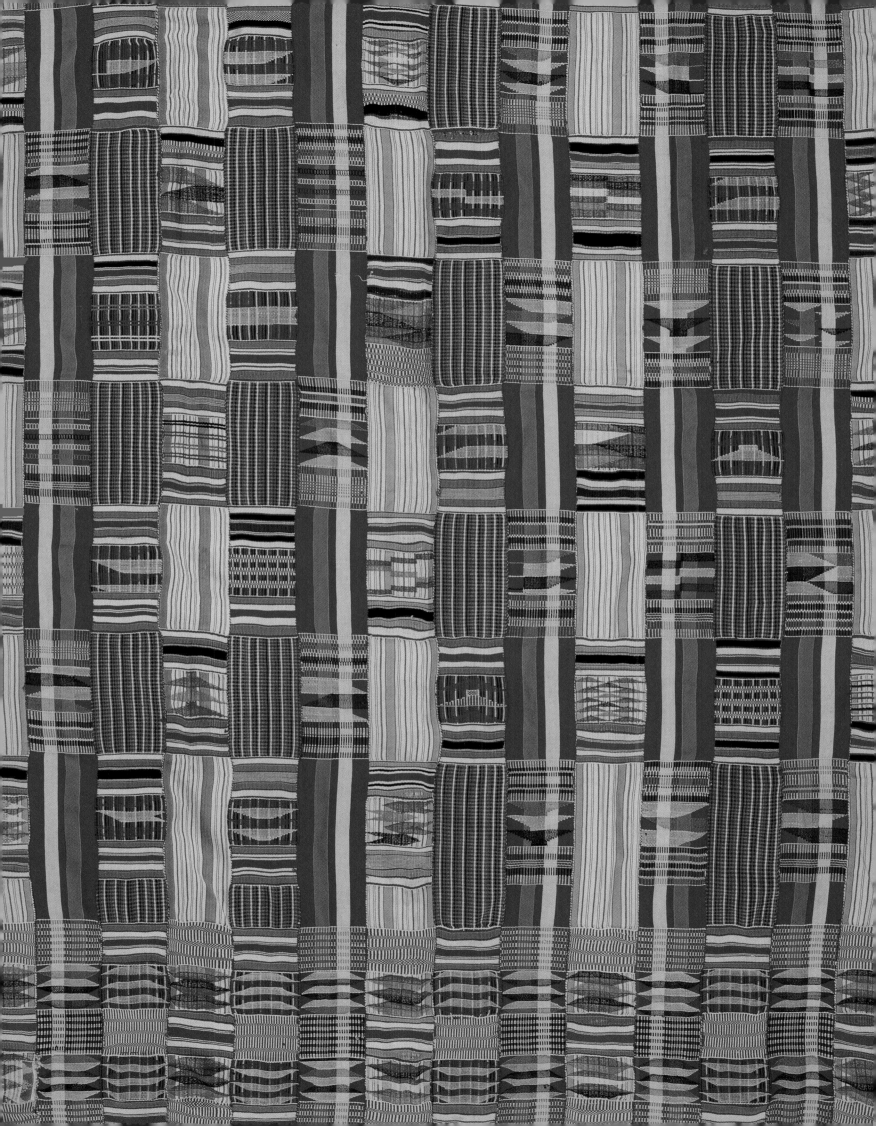

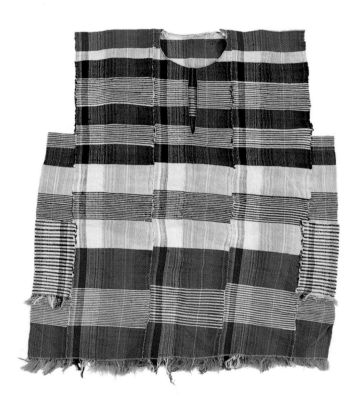

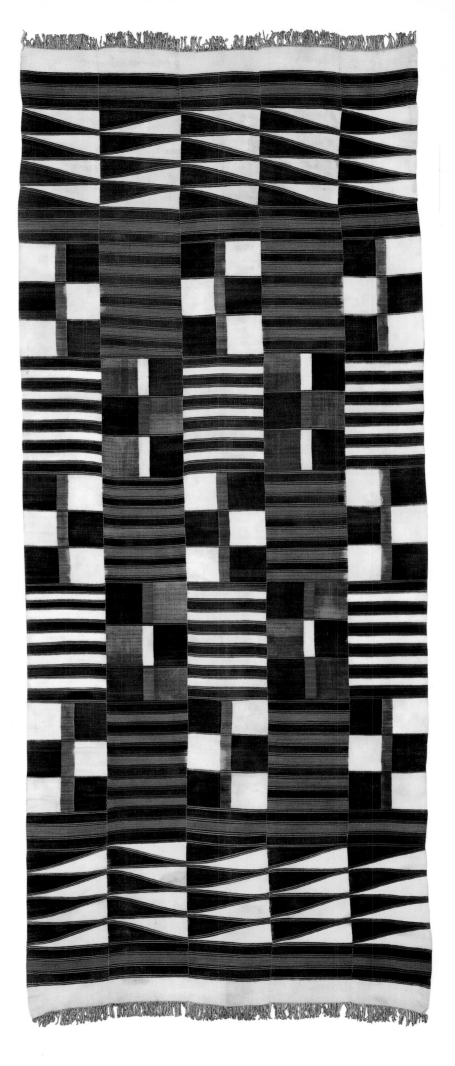

ABOVE Limbe boy's stripwoven cotton smock, Sierra Leone.
RIGHT *Kpokpo* prestige hanging, stripwoven on a tripod loom, Vai or Mende people, Sierra Leone.

OPPOSITE
LEFT Chequered cotton country cloth woven on a tripod loom, Sierra Leone.
RIGHT Chief's stripwoven hammock, Mende, Sierra Leone. Before roads were built, a common form of conveyance was a litter or hammock carried by four strong men.

The tripod loom stripweaves of Sierra Leone and Liberia

The Mande weavers of Sierra Leone and Liberia are reputed to be some of the first to use the stripweaving technique. They were certainly some of the first people in the West African littoral to convert to Islam and it is possible that the stripweaving technique and Islam spread hand in hand eastwards from there. Although the Mende (a sub-group of the Mande) and other weavers of the region weave multi-coloured cloths, their most famous cloths are relatively austere creations in black and white. Much has been destroyed in the vicious civil wars that have afflicted the region, but weavers are once again starting to use their tripod looms. Today, however, they are forced to replace the former natural handspun cotton with synthetic fibres.

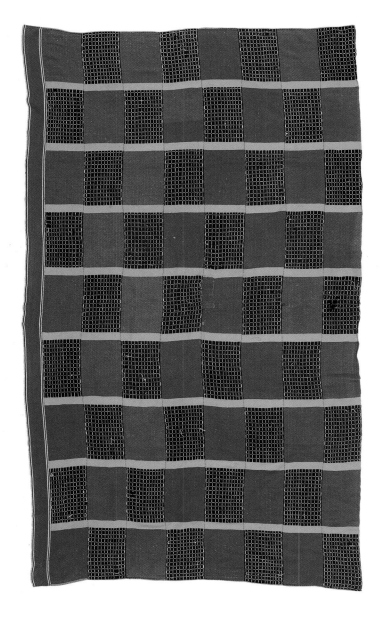

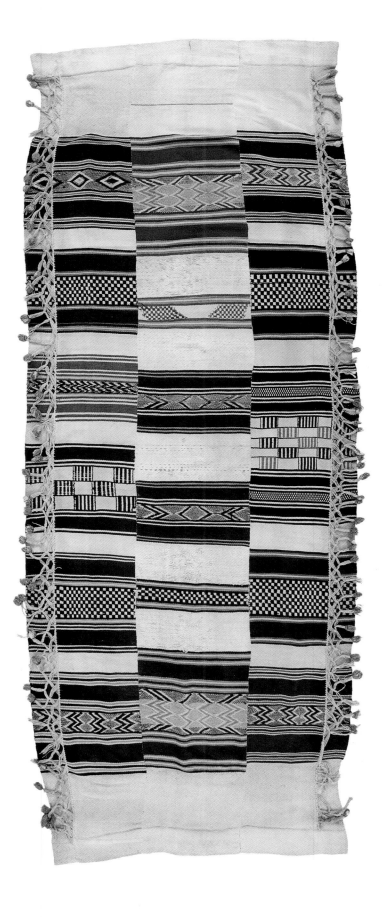

The use of a tripod loom is unique to Sierra Leone and Liberia. As with most looms in the stripweaving genre, it is portable, an essential attribute in a region where the population is scattered and the weaver has to take himself to his work. He is paid in kind, often in foodstuffs that he consumes on the spot. As observed in the town of Bo, the Mende weaver stretches out his warps 9–12 metres (30–40 feet) long, wound around two end batons that are tied to two stakes. He then commences work beneath the shade of a large tree or house. What is unique in this method is that the mechanical parts of the loom move along the warp as the weaving process progresses, rather than being in a fixed position (with the weaver winding on the finished web round a beam and drawing the unwoven warp threads towards him). The twin sets of heddles of the loom are suspended from a tripod. Leashes run down from them through the warps to two foot treadles that are merely short, stout sticks inserted into loops at the end of the leashes. The reed/beater lies on the warps and is equipped with a handle. As the weaving progresses, the reed and the tripod with its heddles, leashes and treadles merely moves down the warps. When enough cloth has been woven to complete the commissioned cloth, the weaver moves on to a new location.

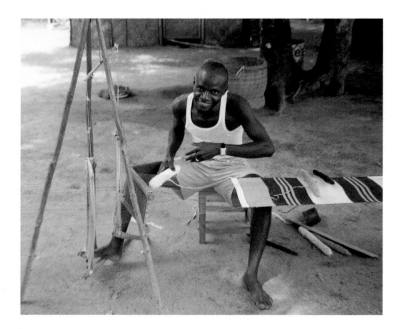

LEFT Mende master-weaver working at his tripod loom, Bo, Sierra Leone.
TOP Mandingo traders, Liberia.
ABOVE Mende girl, Sierra Leone.

OPPOSITE Country cloth woven on a tripod loom with supplementary weft motifs of birds and geometrical devices from Sierra Leone or Liberia.

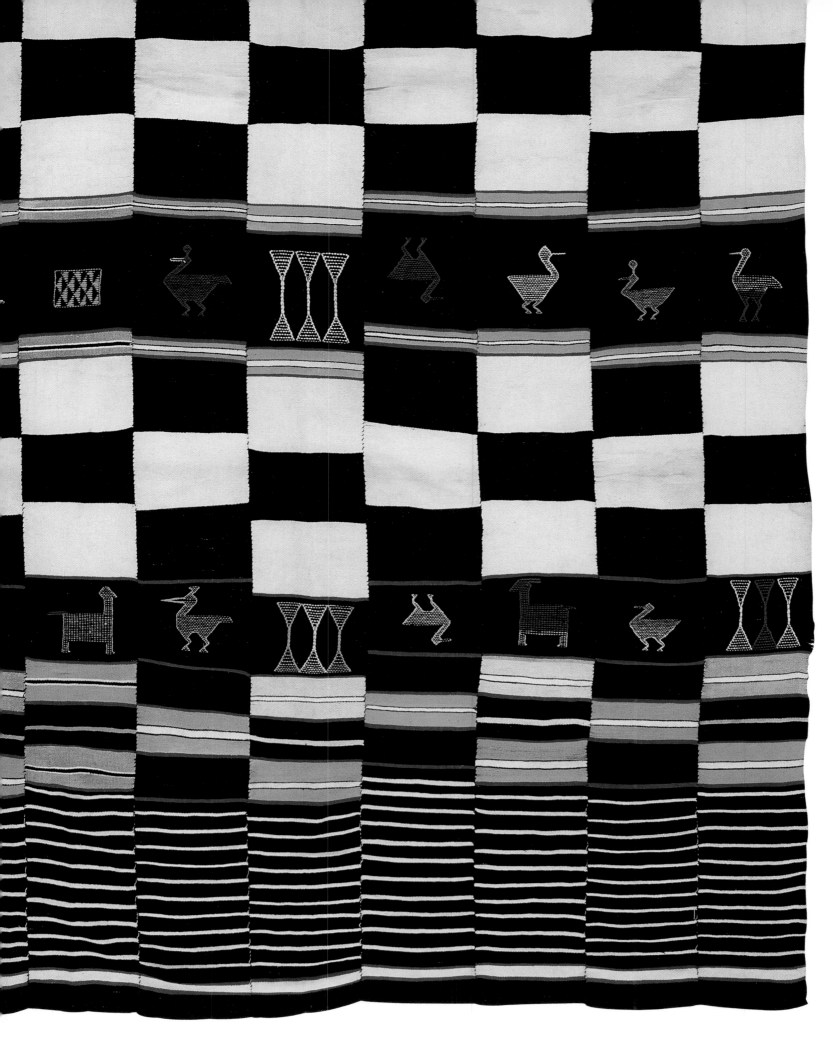

Ashanti stripweaves

The Ashanti were the dominant people of West Africa's Gold Coast. Controlling the only source of gold available to pre-Columbian Christendom, they prospered through trade with Portuguese, Dutch, British and other European traders. They believe they acquired the knowledge of the stripweaving technique from Kong weavers from the present-day Ivory Coast. The Ashanti weave their famous *kente* cloths in cotton or silk. However, since the 1920s, the majority of *kente* cloths have been woven in rayon. The term *kente* is not used by the Ashanti themselves, but may have derived from the Fante word *kenten*, meaning 'basket'. It refers to the chequerboard appearance of the cloths. Although cotton is grown locally, there are no silk-moths indigenous to Ghana. Silk yarn was obtained in two ways. Either Italian waste silk was brought down by camel caravan across the Sahara or silk cloth was bought from European traders on the coast and then unravelled for its yarn.

Blue, green, yellow, red and magenta are typical colours used for the main body of the voluminous toga-like wraps worn by men, with contrasting colours for the weft-faced and floating supplementary-weft details. Usually *kente* are woven in silk or rayon, but simple mourning cloths were made in white and indigo-blue dyed cotton. Women wear a pair of smaller cloths with a pattern that resembles the one worn by men.

The Ashanti only use geometric non-figurative motifs in their weaving. Each motif has a proverb associated with it and the cloth as a whole is given a name such as 'Liar's Cloth' or 'Waterboatman'.

Ashanti weavers sit in a carpenter-made frame loom with foot treadles (discs of calabash or, nowadays, of rubber sandal clasped between their toes) operating two pairs of heddles, sometimes with an extra pair of heddles if any complex supplementary work is required.

One set of the main heddles is rigged up so that the warp threads can be normally spaced, for the warp-faced sections of the strip. The other set gathers the warps into groups of six, which, with the use of thicker weft threads, means

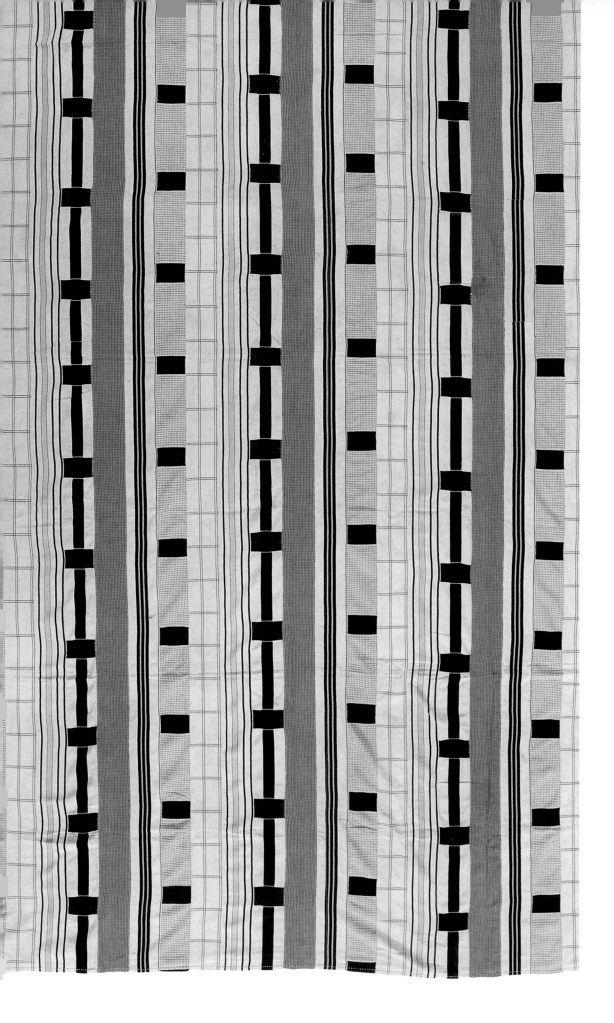

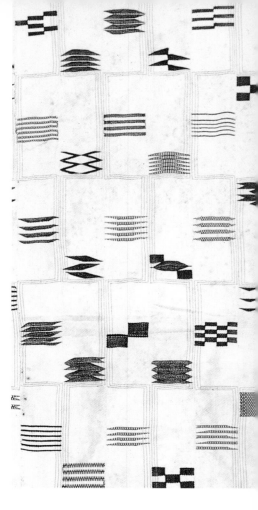

OPPOSITE String heddles from an Ashanti loom with calabash gourd foot grips.

LEFT *Mmaban n'toma*, man's cotton cloth, woven on a narrow loom near Kumasi, Ghana.

TOP Liar's Cloth, in which blue warp threads are taken down the length of the strip in a stepped fashion.

ABOVE A chief from the old Gold Coast (modern Ghana) in ceremonial dress with gold insignia of office.

that the weft predominates and a weft-faced block is woven.

The warp, often 61 metres (200 feet) long, lies out in front of the weaver with the end tied to a stone mounted on a wooden sledge. In this way the warp is made taut. As the weaving of the strip proceeds, the weaver winds the completed part of the strip around the breast beam.

Kente cloths are made up of 16–24 strips, cut to size, then sewn, selvedge to selvedge. Both weaving and sewing are traditionally carried out by men. Cloths for women are smaller and worn in pairs wrapped tightly around the body. Those for men are much bigger and are draped, toga-like, around the body.

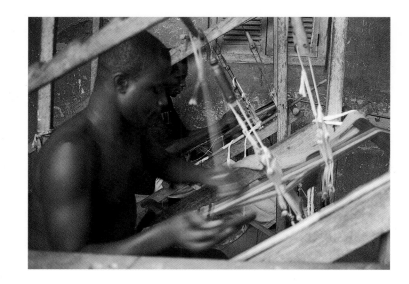

ABOVE An Ashanti weaver at Bonwire in Ghana using a double-heddle loom to weave narrow strips that are then sewn together to make *kente* cloth.

BELOW Woman's silk *kente* cloth, Ashanti, Ghana.
OPPOSITE Woman's rayon *kente* cloth with fine silk details woven at Bonwire village, Ghana.

PAGE 36 Man's *kente* cloth woven out of cotton with silk details. The cloth is named *akyempim* (One Thousand Shields), indicating that the wearer is fearless.

PAGE 37 Man's *kente* cloth woven out of rayon on a narrow loom at Bonwire village, Ghana. Long strips are woven by men and then cut to size and sewn selvedge to selvedge.

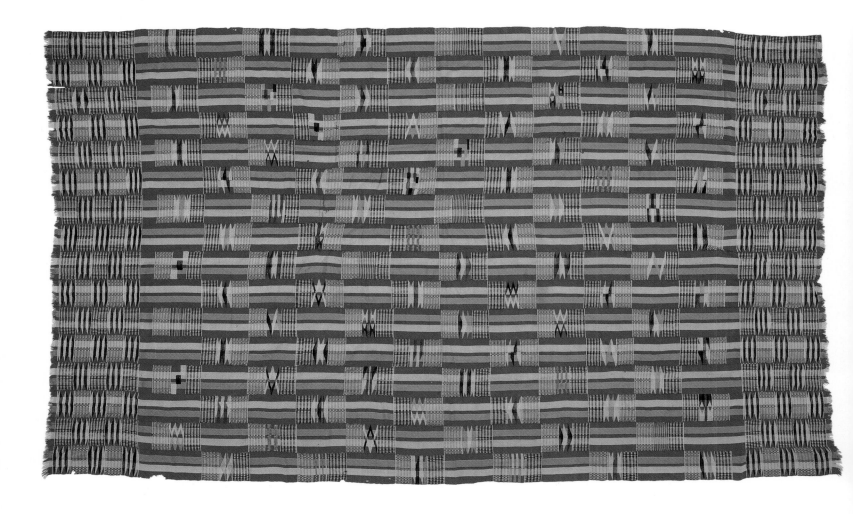

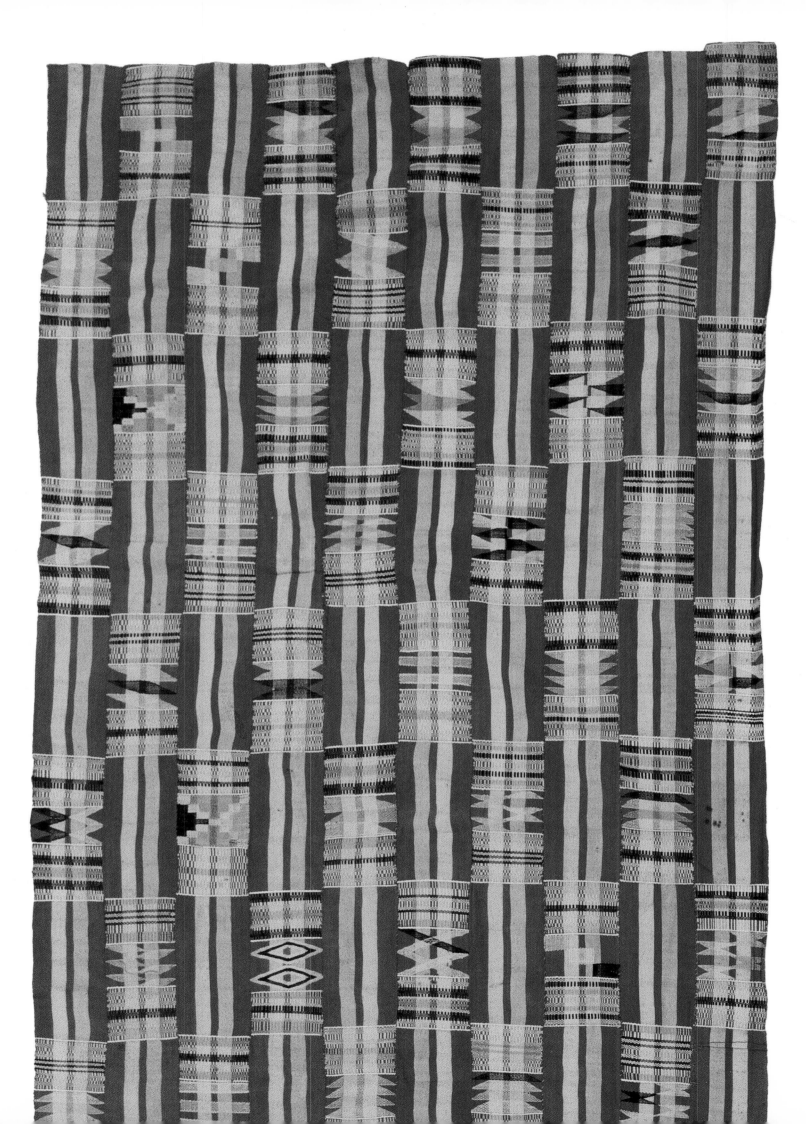

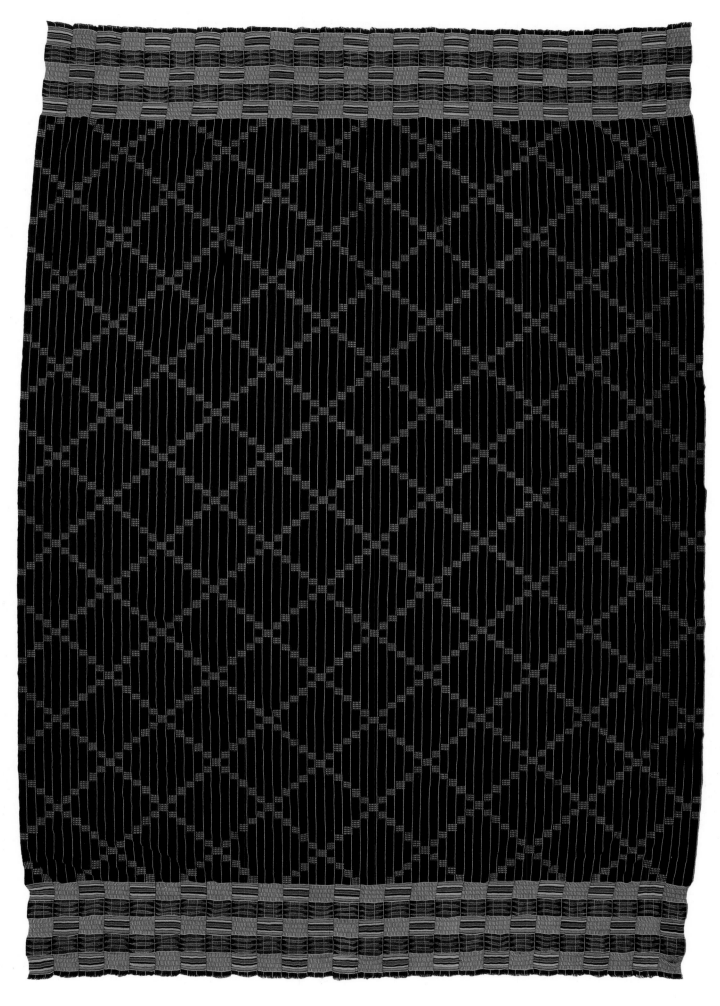

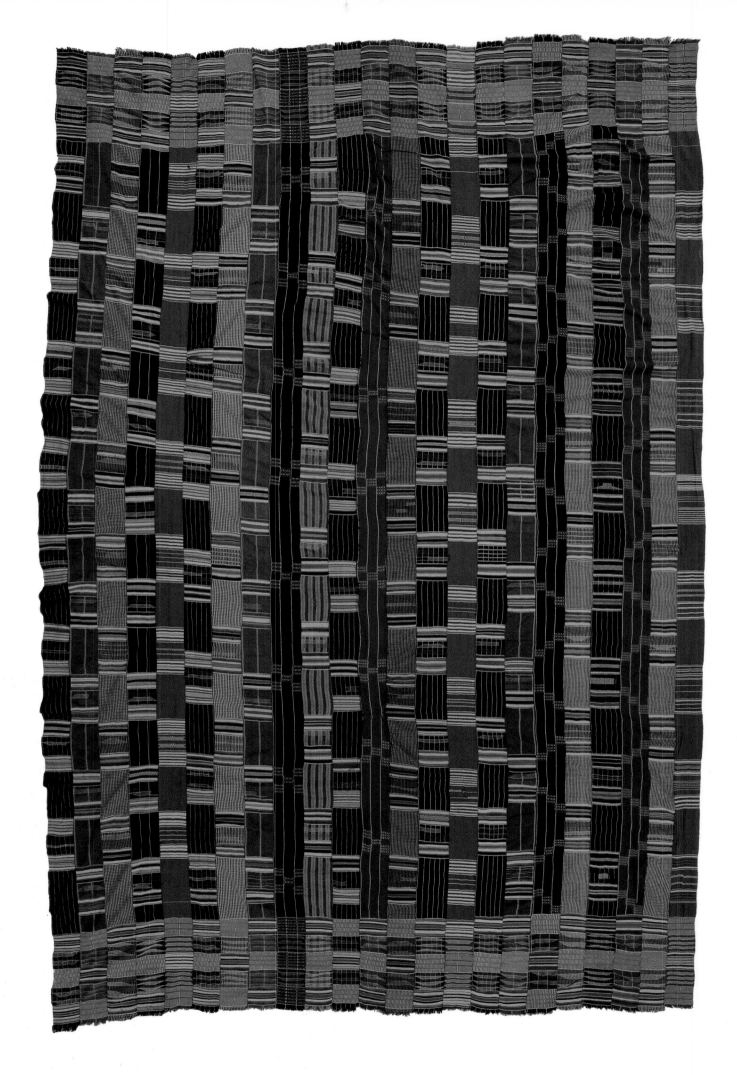

Ewe stripweaves

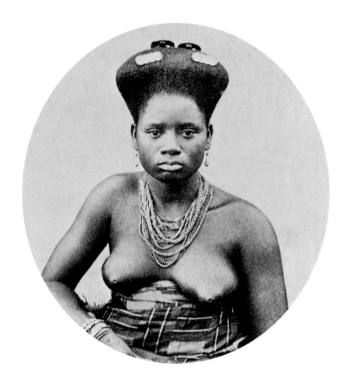

chiefs and elders, with floating weft motifs being introduced into the warp-faced blocks. Knives, hands (what we have we hold), keys (to the castle), chief's fly whisks and even musical instruments are typical. Each has a proverbial meaning.

The Ewe weavers use the same technique as the Ashanti (see page 32). They sit in a carpenter-made frame loom with foot treadles operating two pairs of heddles. If any floating weft work is required, it is added by hand. The weaver often works from a drawing on paper.

One distinguishing feature of Ewe weaving is the way that the threads used for the weft-faced blocks are often made up of filaments of two or more different colours twisted together, which gives a variegated effect.

Ewe cloths consist of 16–24 strips, cut to size, then sewn, selvedge to selvedge. Both weaving and sewing are done by men.

see page 32

ABOVE Akan woman of the old Gold Coast wearing an Ewe stripwoven waist wrap.
BELOW Woman's *keta* cotton cloth stripwoven in Agbozume by Ewe weavers, eastern Ghana.
OPPOSITE Men's *keta* cloth woven in the Kpetoe district by Ewe weavers, eastern Ghana, on narrow looms by men.

Ewe weavers are acknowledged to be some of the most skilful in West Africa. Indeed, they are in such demand that they can to be found working as far away as Lagos and Ibadan in Nigeria. Versatile and adaptable, they weave in three areas of south-east Ghana: at Agbozume and around the Keta lagoon; at Kpetoe; and up around Kpandu. Although examples of the Ewe's work can be seen across the border in Togo and, with their relatives the Fon, in Benin – both weave in a similar style – the best work is probably in Ghana.

Traditionally, the Ewe have always woven in cotton, though nowadays much of their production is in rayon, in strips, following the Ashanti style, for export to the Afro-American market.

What distinguishes traditional Ewe weaving from that of the Ashanti is the use of cotton rather than silk or rayon and the introduction of floating weft patterns of a figurative nature into some of the warp-faced sections of a strip. Much Ewe work is plain chequered cloth made up of strips sewn selvedge to selvedge, with warp-faced blocks alternating with weft-faced blocks in each strip, as is the case around the Keta lagoon. Around Kpetoe, weaving follows the Ashanti style. Whatever the region though, special cloths are woven for

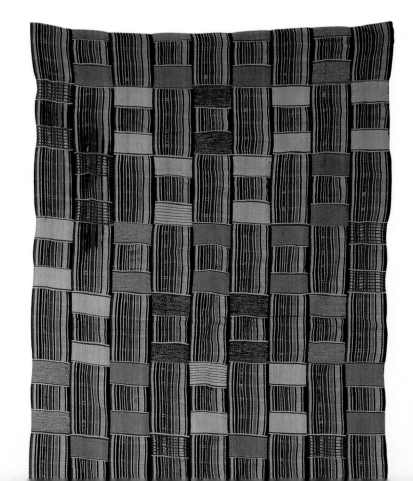

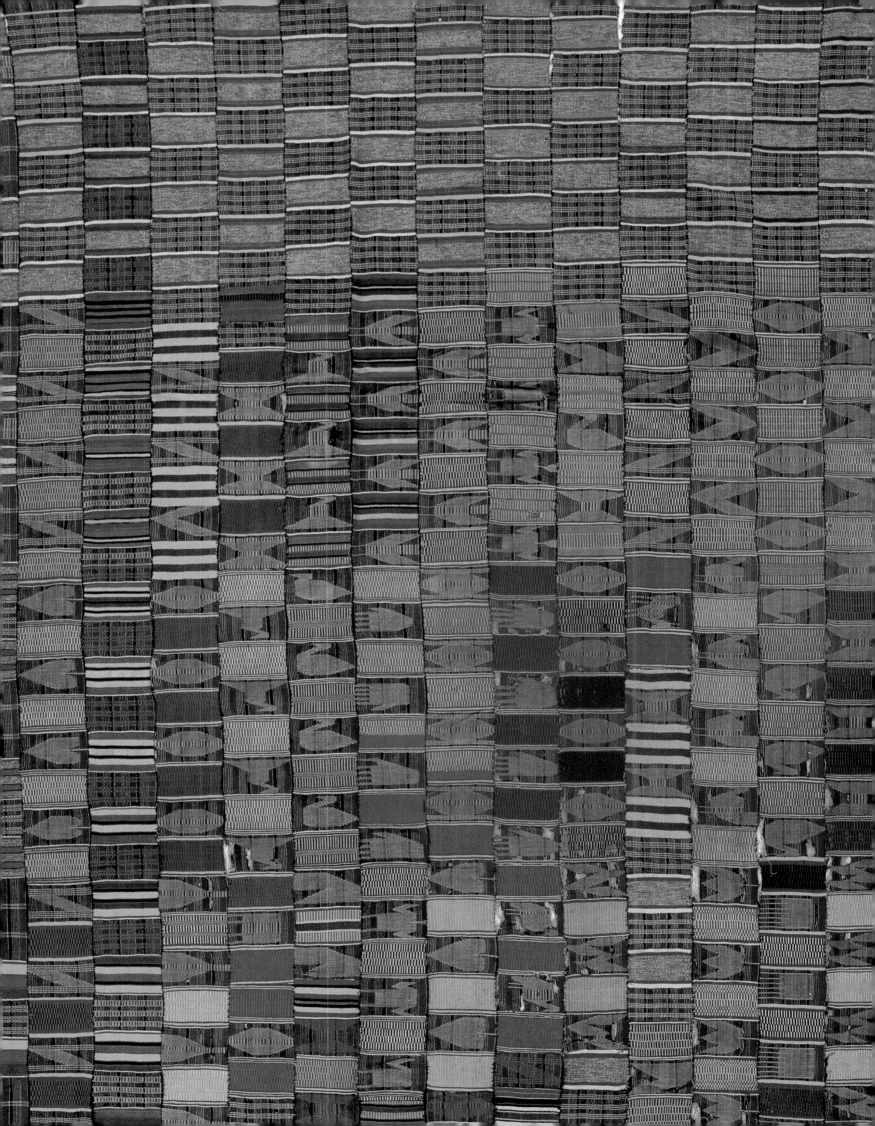

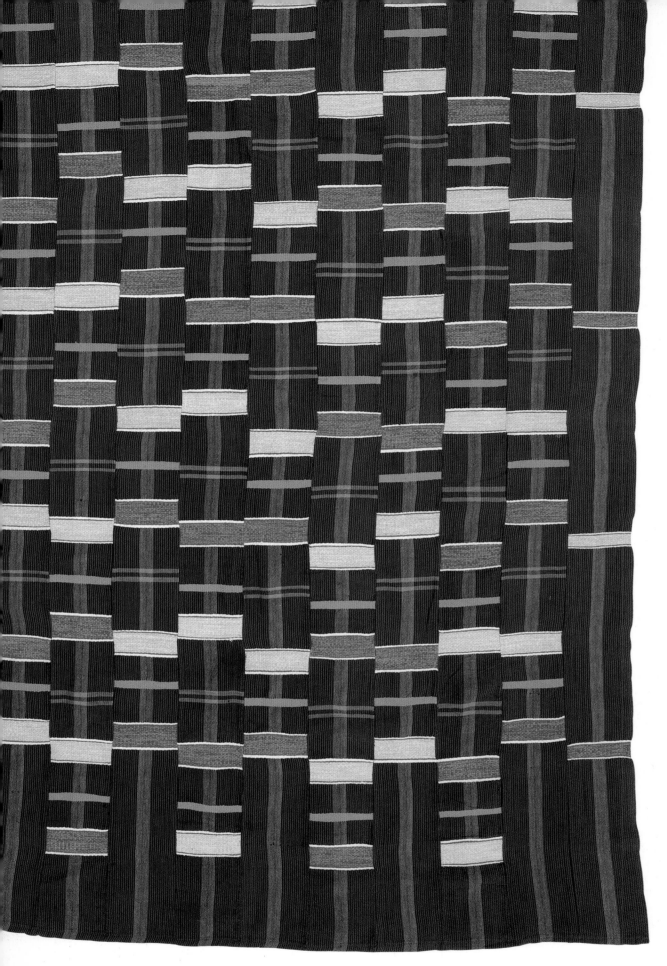

LEFT Ewe woman's *keta* cloth, woven in eastern Ghana. The variegated effect in the weft-faced blocks is achieved by twisting two differently coloured cotton filaments together to form the weft thread.

OPPOSITE
LEFT *Adanudo* Ewe man's prestigious stripwoven cloth with fine supplementary weft details, Kpetoe district, eastern Ghana.
RIGHT *Adanudo* Ewe man's stripwoven cloth with silk supplementary weft details depicting such symbols of royalty as the stool, the fly-whisk and the crown, eastern Ghana.

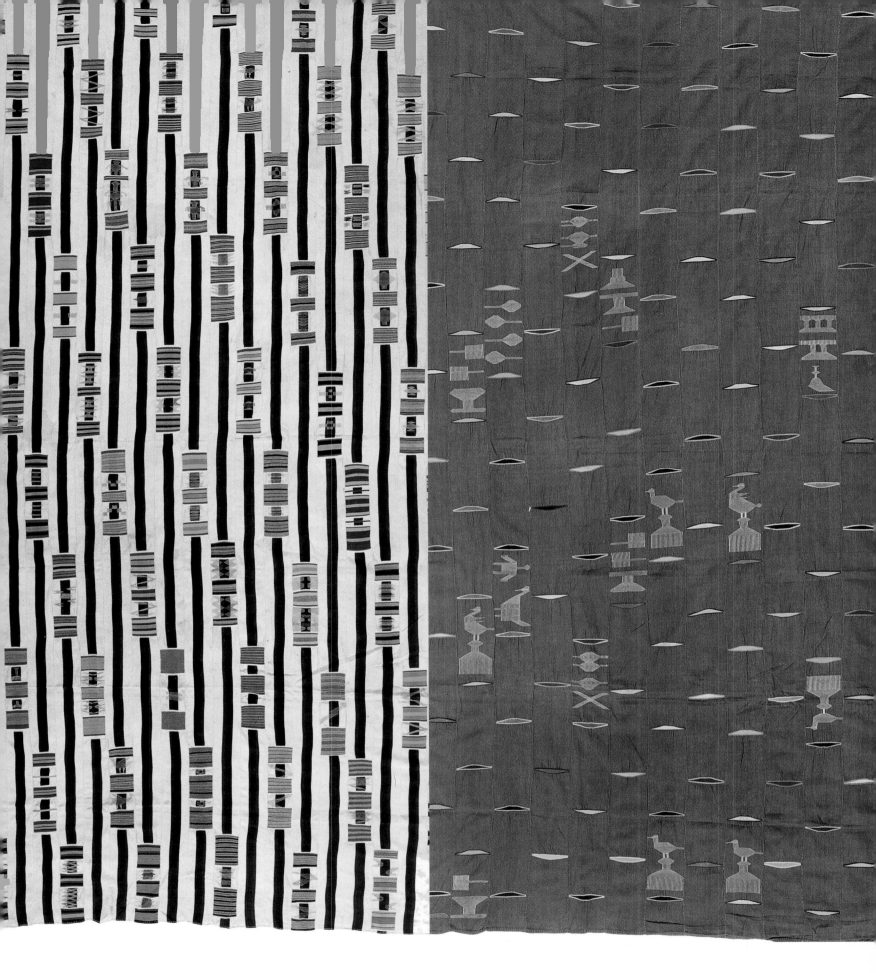

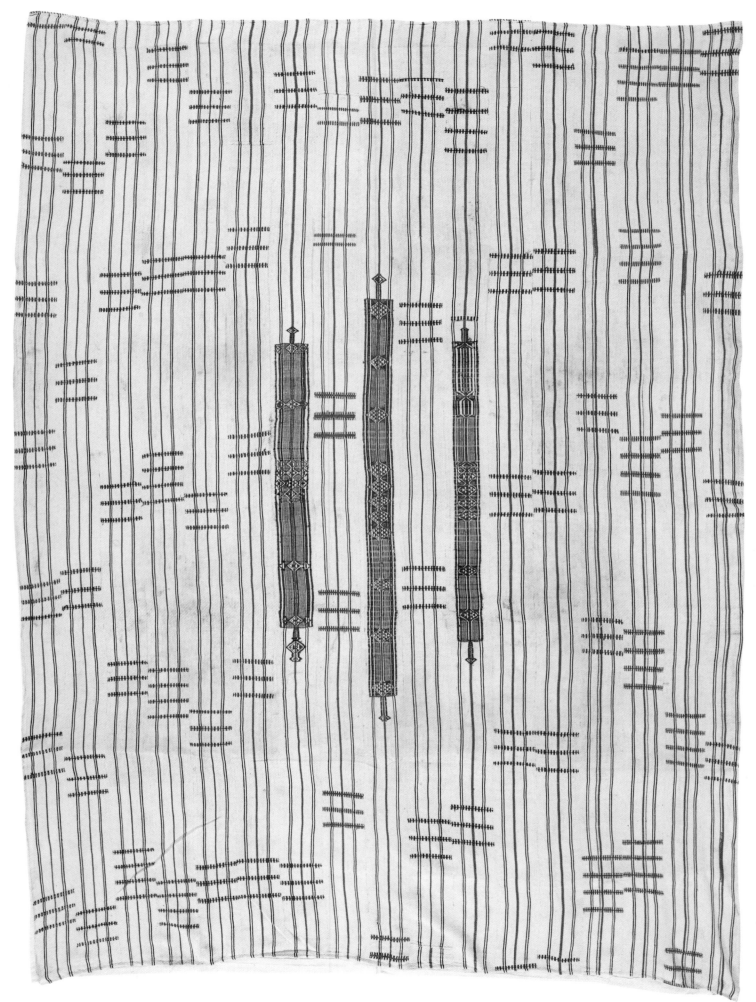

Djerma weaving of Niger and Burkina-Faso

The Djerma are direct descendants of the great medieval Songhai Empire. Nowadays they inhabit the eastern part of the Niger Bend region. Djerma men are accomplished weavers of cotton covers or blankets. Djerma work is characterized by weft-faced blocks in black or red arranged in a diamond pattern against a white ground. More recent work woven in towns, such as Niamey in Niger, is practically indistinguishable from that of neighbouring Songhay and Peul (Fulani) weavers, especially when the blankets are aimed at a tourist market. The blankets are stripwoven out of cotton and the strips are sewn together by men. In former times the cotton would have been grown locally and handspun, but now the cotton thread used for weaving will be millspun and dyed a variety of colours. Yellow, red, green and black are popular colours in modern blankets.

The Djerma weave on the so-called 'Sudanic' loom used by many neighbouring peoples. It consists of a simple frame and round branches and is characterized by the use of a heddle pulley with an unusually long pedal. Traditionally, the weavers are male.

The introduction of factory-spun cotton yarn in a wide range of colours and the urbanization of many of the weavers has meant that a great variety of highly coloured cotton blankets are woven for an urban clientele.

OPPOSITE *Baayon* Djerma stripwoven cotton woman's wrap from Burkina-Faso.

ABOVE Dogon carved wooden heddle pulley, Mali.
RIGHT Djerma cotton blankets hanging out to dry on a mud house in Niger.

PAGES 44–45 Djerma stripwoven cotton man's cloth from Niger.

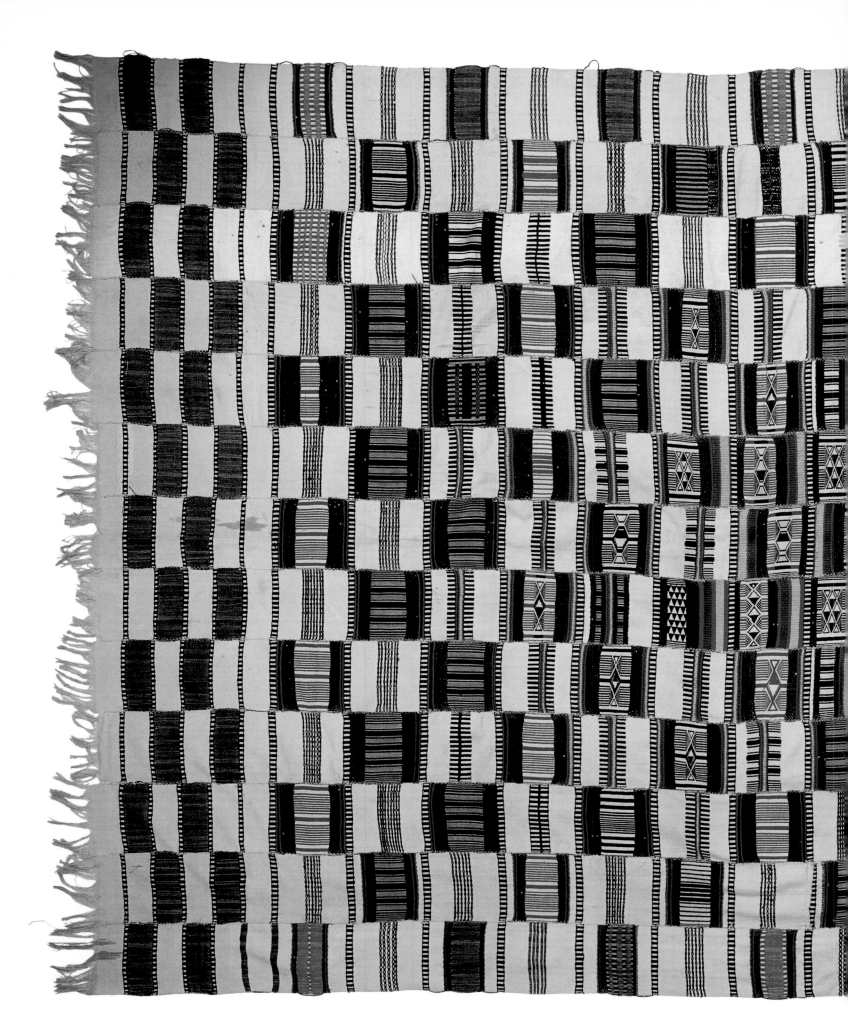

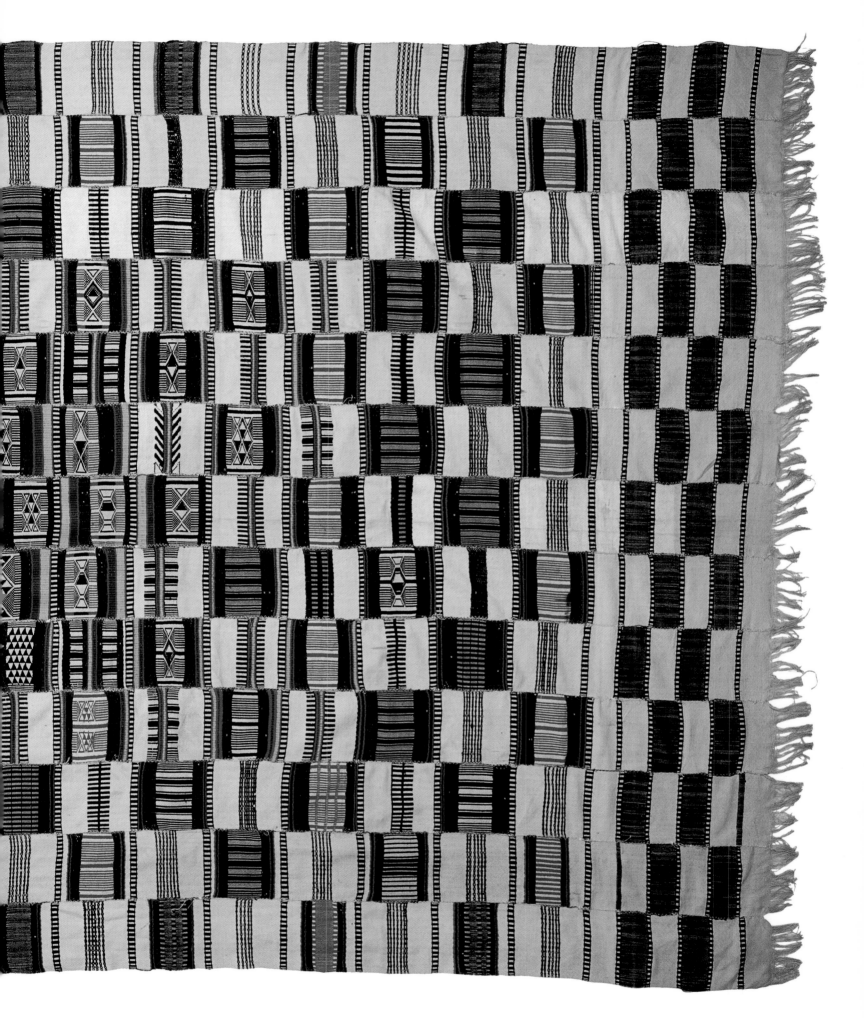

Woollen stripweaves of the Niger Bend

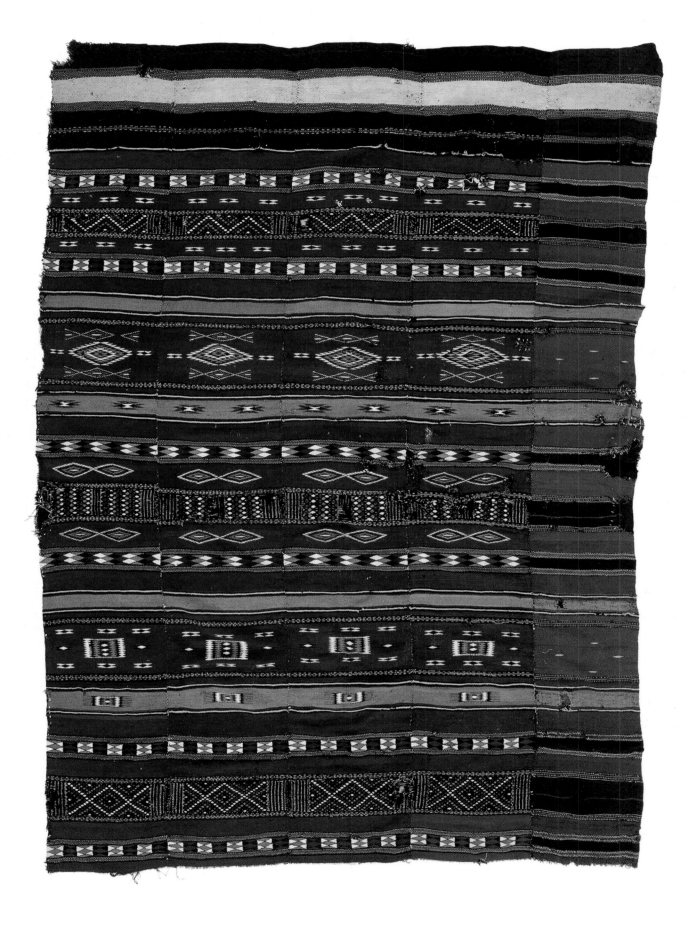

Apart from the area around Cape Verde, the only region in West Africa with climatic conditions suitable for rearing sheep is the Niger Bend of Mali and Niger. It is cool and has enough pasture (from the flooding of the Niger).

Fulani weavers make the *khaasa* blankets that are worn in the cold season. They are sold in Mopti market. Because of their weight and unsuitability for humid climates, they are only exported in small numbers to northern Nigeria, Burkina-Faso and Ghana.

Woven of white sheep's wool on a horizontal strip loom, they are made up of four to six panels, each approximately 15 cm (6 in.) wide, sewn selvedge to selvedge. Each strip has supplementary weft decoration, with motifs influenced by North Africa. The Fulani name all the different motifs. The designs on the upper and lower borders symbolize water and fertility, while the central motif represents the paths taken by the Fulani herds. The strips are sewn together so that the 'Moorish' motifs join up to form lateral bands of pattern.

Itinerant Fulani weavers travel to Tuareg encampments to weave very large chequered tent dividers or bed covers known by such names as *arkilla jengo* and *arkilla kerka*. Like the *khaasa*, the warp is made of cotton and the weft of wool. The combined thickness gives not only warmth at night but also protection from the abundant and troublesome mosquitoes. *Arkilla* are bought by rich Fulani, marabouts (holy men), nomadic Tuareg and Moors.

Sheep are shorn by Fulbe (noble-caste) Fulani shepherds. The wool is spun by women and then given to Maabube (lower-caste) Fulani weavers, who weave it into *khaasa* strips. Sewing together the strips and finishing are tasks carried out by the Fulbe. The same process takes place when the Maabube weave for the Tuareg, though the wool is Tuareg.

According to the acknowledged expert on the subject, Dr Pascal James Imperato, Fulani looms are made up of twelve pieces of wood. Four are driven vertically into the ground. The cotton warps are tied around a stone drag weight on a wooden or metal sledge. From the anchor, the warp passes over a beam and down through two foot-operated string heddles, which are hung from a wooden pulley assembly through a reed-beater and end around a cloth beam.

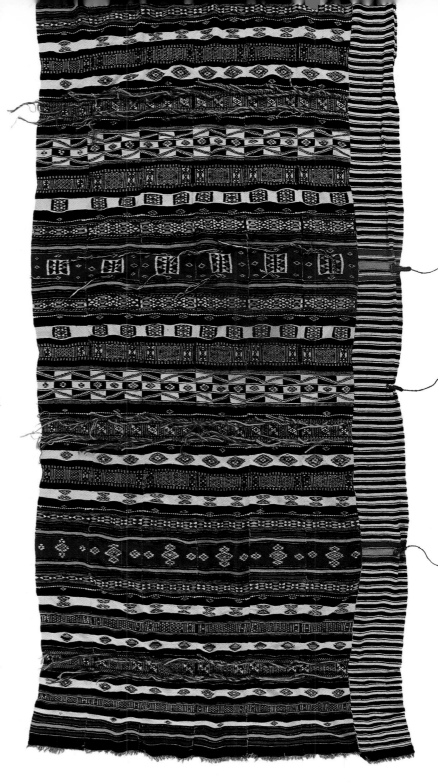

OPPOSITE Part of an old *arkilla kerka* woollen cover woven by the Fulani for the Tuareg.

ABOVE *Arkilla kerka*, a very long wool and cotton cover woven and used by the Fulani to divide off the place for the bridal bed from the reception area in their dwellings.
LEFT A man selling a *khaasa* Fulani woollen blanket by the river Niger.

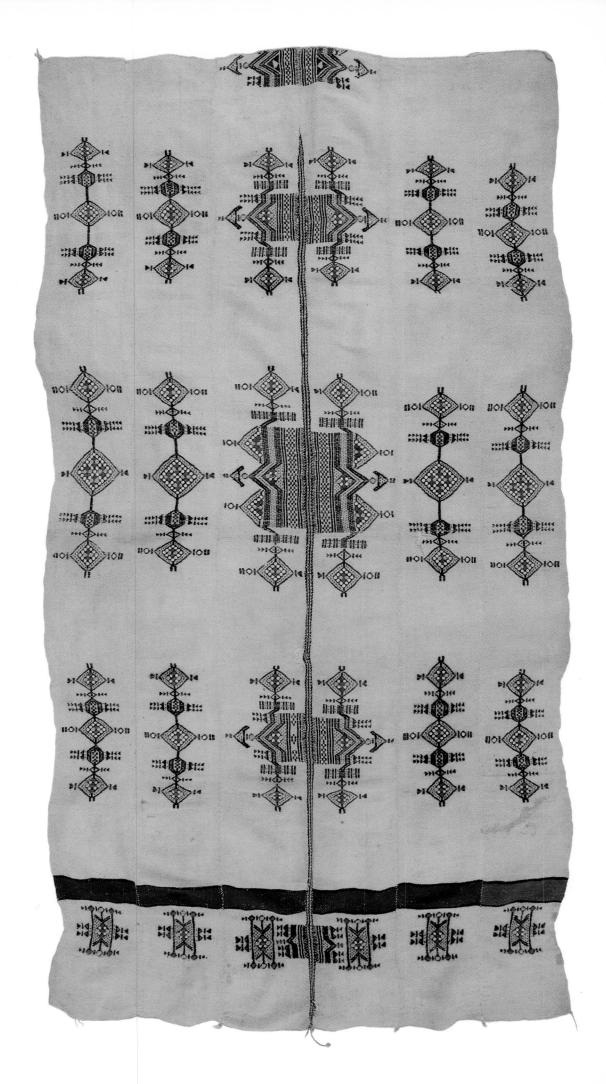

RIGHT *Khaasa* Fulani woollen blanket, Mopti, Mali. Berber weavers in southern Algeria weave very similar textiles, which may be a model for the *khaasa* or an export-driven imitation.

OPPOSITE *Arkilla munga* wedding blanket woven by the Fulani for the Tuareg.

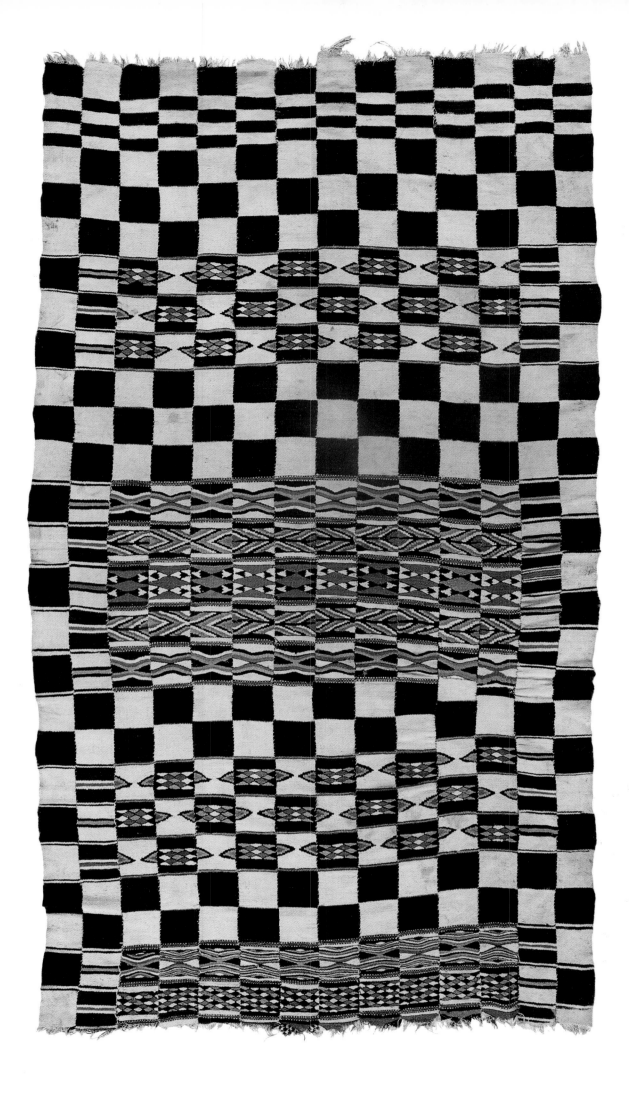

Nigerian horizontal-loom weaving

Men weaving on the horizontal, double-heddle treadle loom can be found in many parts of Nigeria. Two of the most important traditions are those of the Yoruba and the Hausa. According to recent research by textile scholar Duncan Clarke, there are approximately 15,000 weavers working on the horizontal narrow loom in Yorubaland today. They mainly produce women's cloths, *aso oke*, for which there is great demand in Ilorin and Iseyin. At weddings, the bride's and groom's party each wear different sets of *aso oke* in particular colours to distinguish one from the other. Both parties can use up to fifty mainly new cloths – a steady demand for the weavers' wares. Those who cannot afford new cloth will wear a similarly coloured cloth if they have one.

The weavers work under a master weaver in his compound, up to ten weavers sitting side by side in the shade. The warps are tied to a drag stone mounted on wooden sledges stretched out in front of them. Until very recently, the weavers were male and were apprenticed on payment of a fee for a number of years until they learned the trade (if they were immediate family, the fee was waived). Most of the *aso oke* weavers are therefore boys aged between eight and fifteen years, who receive food, but no wages. Clarke states that, in the normal course of events, these boys then stop weaving and go on to forge another career, only to return to the textile business as a master weaver when they have amassed sufficient capital.

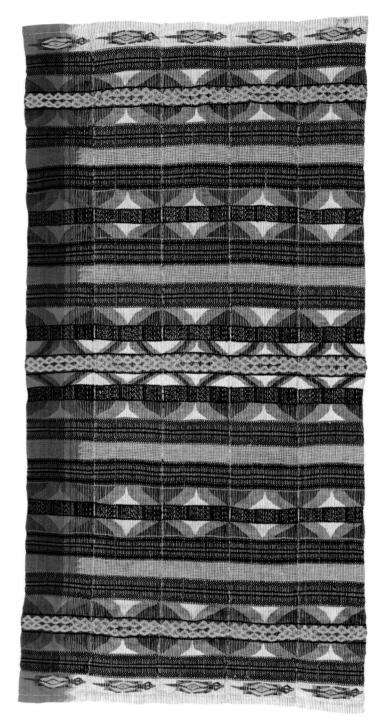

LEFT Yoruba stripweavers in their shed, Iseyin, south-west Nigeria.

ABOVE Prestige cloth formerly woven by men in strips at Owo in Yorubaland, a great centre of weaving. Known as *elegheghe pupa*, it incorporates red in the tapestry design and a lizard motif at the end of each strip.

OPPOSITE Prestige cloth woven by men in the Benue valley, possibly by the Jukun, central eastern Nigeria. Each alternate strip incorporates motifs worked in the very rare supplementary-warp technique.

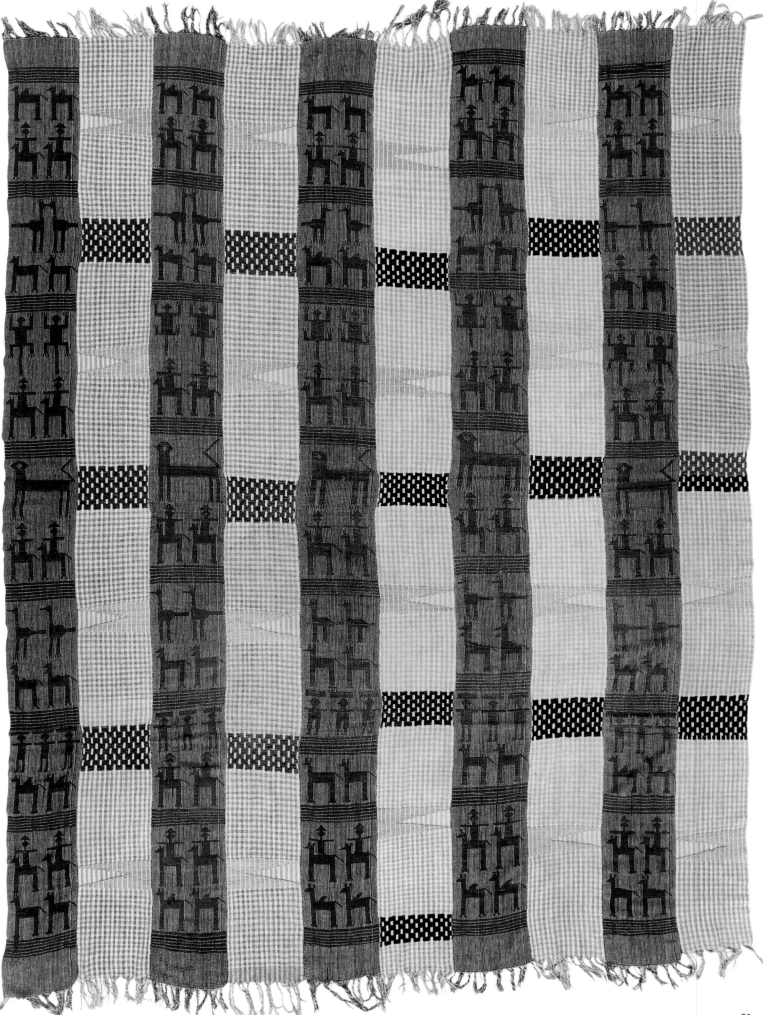

A recent phenomenon is the introduction of girl apprentices, who are taken on under the same terms as the boys, but at a slightly later age. The difference is that they tend to stay in the weaving business and set up as master weavers as soon as they can after serving their apprenticeship. They recruit fresh apprentices, who are often girls. In this way the traditional barriers between the two sexes and their spheres of work are gradually being broken down.

Hausa weavers are to be found all over northern Nigeria. Different categories of looms are used to weave different widths and qualities of cloth. The Hausa weave the narrowest of strips turkudi (2.5 cm; 1 in.) and the widest (45.70 cm; 18 in.) in West Africa. The former is used to make the highly valued Tuareg veils and the latter is so wide that it is often confused with the products of the women's upright loom.

Yoruba weavers weave on a narrow-frame loom of carpentered parts very similar to those of the Ashanti and the Ewe. The basic system and framework of the loom is very similar to that of the Ghanaian weavers, but Nigerian weavers do not use twin pairs of heddles to alternate blocks of weft-faced and warp-faced weaving in the same strip. The Yoruba employ a single pair of heddles and extra string heddles for floats. Yoruba aso oke are very varied in composition. One popular pattern involves weaving one long warp-striped strip. The other strip is woven in white cotton in plain weave. All along this strip, motifs are introduced in floating weft. Recurring motifs are an arrow surmounting a square, which symbolizes the Koran boards on which young boys learn to read and write. Red silk, called al-hareen, originally Tunisian, is the preferred thread for floating weft motifs, although black cotton is often used. Women's cloths are formed by cutting these two strips up into appropriate lengths and then sewing them, selvedge to selvedge, in alternate strips.

The Hausa loom is very portable, with the heddle and beater suspended from above and behind the weaver fixed to a wall or tree. The weaver, who sits on the ground with feet outstretched, operates the pedals that open and shut the shed. The warp is tensioned in the usual way, but the finished web is wound round a cloth beam below his legs.

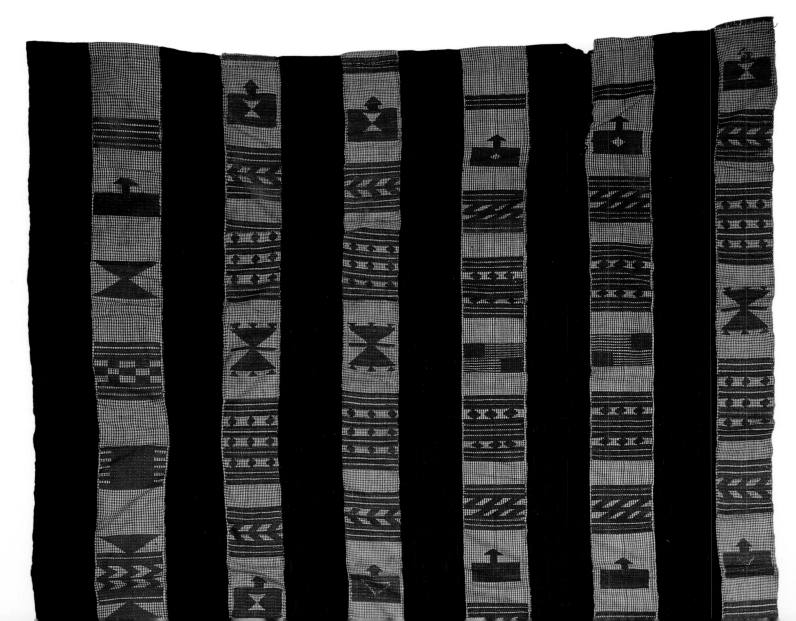

OPPOSITE *Aso oke* stripwoven woman's wrap, Ilorin. Each alternate strip incorporates weft-float motifs worked in imported silk. Koran boards are a popular motif.

RIGHT *Luru* cotton stripwoven blanket woven by a Hausa weaver in or around Kano.

BELOW Woman's wrap woven on the Hausa horizontal loom, Sokoto, northern Nigeria.

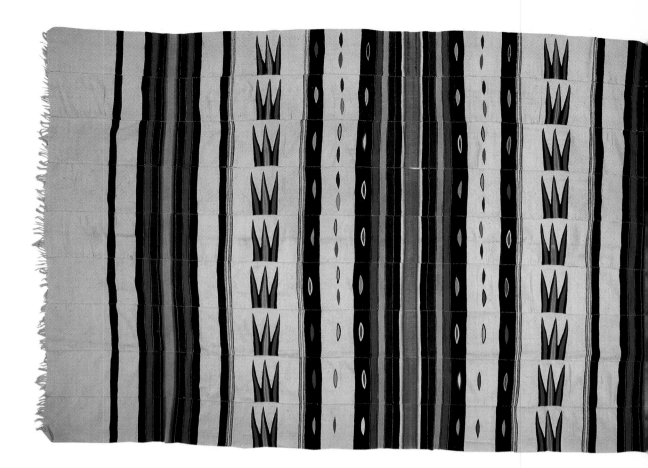

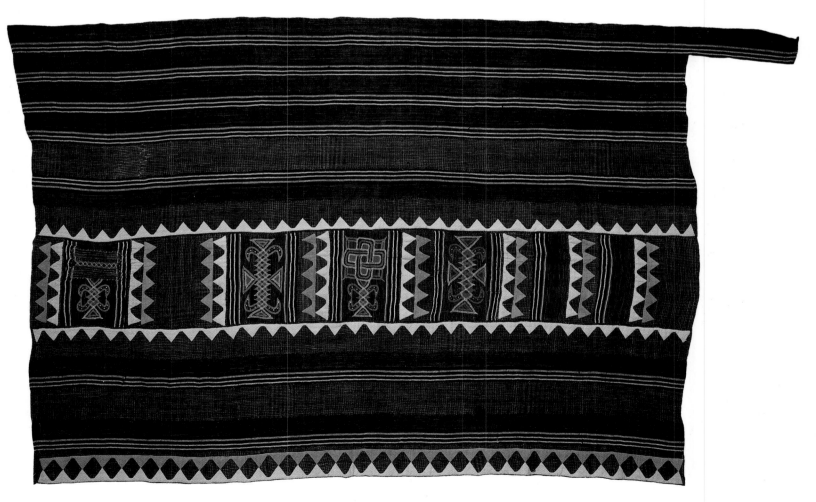

Yoruba lace weave

The Yoruba are a highly fashion-conscious people. A well-to-do Yoruba woman swathed in matching waist, breast and headcloth is a sight to behold.

Although the cloths worn are traditional in shape, size and manufacture, colours can change from season to season and such non-traditional fibres as lurex can be introduced into stripwoven cloth. A common form of decoration in Yoruba stripweaves is to introduce rows of holes along the length of the strip. This method is akin to the openwork technique often referred to as 'Spanish lace.' Lateral rows of four to six tiny holes are spaced every 5 cm (2 in.) or so down the strip. A supplementary warp thread is drawn from hole to hole down the length of the strip, giving an almost lacy effect to the cloth. This effect can be achieved in a number of ways. The more prestigious and more expensive method is to incorporate a series of long, slightly thicker and stronger threads that for most of the woven strip lay along its surface. When the weaver wants to introduce a row of small holes into the strip, supplementary yarn is laid in the shed at intervals. These yarns are woven back and forth three times and then carried on the face of the cloth until the next set of holes is to be woven. The structure differs from Spanish lace openwork as the yarns used are supplementary, rather than part of, the plain weave ground. Or he can stop adding the regular weft and instead take the floating warp threads already mentioned and use them to bind around, and pull apart, the regular warps. In the process a new row of holes is formed.

A quicker, less expensive and less prestigious method is to introduce a piece of thick, barely malleable wire the width of the strip bent into the shape of a fine knuckle-duster or a 'jumping jack' firecracker the width of the strip and then weave around it. When the 'knuckle duster' is removed, it leaves a row of holes that lack the definition and permanence of the former method. These techniques are used to decorate popular sets of women's clothing consisting of one larger, and two smaller, wraps.

BELOW LEFT Yoruba woman's *aso oke* cloth from Ilorin.
BELOW CENTRE Yoruba woman's stripwoven cloth.
BELOW RIGHT *Aso oke* woman's stripwoven cloth.

OPPOSITE Yoruba woman's cloth with supplementary weft float decoration and lace weave.

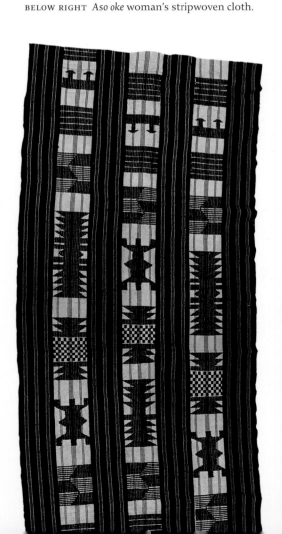
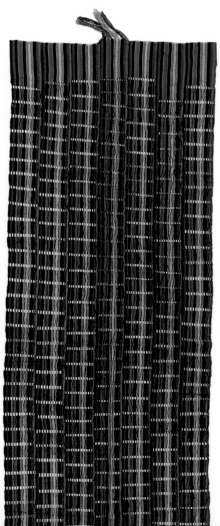

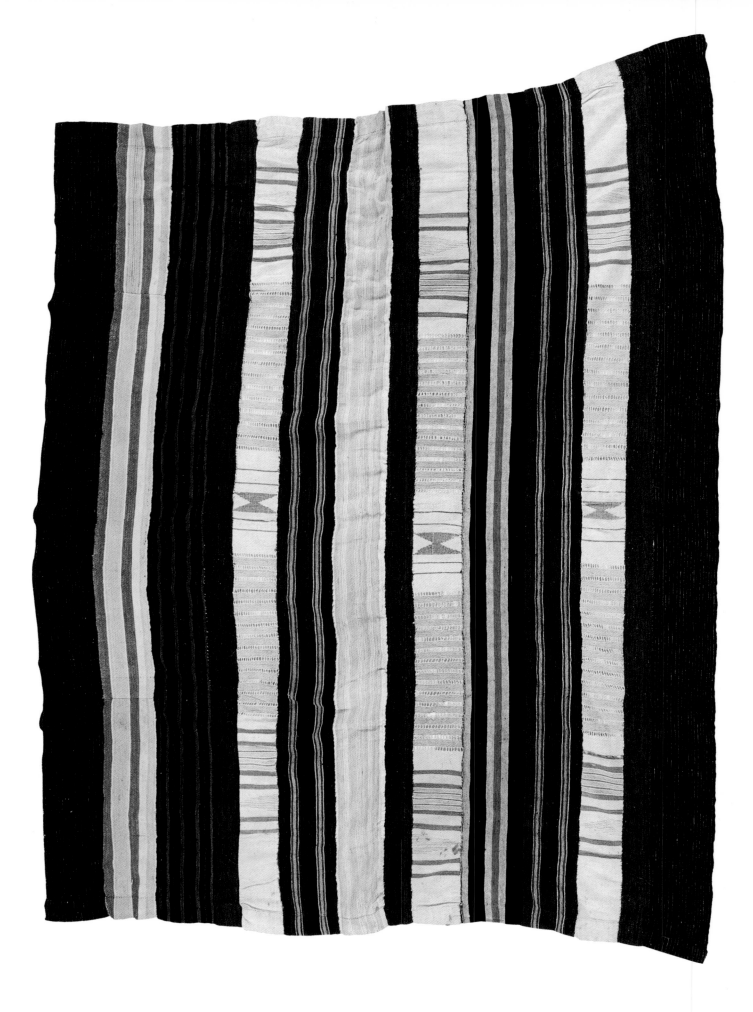

Nigerian women's vertical looms

Nigeria is one of the few places in West Africa where women as well as men weave. This phenomenon was particularly noticeable amongst women of the Yoruba and Igbo peoples and other smaller groups of southern Nigeria. For a variety of reasons, women's weaving in Nigeria has declined markedly in recent times. Almost the only women's vertical looms left in Yorubaland are at Owo, though, amongst the Igbo, the women's looms of Akwete still prosper, as the following pages reveal.

Yoruba women tend to weave together in a secluded shady courtyard. The weaver sits on a mat or stool on the ground in front of the looms.

The woman's loom consists of two sturdy posts set into the ground (usually large palm ribs) and two horizontal beams (again, palm ribs lashed to the posts at an appropriate height), around which the cotton warp is wound. The loom operates with a single heddle with leashes attached to alternate threads of the warp. Shed sticks are inserted in the warps above and below the heddle to preserve the weaver's cross and a heavy wooden sword is used, both for beating in the weft and turned on its side to keep the shed open. The weaver pulls the heddle towards herself, adjusts the position of the shedsticks, turns the sword on its side, inserts the weft in a wooden shuttle, beats that pick in with the sword, lets the heddle go, re-adjusts the shed sticks, turns the sword on its side again and countershed has been made and the whole process is repeated until the cloth has been completed. The loom is continuously warped and, as the looms are quite high, a long length of cloth can be woven. As weaving progresses, the warp is loosened off and the woven portions of the web are taken around the back and the part still to be woven is brought in front of the weaver.

The textile is often plain white cloth, but sometimes incorporates dark warp stripes. The finished cloth is usually dyed by dipping it into the indigo vat. Each strip is about the weaver's cubit wide. A woman's cloth is made up by sewing together two lengths, selvedge to selvedge.

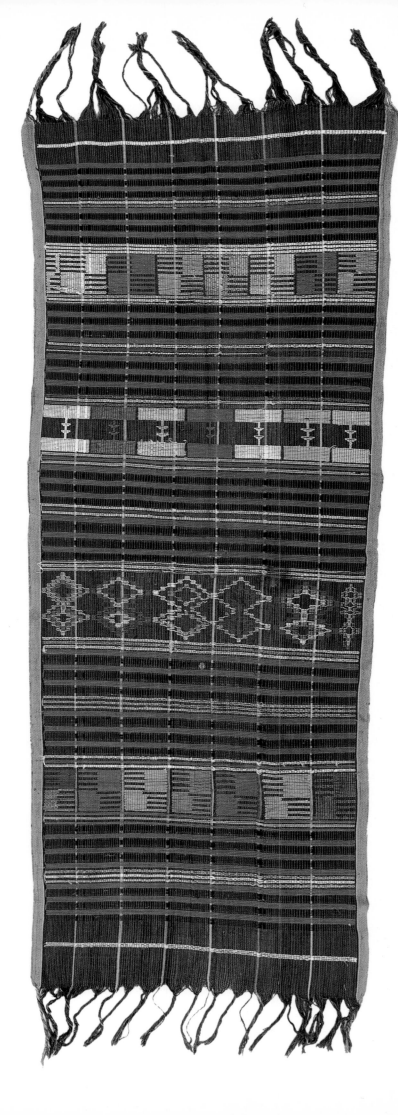

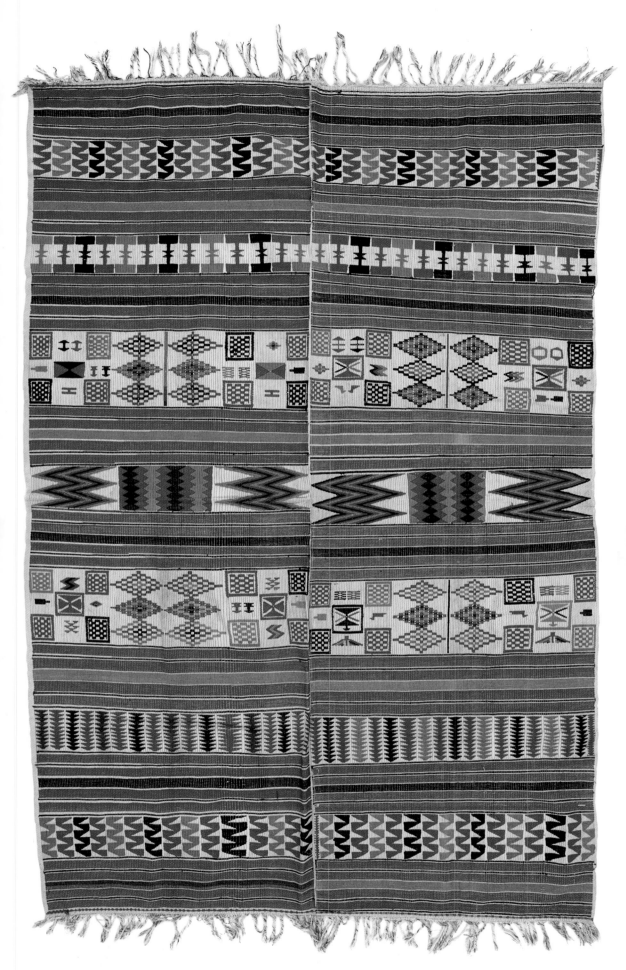

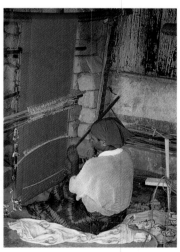

OPPOSITE Woman's cotton cloth with supplementary weft decoration in the Nupe style.

LEFT Fine Nupe supplementary weft-decorated cotton cloth. Two lengths have been sewn together to form a wider cloth.

ABOVE A Yoruba woman weaving on a vertical loom at Owo, south-western Nigeria.

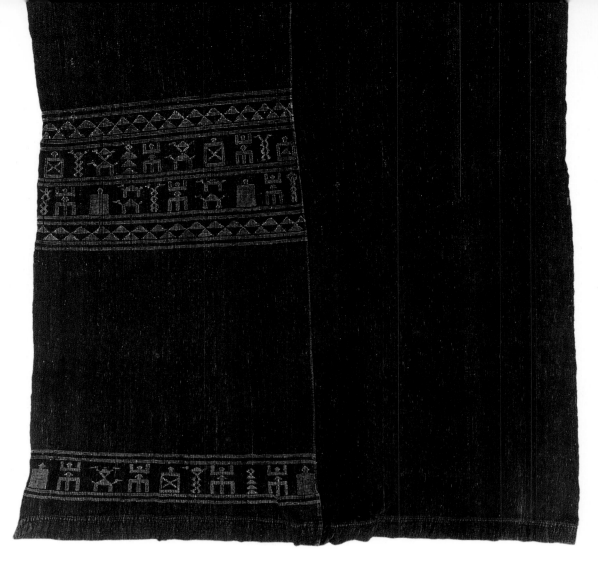

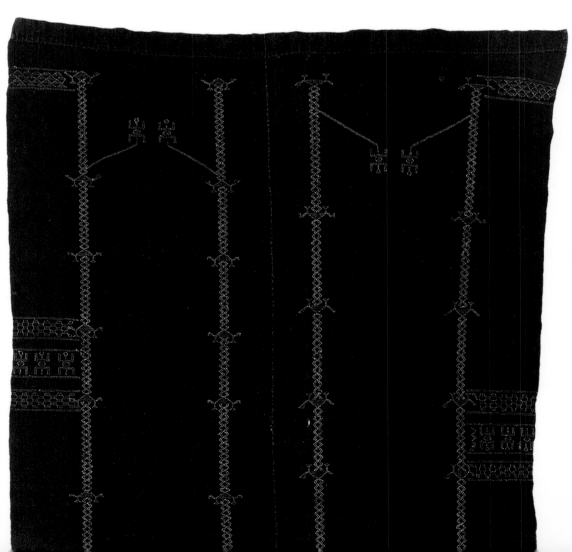

ABOVE Indigo dye vat at Oshogbo, south-western Nigeria.

ABOVE RIGHT Igbomina Yoruba indigo-dyed supplementary weft *alara* (with wonders) marriage cloth from Esie.

RIGHT Igbomina Yoruba indigo-dyed supplementary weft *alara* marriage cloth from Esie. The longitudinal spiral motifs are said to symbolize snakes.

OPPOSITE Nupe woman's cotton cloth with supplementary weft decoration along one border and the central seam.

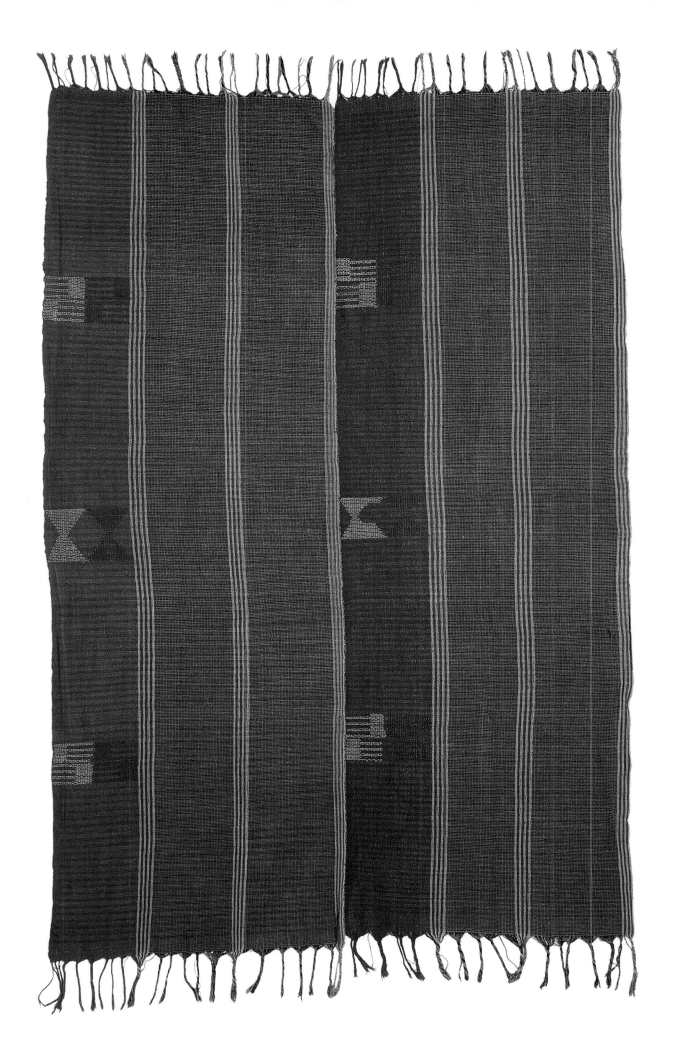

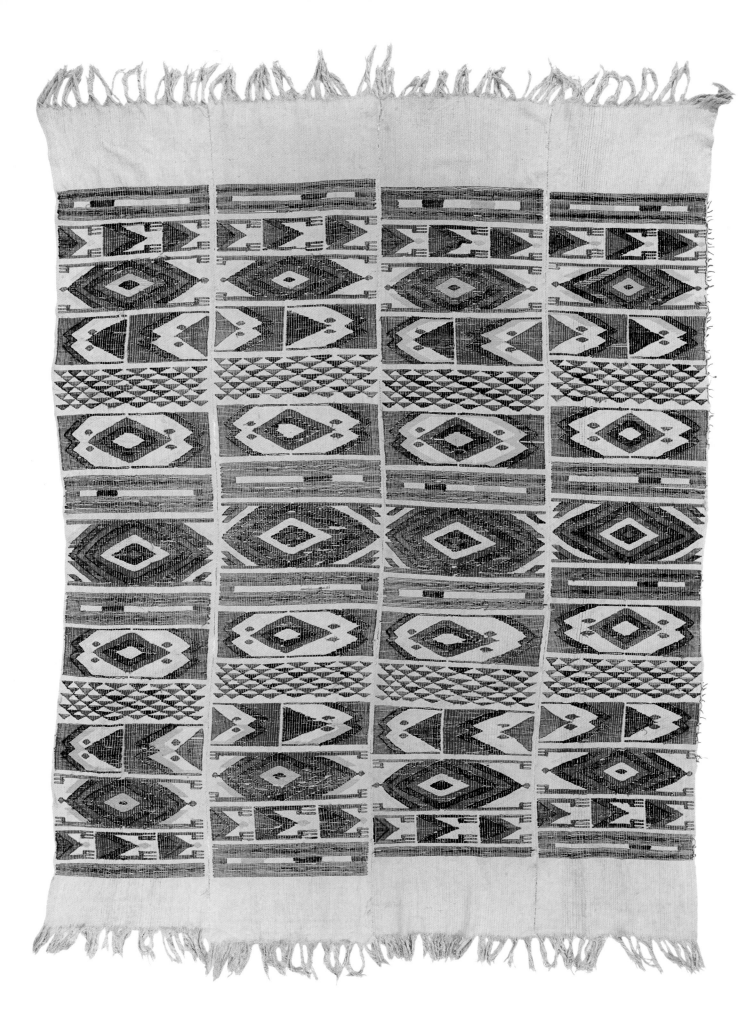

The supplementary weft cloths of Ijebu-Ode and Akwete

Though Ijebu-Ode in Yorubaland and the Igbo town of Akwete are over 400 km (250 miles) apart, there is a strong connection between the textiles woven in the two places. Women weave on a continuously warped, vertical loom and decorate their textiles with very similar motifs worked in the weft-float technique. Ijebu-Ode was historically an important town, both for the external and internal market. The Ijebu Yoruba specialize in weaving a cloth that is known in the Niger Delta as *ikaki*, meaning 'cloth of the tortoise'. Consisting of three or four strips, sewn selvedge to selvedge, it was often traded eastwards to the people of the Niger Delta. It was traded in the town of Ndoki and, in the mid-19th century, copies started to be made by Igbo women weavers in the nearby village of Akwete. Traditionally woven in darker colours, red, blue, green, purple and black are now popular.

The Akwete cloths are mainly used as women's wraps in pairs. Akwete women weave a wide variety of fancy, decorated rayon cloth, mostly for ceremonial and ritual use in the Niger Delta. However, the largest centre for this type of weaving today is Okene, where Ebira women weave narrower rayon cloth for non-ritual use in such cities as Lagos.

The women of Akwete weave on an upright wall loom, with cloth about 100 to 127 cm (40 to 50 in.) wide. The Akwete loom is the widest in Nigeria. Usually the warp is continuous, which gives an evenly coloured background for the weave. Blended or shot effects can occasionally be gained by mixing the colours of the warps or using a contrasting colour for the ground weft. On single-faced fabrics (on which the motif only shows on one side), weft floaters are woven in using the swivel inlay technique. The ground is a low twist yarn, basket weave, usually of cotton. The decorative weft floaters are of low twist cotton, silk or rayon. All the thread is bought ready dyed. The decorative weft not used on one line of base weft is carried up to the next row, often on a diagonal, hence outlining the motif. As the warp is continuous, the finished length of the cloth is twice the height of the loom. Owing to uneven tension the cloths tend to be longer on one side than the other and one end is wider than the other.

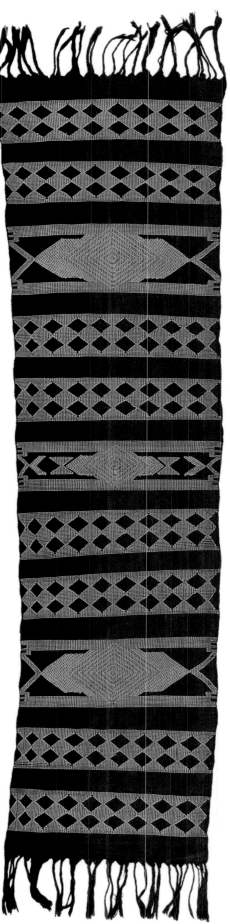

OPPOSITE Man's cloth from Ijebu-Ode decorated with the *ikaki* tortoise pattern.

RIGHT Woman's wrap from Akwete decorated with the *ikaki* tortoise pattern. This motif was copied from Ijebu-Ode cloths traded into the area.

61

Tie and dye

Indigo is by far the most common dye used in West Africa. The most popular way of creating a pattern is by introducing some kind of resist, by tying, sewing or by applying a paste or wax resist to one side of the fabric. Tie-dyeing is the simplest way, teasing up a small section of the cloth into a peak and then, sometimes, introducing some bulking-out medium, such as a seed, grain or chip of wood, and, finally, tying it off.

The way the peak of cloth is tied off creates different kinds of pattern, although the basic pattern is of a white circle containing a blue dot, all set against a blue ground.

In Gambia, women's cloths, sometimes handwoven, and yardage, always mill-woven, are tie-dyed in indigo vats. Most production now uses synthetic indigo mixed with gentian violet to give that fashionable purple tinge. Indigo-dyed tie and dye is found all over West Africa, most often on handwoven women's wraps of handspun cotton. The arrangement of the tied circles varies from place to place. One famous tie-dyed cloth from Mali is known as 'Salamander's Eyes'.

Long veils called *thobes*, made of thin, gauze-like cotton or imported cotton damask, are worn by the women of Mauritania. The current fashion is to tie-dye them. Multi-coloured and dyed with chemical dyes, they have a very Indian appearance. They are tied in workshops in Nouakchott. The fashion has spread north and they are now also reputed to be made in Dahkla.

Much contemporary tie and dye in West Africa is done with synthetic dyes on cotton, damask or synthetic fabric. The larger variety of dyes allows for a much wider palette than was available with natural dyes and the thinner mill-woven cloth permits a greater range of possibilities for pleating and folding than thicker handwoven cloth. However, as with any tie and dye process, the dyeing is always started with the lightest colour.

ABOVE Tie-dyed satin Gara cloth from Sierra Leone dyed with synthetic dyes.
LEFT Woman selling bread in Mali. She is wearing a dress of tie-dyed cloth.
BELOW LEFT Tying knots to give a pattern of separate rings.

OPPOSITE
TOP Tie-dyed cotton Gara cloth from Guinea dyed with synthetic dyes.
BOTTOM Cotton cloth tie-dyed in southern Nigeria for the Igbo market.

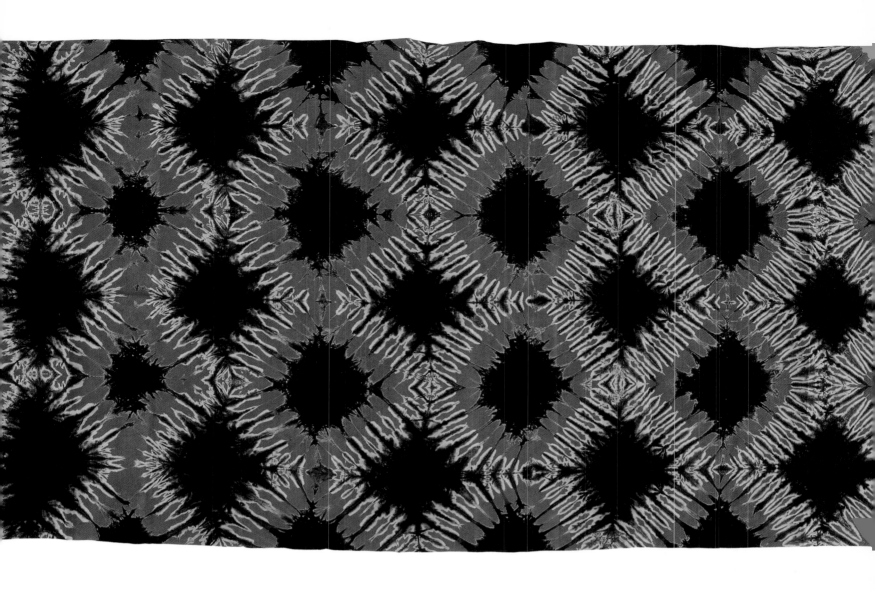

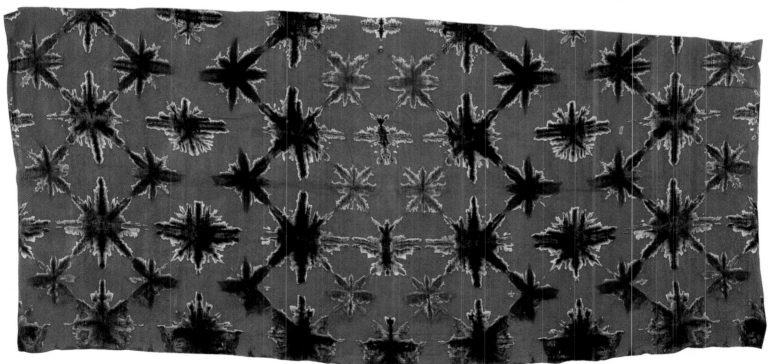

Nigerian tie and dye

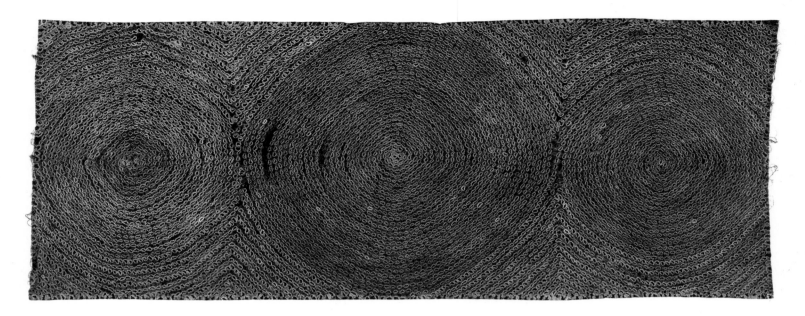

The *adire oniko* (meaning tied resist) cloths of the Yoruba are used as women's wraps. Small wraps are first folded, then tie-dyed to create spiral designs. Concentric circles of ties radiate out from the middle until the tied, but undyed, cloth has a cone shape. Beans, grains of rice or chips of wood may be inserted into the ties to fill them out, or they may be merely sections of fabric teased up and tied with raphia or cotton. One cloth of the Yoruba *etu* (Guinea-fowl pattern) is so prized that, when it is untied, it is never washed or ironed, leaving the cloth gathered into hillocks. Tie and dye is often combined with stitched resist.

The Hausa of northern Nigeria produce many tie-dyed cotton cloths that are similar in style to some of the simpler Yoruba examples. A long narrow woman's wrapper with three motifs of bold concentric circles of tied dots – known as the Three Baskets pattern – is typical of their work. If twine is bound tightly around fabric before it is placed in a dye, the area that is bound will not be dyed. When the twine is undone, an undyed circle will be revealed. Concentric circles are produced by binding the fabric at intervals, while a pattern of small rings is created if several bunches are tied. Sometimes stones are inserted into the bunches to control the shape of the resist area. If the cloth is folded or pleated and tied before dyeing, as the Yoruba often do, a zigzag or criss-cross pattern results.

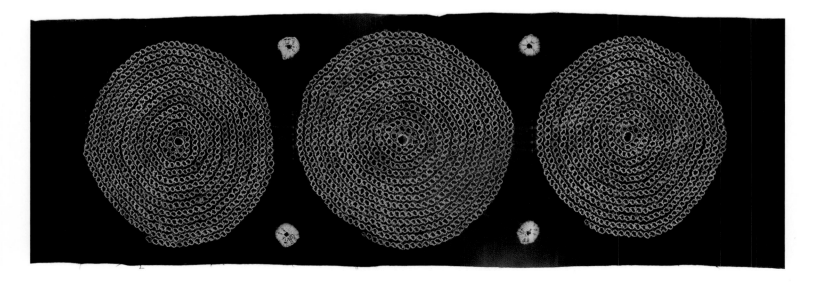

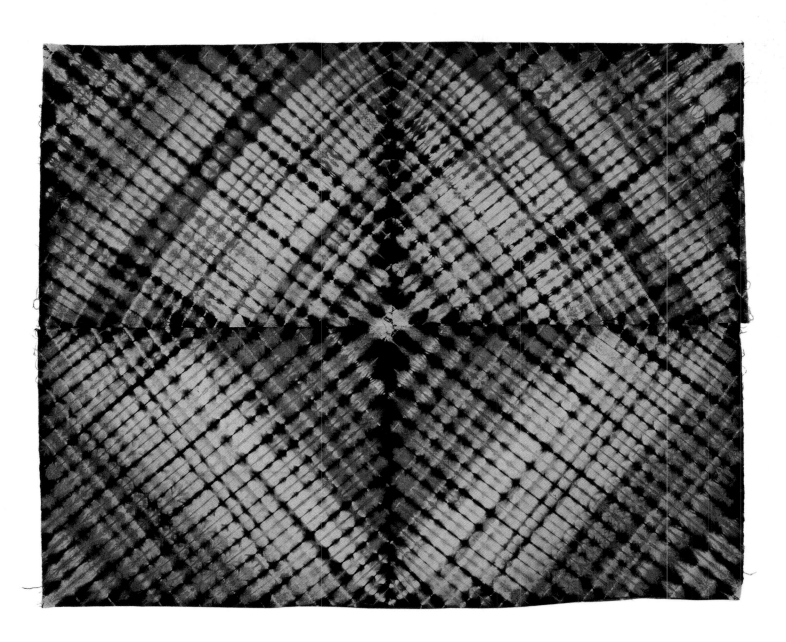

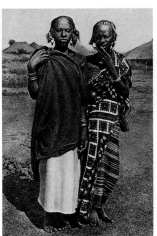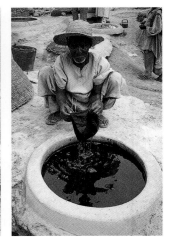

OPPOSITE TOP Yoruba indigo-dyed *adire oniko* tie-dyed woman's wrap, south-west Nigeria.

OPPOSITE BOTTOM Hausa indigo-dyed woman's wrap tie-dyed in the Three Baskets design, bought in 1999 at the dye-pits in Kano, where cloth is dyed indigo (LEFT).

ABOVE Yoruba cotton cloth folded, tied and indigo dyed in the *sabada* pattern.

FAR LEFT Fulani women, Nigeria. One wears a resist-patterned wrap.

CENTRE LEFT A Hausa woman tying resists into cotton cloth in Kano.

65

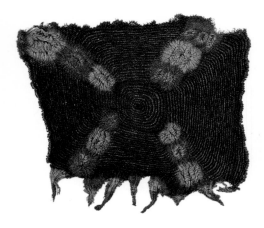

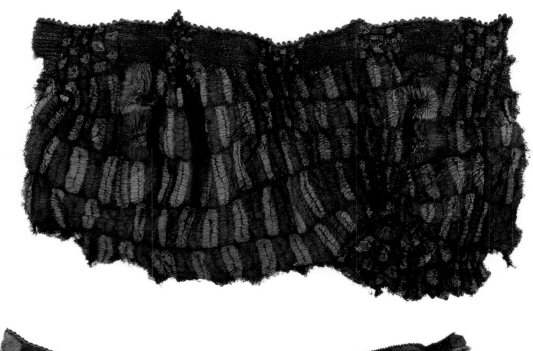

TOP LEFT Ceremonial kerchief made of plaited and then tie-dyed raphia worn by a member of the Dida tribe of the Ivory Coast.

TOP RIGHT Dida ceremonial tie-dyed skirt made of plaited raphia.

RIGHT Dida cloak or dance-robe made up of pieces from old plaited and tie-dyed raphia skirts.

OPPOSITE Ceremonial plaited raphia skirt decorated with bold tie-dyed motifs worn by a woman of the Dida tribe of the Ivory Coast.

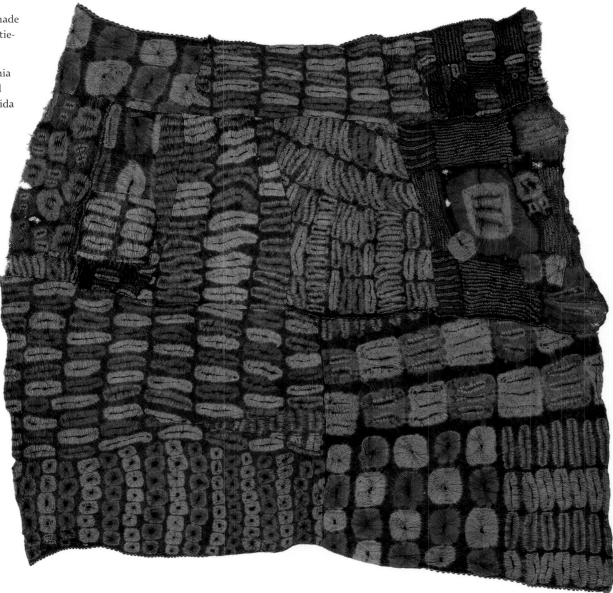

Tie and dye of the Dida, Ivory Coast

The Dida live on the Ivory Coast, where traditionally they make their living by fishing. For ceremonial occasions, they plait strands of raphia into loincloths or skirts, cloaks and kerchiefs, giving them patterns by means of tied resists and dyeing them with natural dyes in a colour palette of forest colours. Red and black on a yellowish ground is preferred. A cloak, tubular skirt or loincloth will typically be decorated with circles, ovals and rectangles, often combined with distinct areas of dots. All motifs are formed solely by variations in the tie and dye technique.

Adams and Holdcraft (1992) state that the yellow dye is obtained from the roots of a shrub and the red from the hardened root of a tree, while the black is said to come from a combination of manganese and leaves. As with all tie-dyed work, the garments are dyed from the lightest colour to the darkest – in this case, first yellow, then red, then black. Where the black shades into red, a reddish-brown colour results, but it remains pure black on the fringes of the garment.

According to textile expert Noëmi Speiser, the technique used for the tubular oblique interlacing is unique. The set of raphia filaments – the total number can reach as much as 1500 elements – is tied into a bunch and attached to a fixed point. It is then split into groups of roughly 50 elements.

Half these groups will move on the S-course, half on the Z-course, thus behaving like warp and weft in weaving. Those on the Z-course are fitted with leashes of a contrasting colour, hanging downward and roughly knotted together. They stay attached to their group throughout.

The worker starts handling two groups, one leashed and one bare, while holding several of the adjacent idle groups between the toes of her outstretched legs.

Astonishingly she forms sheds and introduces 'wefts' without any fixed tension on the 'warp'. In turn, the near ends of each group are made taut by either hand when not engaged in spreading, brushing, smoothing or selecting wefts.

Pulling the leashes downwards makes one shed. The countershed is created by drawing the leashed group upwards, which makes the tips of the leashes lie above the non-leashed layer. Each two groups produce a diamond area of loose and irregular interlacing, which must be smoothed by rubbing with a small, smooth pebble. When the diamonds have been replicated all the way round the tube, they are interconnected by the next transverse row of diamonds. Then, row after row, the tube grows along the natural length of the raphia filaments and ends in roughly knotted fringes. This ingenious application of simple weaving technology to braiding/plaiting makes it possible to produce these unusually large pieces of oblique interlacing.

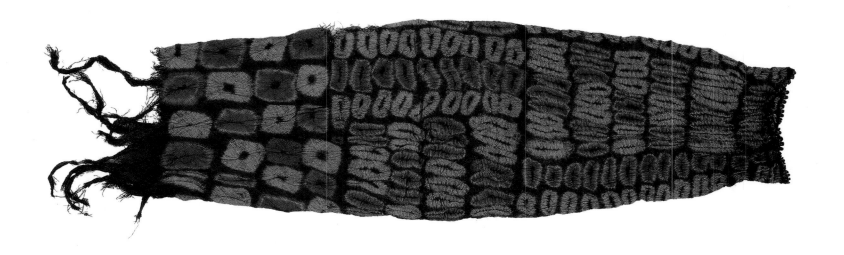

Stitched resist

One common method of preventing the dye reaching the cloth is to stitch the cloth – with running stitch or oversewing stitches – by hand or machine with strong thread, which is then pulled tight, so that the cloth compresses and resists the dye. The cloth that is to be dyed is normally first doubled up or pleated, to create a symmetrical pattern and also to reduce the amount of work involved. Raphia thread is usually used, as it is strong (and so unlikely to break when pulled tight and also easy to snip off after dyeing). When the stitches are removed with a sharp blade and the cloth opened, the pattern is revealed in negative. Patterns vary from simple arrowheads to more complex designs if the cloth is pleated before sewing.

The most complex of all stitched-resist work was practised at St Louis on the Senegal river bordering Mauritania. Before the Second World War, complex cotton resists of Moorish or *Pano d'Obra* inspiration were embroidered on to cotton cloth before indigo dyeing. The resist stitching in the St Louis textiles was always of cotton. It was so fine that it could be truly classed as embroidery.

The task of unpicking the St Louis stitching, carried out with razor blades (first brought back from Flanders by Senegalese soldiers serving in the First World War), was painstaking, far harder than the work involved with raphia resists, which can be easily snipped with a sharp instrument.

The resulting textiles are unrivalled in their complexity and beauty. The art has been revived in St Louis in recent years using synthetic brown and blue dyes, but they cannot compare with the outstanding originals.

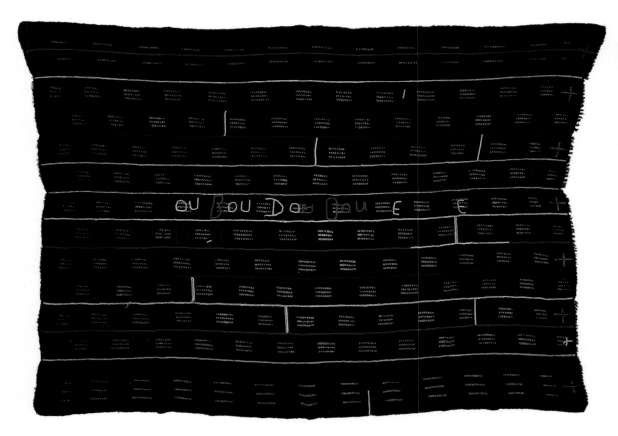

ABOVE Motif of embroidered resist from a St Louis, Senegal indigo-dyed cloth. The motif is derived from *Pano d'Obra* trade cloths from Guinea and the Cape Verde islands.
LEFT Dogon woman's indigo-dyed, stitched-resist cloth from Mali. The embroidery is a phrase from a popular song.
OPPOSITE TOP Dogon indigo-dyed stitched-resist cloth from Mali.
OPPOSITE BOTTOM *Ukara* resist-sewn cloth of the Leopard Society of Cross River, south-eastern Nigeria.

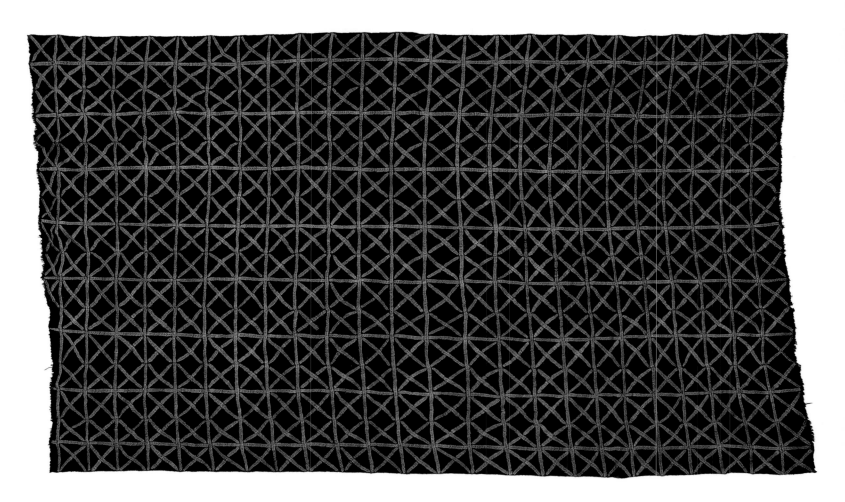

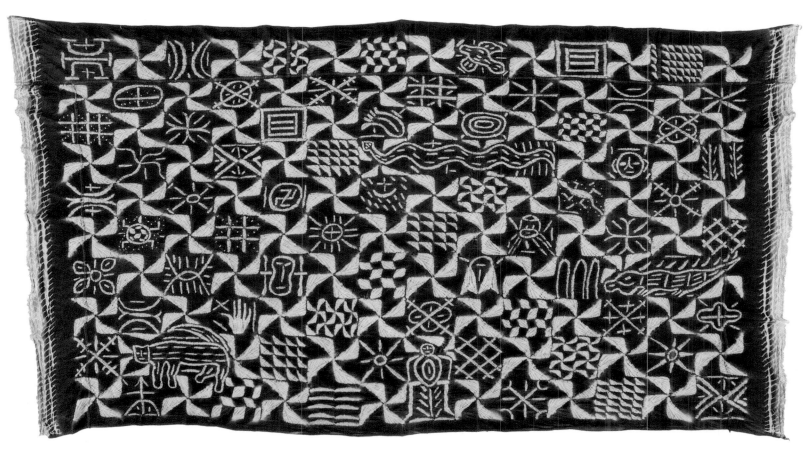

Yoruba stitched resist

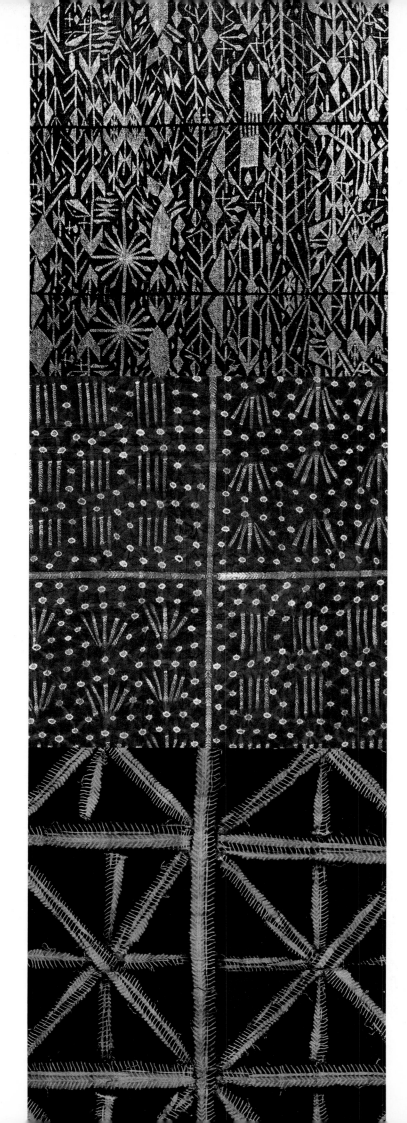

The Yoruba are masters of the indigo-dyeing process. They also have the most varied methods of applying resists to cloth. Mention has already been made of *etu*, the cloths with the Guinea-fowl pattern, where the tied or stitched resists are unpicked, but the cloth is neither washed or ironed, leaving the hillocks of the resists to give a snake-like appearance. The Yoruba term for stitched resist in indigo is *adire alabere*.

In the past, the *adire alabere* technique was worked on handwoven cloth; nowadays, however, it is almost invariably used on readily available mill-made cotton shirting, usually white, but sometimes patterned. In the latter case, the ground pattern appears in the resist sewn areas against the indigo-dyed background.

Yoruba women fold and pleat cloth in numerous ways before stitching in a resist. An interesting variation, which imitates stripwoven cloth, is to take strips of mill cloth, stitch a resist into them, dye them indigo and then, when they are unpicked, sew them up, selvedge to selvedge. Raphia thread is the most common form of resist. The Yoruba have many different *adire alabere* designs, which are given such names as 'Plantain', 'Cocoa', 'Tribal Marks' and 'Fingers'.

The same basic technique for stitched resist is employed by the Yoruba (see previous spread). However, raphia is preferred for the resist, not only because of its strength, but also because of the ease with which it can be cut out without causing any damage.

RIGHT
TOP Detail of a Yoruba *adire alabere*, stitched-resist, indigo-dyed, woman's wrap, south-west Nigeria. The fine resist stitchery is worked so as to show up the pattern against the light.

CENTRE Detail of a Yoruba, stitched-resist, indigo-dyed, woman's wrap, south-west Nigeria. Decorated with the 'Tribal Marks with Fingers'.
BOTTOM Detail of an *adire alabere*. The stitched resist was of raphia thread, removed with a razor blade.

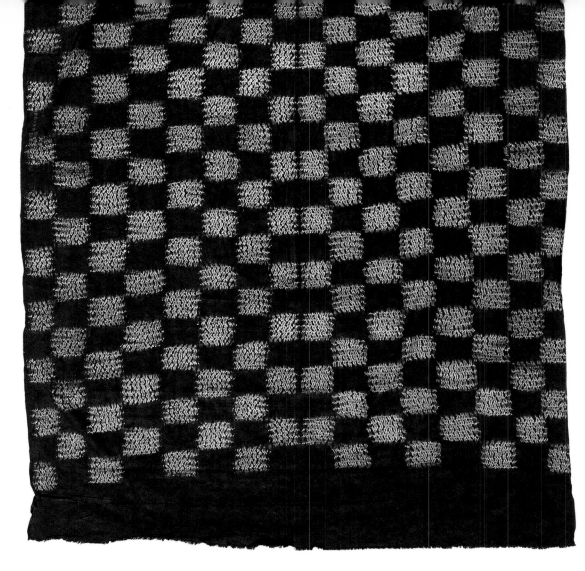

LEFT *Adire alabere*, stitched resist and dyed in synthetic indigo.
BELOW Yoruba woman's wrap. Strips of mill cloth have been resist sewn with raphia thread, dyed blue, then unpicked. The strips have then been sewn together, selvedge to selvedge, to give the impression of prestigious and more expensive stripwoven cloth.

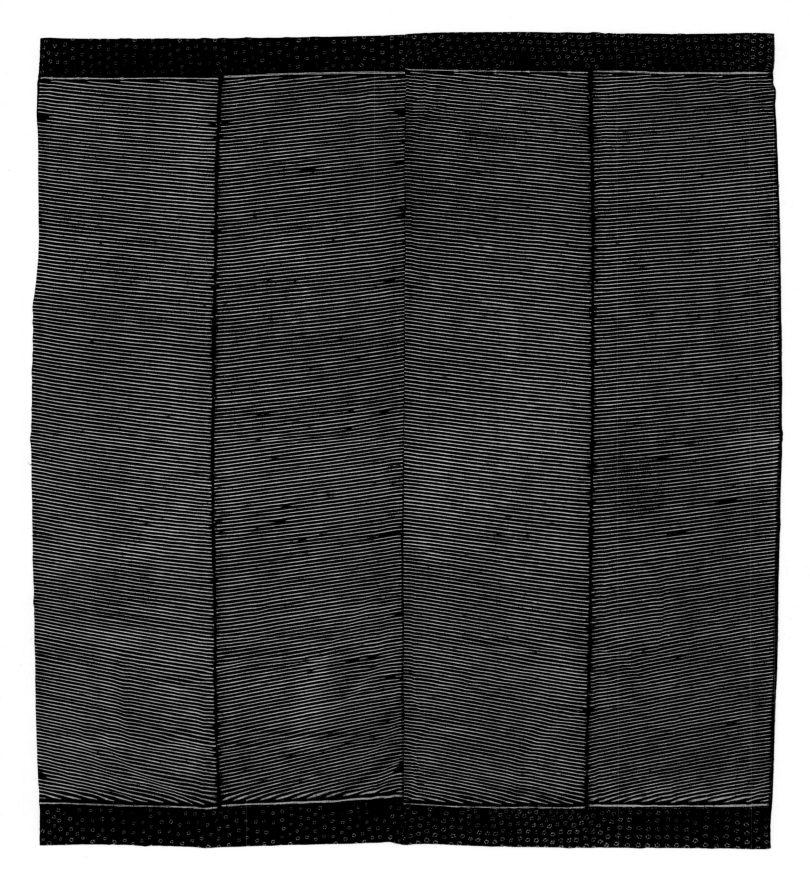

ABOVE *Adire alabere*, Yoruba, stitched-resist, indigo-dyed, woman's wrap, south-west Nigeria.

OPPOSITE TOP A Nigerian chief.

OPPOSITE LEFT An unusually fine stitched-resist *adire alabere*. The clock motif is a rare innovation in design.

OPPOSITE BOTTOM LEFT Yoruba *adire alabere*. The stitched-resist pattern is worked so that it looks like expensive imported damask cloth.

OPPOSITE BOTTOM RIGHT Yoruba *etu* cloth. The indigo-dyed, stitched-resist patterns are so fine that the cloth is never washed or ironed.

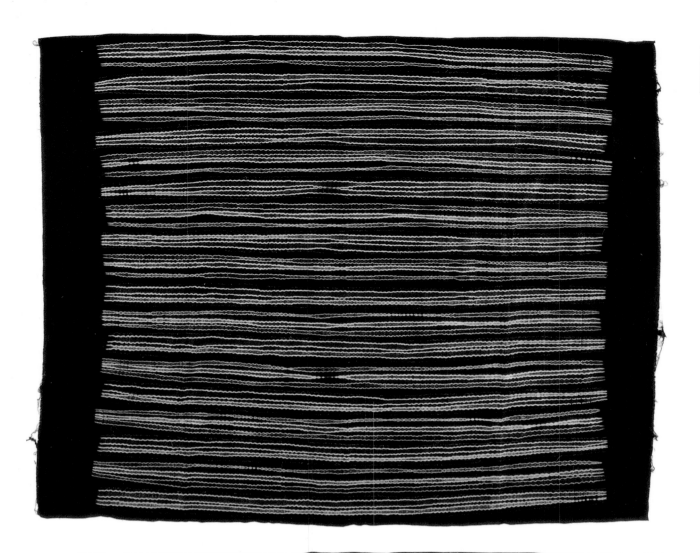

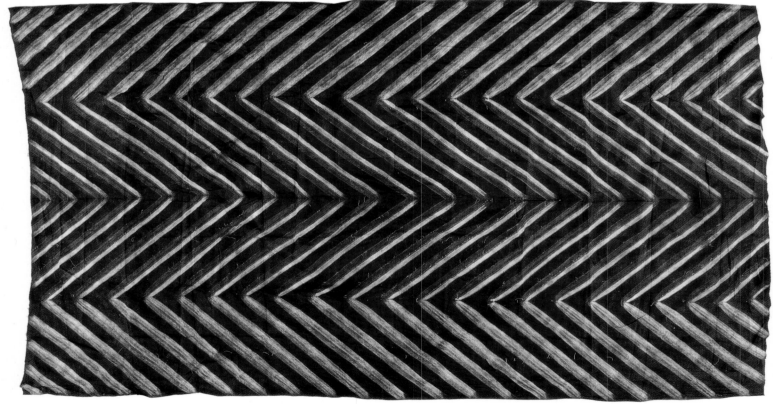

Machine-stitched resist

Singer treadle sewing machines were introduced into Nigeria at the turn of the 19th–20th century and popularized in rural areas by Lebanese traders. It was not long before the inventive Nigerians considered the possibility of stitching resists by machine instead of by hand. Although many of the machine-stitched patterns are similar to the hand-stitched ones, the machines create finer, though normally more linear, designs.

For many years, this work was the domain of male tailors, but, with the weakening of traditional demarcations between the sexes, many women now undertake this task.

All machine resist is carried out on mill cloth, such as white shirting, otherwise it would snag. Mill cloth is pleated and, along the crease, two to four rows of tight stitching are sewn. This process is repeated with each pleat, until the whole cloth is concertinaed.

At this stage the cloth is dyed in the traditional indigo or, mostly nowadays, in a range of synthetic dyes, of which brown and purple are possibly the most popular. The machine-stitched cotton thread is then unpicked with a razor blade, taking care not to damage the cloth. A pattern of columns of fine white dashes remain against a coloured ground. There are many variations on this theme.

OPPOSITE
TOP Yoruba indigo-dyed wrap. Prior to dyeing, the cloth has been pleated and sewn by machine. After dyeing, the stitches are painstakingly unpicked.
BOTTOM Machine-sewn resist textiles are a major export from Nigeria to other parts of Africa. This pleated and diagonally stitched cloth was chemically dyed, probably at Abeokuta, Yorubaland, but bought in a market in Cameroon.

RIGHT A Yoruba indigo-dyed cotton cloth. Machine stitching has been used to resist the dye and make the pattern.

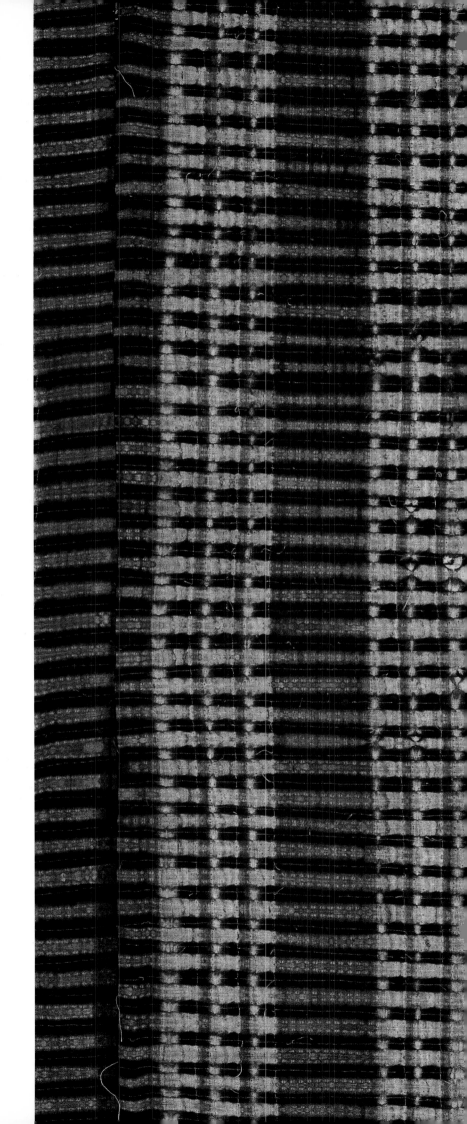

Yoruba and Baulé warp ikat

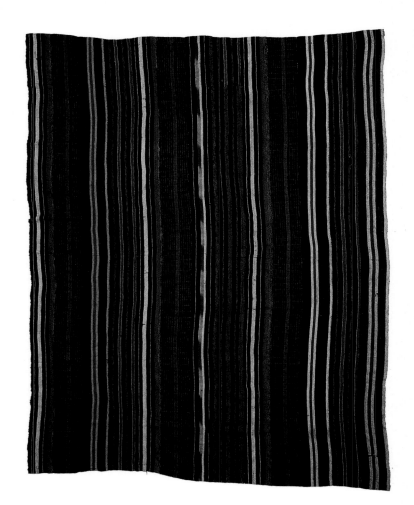

Ikat is the process whereby threads are tie-dyed before weaving takes place. When the cloth is woven, any section of the cloth where the threads have been previously ikat-dyed will have a rather frayed pattern in the colour of the undyed thread against the dyed ground. The ikat process can be applied to warp or weft or both. It is only warp ikat, though, that is used, albeit sparingly, in West Africa.

There are no records of African weft, double or compound ikat, but both the Baulé of the Ivory Coast and the Yoruba use warp-ikat details in some of their stripweaves. The technique was practised at one time in parts of Ghana and by present-day northern Edo women in Igarra, Nigeria. It is used sparingly, though the colour range can vary. However, white warp threads are often simply tied and then dip-dyed in indigo. The Yoruba use warp stripes of alternate colours to create contrasts in their 'country' cloths. In the Ivory Coast around Tiébissou, Dioula dyers tie-dye patterns into warp threads for Baulé weavers. The resulting warp-ikat textiles can be more complex than those of the Yoruba, though they usually also keep to a blue-and-white colour scheme.

One of these Baulé cloths was found as a backing for a Central Asian ikat – evidence of the trade that co-exists with the Haj pilgrimage to Mecca.

The warp-ikat method gives the textile a pattern by tying resists tightly around the warp threads that have been stretched out on a frame. The tied hanks are then immersed in a dye-bath. Warp ikat in West Africa is often a plain blue and white. If the original white thread is placed in an indigo dye-bath to give blue, the tied portions make a white pattern against a blue ground. When the dyeing process is finished, the dyed warp is woven with a plain coloured weft to create a warp-faced, patterned textile.

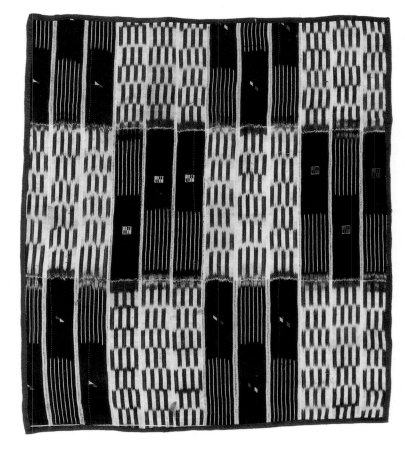

TOP RIGHT North Ghanaian stripwoven 'country cloth'.
RIGHT Section of a cotton warp-ikat woman's wrap, Baulé people.
OPPOSITE
TOP LEFT Igarra stripwoven cotton woman's cloth with

warp-ikat details, Nigeria.
TOP RIGHT Baulé man's cloth.
BOTTOM LEFT Yoruba stripwoven 'country cloth' with simple warp-ikat details in alternate strips.
BOTTOM RIGHT Yoruba stripwoven cotton cloth with warp-ikat details.

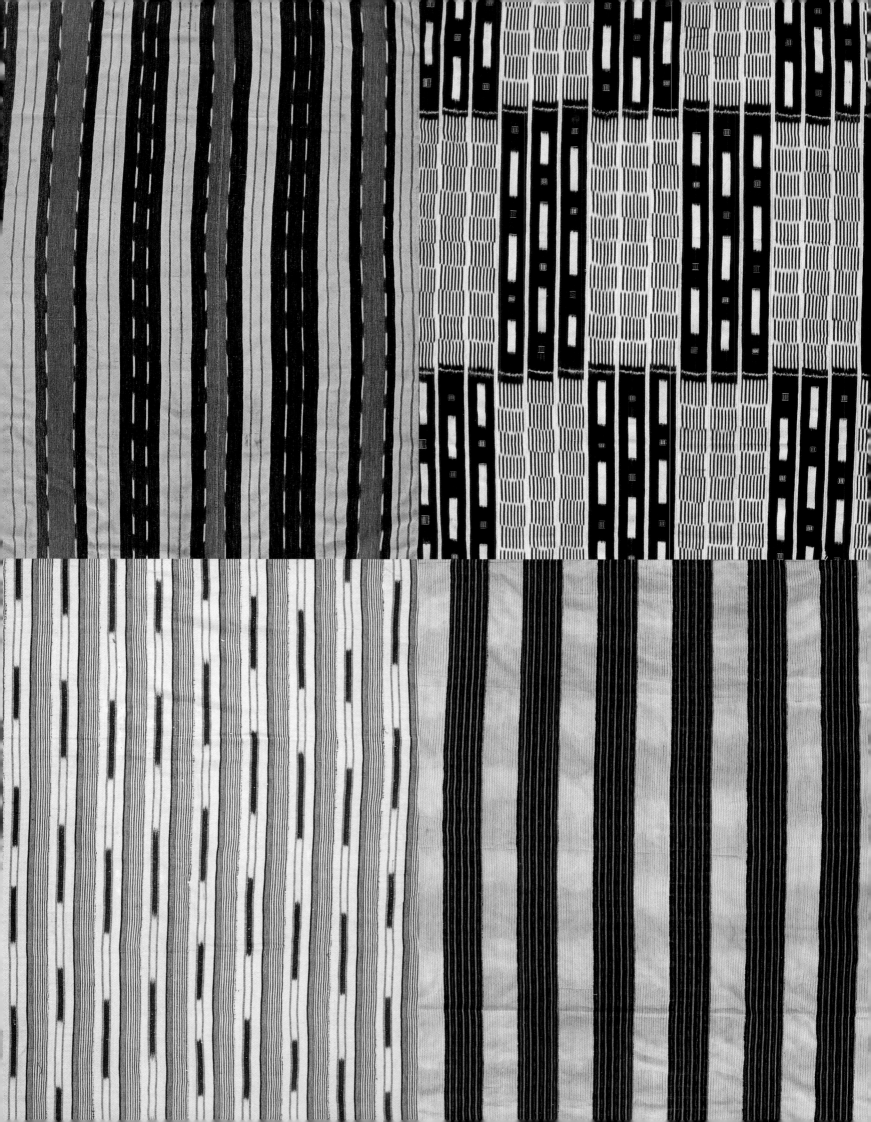

Nigerian starch-resist by hand

In the towns of Yorubaland in Nigeria – Ibadan, Ilorin, Owo, Oshogbo – there was a fashion amongst women for making *adire eleko* (starch-resist) cloths. They were worn in pairs by Yoruba women. These cloths had a cassava starch-resist applied to them before they were dyed in indigo. Unlike the stencilled cloths of Abeokuta, they had patterns drawn by hand, featuring birds, lizards and well-known landmarks, such as the Ibadan town hall.

After 1929, production went into steep decline. It was only revived in the 1960s and 1970s, partly to cater for a large expatriate market attracted by Nigeria's burgeoning oil wealth. Since then, the starch-resist method has again suffered, as Nigeria has spiralled downwards in a cycle of corruption, inter-ethnic rivalry and ensuing poverty. The expatriate market has disappeared and there is now very little local demand.

Using this technique, a woman dips a sharpened quill of a large bird into a paste of cassava flour mixed with copper sulphate and water, known as *lafun*. She draws on one side of the cloth only. First, she folds the new mill cloth so that, upon opening it out, it forms a squared grid. (A typical *adire eleko* of the 1960s consisted of a central section of twenty squares surrounded by thirty-two smaller rectangles.) Second, she outlines the grid in *lafun* and then proceeds to fill the squares with bold designs. The motifs within each square (such as birds or the sun) have a proverbial meaning. Moreover, the whole cloth is given a name that is recognized in the marketplace, such as 'I am getting myself together'. Within the overall design, the squares are repeated, at least twice.

The cloth is dip-dyed in an indigo bath as many times as is necessary to achieve the deep blue-black so prized by the Yoruba. In between dippings, the cloth is laid out on racks to dry. Great care is taken not to crack the *lafun* paste, which is only applied to one side of the cloth. As the starch does not resist the dye completely, the cloth takes on a light-blue pattern against a dark-blue background when the dried paste is removed. The *adire* worker often adds her maker's mark.

ABOVE A starched, but undyed, Yoruba *adire eleko*. The resist-paste of cassava flour will be scraped or flaked off after dyeing.

OPPOSITE Indigo-dyed starch-resist *adire eleko* cloth from the 1960s in the *Ibadan Dun* pattern.

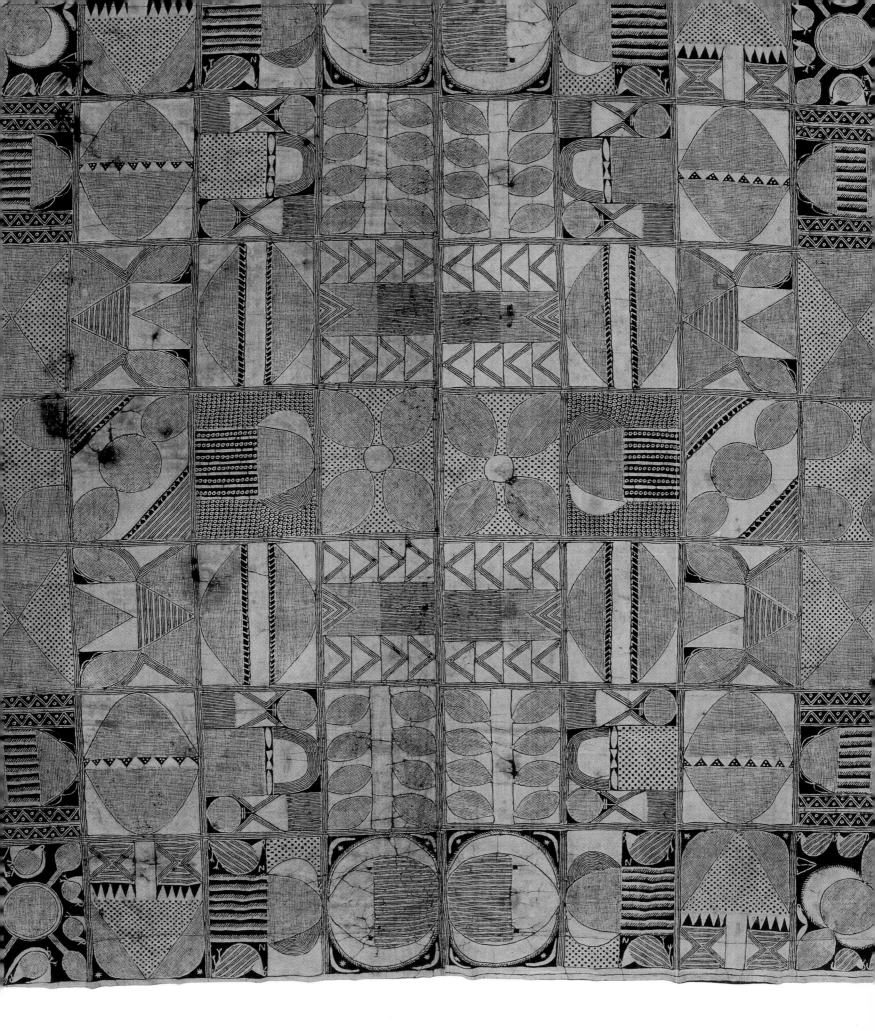

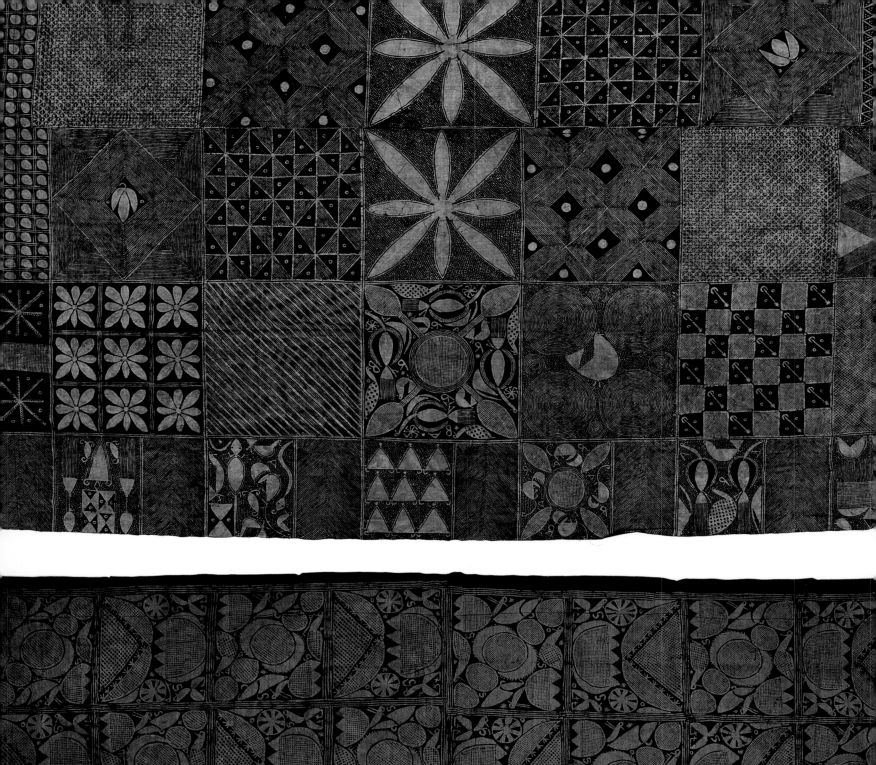
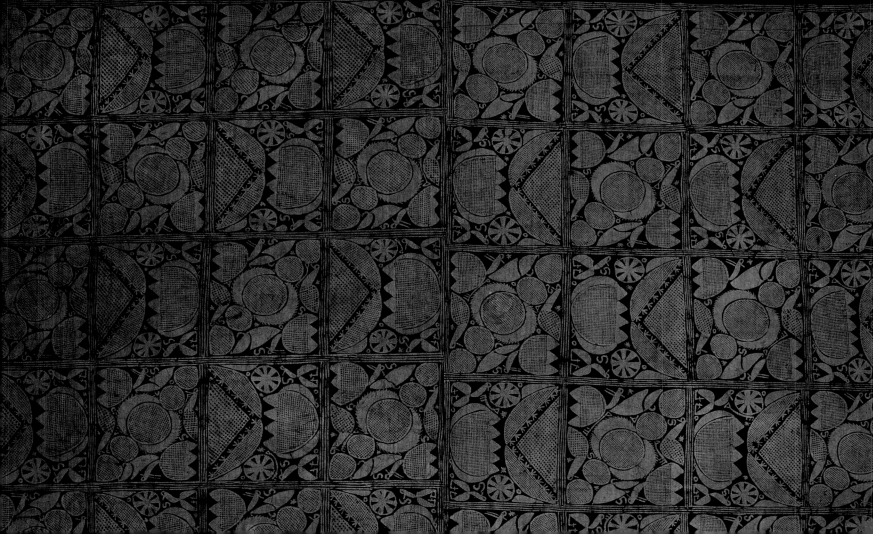

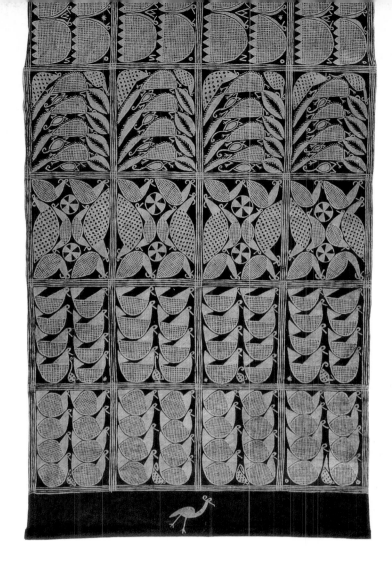

OPPOSITE

TOP Indigo-dyed starch-resist *adire eleko* cloth from the 1960s in the *olukun* or Sea-goddess pattern.

BOTTOM *Adire eleko*, from Nigeria, with a pattern created by applying a resist-paste of cassava flour by hand. This pattern, made up of two particular motifs, conveys the message, 'I'm getting myself together'.

ABOVE Indigo-dyed starch-resist *adire eleko* cloth with a pattern of banana trees and plantains. This cloth is unusual in that it is not really symmetrical.

RIGHT Indigo-dyed starch-resist *adire eleko* cloth from the 1960s with a pattern of birds. The bird at the bottom is the maker's mark.

BELOW Hand-drawn starch resist *adire* imitating the stencilled King George V and Queen Mary pattern.

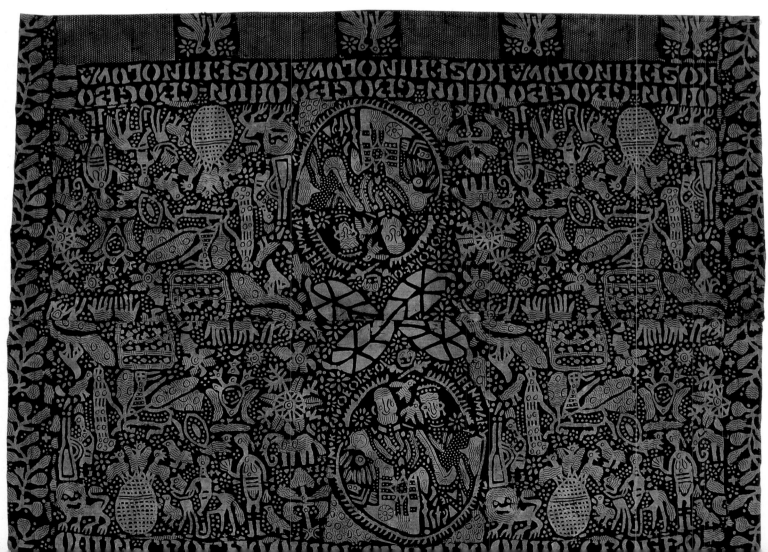

Stencilled starch-resist

One of the many ways of applying a dye-resisting agent to fabric is by coating the surface of cotton cloth with a flour paste and then immersing it in a cold water dye such as indigo. Noted for their arts, the Yoruba people of south-west Nigeria are not only some of Africa's most versatile weavers, but are also unsurpassed as indigo dyers. While much of the weaving profession is carried out by men, indigo-dyeing – along with hand-drawn starch-resist, which has always been a female occupation – is very much a task for women.

Stencils were first cut from the lead linings of tea and cigar boxes in the early 20th century at the town of Abeokuta, but, for most of the 20th century, 30 × 20.3 cm (2 × 8 in.) panels of zinc have been used, with the required pattern chiselled into them. Until recent times, the application of the cassava starch-resist through stencils was exclusively a male occupation. Nowadays, many roles have changed. For instance, in Oshogbo, one of the last places for dyeing in natural indigo, women play a major part in the manufacture of these cloths, which are known, like their hand-drawn cousins, as *adire eleko*.

Starch is only applied to one side of the cloth. The starch-resist technique works on the same principle as wax batik. It is well-suited to indigo dyeing, in that the temperature of the vat never rises high enough to dissolve the starch. The cloth to be stencilled, which may be plain white or patterned mill cloth, is nailed flat to a table. The zinc stencil is placed firmly on top of the cloth and cassava or cornflower starch mixed with alum (the paste is known as *lafun*) is applied and pressed into the cloth with a metal spatula. Any surplus is scraped off and retained. Most designs require a series of stencils, which are used in the order of their importance to the overall design. Repeated immersion in the indigo dye-bath is required. Great care is taken not to crack the resist while handling it during this process. When the dyeing is completed, the *lafun* is scraped off the cloth, which is then hung out to dry. Starch is not a particularly strong resist; it is permeable to a limited extent. The resulting cloth, if a white base is used, therefore has a light-blue design on a very dark-blue ground. One of the favourite central motifs shows King George V and Queen Mary upon the occasion of their Silver Jubilee in 1935.

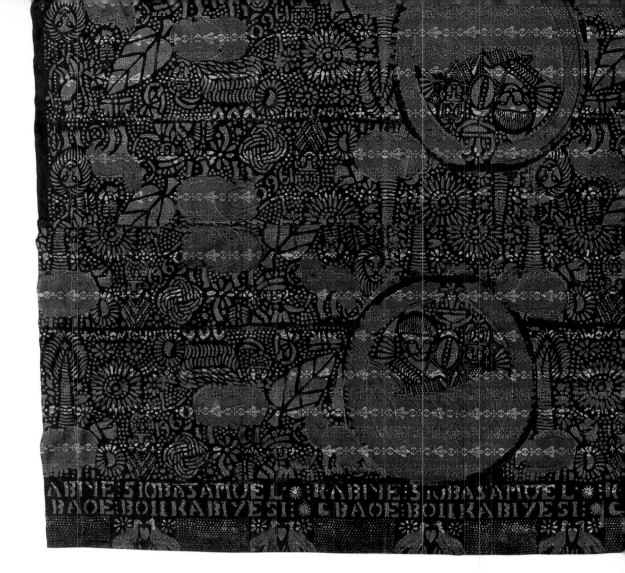

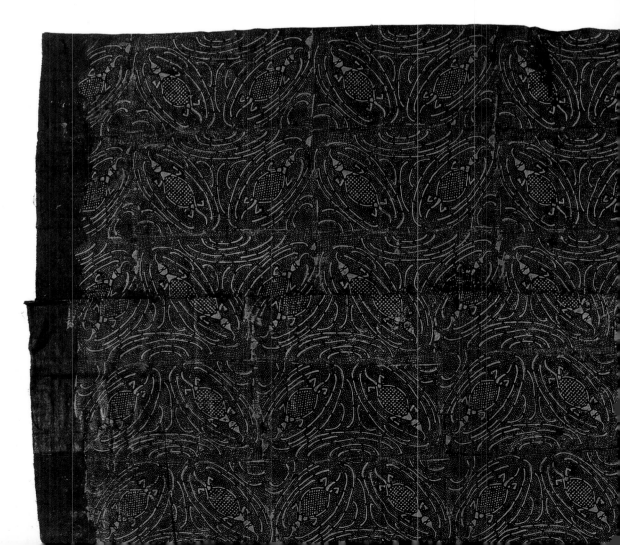

OPPOSITE *Adire eleko* indigo-dyed woman's wrap with a stencilled Yoruba proverb.

TOP A 1970s Nigerian market scene. The woman wears an *adire* wrap.

ABOVE Zinc *adire eleko* stencils, Oshogbo.

TOP RIGHT Yoruba, stencilled *adire eleko* showing King George V and Queen Mary in 1935, their Silver Jubilee year. Cassava starch has been stencilled on to mill-patterned cloth. The base pattern is revealed where the starch has been applied.

RIGHT *Adire eleko* indigo-dyed woman's wrap with a lizard or terrapin stencilled motif.

Wax resist

Though never esteemed in the same way as stripwoven or other forms of resist-dyed cloth, wax-resist cloths are by far the most widespread of handmade cloths in West Africa. With their bright colours and 'psychedelic' designs, they are used as women's and men's cloths and made into dresses, shirts and gowns. Cheap and cheerful, the generically known *gara* cloths of Sierra Leone and neighbouring countries have sparked screen-printed and factory-made imitations that are often very difficult to distinguish from the originals.

The West African love of wax-batik cloth is said to have originated because the Dutch took soldiers from the Gold Coast to Java to fight in their colonial wars during the 18th century.

West Africa has no equivalent of the Indonesian *canting* or the South Indian *kalam*, instruments for the application of wax. Practitioners of wax batik in West Africa have to make do with the humble commercial sponge. Laying out the mill-woven cloth on a padded table, the worker dips a sponge into a little heated metal pot of molten paraffin wax and applies it to the cloth, which is then dip-dyed in a vat of chemical dyes.

The feathering, or veining, of the design is achieved by scrunching the waxed cloth before dyeing so that hair-line cracks appear in the wax resist, through which the dye can penetrate. This feature, which in Java would indicate inferior batik, is highly valued in West Africa.

TOP A multi-coloured wax-batik woman's cloth from the Gambia. The veined effect is achieved by crumpling the wax resist before dyeing.
LEFT Wax has been printed on to this cloth from Mali with simple wooden stamps before it has been dyed.

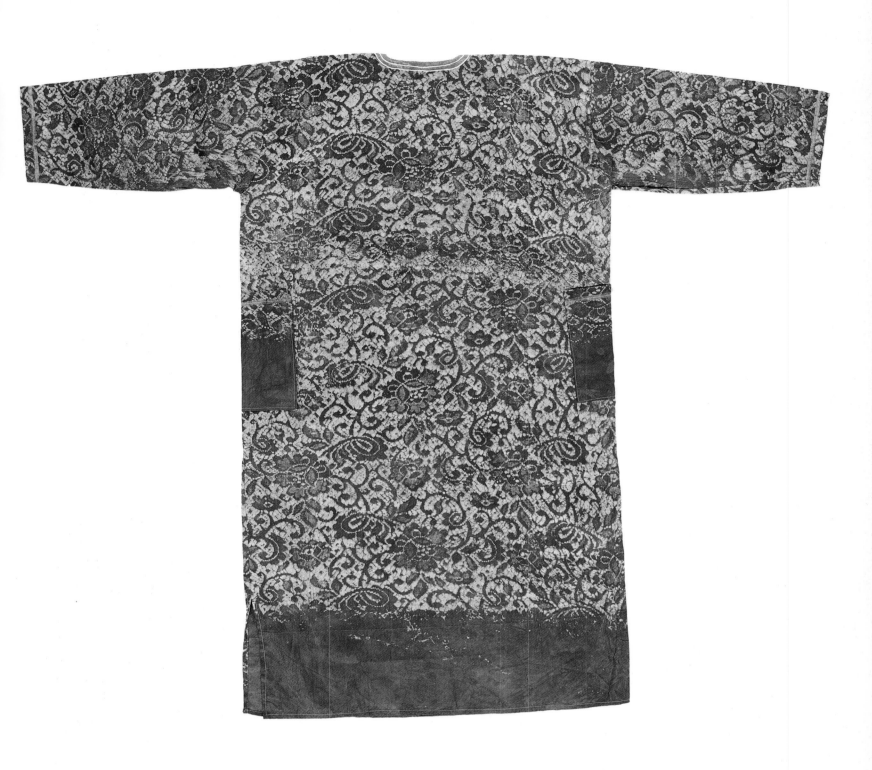

ABOVE A woman's gown from eastern Nigeria. The cloth from which it has been made had a wax resist applied to it through plastic lace curtains.

RIGHT Wooden stamps from Guinea for applying wax resist.

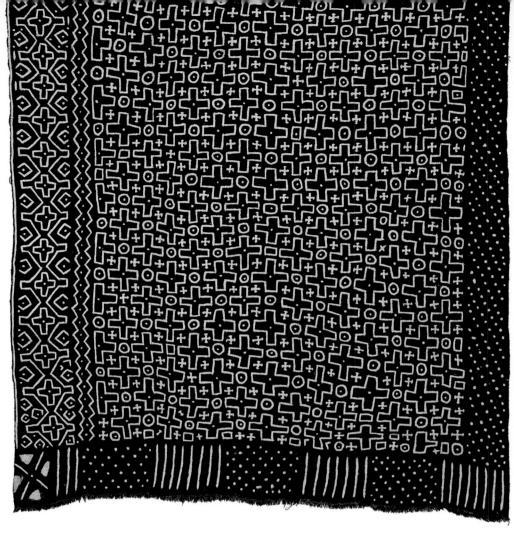

RIGHT *Bogolanfini* mud cloth made by the Bamana of Mali. The dense application of iron-rich mud to the tannin-mordanted cotton cloth results in an intricate negative pattern of exposed bleached areas.
BELOW *Bogolanfini* mud cloth made by the Bamana of Mali.
BELOW RIGHT Bamana *Bogolanfini* mud cloth from Segui, Mali. The meandering patterns are designed so that any threatening spirits will become disorientated and not penetrate the body of the vulnerable wearer.

OPPOSITE *Bogolanfini* mud cloth made by the Bamana of Mali. These cloths have become symbolic of a Pan-African identity and are exported to Europe and America and other parts of Africa.

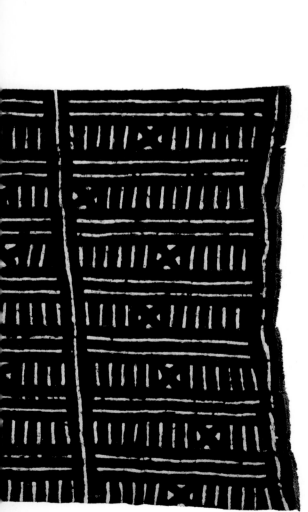

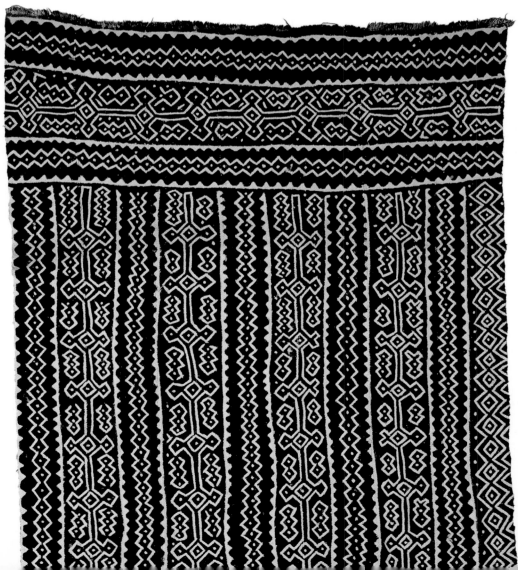

Mali mud cloths

One of the best-known types of cloth from Africa are the *bogolanfini*, the so-called mud cloths from Mali. Made by Bamana women to the north of Bamako, they are decorated with geometric patterns in white on a black background. This work is carried out on locally stripwoven cotton cloth to make hunters' shirts and women's wraps.

The cloth is first soaked in a mulch of leaves from local trees such as *Anogeissus leiocarpus (n'galman)* and *Combretum glutinosum (n'tjankara)*, which contain the mordant tannin that dyes it a deep-urine yellow. Designs are drawn in outline on the cloth in river mud that has been kept for one year or more and is rich in iron salts. The remainder of the cloth is then carefully covered with the mud around the outlined motifs, using a blunt knife, spatula or even a toothbrush. The iron oxide in the mud reacts with the tannic acid in the cloth to produce a colourfast black ground for the design. Finally, the mud is washed off and the remaining yellow areas are bleached white with a mixture of millet bran and peanuts and the active ingredient, caustic soda. The whole process may be repeated several times to deepen the shade of black.

Bogolanfini were traditionally worn by hunters, pregnant or menstruating women or anyone in danger of losing blood. They are protective clothes, keeping away threatening evil spirits, who are meant to be confused by the meandering patterns or the close weave of the fabric, and are thus unable to penetrate the wearer's body, but go away without causing any harm. First made commercially for an international film festival at the Malian capital of Bamako in the 1970s, they generated a Pan-African, then a worldwide demand. Production is centred on the town of Segui, north of Bamako. There is a large export market to the United States for those concerned with 'black consciousness'.

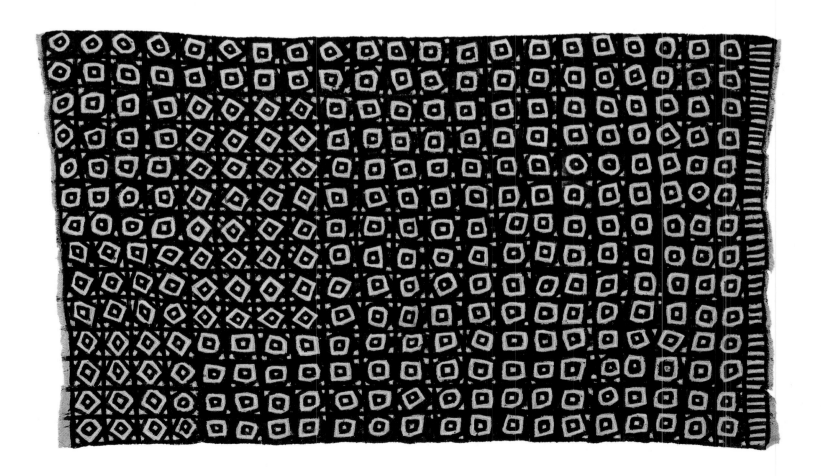

Adinkra stamped cloths of Ghana

In Ghana, as in many parts of Africa, funerals have great symbolic value and mourners dress in dark, sombre colours. In the village of Ntonso, close to Bonwire (the centre of Ashanti weaving) and the great market town of Kumasi, specially commissioned robes of *adinkra* hand-printed cloth that are traditionally associated with mourning are made. Elderly men print motifs such as the fern or the moon, each of which has a proverbial meaning, on to Chinese mill cloth with stamps carved out of a calabash gourd. *Adinkra* cloths made for funerals and mourning are overdyed red or black, but others retain their white background and are worn at festive occasions. Those who cannot afford a new *adinkra* cloth will dye an old, brightly coloured *kente* cloth a sombre hue in an infusion of the bark of the *badee* tree.

The design motifs for *adinkra* are carved into the hard outer surface of sections of calabash. A handle is made by pressing four raphia-palm splints into its soft inner skin and drawing their ends together with a cloth rag. The printer draws out a grid on the 2.7 × 3.6 metres (3 × 4 yds) mill cloth with a bamboo splint dipped into a thick dark goo that is obtained by boiling down *badee* tree root bark mixed with iron slag. He then applies rows of a different set of design motifs to each square of the grid by repeatedly rolling one of the slightly curved stamps within that area. Sometimes he may decorate alternate squares with parallel lines by drawing a small bamboo comb across them. In one day each worker can complete about two cloths, which are then hung out overnight to catch the dew. Nowadays the rows of printed squares on *adinkra* cloths are divided by longitudinal lines using a type of faggoting stitch in red, black, yellow and green.

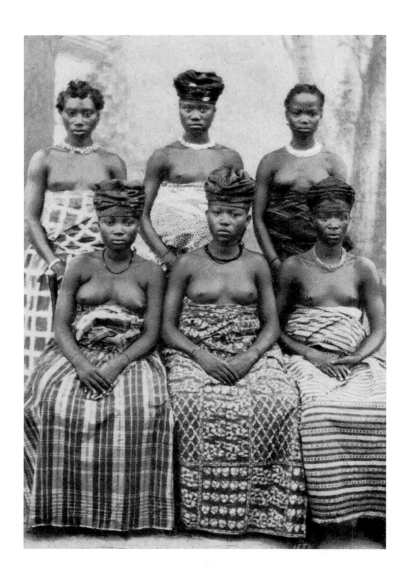

OPPOSITE

TOP Young Fante women
of the old Gold Coast wearing
country-made cloths. The woman
sitting in the middle at the front
is dressed in an *adinkra* calabash-
printed cloth.

BOTTOM Stamps carved from
calabash shells for printing *adinkra*
cloth.

RIGHT Detail of an *adinkra* cloth
made at the village of Ntonso,
Ghana, printed with calabash
stamps with the moon motif.

PAGE 90 Early 20th-century Ashanti
adinkra cloth with allegorical motifs
printed within a black, stripwoven
grid.

PAGE 91 *Adinkra* cloth from
Ghana. The cloth has been divided
into squares, each of which has
been filled with prints of one
allegorical motif.

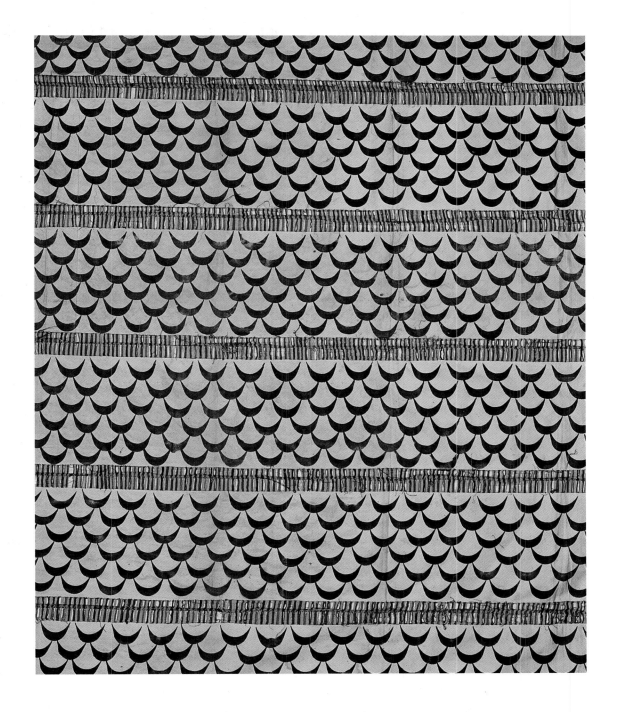

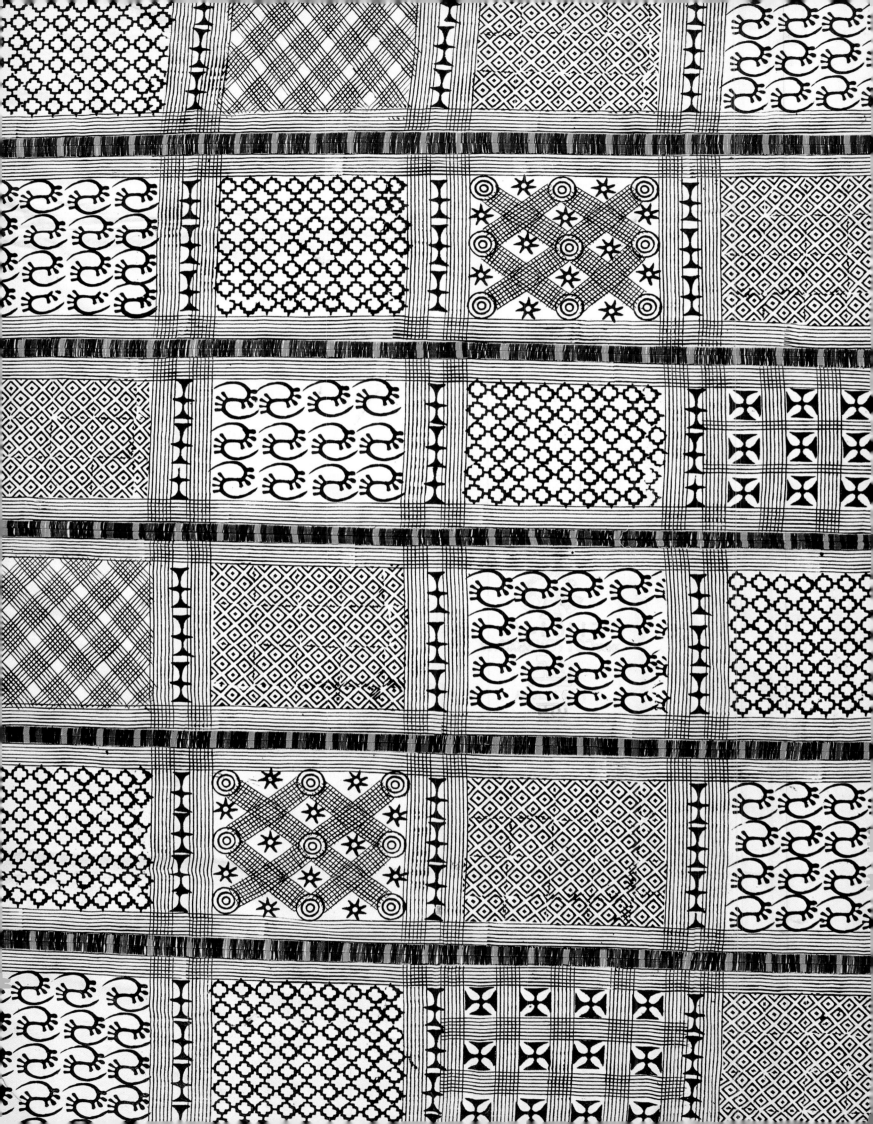

Stamped, stencilled and dyed clothing from Sierra Leone, Guinea and Mali

Kola nut (usually *Cola nitida*) grows abundantly in this region, in both the wild and the cultivated state. It is traded throughout West Africa and is generally chewed as a stimulant, in the manner of areca nut and betel leaf in India.

Other varieties, such as *Cola acuminata, Cola verticillata* and *Cola anomala*, are grown in other parts of West Africa, but *Cola nitida* is the most important one. It was exported to Britain in the 1890s and, later, to America, where it formed the basis of carbonated cola drinks.

In West Africa *Cola nitida* is also used as a quick and easy colouring agent to dye clothing an orangey brown. This clothing may also be decorated by stamping or stencilling with vegetable dyes. In Guinea, women stencil out simple vegetal designs on to kola-dyed women's wrappers. The Bamana in Mali stamp leaf patterns on to kola-dyed men's and boy's smocks.

In the north of Sierra Leone, the dyes are different. The Limba and Yalunka stamp simple designs with vegetable dyes on to brown-dyed cloth, a technique called *huronko*.

The pioneering textile researchers Venice and Alastair Lamb observed that, in Sierra Leone, the brown dyes were obtained from mahogany and other tree roots and some bark. These dyes were then boiled up, left overnight and strained. Cloth was immersed in the resulting dye-bath for a few hours, then left in the sun to oxidize. This process would be repeated from four to fifteen times to deepen the shade of brown. Yellow was obtained by just using mahogany bark. The stamping mixture consisted of a compost of leaves and iron-bearing river mud, while the stamps were carved out of raphia palm. One popular pattern today is the 'Commando Boot Sole', reflecting the horrendous civil war of the 1990s. In Guinea, the women break the kola nut up and immerse it in water for a short period until it produces a suitable dye.

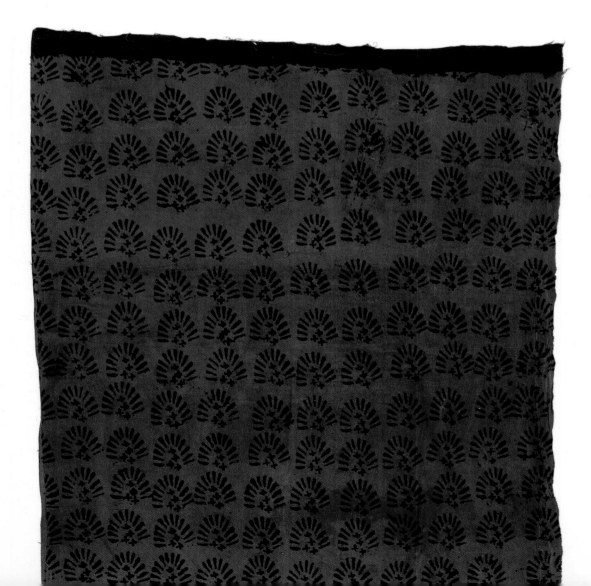

LEFT *Huronko* woman's wrap printed in the Commando Boot Sole pattern, Limbe people, Sierra Leone.

OPPOSITE
TOP LEFT Dyeing with kola nut in Guinea.
LEFT CENTRE Women in Guinea stencilling patterns on to kola-dyed cloth.
LEFT BOTTOM Selling *huronko* cloth in the market in Freetown, Sierra Leone.
TOP RIGHT Stripwoven, kola-dyed cotton smock of a Bamana farmer, Mali.
BOTTOM RIGHT Limbe hunter's shirt dyed with an infusion of tree roots and printed with a leaf and mud-based dye. This type of work is known as *huronko*.

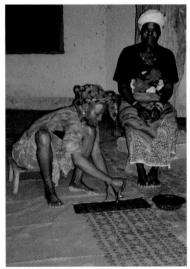

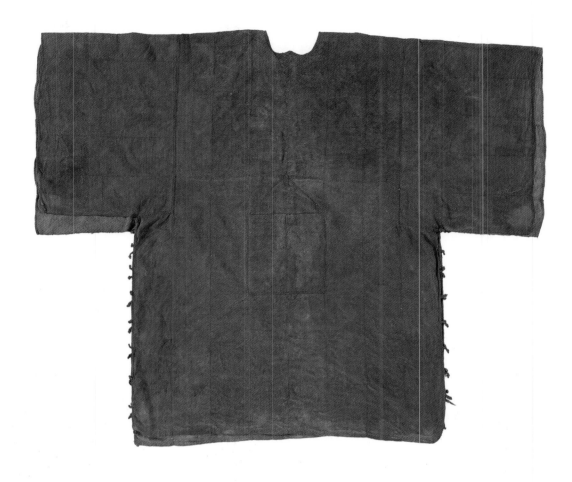

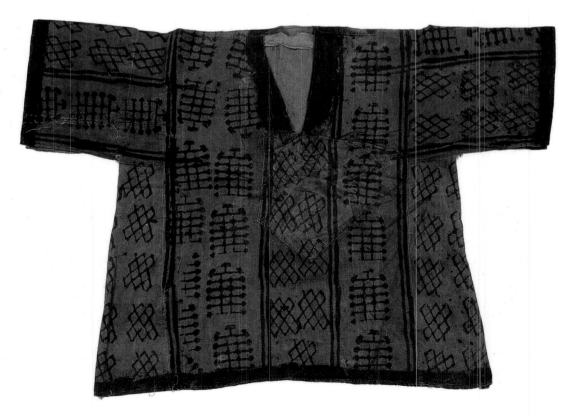

RIGHT AND BELOW *Asafo* festival flags
of some of the Fante 'companies'
of the coast of Ghana. The flag in the
corner (right) commemorates the
coronation of Edward VII in 1902.
Each flag is appliquéd or
embroidered with allegorical motifs.
The proverb to which they relate
extols the bravery and power of
their own company and denigrates
the rest.

OPPOSITE

LEFT *Asafo* festival flag of one of the
Fante 'companies' of the coast of
Ghana. This flag is appliquéd with
allegorical motifs relating the power
and wealth of the company.

RIGHT Fante *Asafo* festival flag of
Number 4 company of the coast
of Ghana.

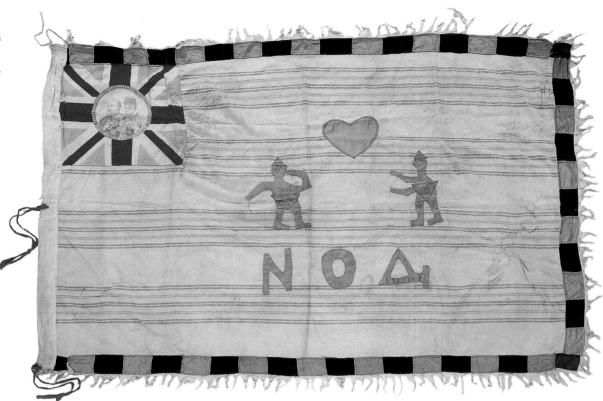

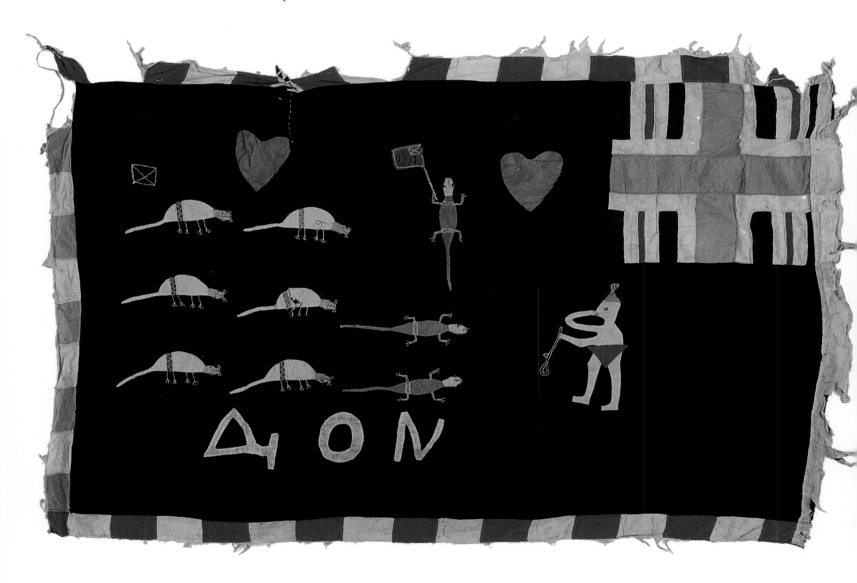

Fante flags from Ghana

The Fante inhabit the central portion of the coastal plain of Ghana. Historically known as the Gold Coast, this part of Ghana was where the European traders built forts, from which they traded with the hinterland. The Fante acted as intermediaries between the dominant Ashanti confederation and the Portuguese, Dutch and British, as well as other European forts in the trade in gold, slaves and ivory.

The Fante developed a religious cult devoted to military power. Dividing themselves up in the European fashion into military companies (No. 1, No. 2, etc.) – known as *Asafo* (literally, 'our people') – they became great rivals to each other and paraded with flags at the festivals held in their country in June or July. One corner of each flag sported the Union Jack, the flag of the British, the dominant colonial power. The Fante flag also frequently appeared on a white or red background, imitating British naval, or merchant marine, flags. In this way, the Fante hoped that, through imitation, the immense power of the British would somehow, and by a form of sympathetic magic, be rubbed off on the flags and their companies. As well as the Union Jack, and sometimes the number of the company, pictorial proverbs – such as the cat eating the mouse or blood-thirsty renditions of guns and executions lauding the superiority of one company over another – were appliquéd on both sides of the cloth.

Fante flags are made of mill-woven cloth, usually cotton, occasionally silk and, nowadays, sometimes man-made fibres. The figures used to illustrate the proverbial meaning of the flag are cut out by hand or with the aid of a card template. Two methods are then possible. The more common one is to use two cut-outs and to apply them to either side of the flag in mirror-image of each other. The motifs are tacked to either side of the flag. Edges are then turned in and hemmed or slip stitched. The other method is to cut out only one motif, which is inserted and sewn into a hole in roughly the same shape and size in the ground fabric of the flag. Both sides of the insert are visible on either side of the flag. The Union Jack or Ghana ensign part of the flag is made up of patchwork.

The craft of appliqué probably started at the same time as cotton fabrics were imported from the industrialized mills of Europe. It is difficult not only to fold handwoven cloth (as it is too thick), but also to add a pattern (as it is on too large a scale).

Further along the West African coast, the Fon of Benin at their old capital of Abomey are also fond of their appliquéd cloths, which take the form either of a seemingly random arrangement of birds, animals and human figures or a grid depicting the Fon kings with the dates of their reigns.

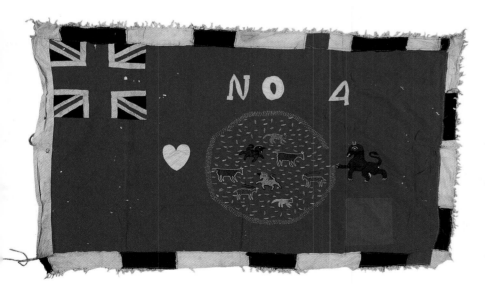

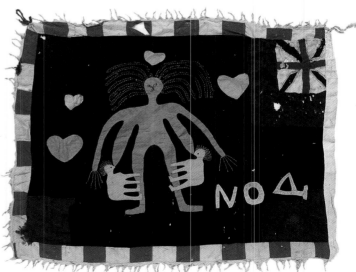

Painted calligraphy cloths and amulets

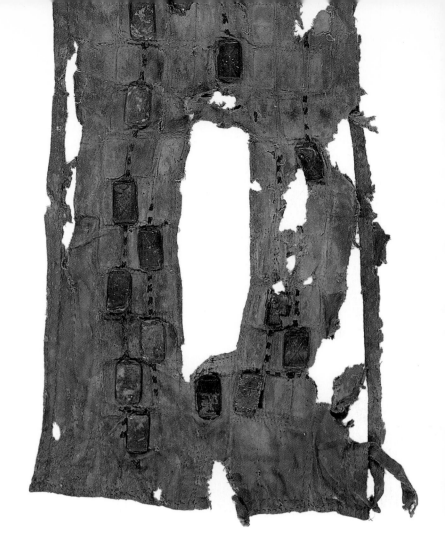

Throughout the Muslim world, there is a strong belief in the protective power of the Koran's written word. Important Muslim warriors would wear a shirt enscribed with all, or part of, the Koran underneath their body armour. There are well-known examples in Turkey, Iran and India, as well as North Africa, from where it is thought that the fashion for calligraphy cloths has spread down to West Africa along the caravan trails. The British Museum in London has a fine calligraphic undershirt made for either the Fulani emirs of northern Nigeria or for the Ashanti, which is probably the work of Hausa craftsmen.

Poorly paid Hausa Koranic scholars have traditionally supplemented their meagre income by drawing embroidery patterns. The expert on the Hausa, David Heathcote, believes that the calligraphy cloths of West Africa were drawn by these Hausa scholars. The Ashanti, though not Muslim, have adopted this talismanic calligraphy, but they wear it on large toga-like cloths. They had a strong warrior tradition and were no doubt proud to embrace an Islamic custom that celebrated valour. Also prevalent across West Africa is a tradition of wearing amulets, which are attached to the clothing of warriors and hunters.

These calligraphic cloths were laid out in a grid of tiny squares, which were partly filled with Arabic-style writing and partly painted, usually in red and green, yellow and black.

Amulets are prepared by Islamic scholars or marabouts (holy men), who write out Koranic or magical inscriptions in locally made black ink, bless them with incantations and bind them in leather or wild-animal skin.

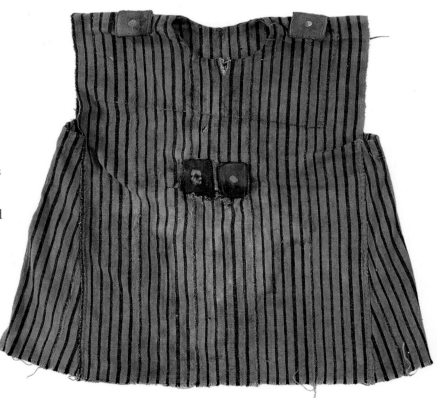

TOP AND RIGHT Ashanti warriors' shirts embellished with leather-covered amulets containing Koranic verses.

OPPOSITE TOP LEFT An Ashanti warrior's cap decorated with leather-covered amulets containing Koranic verses.

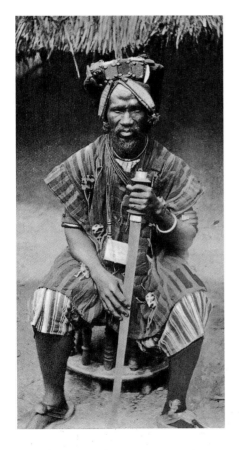

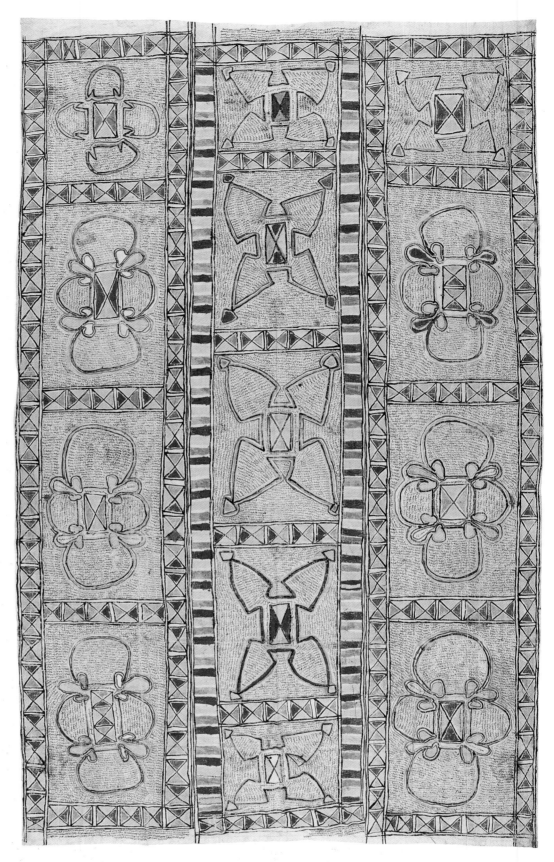

ABOVE A chief from Sierra Leone dressed for war in smock and cap with leather-bound amulets.
RIGHT Prophylactic painted cloth made for the Ashanti of Ghana, most probably by Hausa craftsmen. Although not Muslim, the Ashanti revered the protective and magical power of the Arabic written word.

PAGE 98 *Rigan yaki* charm gown (back), inscribed with Koranic verse, magical diagrams and with leather amulets sewn on the inside.

Probably drawn by Hausa scribes for a north Nigerian or Ashanti patron.

PAGE 99 Front of the same garment.

99

Embroidered robes of the Hausa and the Nupe

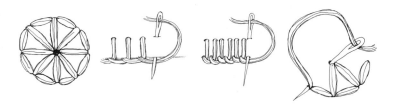

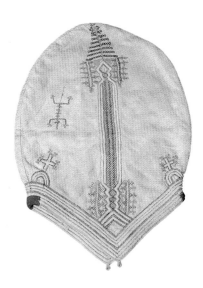

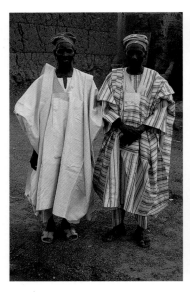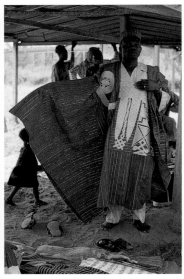

The most characteristic of West African men's clothing is the vast, deep-sleeved *agbada* or *boubou* robe, worn by prestigious Muslim men or anyone else with an important social or material position. The fronts and backs are embroidered by hand or machine. The collar and the breastpiece are typically adorned with the two- or eight-knife pattern, the breast pocket with a circle broken up into squares, a pattern recalling the cabbalistic pseudo-science of numerology. The back is often embellished with a great embroidered spiral. These dramatic embroideries are drawn out, and often worked, by impoverished Koranic scholars amongst the Muslim Hausa and Nupe peoples of northern Nigeria. Hausa hand and machine embroiderers are to be found in many other countries in West Africa.

Hausa and Nupe embroidery is worked largely in button-hole stitch, which resembles blanket stitch, except that, for greater strength, the stitches are packed tightly together, giving it a much more solid appearance. The hole itself is cut after the stitching has been completed. Detached buttonhole stitch, which is made by working a row of stitches on to a previous row, independently of the fabric, is used for the neck decoration of Hausa robes.

TOP LEFT Embroidered man's bonnet from Sierra Leone of Mandingo origin.
ABOVE LEFT Two Nigerian notables dressed in *agbada* robes.
ABOVE RIGHT Selling an *agbada* robe at a country fair in eastern Nigeria.
TOP RIGHT Buttonhole stitch.
RIGHT AND FAR RIGHT A Hausa man embroidering for the export market.

OPPOSITE
TOP Nupe *agbada* robe woven of wild silk and cotton and embroidered in wild silk.
LEFT A Central African chief wearing a ceremonial robe adorned with Hausa embroidery.
RIGHT The finely embroidered breastpiece of an 'Eight Knives' *agbada* Hausa robe.

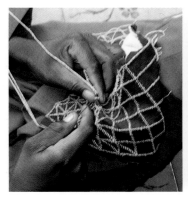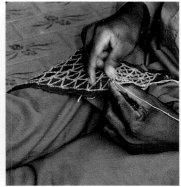

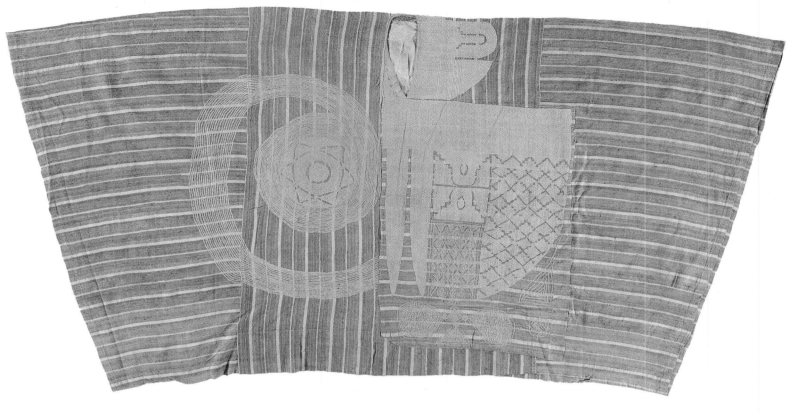

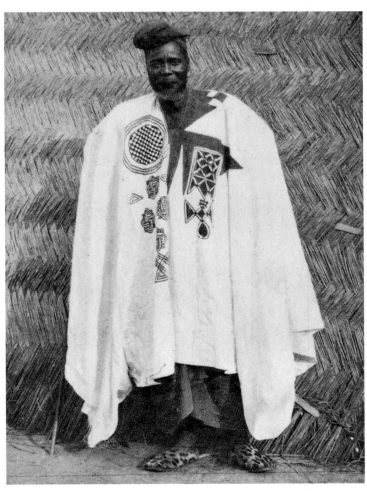

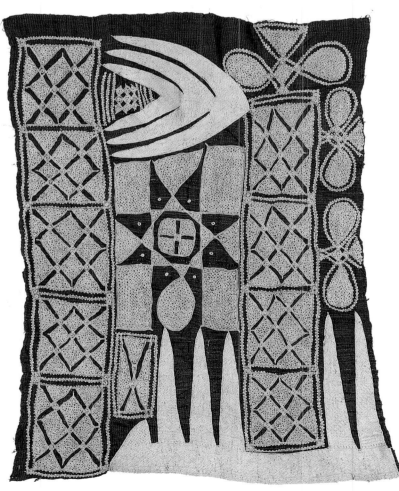

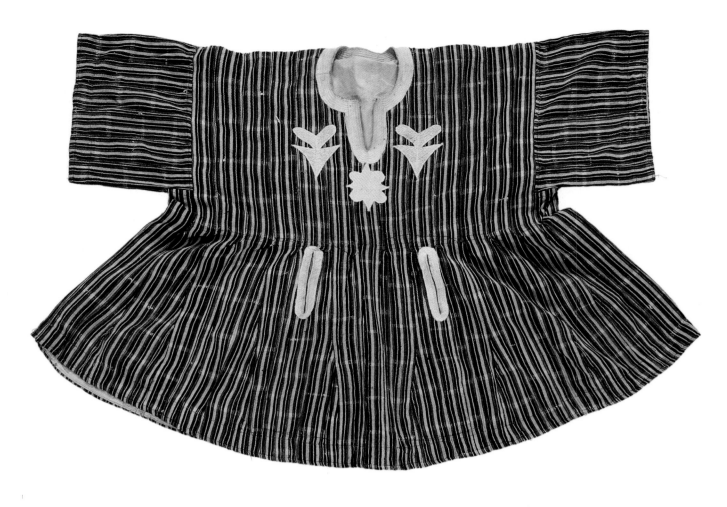

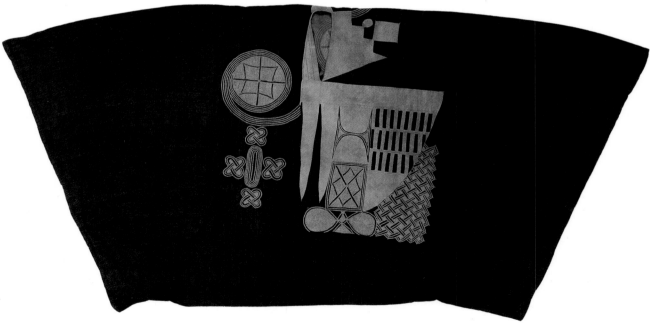

TOP *Batikari*, a boy's smock of stripwoven cotton, embroidered by Hausa tailors in Bolgatanga, Ghana. ABOVE *Agbada* Hausa robe. The patterns are derived from the pseudo-science of numerology.

OPPOSITE

TOP Hausa or Nupe *agbada* robe woven of red *alaari* and imported white silk with *alaari* embroidery. BOTTOM A *boubou* from Mali embroidered in the *lomasa* style.

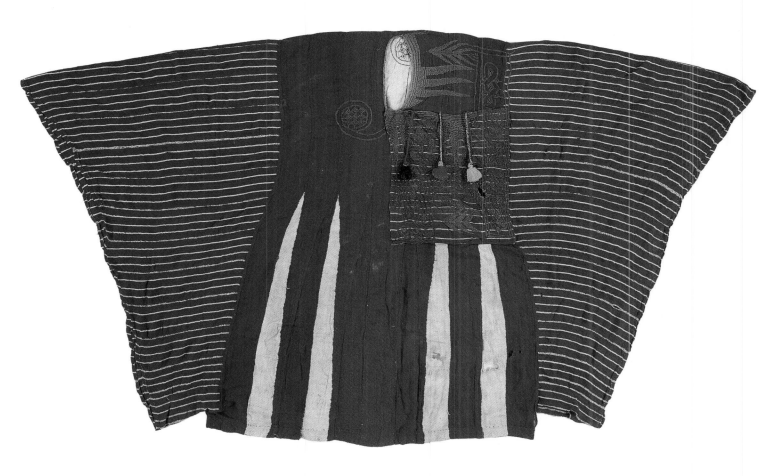

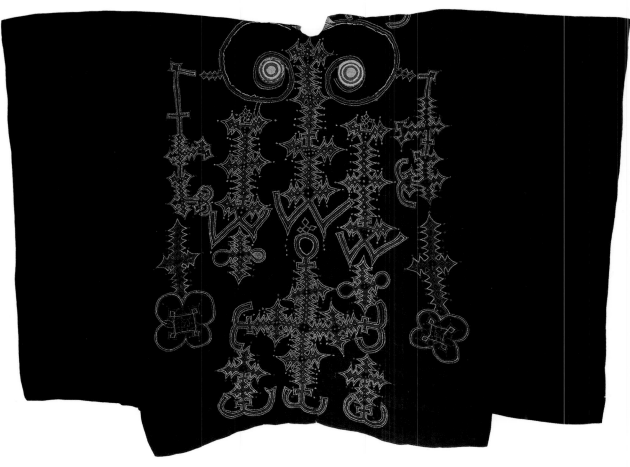

Yoruba beadwork

The rich lands of southern Nigeria have seen many great artistic achievements during different periods. The bronze castings of Ife and later at Benin are notable examples. These kingdoms were wealthy enough to generate a large trade with the outside world. One of the prized items that they imported were foreign beads, from India before 1500 and from Venice, Bohemia and other parts of Europe thereafter. There is some speculation that beads were made (probably from melted-down imported trade beads) at Ife in the 10th century.

Yorubaland is traditionally divided up into sixteen different major kingdoms, of which Ife is the most prestigious. In the late 19th century, hereditary carvers and crown makers began to make crowns and other regalia for the Obas (kings) in a new style out of trade beads, adorning them with freestanding birds, askaris (soldiers), kneeling women, colonial figures, etc. The craftsmen at other courts adopted the fashion, which then spread to the Yoruba priesthood, who required beadwork collars and diviners' bags. A large cottage industry sprang up. Today there is also a tourist market for replicas. Some of the most charming of the Yoruba crowns are in the shape of an English barrister's or judge's wig.

To make a crown, first a conical basket, which is covered in starched cotton cloth, is made. On to this cloth small seed beads are sewn. The pattern may be drawn on to the cotton base or the artist may work entirely according to his inspiration or 'dream'. With any work in relief, as with freestanding birds or other figures, the beads are sewn on to pre-shaped bundles of starched cotton. The inside of the crown is lined with cotton fabric to hide the stitches. Some crowns are so elaborate that they can take six months to complete.

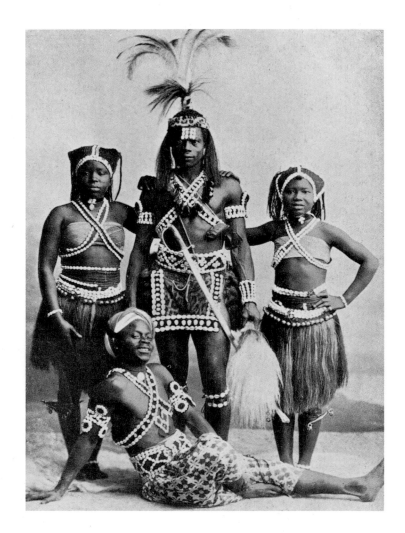

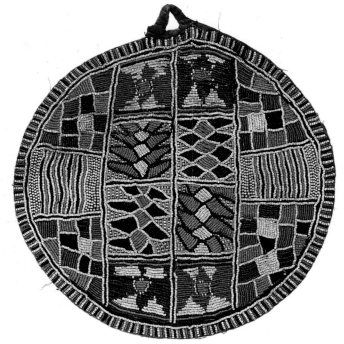

ABOVE Male and female warriors of Dahomey wearing bead and shell work adornments.
RIGHT A Yoruba ceremonial beadwork fan.

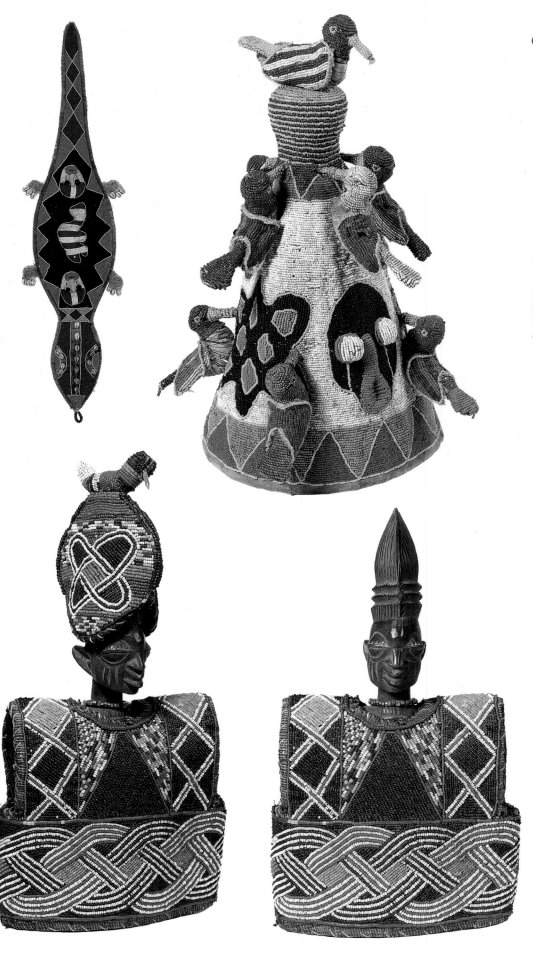
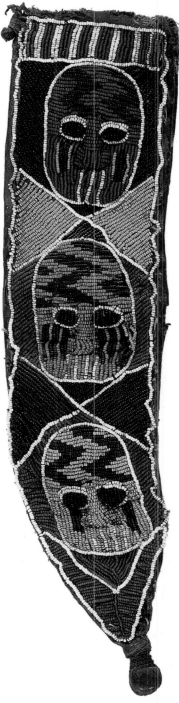

CLOCKWISE FROM TOP LEFT

TOP LEFT Yoruba beadwork crocodile
or lizard.

TOP CENTRE A contemporary Yoruba
beadwork crown with freestanding
birds.

ABOVE Yoruba scabbard. The heads,
worked in beadwork, symbolize
power in Yoruba mythology.

LEFT Twins (*ibeji*) are thought to
bring either fortune or misfortune.

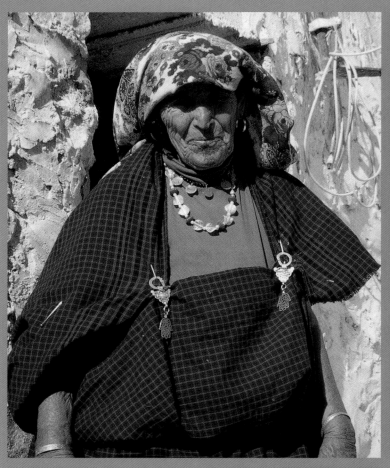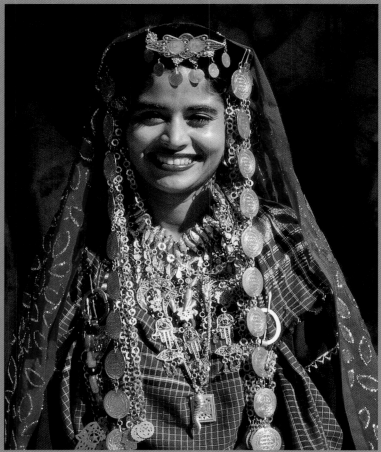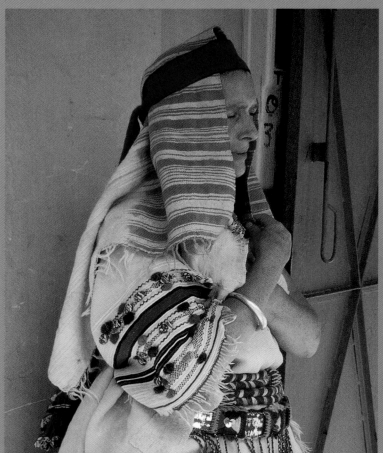

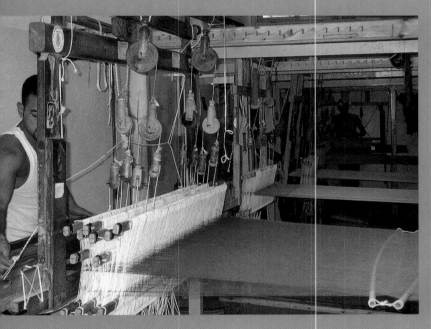
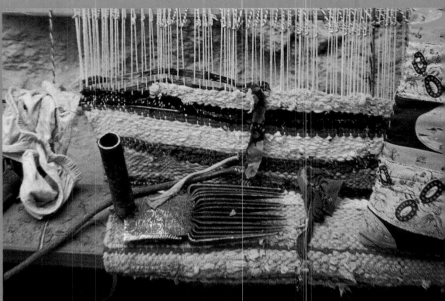

NORTH AFRICA

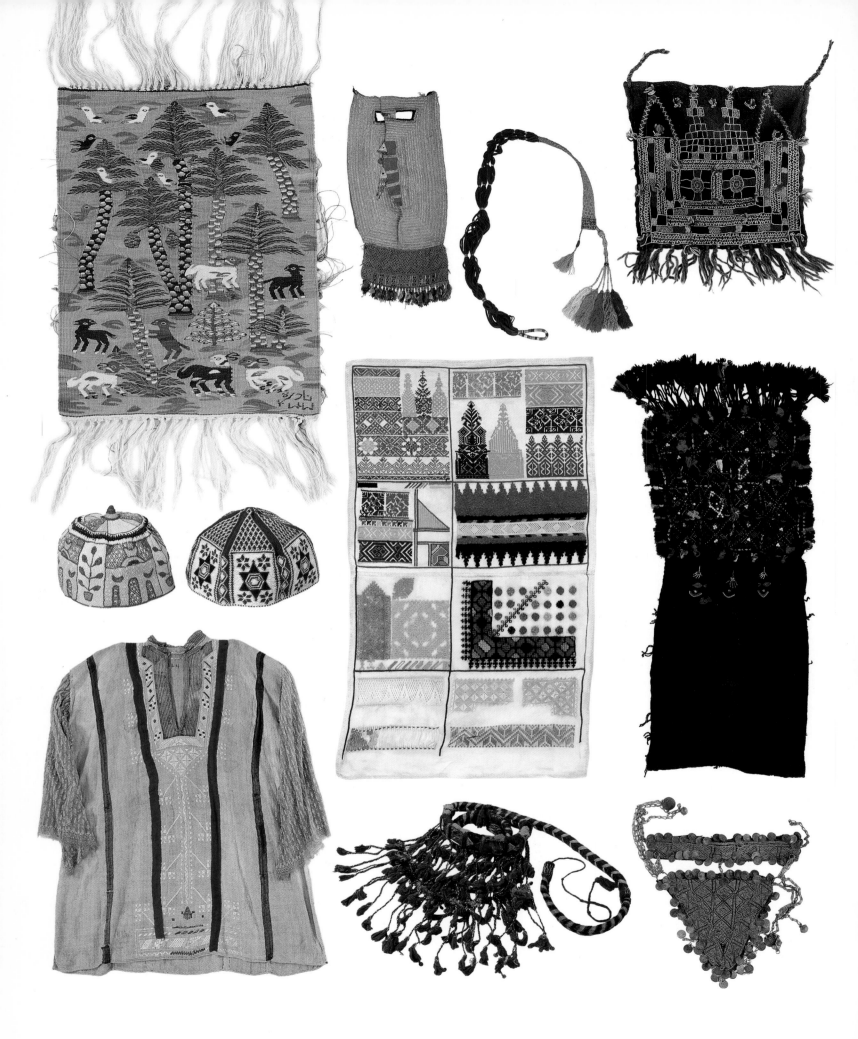

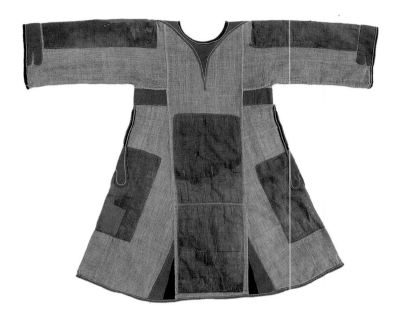

Introduction

NORTH AFRICA

Narth Africa, bounded by Morocco to the west, Egypt to the east, the Mediterranean to the north and the sand desert of the Sahara to the south, forms a well-defined geographical entity. Known as the Maghreb by the invading Arabs, it has been subject to numerous different cultural influences for more than two millennia.

While adopting Islam, the indigenous Berbers have retained a culture markedly different from the largely urbanized incoming Arabs. As pastoralists and peasant farmers, they have a large part of their economy based around sheep breeding. Their textiles are untailored woollen wraps, woven by women on upright looms.

Often living cheek by jowl with the Berbers are tribes of Arab nomads, whose women weave sheep's wool on ground looms into strips used to make up tents and storage bags.

The great cities of the North African litorral are subject to Arab and Turkish influences. In such towns as Fez in Morocco and Mahdia in Tunisia, all sorts of sophisticated silk and cotton textiles such as lampas and double weave are produced on Jacquard and drawlooms.

The expulsion of Muslims and Jews from a newly united and re-Christianized Spain in the 15th and 16th centuries and their emigration to the cities of the Maghreb also had a profound effect. Jews were renowned for many textile skills. They dominated the dyeing industry and such specialized crafts as tablet weaving. Andalusian styles of weaving and embroidery can be found in many of the towns of Morocco, Algeria and Tunisia, where weaving is carried out by men.

By contrast, embroidery was mainly a female occupation. Embroidery on leather and gold work was generally done by men, while most other forms were carried out by women for domestic consumption, with any surplus perhaps being sold. Gold work was a speciality influenced by Ottoman styles. A professional embroideress makes heavily embroidered wedding clothes and teaches embroidery skills to the future bride. The influence of southern Europe is not to be underestimated. Through trade, immigration, the intermittent Christian conquest of coastal ports and the regular influx of Christian slaves, textile patterns, especially embroidery motifs from Italy, Spain and France, are to be found in specific locations in the Maghreb. Many of the

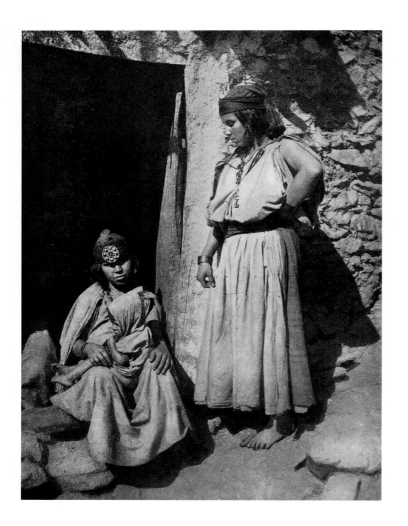

embroidery motifs in Tunisia, for instance, such as the fish, predate the Arab conquest. Their origins lie in the preceding Christian Byzantine culture or even before then.

Libya has strong Ottoman influences, though the desert oases are Berber. By contrast, Egypt, now 'the land of cotton', has an ancient textile culture based on the cultivation and weaving of linen, dating back to Pharaonic times, and exhibits parallels with the textile industry of neighbouring countries in the Levant, such as Syria.

The influence of sub-Saharan Africa is debatable. Along with slaves, gold and ivory, red-dyed leather from Sokoto (in modern Nigeria) and dye stuffs came up the caravan routes from West Africa. However, the influences on West Africa from the north were perhaps more important. Nearly all West African male clothing styles before the 19th century were based on Muslim models that had arrived via North Africa.

Despite the proximity of North Africa to Europe and the varying degrees of colonization to which all these countries were subjected, handmade textiles still play a part in the lives of North Africans. Morocco and Tunisia have the liveliest remaining handcrafted textile industries, whether it be

weaving or embroidery or forms of resist dyeing. Algeria suffered from long colonization (the French took power in 1830), an extremely destructive war of independence, reliance on massive oil deposits and a socialist way of running the economy – all factors that have militated against the preservation of handcrafted textiles. Libya's crafts have been virtually eradicated by oil wealth and Colonel Gadafy's economic policies. Egypt's proud textile tradition is a very pale imitation of its former glories. Its fine, long stapled cotton goes to the mills or for export, and, although there have been revivals like the tapestry-weaving workshops founded by Dr Ramses Wissa Wassef at Harraniya, it is only really at Kardassa, and to a lesser extent at Naqada, that handweaving survives as a commercial operation. Embroidery is still actively practised at Siwa in the western desert and, to a lesser degree, in the other oases. The Street of the Tent-makers is still very active, producing appliqué.

The exodus of the Jews in the 1950s to the newly formed Jewish state of Israel has had a largely unchronicled effect on North African textile production, as Jews were heavily engaged in such crafts as dyeing and tablet weaving and in textile distribution.

Handweaving for the urban market is probably healthiest in Tunisia, where silk and cotton shawls in both simple and complex weaves for ceremonial wear are produced on the many looms of Djerba and Mahdia. Although Gafsa and Kairoun are better known for their carpet and kilim production, it is in the villages around Gafsa that the tradition of weaving *bakhnug* shawls, with their cotton supplementary weft decorative elements, is still alive, albeit for commercial rather than domestic reasons. The beautiful weaving tradition in the same style of the Berber villages south of Gabes was lost when those villages were abandoned in the 1950s.

Morocco was always the exception in the Maghreb. Its rugged terrain made it difficult to conquer, let alone to administer centrally. The different tribes still have vibrant weaving traditions, particularly those of the Middle Atlas. Dyeing with traditional vegetable dyes has nearly disappeared, except for self-conscious revival schemes. Dyeing wool with henna, an easy task, is practised in the Anti-Atlas mountains.

The need for traditional textiles at important phases of a person's life – at marriages and circumcisions – plays a large part in keeping what is left of the handcrafted textile industry alive.

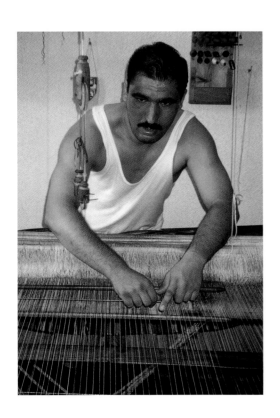

OPPOSITE
TOP Kabyle Berber women wearing *haik* body wraps.
BOTTOM LEFT Sheep at a market in southern Morocco.
BOTTOM CENTRE Carding combs from the Anti-Atlas, Morocco.
BOTTOM RIGHT Henna leaves for sale in Gabes, Tunisia.

LEFT Inserting the metal-thread wefts on a *rda* at Mahdia, Tunisia.
TOP RIGHT Wool-shearing scissors.
RIGHT Carding comb, Anti-Atlas, Morocco.

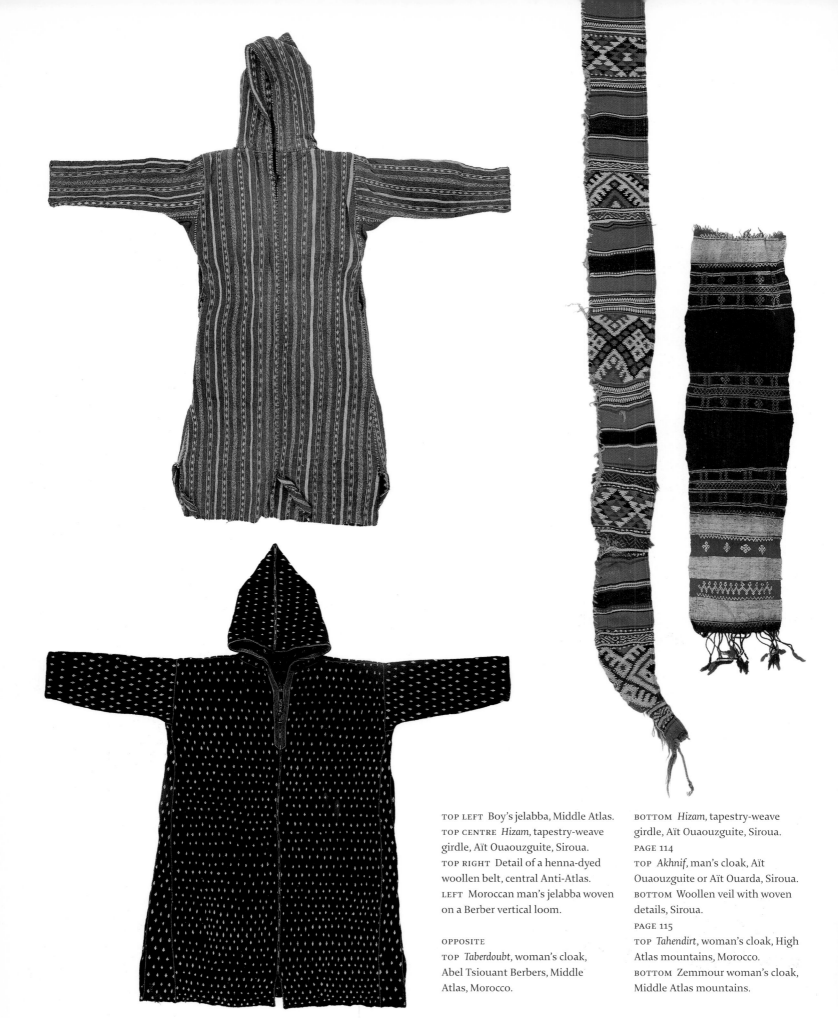

TOP LEFT Boy's jelabba, Middle Atlas.
TOP CENTRE *Hizam*, tapestry-weave girdle, Aït Ouaouzguite, Siroua.
TOP RIGHT Detail of a henna-dyed woollen belt, central Anti-Atlas.
LEFT Moroccan man's jelabba woven on a Berber vertical loom.

OPPOSITE
TOP *Taberdoubt*, woman's cloak, Abel Tsiouant Berbers, Middle Atlas, Morocco.

BOTTOM *Hizam*, tapestry-weave girdle, Aït Ouaouzguite, Siroua.
PAGE 114
TOP *Akhnif*, man's cloak, Aït Ouaouzguite or Aït Ouarda, Siroua.
BOTTOM Woollen veil with woven details, Siroua.
PAGE 115
TOP *Tahendirt*, woman's cloak, High Atlas mountains, Morocco.
BOTTOM Zemmour woman's cloak, Middle Atlas mountains.

Berber vertical looms

The Berber vertical single-heddle loom is found from Morocco all the way east to Libya and Siwa in Egypt. Berber women weave all kinds of items on it, from knotted carpets, to kilims and rag-rugs to articles of clothing. Primarily for weaving wool, this versatile loom takes up little space in the house, tent or courtyard and can be easily moved. Weaving can be carried out at odd times of the day when convenient or in an intensive way during the quiet periods of the agricultural season. Natural coloured wool probably forms the bulk of Berber weaving, but weft striped wool is popular in the High and Middle Atlas regions of Morocco for women's cloaks.

Two vertical posts are set into the ground and two cross-bars are lashed or joined to them at the top and bottom. Though women are the weavers, men will generally make and assemble the loom. The warps are wound continuously around the beams. As the weaving progresses, the extra lengths of warp rolled up on the upper warp beam can be progressively unwound at the same time as the already woven web is rolled up on the lower 'cloth' beam. Warps can be either wool or cotton, while the weft is generally wool. The heddle rod is leashed to one set of warp elements (which have been divided up into two sets of alternate threads when the warp is laid out). This heddle is tied firmly to pegs in an adjoining wall. Shed and countershed are obtained by moving a shed stick. Alternate warp threads are incorporated into the woven web. The woman weaving usually passes the weft through by hand, without the aid of a shuttle. After every pick or so of the weft, the weaver will beat them in with an iron comb, which helps to create a weft-faced fabric.

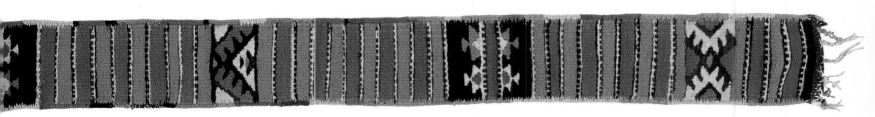

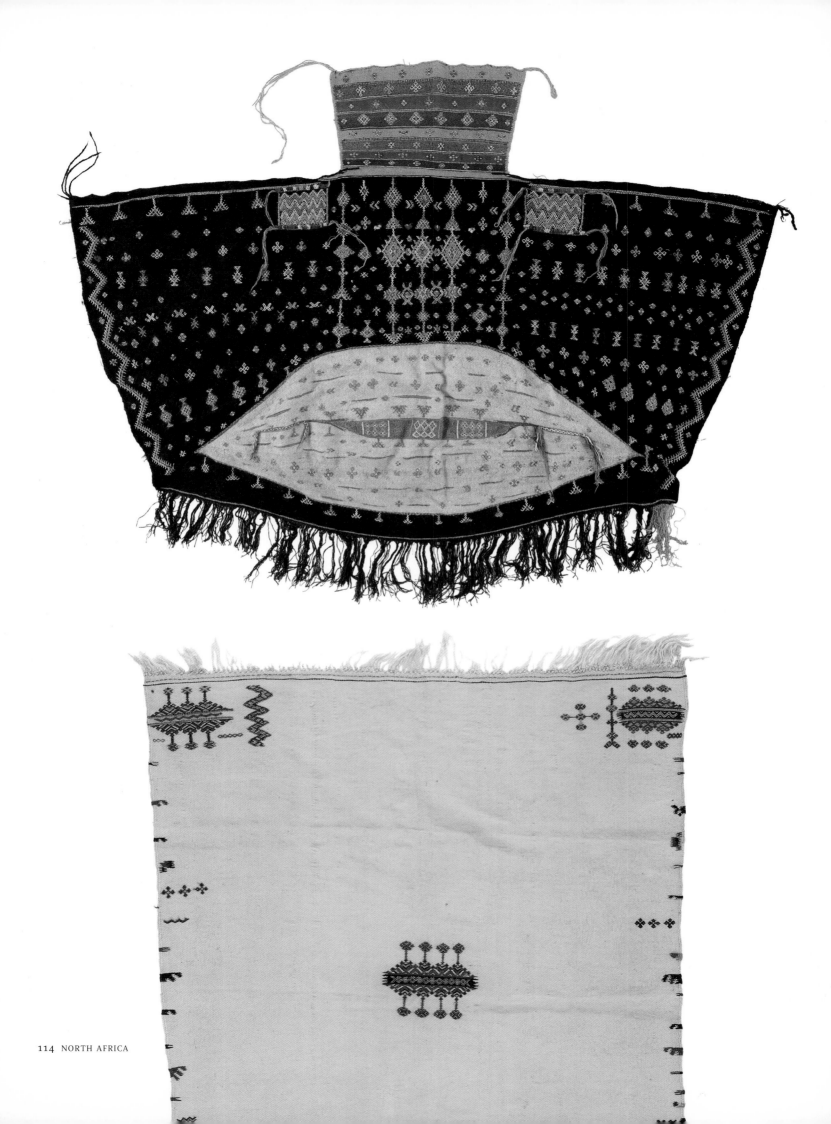

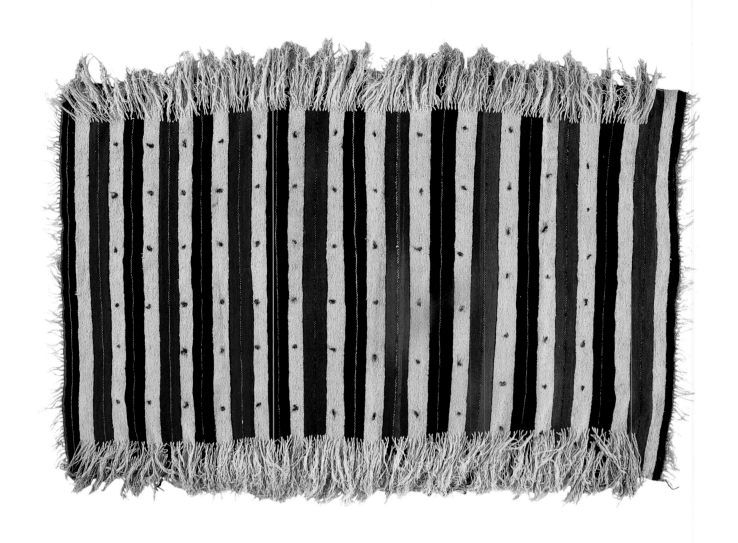

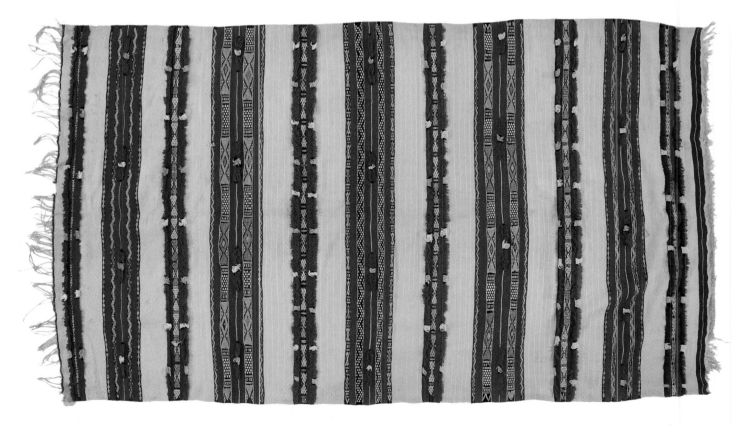

Ground weaves

Many of the deserts and mountains of North Africa contain tribes of Arab nomads who arrived from the Arabian peninsula with the successive waves of the Islamic conquest. The Bedouin of North Africa use the same ground loom as the nomads of Arabia and the Middle East. Nomad women weave sheep's wool and goat hair on ground looms into strips known as *flij*, which are used to make tents and storage bags.

Sheep- and goat-rearing pastoralists inhabit the edges of the desert where there is pasture to be found and trade with the sedentary communities. Climatic conditions can be harsh, searing heat on a midsummer's day to frost and extreme cold on a winter's night.

In these conditions, it is essential to have tents, which are made up of the *flij* strips. The fabric is warp-faced and the preferred material is black goat's hair, which is stronger than sheep's wool. When the former is scarce, goat's hair is used for the warp and wool for the weft. For decorative items such as bags, though, sheep's wool is preferred.

The layout of the horizontal fixed heddle ground loom used by the Arab nomads is very simple. The warp is tensioned between two beams, which are pegged very securely to the ground. A heddle bar lifts up every alternate thread to make the shed. A thick flat rod is inserted behind the fixed heddle. When this rod is brought towards the fixed heddle and turned on its side, the countershed is made by forcing the second set of threads above those that were raised to make the shed. On this very simple loom Bedouin women weave both plain and very complex patterned cloth. The distance between the two beams is approximately the length of the finished weaving.

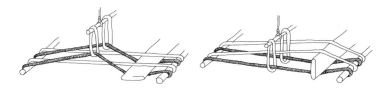

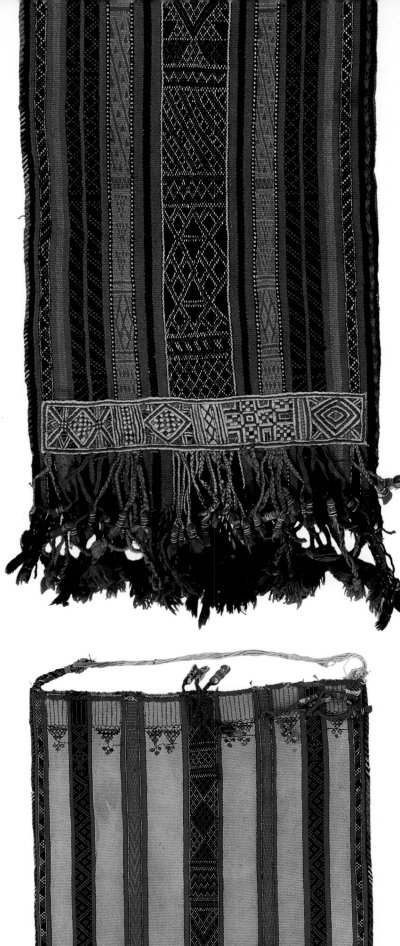

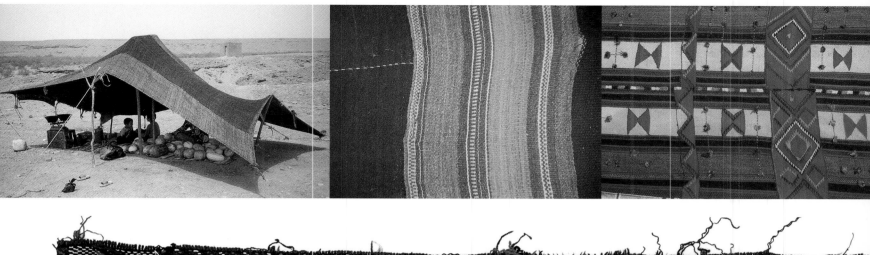

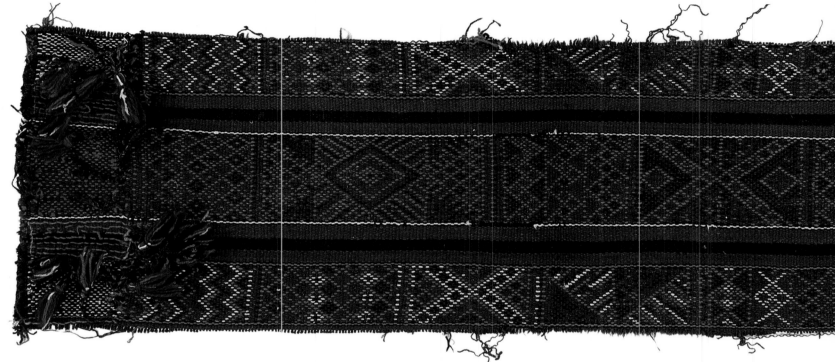

OPPOSITE
TOP Long bolster with columns
of supplementary warp woven
like a *ras haml*, southern Tunisia.
BOTTOM RIGHT Bedouin woollen
storage bag with embroidery and
a supplementary warp panel.
BOTTOM FAR LEFT Opening a shed
with a shed stick on a single-heddle
loom.
BOTTOM LEFT Opening the counter-
shed by lifting the heddle rod.

TOP LEFT A tent in southern
Morocco made out of *flij* strips.
TOP CENTRE Striped *flij* strip from
a Bedouin tent, southern Tunisia.
TOP RIGHT AND BOTTOM *Flij* strips for
a Bedouin tent, southern Tunisia.
CENTRE *Flij* strip with supplement-
ary warp woven like a *ras haml*,
Tunisia/Libya border region.

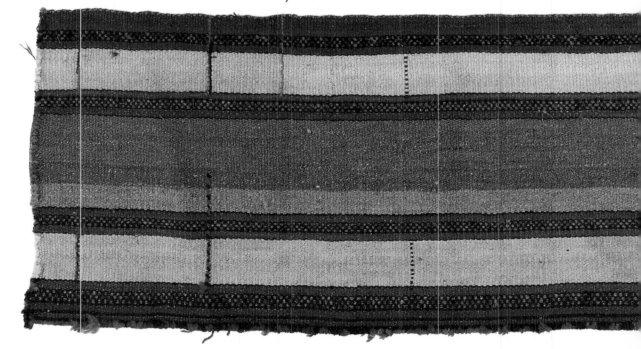

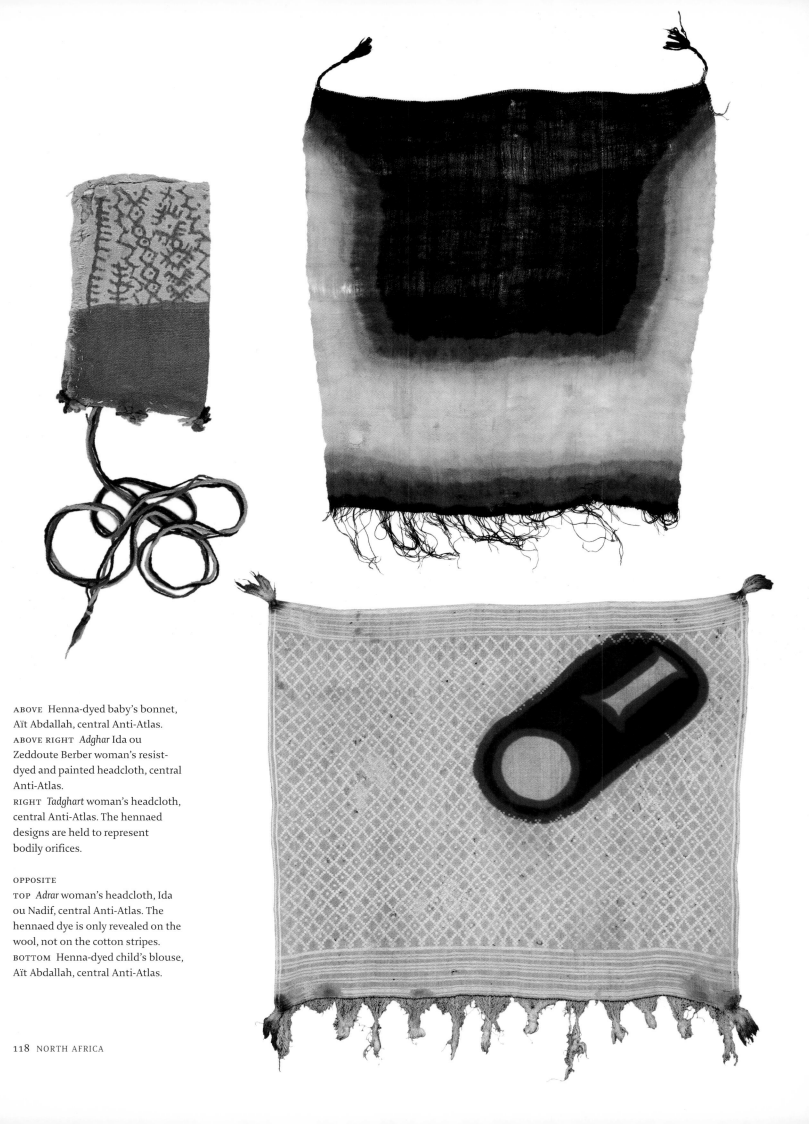

ABOVE Henna-dyed baby's bonnet, Aït Abdallah, central Anti-Atlas.
ABOVE RIGHT *Adghar* Ida ou Zeddoute Berber woman's resist-dyed and painted headcloth, central Anti-Atlas.
RIGHT *Tadghart* woman's headcloth, central Anti-Atlas. The hennaed designs are held to represent bodily orifices.

OPPOSITE
TOP *Adrar* woman's headcloth, Ida ou Nadif, central Anti-Atlas. The hennaed dye is only revealed on the wool, not on the cotton stripes.
BOTTOM Henna-dyed child's blouse, Aït Abdallah, central Anti-Atlas.

Henna-dyed Anti-Atlas woollens

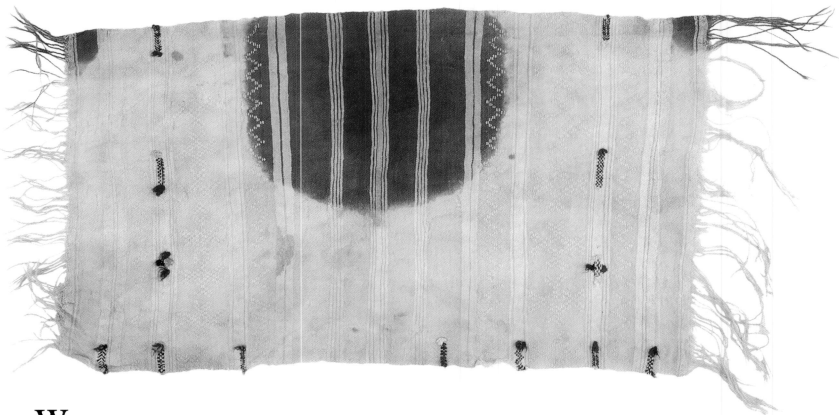

Women of the Ida ou Nadif and the Ida ou Kensous Berbers of the Moroccan Anti-Atlas wear white woollen *haiks* (body wraps) and headcloths decorated with prophylactic devices dyed with henna. Apart from the discreet areas dyed henna brown, the headscarves are often embellished with a pair of red woollen bobbles and the edges of the *haik* with supplementary woven or embroidered details on the breast and shoulder portions. Many of the devices henna-dyed on to the woman's garments take the same shape as the protective tattoos that adorn her throat and other parts of her body deemed to be vulnerable to malign influences. Women of other Berber communities of the Anti-Atlas mountains, such as the Aït Abdallah, also wear woollen *haiks* and veils with henna patterning, but they use it in block form.

A compress of mashed henna leaves is applied to the areas of wool to be dyed. After a couple of days, the compress is scraped off, leaving a red-brown design on the white woollen ground. To deepen the colour, the process may be repeated. When the textile alternates cotton weft stripes with woollen stripes, the henna colours the wool, but leaves the cotton undyed, resulting in a striped, whitish pattern against an orange-brown ground.

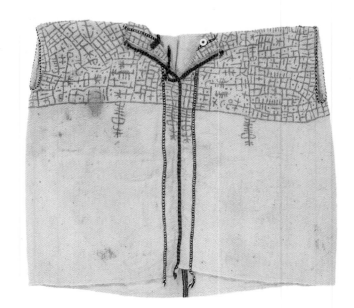

Algerian Berber weaves

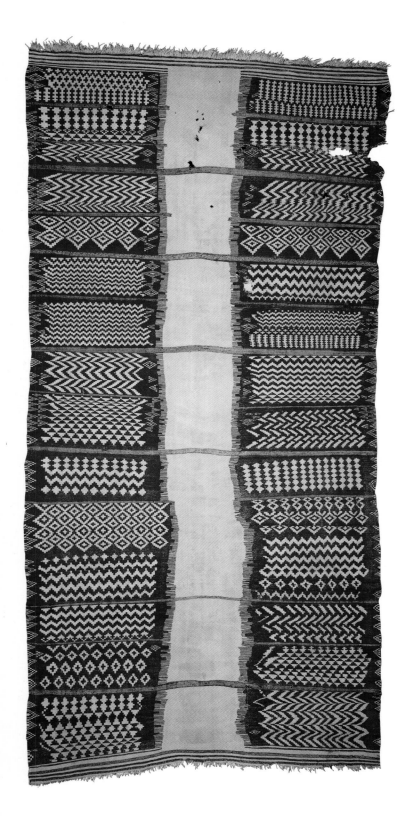

At one time Algeria had just as vibrant a handweaving tradition as its neighbours Morocco and Tunisia. It is sad to note that, since independence in 1962, much has been lost. In the Kabyle hills there was a strong tradition of weaving women's *haiks* and cloaks in a chequerboard pattern in wool on the upright Berber loom. As in other parts of the Maghreb, this weaving was women's work. The Kabyle name for a *haik* is *axellal*. Often striped, the back was highly decorative with very fine extra weft patterning. A smaller cloak, the *ddil*, woven in the same pattern, was worn over the back and shoulders, often with a weft striped silk scarf pinned with fibulae brooches. Further south in the Mzab region, in oasis towns such as Ghardaia and further south at El Golea, women wove striking tapestry-weave marriage shirts in wool for young bridegrooms. However, this tradition has now disappeared. Attempts to revive it twenty years ago came to nothing because of Algeria's political troubles. Efforts are currently being made to reintroduce weaving and vegetable dyeing again in El Golea, under the auspices of BP, the oil company.

The weaving technique used by the Berbers of Algeria is, with minor regional variations, identical to that found in Morocco and Tunisia. However, it is worth mentioning the dyeing techniques.

Weaving expert Alastair Hull observed that in Ghardaia the way of dyeing wool a henna brown involves first soaking the hanks of wool in a tepid mordant of alum (aluminium potassium sulphate), to which a tiny quantity of cream of tartare is added. Chopped henna leaves and pomegranate rind are boiled and then the resulting liquid is drained. The mordanted hanks of wool are added to the liquid and boiled for between fifteen and thirty minutes. A colour-fast shade of apricot-brown results.

LEFT Kabyle woman's *axellal* woollen body wrap woven on the Berber vertical loom, Algeria.
OPPOSITE Tapestry-woven woollen blanket from Mzab valley, south-central Algeria.

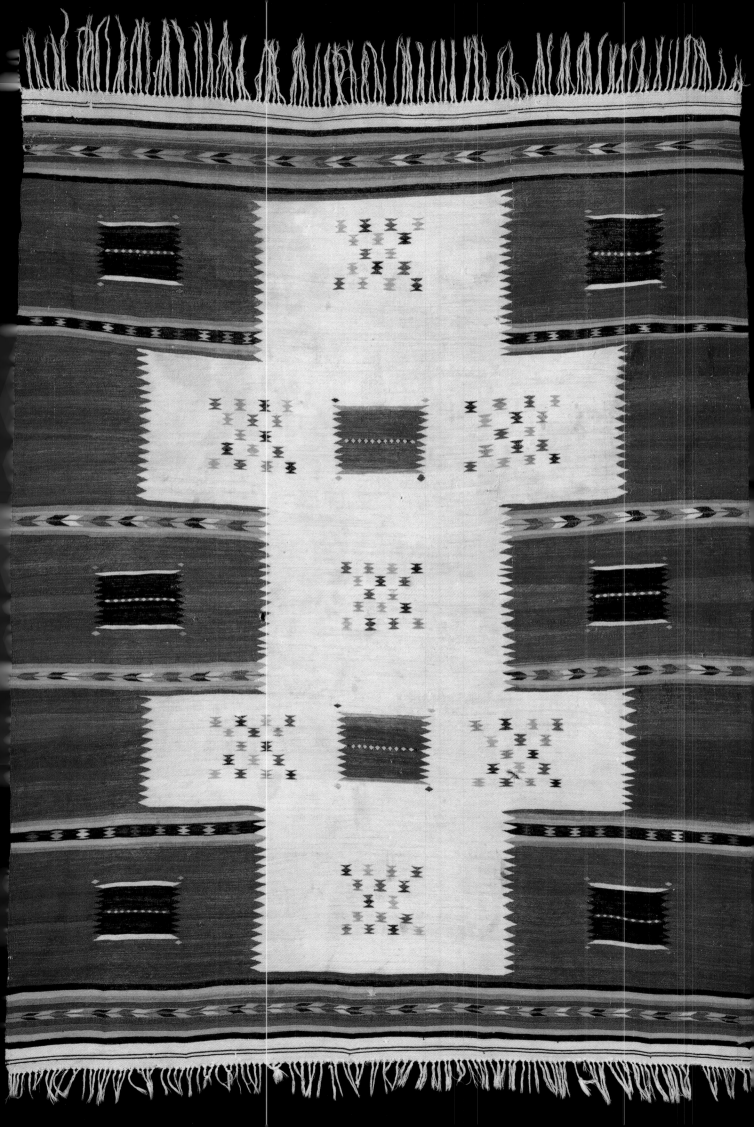

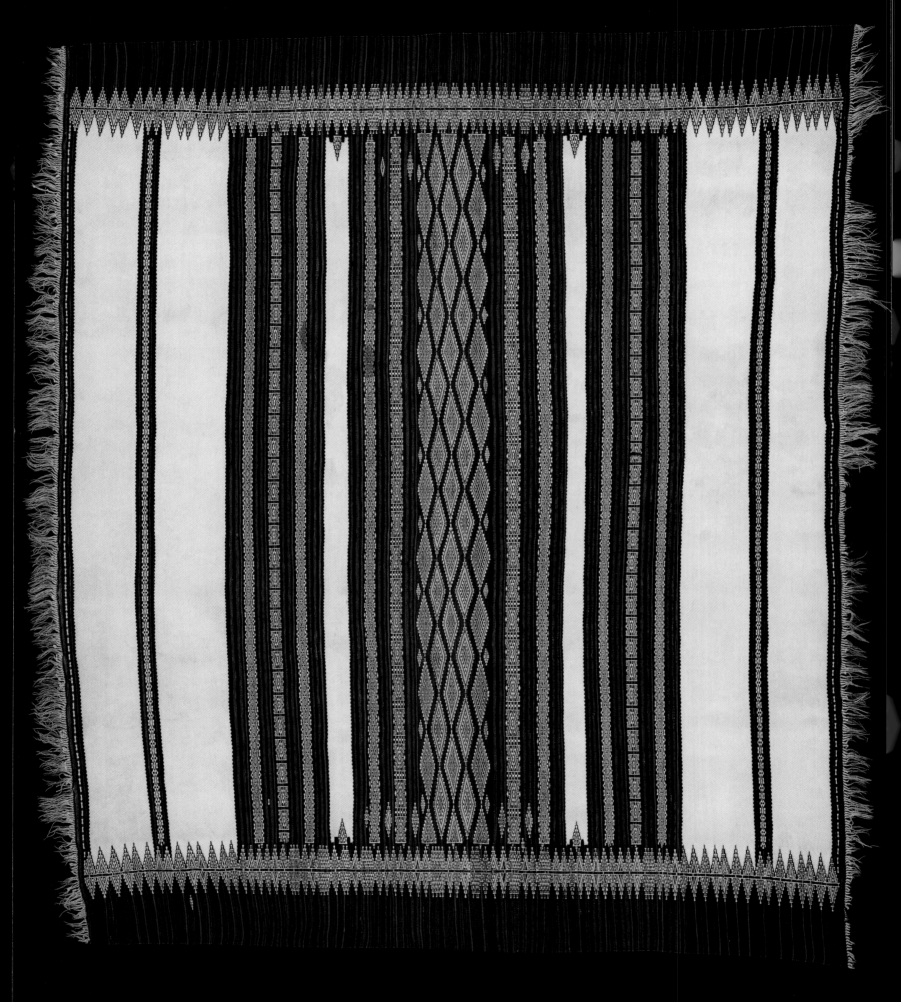

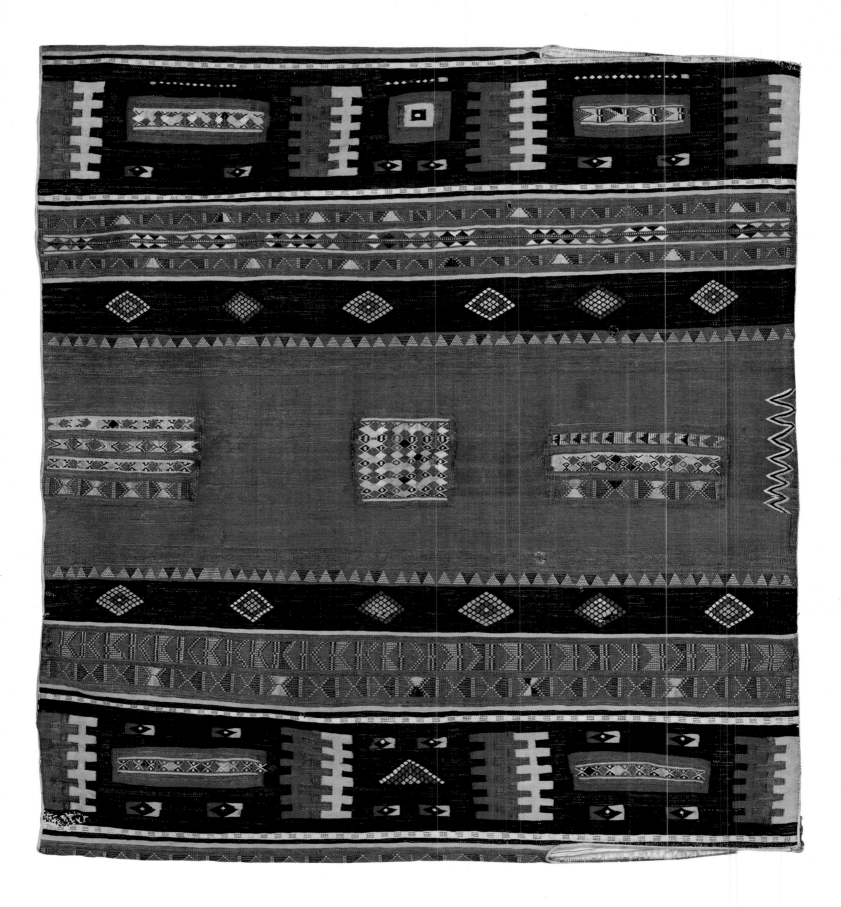

OPPOSITE Kabyle woollen *ddil* (woman's cloak) from the mountains of central Algeria.

ABOVE *Gandura*, a man's tapestry-woven tunic from Mzab valley, south-central Algeria.

Berber wool and cotton weaves of Tunisia

High on the jebels of southern Tunisia stand the *ksar* (fortified granaries), in which the Berber people traditionally lived. There Berber women wove, on upright looms, woollen shawls with supplementary cotton details in motifs echoing the patterns of their jewellery and tattoos. At Independence in 1956, new villages were built down by the new roads, girls started to go to school and the old way of life changed for ever. Each area had its own particular style. The villages around Gourmessa favoured a plain central field with fine details along the borders. Around Gafsa they preferred a central arrangement of lozenges and triangles. Although these cloths are no longer woven in most southern Berber villages, at Bou Said and other villages around Gafsa, along with a healthy kilim-weaving industry, new *bakhnugs* are woven that are chemical dyed, then pounded and bleached. They are sold to the many tourists who flock to Tunisia.

Local sheep's wool is handspun, then woven in plain weave on a continuously warped vertical loom. The shawl to be woven will be roughly the distance between the two crossbeams that keep the warp taut as the front and the backside warp threads are incorporated into the woven web. The loom is equipped with a single heddle and two or three shed rods. After about fifteen picks of the weft have been passed through by hand, the weaver beats them down with a wrought-iron comb known as a *khlal*. White wool is mainly used, although black wool can employed in small areas as a decorative contrast. Supplementary details are woven in cotton. After weaving, the cloths are dip-dyed, often in successive

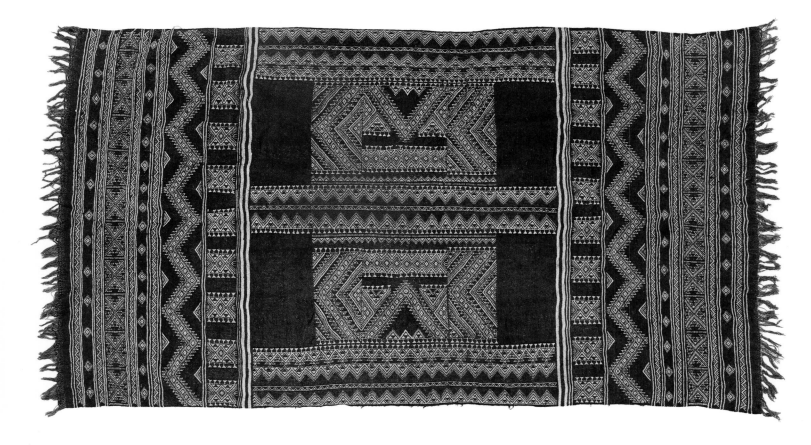

dye-baths of different colours. The natural dyes used are henna, pomegranate-rind, madder and cochineal, which often gives a variegated impressionistic effect rather than a standard overall colour. The supplementary weave patterning very cleverly exploits the dye-absorbing properties of different materials. Wool takes up these dyes readily and permanently, though cotton is less successful. The effect is also only to be revealed in the long term. When they are first woven, the shawls have a rather thick nap and the cotton details, although not per-manently, initially hold some of the colour of the dye-bath. It is only after long wear and the consequent washing and pounding that the nap wears down and the dye is bleached out of the cotton details, leaving a subtle design of white motifs against the red, blue, black or brown ground. This exploitation of the different dye-absorbing properties of wool and cotton is to be found in other parts of North Africa, notably Morocco.

Three main articles of women's clothing are woven: the *katfiya*, a small rectangular cloth worn over the shoulders to protect their dresses from hair oil (it was often tie-dyed after weaving); the *tajira*, a square or rectangular shawl; and the *bakhnug*, a larger rectangular shawl. On rare occasions a much longer, wrapped and pinned garment known as a *houli* was also woven. A young girl wears a white shawl, a bride or newly married woman red and an older woman blue, black or brown.

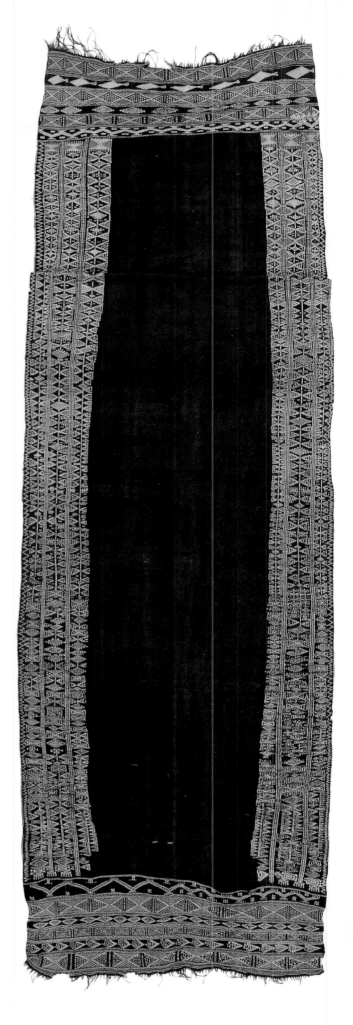

OPPOSITE
TOP Rugs on a wall in front of a mosque at Mahdia, Tunisia.
BOTTOM Contemporary *bakhnug*, woven at Bou Said near Gafsa, Tunisia. It has been dyed with synthetic dyes and washed, beaten and bleached to whiten the cotton details against the red ground.
BELOW *Bakhnug*, Berber woman's shawl. Woven of wool and silk, Chenini, southern Tunisia.
RIGHT *Houli*, older woman's garment from Chenini.

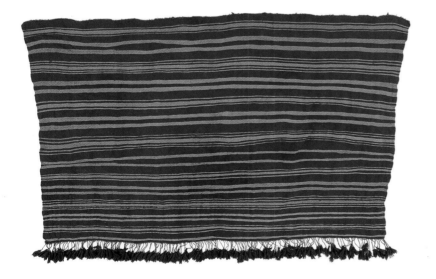

Horizontal loom urban weaves

Throughout the towns and cities of the Maghreb, weaving workshops turn out the sophisticated silk textiles that their urban clientele require. The town of Mahdia in Tunisia still boasts over one thousand looms, producing everything from figured ribbons to the patterned silk and metal thread wraps known as *rda*.

The figured ribbons known as *hashiya* are woven on drawlooms just outside the town. The technique is reputed to have been brought from the Tripoli area of Libya by Jewish weavers in the 19th century. *Hashiya* are used to embellish wedding costumes and curtains in the Tunisian Sahel. The *rda ahmar* of Mahdia are woven on horizontal treadle looms and have equal-sized patterned areas at each end. They are known as *rda biskri* in Djerba, where they have a large patterned area only at one end. In Djerba they are woven in red as well as black. In both places the motifs are worked in by hand in metal thread. Older *rda* borders from Djerba often feature the star of David, a tribute to the once plentiful Jewish weavers and dyers of Djerba.

Men work at horizontal treadle looms with anything from one to ten looms per work space. Silk yarn is imported from Italy, China or Japan, metallic thread from France (Lyons). Usually both warp and weft are of silk. The looms may be hand operated, with the weft being passed by hand in a shuttle, or they may be semi-automatic. More complex weaves require Jacquard devices or are woven on drawlooms.

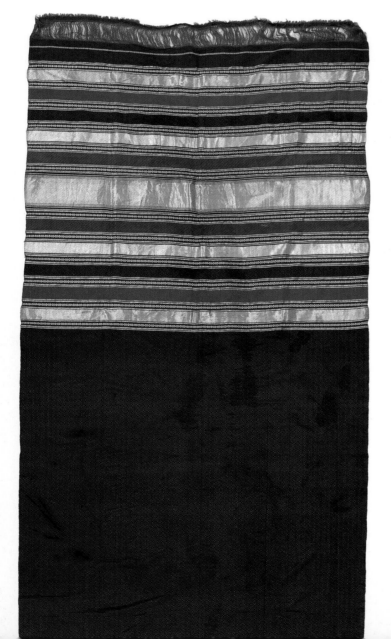

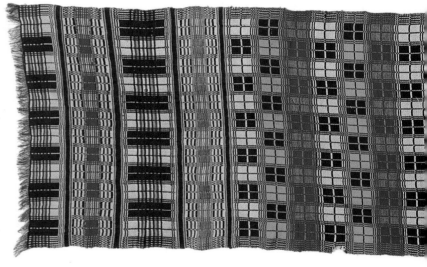

LEFT *Rda harir* wedding *haik* from Mahdia, Tunisia, worked in brocaded silk and metal thread.
ABOVE Silk double cloth from Mahdia, Tunisia.

OPPOSITE
TOP LEFT End of woven silk belt, southern Morocco.
TOP RIGHT Chequered silk woman's shawl, probably from Fez, but worn in southern Morocco.
RIGHT Silk, cotton and metal-thread woman's marriage *fouta*, probably Tunisian Sahel.

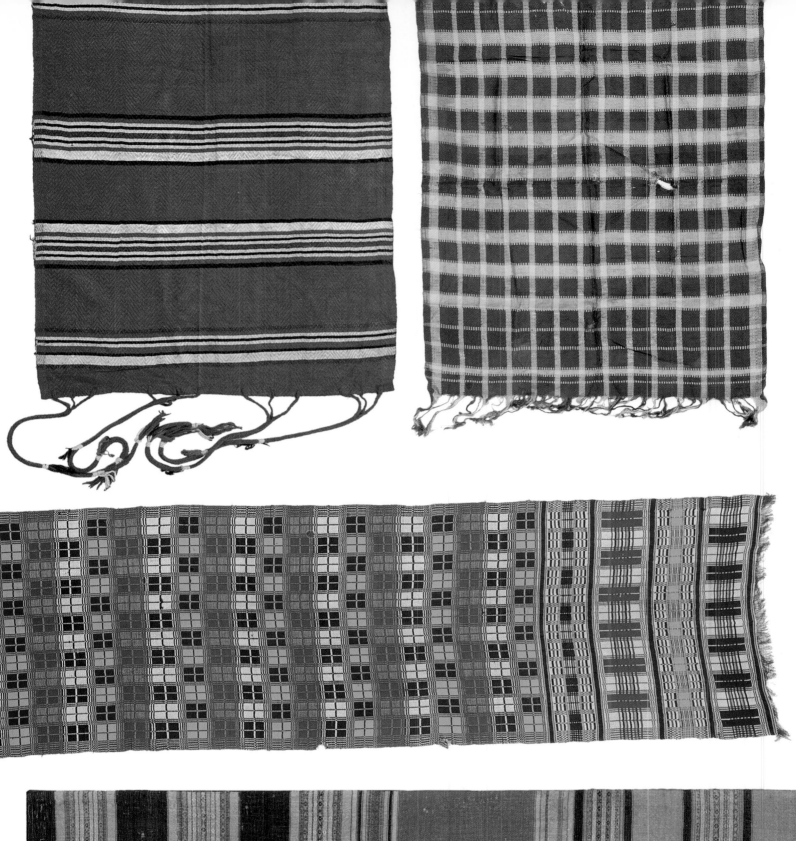

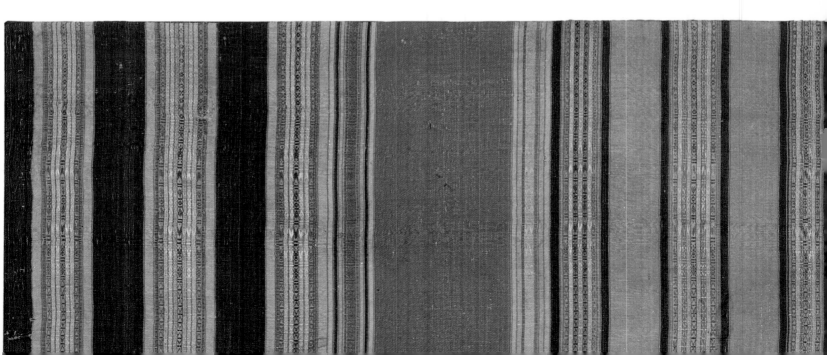

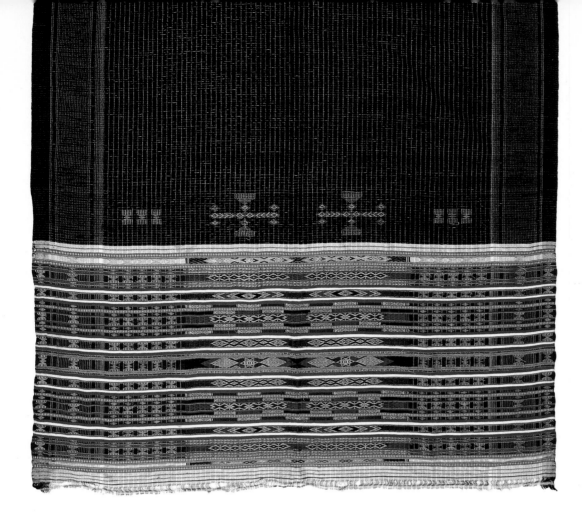

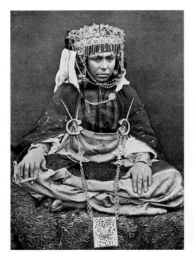

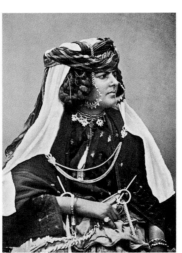

TOP LEFT Bridal *rda* with metal-thread motifs from Mahdia, woven on a horizontal treadle loom.
TOP RIGHT *Rda biskri* cotton woman's wedding garment, Djerba island.
ABOVE LEFT AND RIGHT Algerian women of the Ouled Naïl wearing *haiks* pinned with fibulae brooches.
FAR RIGHT Woman's brocaded silk belt, woven at Fez, Morocco.
RIGHT Balanced tabby weave.

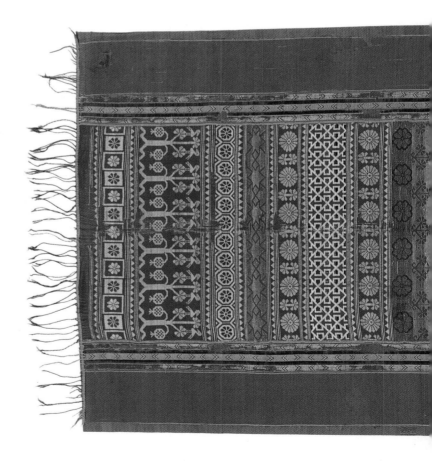

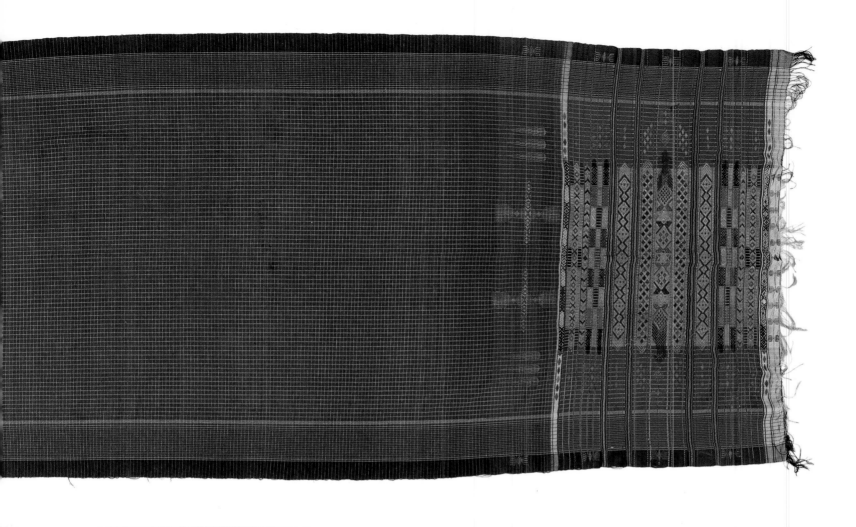

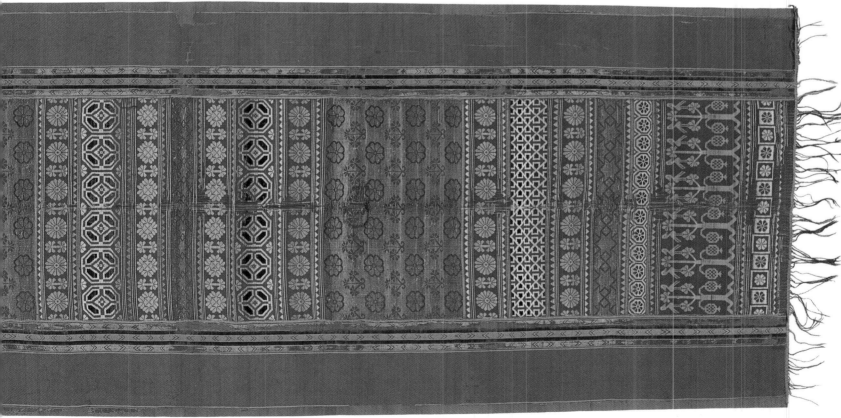

Pit-looms of Egypt

In the predominantly Coptic village of Naqada, just south of Luxor, on the west bank of the Nile, it is still possible to see many handlooms. Once famous for weaving the black and dark mauve silk and cotton marriage shawls used in the western oasis of Bahariya, the village now mainly produces cotton or synthetic thread for export to the Sudan and Libya. However, because of political problems, both these markets have slowed down.

Mention should also be made of the metal-thread, tapestry-woven garments and hangings in the Syrian style from Naqada, Upper Egypt. Silk *aba* surcoats like those of Aleppo were woven here, but it is unlikely that they were ever as fine. Today production is limited to simple chequered cotton cloth for rural use and for the small surviving trade with the western oases.

One of the shawls (*milayah*), worn by the Berber women of Siwa oasis, is made up of two strips of blue-and-white chequered cloth, joined along the selvedges with silk embroidery in black and yellow. These shawls were woven at Kardassa village near Giza, which, in times past, was the starting-point for camel caravans to Siwa. Many handlooms still operate in and around there.

Lengths of cloth are woven on pit-looms in cotton, silk and, nowadays, frequently rayon to be made up into shawls and items of clothing. Traditionally, the weavers are male, though, as in many parts of the world, the differences between the sexes are now less marked, and women are becoming professional weavers. With the pit-loom, all the warp elements are leashed to the heddles. Shed and counter-shed are made by operating foot treadles, which are set in a pit, with the weaver sitting on its edge. In this way the loom was given its name. Similar looms are found all over the Middle East and India. With this loom the weaver's hands are free to insert and beat down the weft, so the weaving is fast.

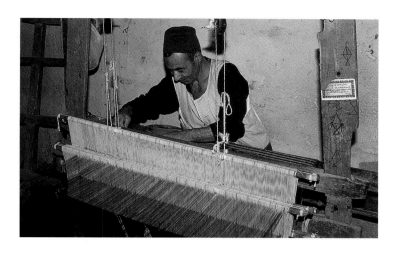

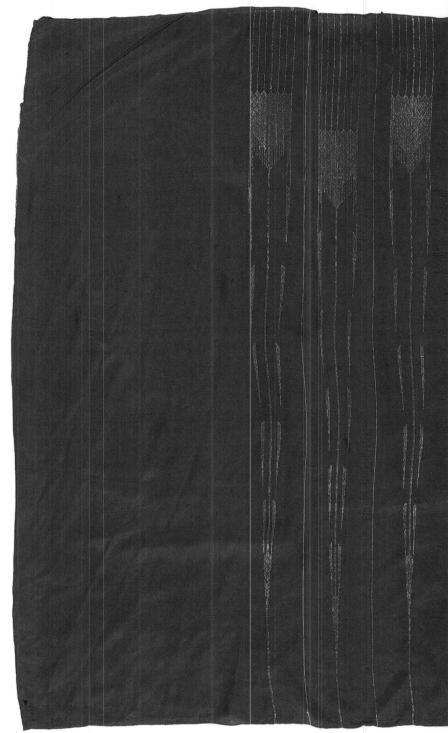

OPPOSITE *Derfudit* shawl worn by the Berber women of Siwa Oasis for outdoor wear. Woven in cotton on pit-looms at Kerdassa village outside Cairo.

TOP Weaver at work at his pit-loom in Kerdassa village, near Giza, Cairo.

ABOVE Egyptian *fellah* wearing a long cotton shirt.

RIGHT Silk *aba* with silvered thread-tapestry weave details in the Aleppo style, Naqada, Upper Egypt.

Tapestry weaves of Egypt and Morocco

The so-called 'Coptic' tapestry weaves of Roman Egypt (1st to 4th centuries) are justly famous. Produced at state workshops, figurative depictions of birds, animals and people often set in vegetal circles were woven in wool using the tapestry technique. Realistic and finely detailed, they were used to decorate clothing, furnishings and shrouds.

Dr Ramses Wissa Wassef, the late Egyptian architect, made a determined attempt to revive tapestry weaving by

teaching children the craft in the village of Harraniya outside Cairo. Using vegetable-dyed wool, the children wove scenes from village life, birds and animals for sale to a cosmopolitan market. Many of the child weavers have now become middle-aged and developed an individual style recognizable to their patrons. The other main area of tapestry weaving in North Africa is in the foothills of the Eastern Anti-Atlas. In the villages around Tazenakht, Berber women weave brightly coloured sashes for themselves in the tapestry technique. They also add tapestry woven details in the same colour scheme to their white woollen *haiks*.

It is not necessary for the weft thread to pass from one edge to the other (selvedge to selvedge) when weaving a weft-faced textile. A new weft thread of a different colour may be added at any chosen place. In this way, it is possible to introduce numerous colours and to build up blocks of pattern. This technique is known as a discontinuous weft.

OPPOSITE

TOP LEFT Tapestry weaver working
at his loom in the Wassef
workshops, Harraniya village,
near Cairo.

TOP RIGHT AND BOTTOM LEFT
Tapestry-work panels woven
in naturally dyed wool at the
workshops of Ramses Wissa Wassef,
Harraniya village, near Cairo. They
depict (top right) animals and birds
and (bottom left) fish.

ABOVE AND PAGE 134
These tapestry-work panels woven
in naturally dyed wool at the
workshops of Ramses Wissa Wassef,
Harraniya village, near Cairo, depict
(above) village life and (overleaf)
a biblical scene.

ABOVE A panel of tapestry-woven cloth made by Christian Copts in 6th-century Egypt.

ABOVE RIGHT A fragment of tapestry-woven cloth made by Christian Copts in 6th-century Egypt.

RIGHT A panel of tapestry-woven cloth woven in 4th-century Egypt.

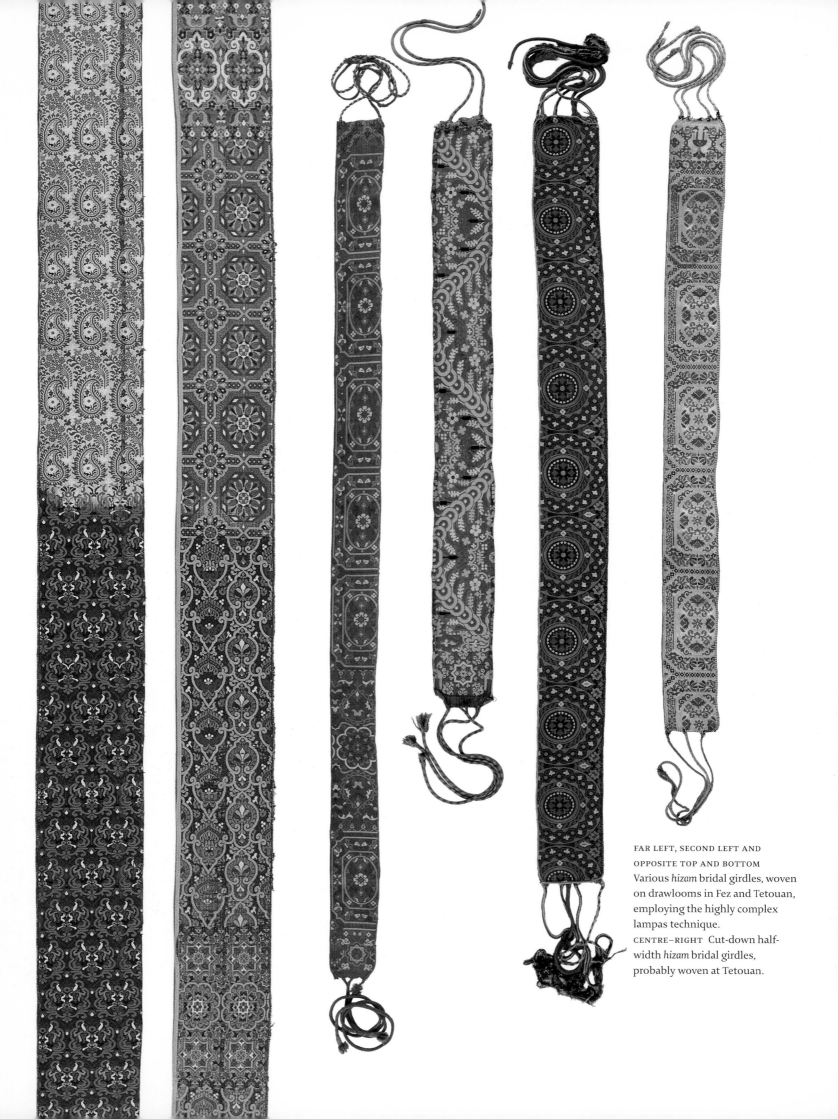

FAR LEFT, SECOND LEFT AND
OPPOSITE TOP AND BOTTOM
Various *hizam* bridal girdles, woven
on drawlooms in Fez and Tetouan,
employing the highly complex
lampas technique.
CENTRE–RIGHT Cut-down half-
width *hizam* bridal girdles,
probably woven at Tetouan.

The lampas weaves of Fez and Tetouan

Long wedding sashes are bound tightly round the waist of the Moroccan bride. They are released after the wedding ceremony as a sign that they are no longer a hindrance to conception. Known as *hizam*, the most prestigious of them were woven in Fez and other towns in north Morocco. They were also reputed to have been woven in Algeria. Patterns were influenced by French brocades and heraldic motifs and most probably harked back to the Hispano-Moresque background of the weavers. Floral and architectural designs are common and the ends are often decorated with the auspicious eight-pointed star and the *hamsa* – the Hand of Fatima. The great traveller Ibn Khaldoun describes the complexity of the silk brocades of Morocco and the Ben Cherif family of artisans (of Fez) were still weaving complex *hizam* at the end of the 19th century. Nevertheless, the fashion for these girdles waned at about that time. It survived in provincial Tetouan and Chefchaouen into the early decades of the 20th century. It is in this region that most of the examples of the genre are to be found. The *hizam* were generally worn folded in two lengthways. Only women of the Sayeed community (those claiming descent from the Prophet) wore them at their full width.

The technique of weaving *hizam*, carried out on a drawloom, was brought to Morocco from Spain by Andalusian refugees. Lampas is a highly complex technique that requires a weaver using a cartoon to guide him and one or two boys, as assistants, to draw up the supplementary heddles as required. When the pattern on the face of the belt is multi-coloured, the effect on the underside is akin to silk weft ikat.

One of the distinguishing features of lampas weave is that a background is created that is technically different from the patterned surface. Lampas requires two warps, a main foundation warp and a binding one. It also needs two different kinds of weft to obtain two different weave structures for the foundation and pattern. In most cases, a weft-faced weave is used for the pattern and a warp-faced one for the foundation, with the result that the pattern appears in relief against the foundation. The foundation warp not only separates the pattern wefts, but it also produces, together with the foundation weft, a foundation weave. It is therefore visible in the foundation areas, whereas the pattern wefts appear on the front of the fabric only in the motifs. To make two separate structures, the foundation warp and the binding warp require two sets of shafts and accompanying treadles.

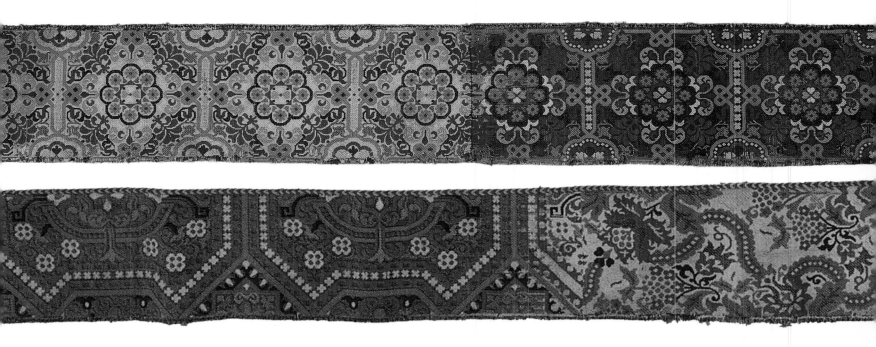

Moroccan tie and dye

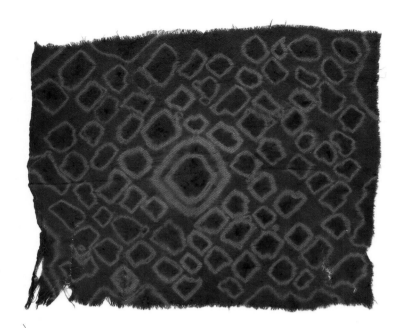

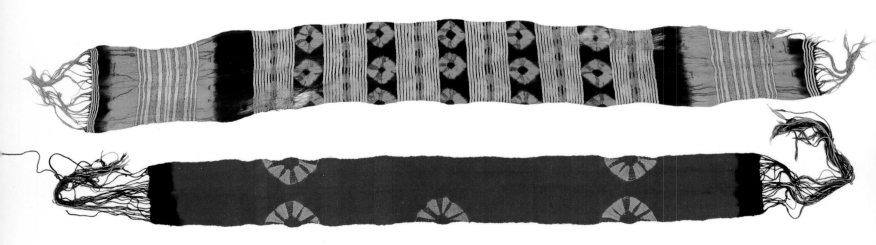

favoured. Decoration was achieved by the tie-and-dye technique. Relatively large-scale star-burst motifs were placed all along the length of the sash.

In the High Atlas, women of the Aït Atta Berbers tie-dye woollen headscarves in yellow and brown for festive wear. A single tie produces a great brown sun motif against a yellow ground, taking up nearly all of the area of the square field.

In the Anti-Atlas around Tafroute, woollen sashes and head or shoulder scarves are tie-dyed, with simple patterns against a mauve ground.

The star-burst motifs of the sashes are achieved by folding and pleating the fabric into cones, then tying them. The square headscarves are first dyed yellow, then the whole material (apart from small areas left over at each corner) is tied and dipped into a brown dye-bath. The traditional dyes used are henna for brown, pomegranate for yellow, henna with ferrous sulphate for black and madder for red.

Patterning on the sashes from the Rif is achieved by the unique Berber technique of weaving in occasional cotton weft strips that only faintly absorb the dye, if at all. The colour does not take, or bleaches out of, the cotton strips, causing the tie-dyed pattern to disappear in the cotton areas, then reappear in the woollen areas.

Tie-dyed articles of handwoven wool are used as headscarves and belts in different parts of Morocco. Women's sashes woven of sheep's wool in twill were made in the Rif region of northern Morocco, in urban centres, notably Tetouan. To be wrapped around women's robes, they vary in width between 10–46 cm (4–18 in.) wide and were typically 1.20–1.8 metres (4–6 feet) long, including a tasselled fringe. Combinations of black and red and brown and yellow were

TOP *Agounoune* tie-dyed woman's headcloth, Aït Hadidou, High Atlas, Morocco.
ABOVE Tying knots for concentric rings.

BELOW Rif mountain woollen girdles, tie-dyed in an urban centre such as Tetouan or Chefchaouen. In the top one, the tie-dyed pattern disappears in the cotton weft bands.

South Tunisian tie and dye

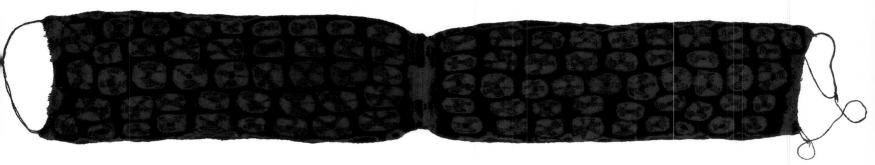

The tie-and-dye technique is used mainly for supplementary decoration on the woollen textiles of southern Tunisia. The ends of veils, headscarves and shawls are adorned with often random-seeming patterns of multi-coloured dots. Red, green, brown or yellow spots form a counterpoint to embroidery or a regular pattern of supplementary weft.

Tie-dyeing was a speciality of the villages around Gabes, such as Matmata, Chenini or Gourmessa. Headscarves with bold circular patterns against a red-brown background were a speciality of Gharyan in western Libya.

The undyed woollen fabric is tied with thread and is then dip-dyed in the background colour. Little chips of wood or grains are often inserted into the ties to make them more bulky. As is often the case with Berber dyed textiles, narrow cotton weft stripes woven into the woollen textile do not take the dye and interrupt the tie-dyed pattern. The resisted areas are then spot-dyed with, for example, henna, which colours both the resisted areas a reddish brown and the central spot of the circle, which has taken the first dye, a much darker brown. In this region tie and dye is at present used to the same effect with chemical dyes. One of the peculiarities of North African Berber tie and dye is that the tying can be done on both sides of the fabric.

TOP *Assaba* tie-dyed Berber woman's headband of woollen sprang, south Tunisia.
ABOVE RIGHT Berber woman's *tajira*, headscarf, Taoujout, Tunisia. Tie-dye worked on wool and then embellished with embroidery is characteristic of this area.

Mediterranean-influenced urban embroidery

The Christian reconquest of Spain and the consequent exodus of Andalusian Moors and Jews to North Africa in the 15th and 16th centuries had a profound effect on some of the textiles in the Maghreb. In places of Andalusian settlement, textile motifs, particularly those of embroidery, differed markedly from indigenous patterns. Although it has long been regarded as the acme of sophisticated work, Andalusia was, of course, not the only outside influence on North African embroidery. European settlements on the coast, however transitory, trade in textiles and the constant influx of Christian slaves brought embroidery styles from Portugal, France and Italy. The influence from the Eastern Mediterranean increased with the Ottoman conquest. All these foreign styles were mixed with existing Berber, Arab and Byzantine designs and motifs, to such an extent that it is often hard to tell which is the predominant influence. It is relatively easy to guess the town of origin of a piece of embroidery, as each town has its own distinct style.

The *ma'allema*, the professional embroideress, embroidered marriage costumes to order and taught young girls the rudiments of embroidery. In places such as Salé, Rabat, Azemmour in Morocco, Algiers, and Raf-Raf, Tunis, Hammamet and Mokhnine in Tunisia, girls between the ages of six and fifteen would learn embroidery from her as well as some of the Koran and the etiquette required of a future young bride. Many of the motifs hark back to the classical world. Such European motifs as stylized birds, vases and flowers were common.

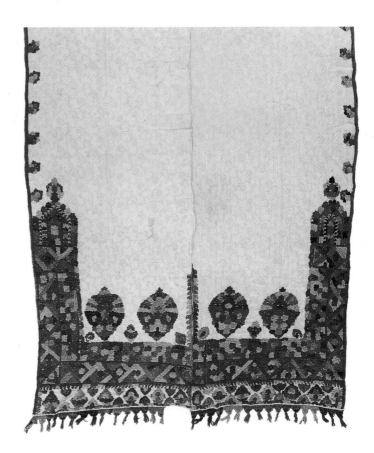

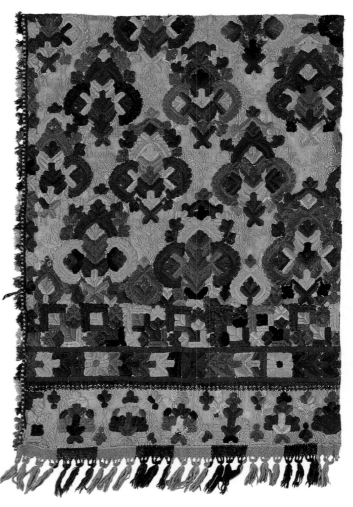

TOP LEFT Running stitch.
TOP RIGHT Satin-stitch embroidered curtains from Rabat, Morocco.
RIGHT Silk-embroidered curtain or cover for a chest, Rabat, Morocco.

OPPOSITE
TOP LEFT Details of an embroidered mattress border from the port of Azemmour, Morocco, showing distinct southern-European influence.
TOP RIGHT Bath wrap from Meknes, Morocco, embroidered in silk on a fine cotton gauze weave.
BOTTOM Fez-work mattress border embroidered in a classical blue silk with grey details.

Embroidery expert Caroline Stone remarks that a limited range of stitches is used in North Africa. It is common for silk embroidery, including that influenced by Turkey, to be based largely on variants of satin stitch, brick stitch, darning stitch and stem stitch, while the gold work involves couching and sequins, traditionally using gilt silver thread.

Regional embroidery tends to concentrate on a few very basic stitches. The often spectacular effects result from the skill with which they are used, rather than the wide variety of techniques employed.

The embroidery is worked on a frame, called a *gourgaf*. The designs are often first traced out by a female specialist known as the *rassama*. There is a variety of stitches, for example, forms of darning stitch and Rhodian stitch in the striking embroideries of Chefchaouen. Fez embroidery is counted thread work, in most cases using a sort of reversible back stitch.

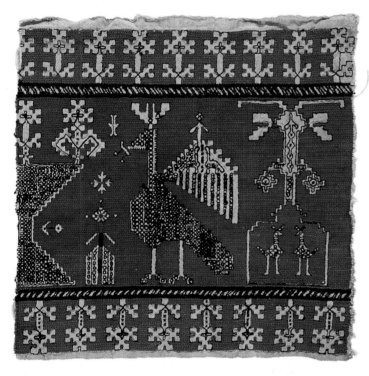

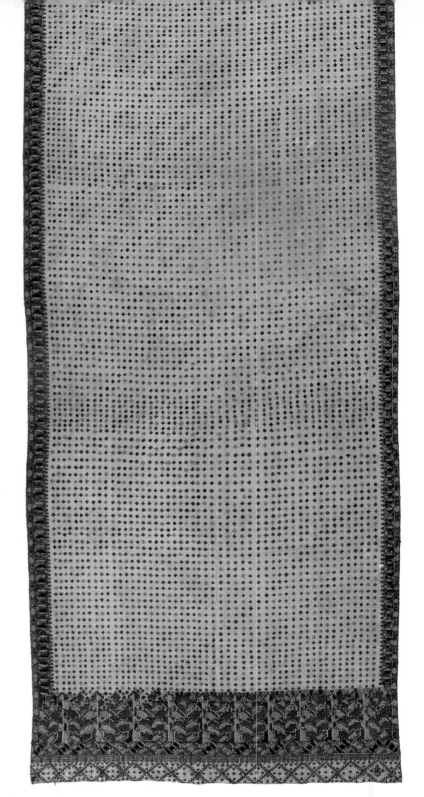

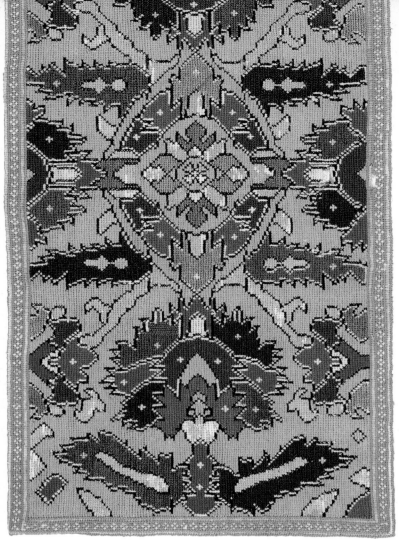

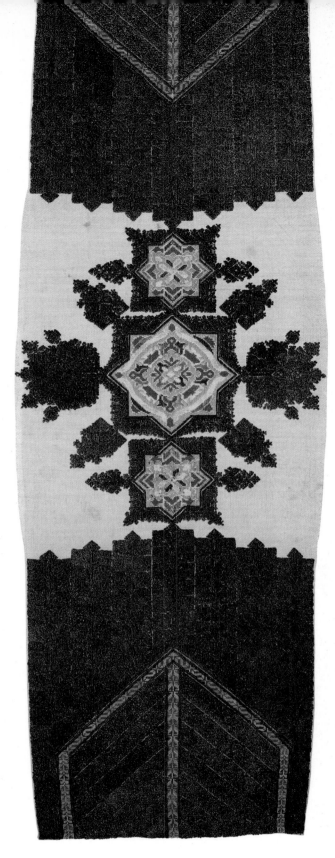

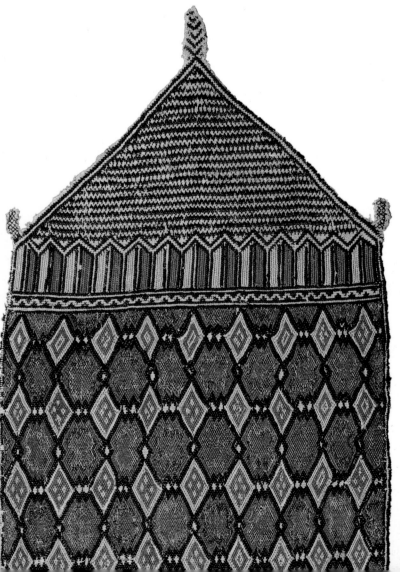

ABOVE LEFT Moroccan furnishing
cloth embroidered in silk cross
stitch on linen from Chefchaouen.
ABOVE AND OPPOSITE Chest or bed
covers embroidered in silk on linen
from Chefchaouen, Morocco.
LEFT Panel from a furnishing cloth
from Chefchaouen, Morocco.

Ottoman-influenced urban embroidery

In its heyday, in the days of Suleiman the Magnificent in the 16th century, the western boundaries of the Ottoman Empire reached as far as the Moroccan Rif and nearly to the gates of Vienna. For hundreds of years, Turks ruled most of North Africa, all of the Levant and Arabia and nearly all of the Balkans. Throughout the towns and cities of the empire, embroidery styles were based on Anatolian models. They had so much in common that it is often difficult to tell the different regions apart. Heavy metal-thread embroidery is common throughout North Africa, but probably less so in Morocco, which escaped direct Turkish domination.

Delicate floral embroidery similar to the pomegranate or artichoke pattern in Turkish embroidery was worked in Algiers on finely woven linen or cotton and used for coifs, bath towels and chemises. After Algiers was incorporated into the Turkish Empire in the early 1500s, its embroidery showed many similarities with that of Istanbul and Smyrna. It was also influenced by Persian, Syrian and Italian embroidery. A delicate floral style began to develop, worked on linen or cotton net for bridal coifs, scarves and coverlets. Tulips, carnations, hyacinths and wild roses were all recurrent motifs. The style continued to be popular until the early 20th century. Bone (modern Annaba) and Constantine had their own styles, reflecting Ottoman influences, but with regional differences incorporating elements from neighbouring Tunisia.

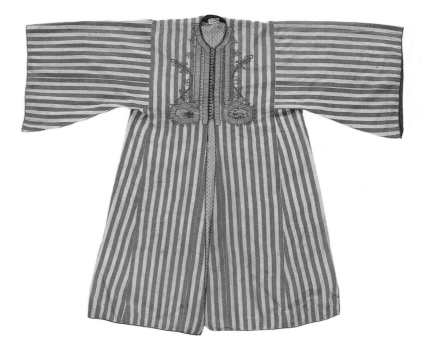

Algiers work is counted thread work carried out by professional embroideresses on fine, loosely woven linen on a frame of Turkish origin known as the *gourgaf*. Designs are outlined in black silk or sometimes gold thread in double running stitch, enclosing areas decorated mainly in a form of brick stitch and some satin stitch in blue, red or purple silk. The embroideress traditionally worked while sitting on the floor. The use of eyelet stitch, giving a chequerboard effect, is very characteristic of Algiers work.

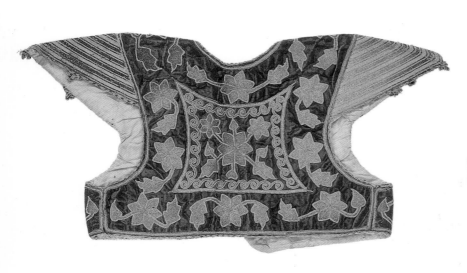

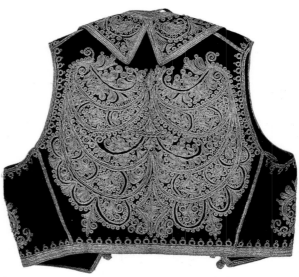

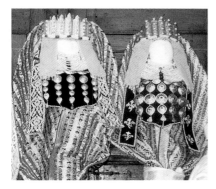

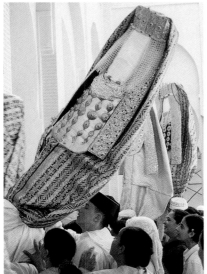

OPPOSITE
TOP Woman's silk kaftan of warp-striped silk, Morocco or Algeria.
BOTTOM LEFT AND RIGHT Women's waistcoats, Tunisia.
TOP AND CENTRE ABOVE The 'wives' of Moulay Idriss, the founder of Fez.
ABOVE A *hiti* screen at Fez, Morocco.
RIGHT Very fine *tanshifa* Algiers embroidered scarf.

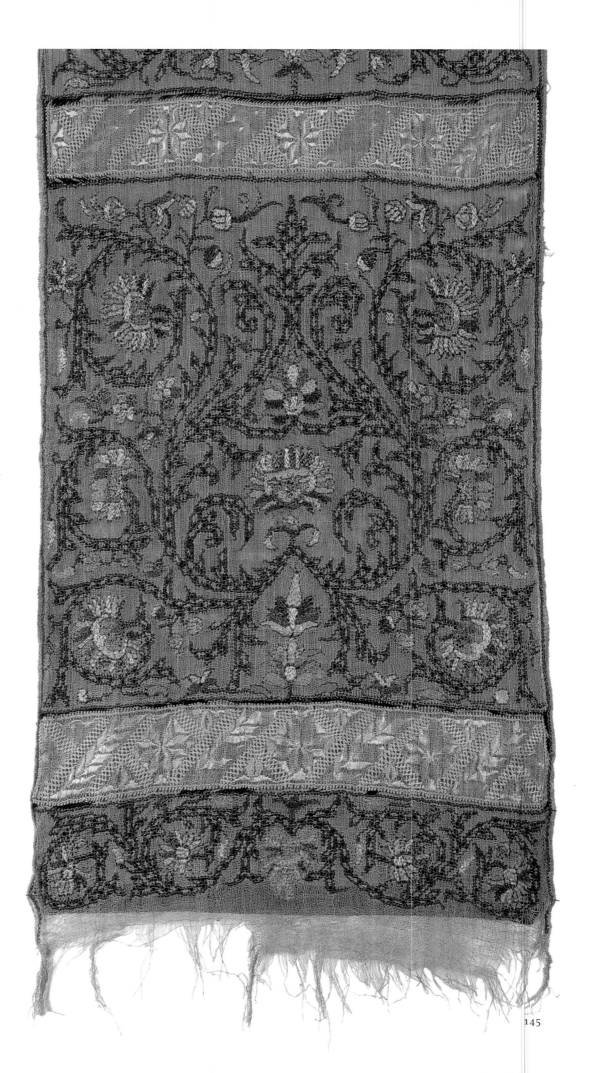

Tunisian metal-thread embroidery

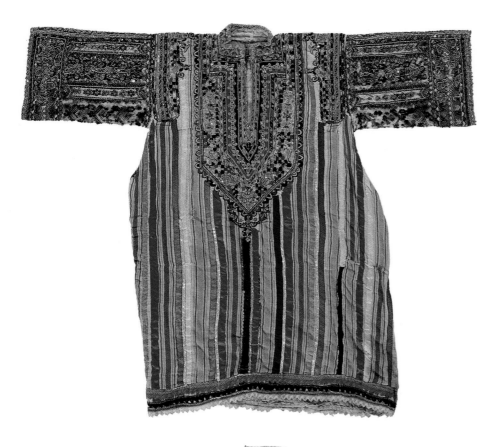

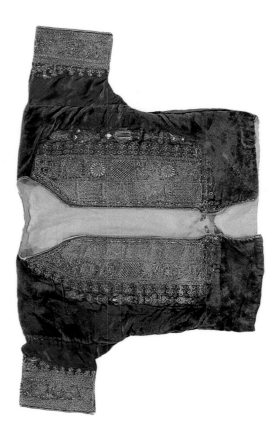

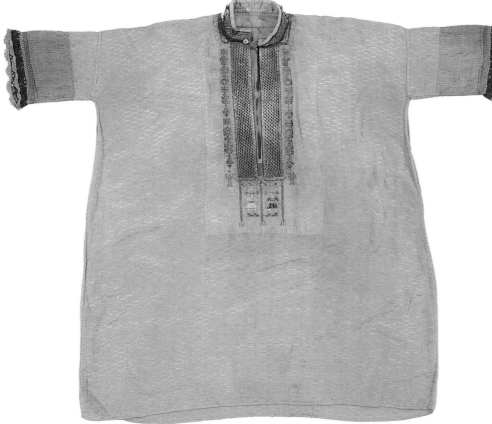

TOP LEFT *Tatouee*, the metal-thread and sequin-embroidered bridal dress worn on the third day of the wedding, Raf-Raf, north Tunisia.
TOP RIGHT Bride's waistcoat embroidered with silver strip, Mokhnine, Tunisia.
LEFT Bride's blouse embroidered with silver strip, Mokhnine.
BELOW AND OPPOSITE TOP Women's cloaks from Jembiana, Sahel.
OPPOSITE
CENTRE LEFT Couching-laid threads are held in place with stitches.
BOTTOM Bride's coif embroidered with metal-thread, Sahel, Tunisia.

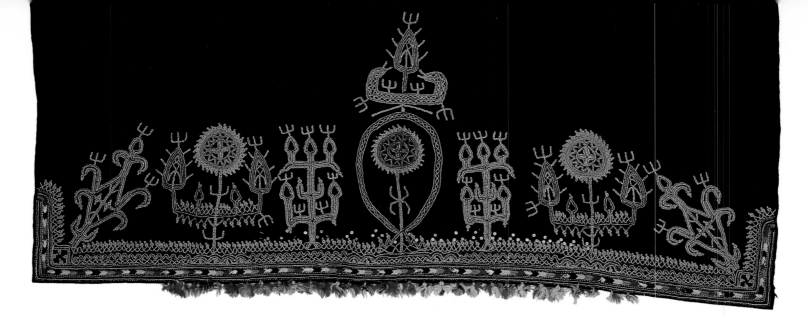

Tunis and the towns of the fertile Tunisian Sahel have a tradition of creating stiff, heavy marriage garments for the bride. Covered in metal-thread embroidery, she appears in this dress in public as a married woman for the first time at the *jelwa* on the third day of the marriage. Her face powdered a stark white, her body clad in layers of stiff garments, she holds up her arms, palms open, to bring down a blessing upon her and her marriage. All the embroidered finery that she has worked for her trousseau is displayed to an invited audience. Though similar ceremonies are held all over the Maghreb, those for wealthy Tunisians are perhaps the most elaborate.

Even in such a small country as Tunisia, wedding costume varies very much from town to town. Gold- and silver-thread embroidery is the preferred decoration for garments intended to be worn for marriage and circumcision. Tunis work uses metallic strips with motifs of flowers and birds. Hammamet, Nabuel and Mahdia employ dense amounts of golden metallic ribbon in patterns of concentric squares and circles. Mokhnine is famous for its delicate work in silver ribbon of geometric motifs with pre-Islamic details, such as the fish, the vase and the bride with upraised hands. At El Jem and Jembiana and in the winter skirts of Mahdia, free-form, gold-thread embroidery with motifs of flowers, birds, fish and a stylized bride are the norm. Sfax and Sousse again have bridal costume embroidered heavily with metal thread. Sequins are often used, applied to the bride's coif and to young boys' circumcision robes. Bridal clothes are often commissioned from a professional embroideress or, nowadays, hired from her or from a family possessing old and beautiful wedding garments.

North Africa, particularly Morocco, was famous for its gold embroidery worked by men on leather and velvet, mainly for horse trappings and military accoutrements. Jewish jewellers traditionally made all the golden and silver threads and sequins. Since their exodus to Israel in the 1950s, cheaper and much less satisfactory substitutes have been used.

Forms of couching are the commonest stitches employed. Metal threads or strips are laid on the ground cloth and couched down in a matching or contrasting colour. To add bulk, the metal threads may be laid over a base of cotton threads or even wrapped around a cardboard shape before sewing down.

Also common in Tunisian metal-thread embroidery is buttonhole stitch, which is similar to blanket stitch except that the stitches are sewn together in a small area. A series of stitches are made around the edges of the cloth. Each stitch links through the previous one. In this way a line of thread is built up that will prevent the fabric fraying.

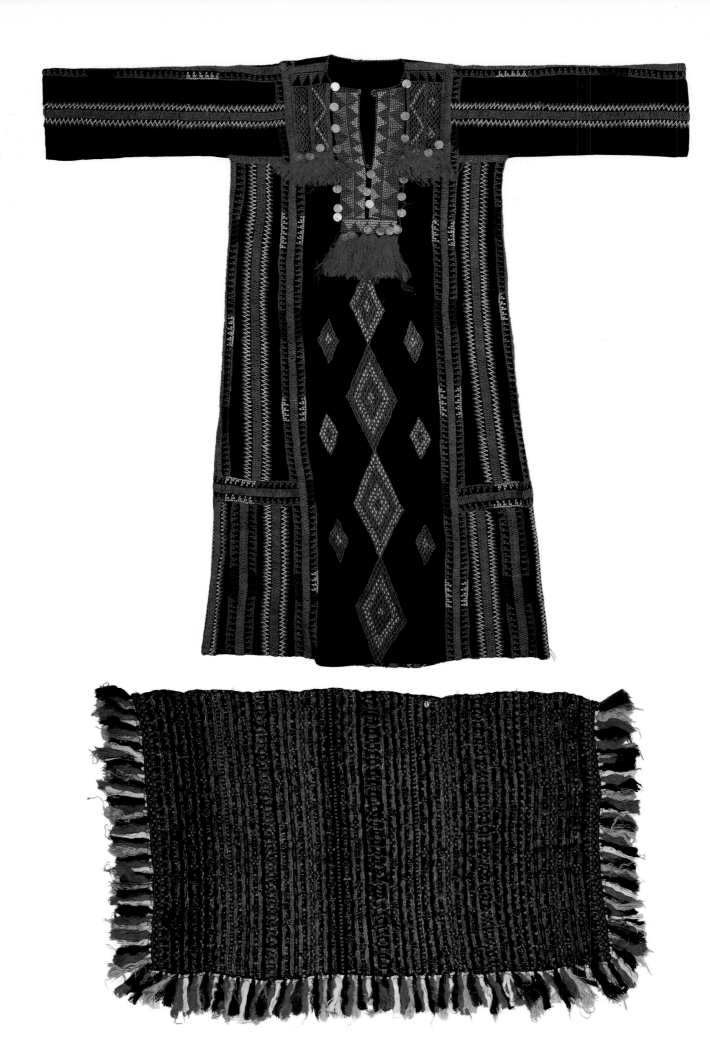

The embroidery of Siwa Oasis, Egypt

Siwa lies in the western desert of Egypt on the Libyan border. Inhabited by Berber people, it has an ancient history. Before embarking on his journey to India, Alexander the Great consulted the oracle there. A Siwan bride traditionally wears seven different coloured dresses underneath a very large, T-shaped, loose and wide-sleeved wedding smock. It is embroidered in silk with motifs of flowers and auspicious symbols and embellished with buttons, glitter and even, in modern times, with bits of gaudily coloured plastic. The material of the dress and the baggy trousers worn with it are made either of cheap black cotton or white synthetic damask. Both the cuffs of the trousers and the small black voile shawl that completes the wedding costume are embroidered in silk.

The embroidery threads used are coloured blue, black, green, red, yellow and orange, which, with the white buttons, make up the seven colours deemed to bring good luck. The neckline is embroidered in chain stitch, which is bordered by blocks of Romanian stitch. From this central panel simple cross stitch and a complex combination of stitches are employed to form the lines that radiate from the breastbone like a sunburst.

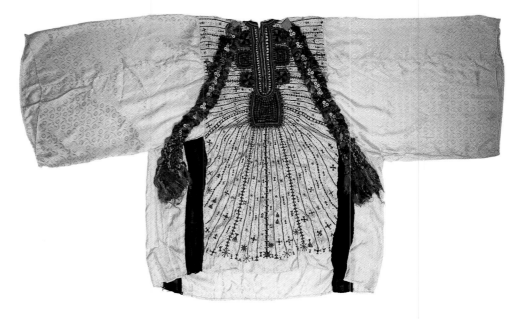

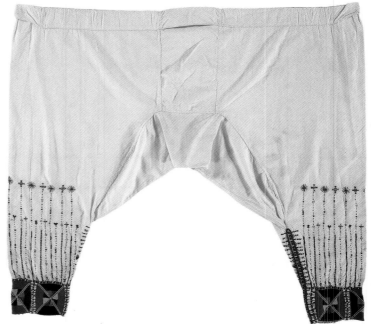

OPPOSITE
TOP Bridal dress from one of the inner oases, western desert, Egypt.
BOTTOM Siwa oasis embroidered wedding shawl held over the bride's head at the wedding ceremony.

TOP AND ABOVE Woman's marriage smock and trousers from Siwa oasis, western desert.

Egyptian appliqué

In the little cubicles of the *Khiyammiya*, the Street of the Tent-makers in the Old City of Cairo, male tailors and their apprentices sit appliquéing by hand cushions, bed covers and wall hangings for the domestic and tourist market. Current popular patterns are of arabesques, calligraphy, birds and scenes from ancient Egyptian mythology. However, the main production was always *qanat* panels – large-scale drapes in heavy cotton, with bold arabesque patterns, that made up the screens and canopies at festivities all over Cairo and Lower Egypt. Although, if the panels in use today are studied carefully, it becomes apparent that the majority are machine printed rather than appliquéd.

In the past they would all have been made in the Street of the Tent-makers.

After Lord Carnarvon's excavation of the tomb of Tutankhamun in the 1920s and the ensuing popularity of all things Egyptian, many hangings on the Tutankhamun theme were made in the Street of the Tent-makers for sale in Luxor and Port Said. They turn up in British antique shops.

The simplest form of appliqué is hemmed appliqué, in which the figurative, geometric or calligraphic motifs are cut out of the fabric using a template and tacked on to the ground. The next step is to turn in and hem or slip stitch the edges, leaving the ground fabric visible between the applied pieces.

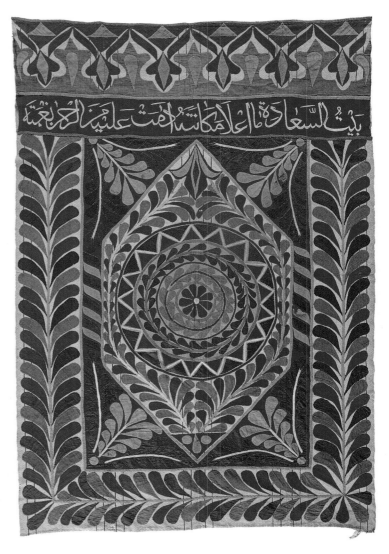

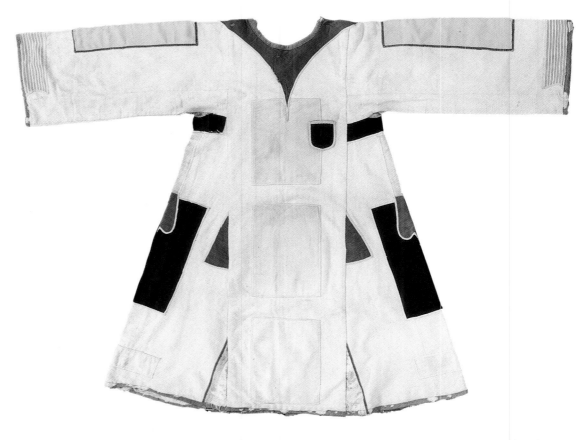

OPPOSITE

TOP LEFT Cotton appliquéd panel made in the Street of the Tent-makers, old Cairo, for domestic use.
RIGHT Panel of appliquéd cotton fabric with typical arabesque designs, Street of the Tent-makers, old Cairo, used for marriage and circumcision celebrations.
BOTTOM LEFT Upper border of an old festive panel from the Street of the Tent-makers.

RIGHT *Jebba*, an appliquéd uniform coat of the Madhiist army, Sudan.
BELOW Saw-toothed edging is a common appliqué device.
CENTRE AND BOTTOM Appliquéd 1930s panels made for the colonial and tourist market.

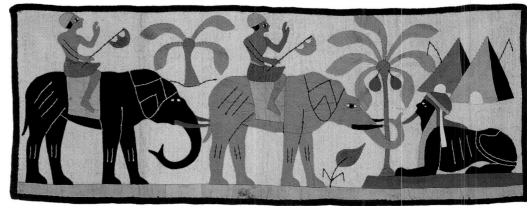

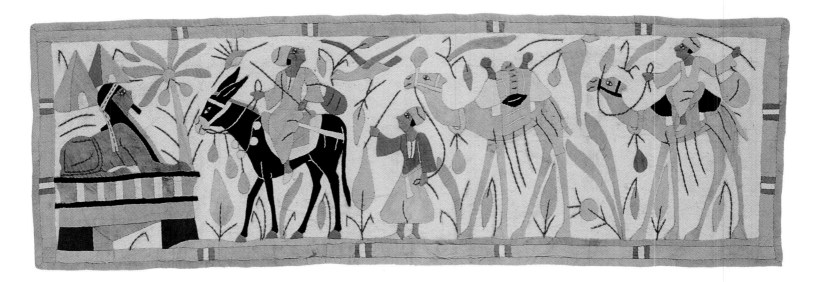

151

Assyut silvered work on net, Egypt

In the town of Assyut in Upper Egypt there is a long tradition of metal work on white, black or blue net. A Coptic Christian speciality, this technique was used to decorate shawls intended as bridalwear. The subject matter – flowers, animals, women – of the geometric patterns was worked on the diagonal with little flat strips of silvered metal. Initially, particularly when the strips incorporated real silver, they were sold by weight. Sizes vary, though most of the scarves are long and narrow.

Because of the growing popularity of Egypt as a tourist destination after the discovery of Tutankhamun's tomb, the scarves have also become an item sold to tourists on the Nile, at the Pyramids or at Suez. Scarves and dresses decorated in this manner were particularly popular in the period between the First and Second World Wars. Similar garments using the same technique were also produced in Lebanon and Syria. Silvered work on net went through a revival in the 1980s.

The older pieces incorporated strips of gilded copper, while modern workers use chrome-plated copper or brass on inferior net. The aim is to form a narrow S-shaped stud that lies flat, is very strongly held within the net and will not snag. Patterns are built up from combinations of these studs.

It is likely that the technique originated in Turkey and spread to areas of Ottoman influence, including Egypt. A similar method is used in India: the embroiderer holds the fabric taut between his fingers. One end of a short length of sewing thread is tied to the eye of a needle and the other is knotted into a loop. The end of a short length (30 cm; 11³/₄ in.) of metal strip is hooked into the looped thread. The metal strip is pulled through the fabric until a short piece is left, which is turned over to secure the strip to the fabric. The needle is taken down near the secured end and out to the left. The metal strip is pulled through gently, leaving a loop on the surface of the fabric. The needle is passed under the metal strip, which is then pulled tight, bent back and broken off with a quick twist. Finally, the fabric is rubbed with a smooth object, which flattens the metal on to the fabric.

ABOVE Assyut shawl worked in silvered metal strip on net with patterns of rural life for a wedding.
LEFT A method of embroidering with metallic strip.
OPPOSITE An Assyut shawl worked in silvered metal strip on net in Upper Egypt for a Coptic wedding.

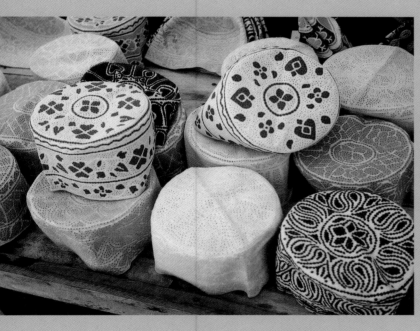
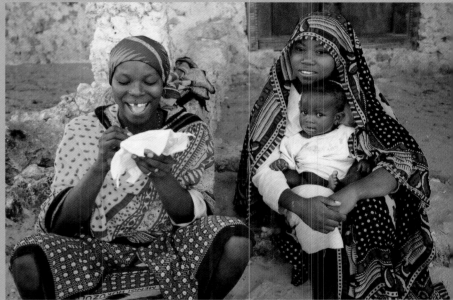

EAST AFRICA

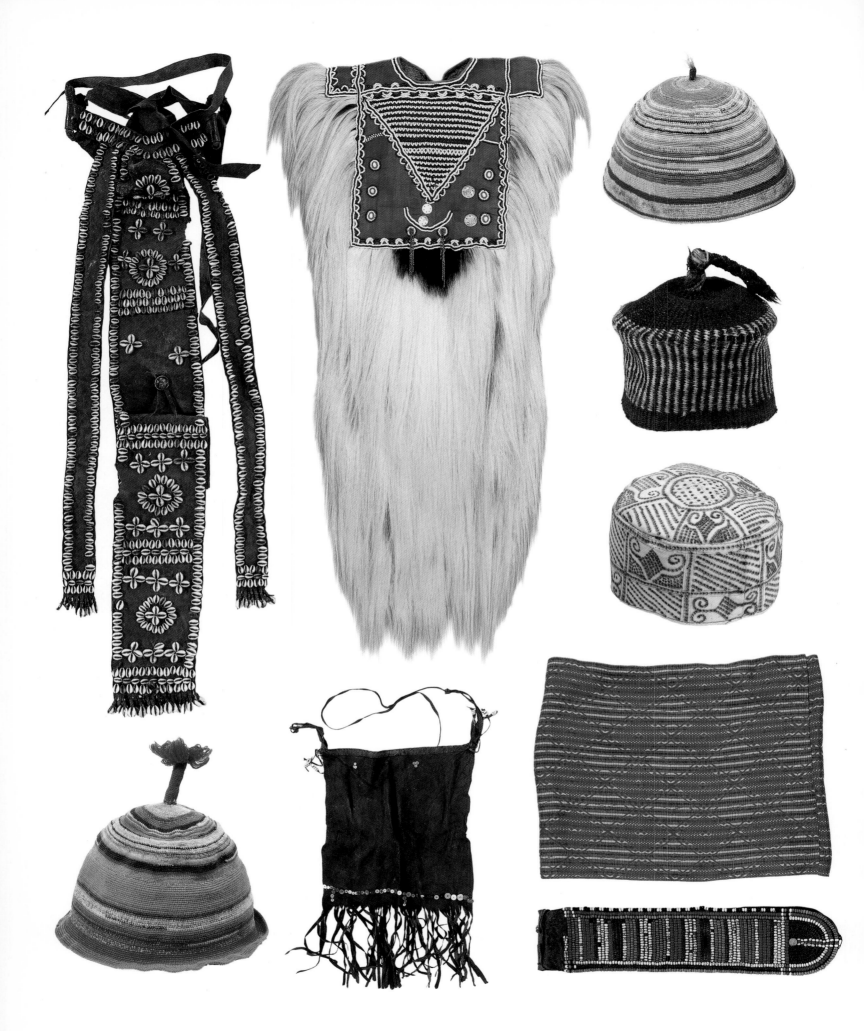

Introduction

EAST
AFRICA

Last Africa stretches from the highlands of Ethiopia, down through the deserts of the Horn to the game-rich plateau that makes up much of Kenya, Tanzania and Uganda. The region is inhabited by a wide variety of peoples – the Christian Amhara and Tigray of Ethiopia are of Semitic origin and the Somali peoples of the Horn of Cushitic origin. Both have links to the Arabian peninsula. The Swahili people of the Kenyan and Tanzanian coast and the offlying islands are of mixed Arab and African descent, whereas the pastoralists, hunters and agriculturists of the plateau are Bantu-speakers like the Kikuyu or of Nilotic origin like the Maasai.

The textile-producing culture is strongest in the north of the region, particularly in Ethiopia, where there are good cotton-growing conditions and many weavers. Groups such as the Dorze, once warriors, are now renowned weavers, not only in their home district, but also in Addis Ababa, the capital. There are 1st-century records of cotton being imported via the Red Sea into Axum, the then capital of Ethiopia, although it is unclear when it was first cultivated. For centuries the use of cotton cloth was restricted to the aristocracy, whereas everyone else had to make do with skins and hides. Although leather garments are particularly to be found in southern Ethiopia, most people in the country wear cotton clothes.

Weaving flourished at the centres of royal and ecclesiastical patronage, such as Gondar, Harar and, latterly, Addis Ababa itself. Harar is an ancient Muslim city with its own traditions. Amongst other crafts, it was renowned for its embroidery and the inclusion of imported, particularly Indian, fabrics into female costume. Cotton *shamma* shawls, often with decorative borders, are woven on pit-looms in Ethiopian workshops containing two or more weavers. Weaving is generally highly commercialized, with a strong market guaranteed because of religious and ceremonial requirements.

The Amhara and the Tigray people of the highlands are probably the main market for handwoven cotton cloth. Though various southern groups, such as the already mentioned Dorze, are prolific weavers, the Oromo or Galla

groups, who form the majority of the southern population, will wear cloaks and aprons made of hide, sometimes decorated with shells. The cotton that the Oromo or Galla weave will be smeared with clarified butter to make the material warmer and more waterproof.

The Somalis and related groups of the Ethiopian Ogaden, Djibouti and Somalia proper traditionally wear handwoven cotton loincloths. Indeed, in the 19th century, they had a strong export market for their cotton cloth, but nowadays they tend to wear imported cloth. Like the north Sudanese, both the Ethiopians and the Somalis weave on pit-treadle looms, very similar to Asian pit-looms and former cotton-weaving looms of the Swahili coast. Because of their close links with India and Arabia, Kenya and Tanzania did not develop a textile manufacturing industry that could compete with the products of the subcontinent or peninsula.

The same could be said of such previously isolated groups of the interior in modern Tanzania who wove simple, sometimes warp-striped cotton wraps on single-heddle looms. The products of these long-forgotten looms are now merely of historical interest.

Isolated in the interior until the Uganda railway was built in 1900, the peoples of the plateau wore skins and hides decorated with applied ostrich shell or, after 1900, with European trade beads, which were especially used by the pastoralists, the Maasai, the Pokot and the Turkana. Their costume was augmented by trade blankets of European, and particularly British, origin.

With its rich and fertile soil, Uganda differed from the rest of the plateau, as many of its peoples were settled farmers or fishermen around the vast Lake Victoria. Traditional clothing needs amongst the farmers, such as the dominant Ganda, were met by bark cloth obtained from the bark of tropical fig trees. The swamps of south Sudan are inhabited by tall, slender Nilotic tribes, principally the Dinka, Nuer and Shillook, who traditionally go naked. They adore beads. Young, unmarried Dinka men and women wear a corset made of tubular beads.

A strong market for specialized textiles developed, especially in agriculturally rich Kenya. The use of cotton wraps, worn in pairs by women and embellished with Swahili proverbs, known as *kangas*, spread from the Swahili coast to the interior to such an extent that they became

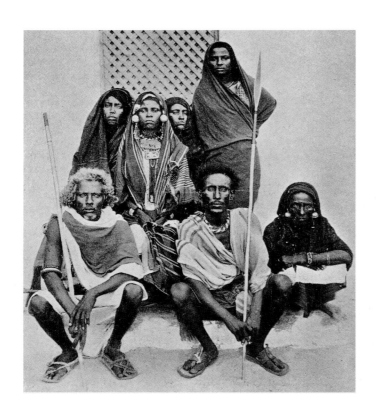

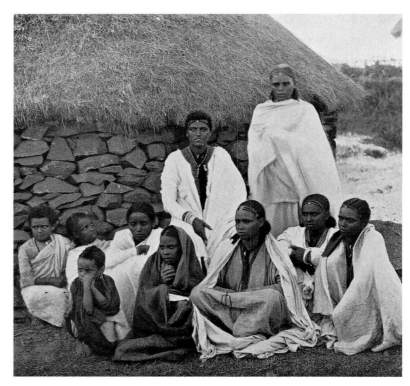

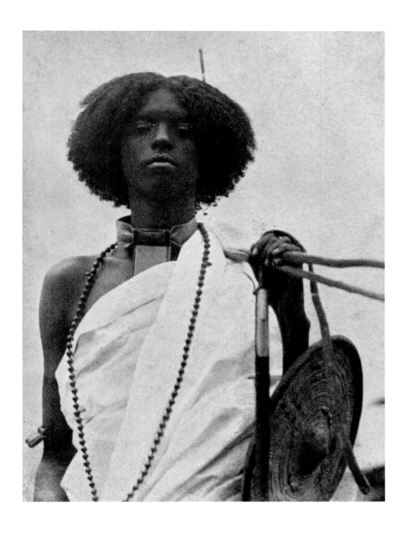

OPPOSITE
LEFT Somali tribespeople at
Djibouti. The men are wearing
kikois.
RIGHT A group of Amhara women
in the highlands of Ethiopia
wearing cotton *shamma* shawls.

LEFT A young warrior from the
Ethiopian highlands.
BELOW A young warrior from the
Ethiopian-Sudanese border region.

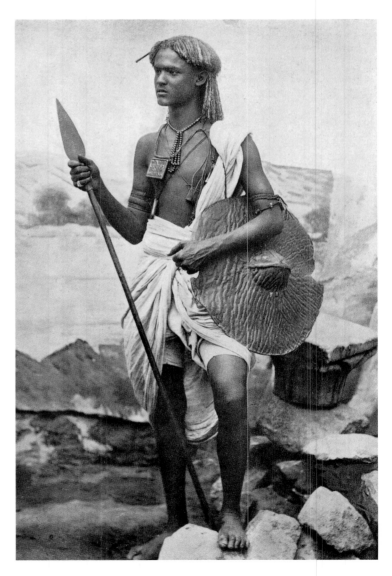

a form of national dress. Despite speculation that they
were originally block printed on the island of Zanzibar,
it is likely they were always mill-woven and machine
printed. In any case, they certainly became extremely
popular after the Second World War. In a similar manner,
striped fringed cotton or synthetic *kikois*, an item of
traditional Somali male attire, were worn by such groups
as the Kikuyu.

As in most parts of Africa, traditional handmade
textiles are in decline throughout the region, with the
exception of Ethiopia. Ceremonies, particularly funerals,
require traditional dress to be worn, a practice that keeps
at the very least a small number of cloth producers in
work. It is likely that the situation will remain the same
for some time. Certainly, it is difficult to see the textile
market flourishing, except perhaps in response to tourist
demand.

The cotton shawls of Ethiopia

The highlands of Ethiopia are home to peoples with an ancient history of Christianity. Syrian Christians, who were reputed to have been shipwrecked on the Red Sea coast on their way back from India, were thought to have brought Christianity to Axum in the 1st century.

Historically linked to Southern Arabia, the Tigray and Amhara people weave on the horizontal pit-loom found all over the Middle East and even as far away as India. They and other more recent practitioners of the weaving arts, such as the Dorze and the Gurage, weave thin muslin shawls known as *shamma* with colourful supplementary weft borders as well as *kutta*, heavy shawls. *Shamma* have been adopted as everyday wear for rural women and church-going or special attire for the more Westernized urban élite. The men have an almost identical shawl known as a *jebba*. Women wear *shamma* over a handwoven, plain-muslin cotton smock called a *kemis*, which has an embroidered neckline and is embellished on the front and back with often elaborate cruciform devices. The predominant colour of the embroidery is green, but red, yellow, blue and even gold thread are popular.

Shamma and the other types of shawl in Ethiopia are woven on double-heddle treadle looms. The weaver generally sits on the edge of a small pit dug into the ground (hence the term pit-loom). The weaver's legs fit into the pit and, with his feet, the weaver operates the twin treadles that move the double heddles. As all the warp threads are attached to one of the heddles, the weaver makes the shed by depressing one of the treadles, passing the shuttle through and then depressing the other treadle to make countershed and so on as the weaving progresses. The warp is made taut by taking it underneath a beam of the loom frame, up and round another higher beam so that it comes back to a beam over the weaver's head. It is then taken forward again, to be tied round another horizontal beam placed midway between the first two beams mentioned. This doubling back and forth of the warp threads saves on space and allows a number of weavers to work in the same compound or room.

Shamma are woven out of locally grown and spun cotton in a relatively gauze-like tabby weave. The main body of the shawl is white. The decorative element is provided by multicoloured, supplementary weft borders known as *tibeb*. To facilitate the raising of the individual warps required for the working of the complex, usually geometric, patterns of the *tibeb*, ten or more supplementary shed sticks may be inserted in the warp to replicate the complex pattern required.

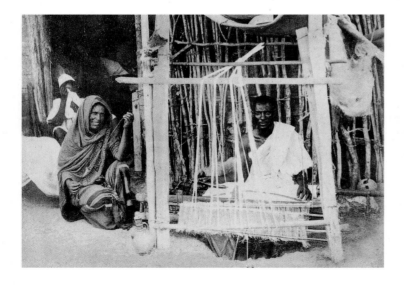

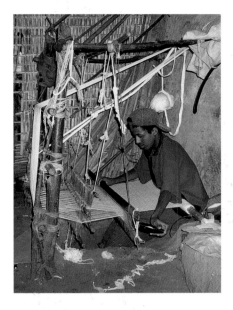

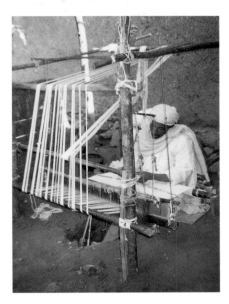

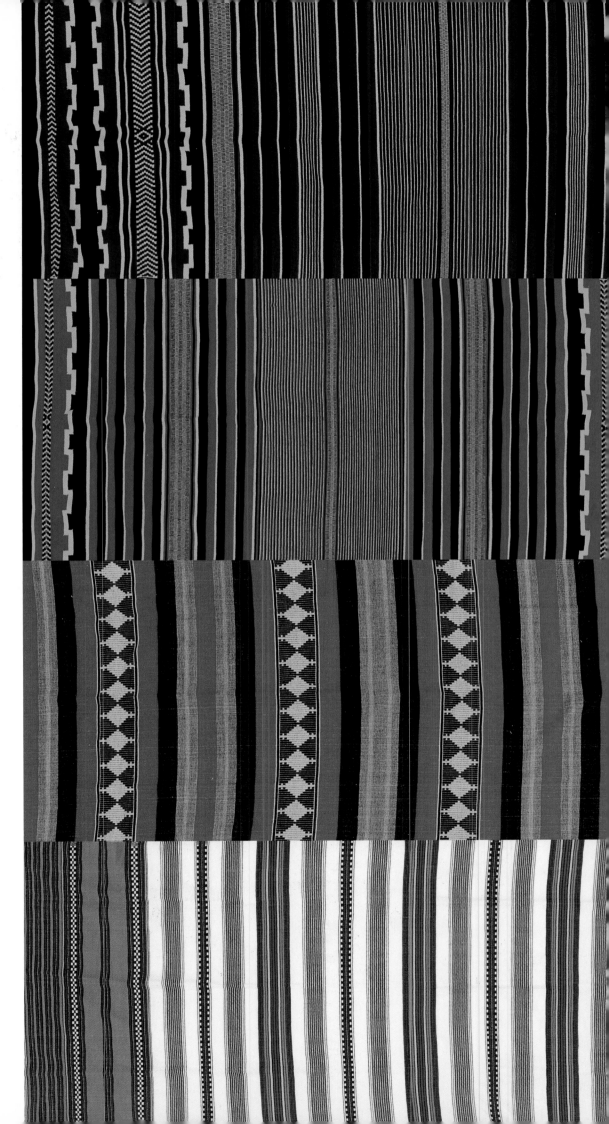

OPPOSITE
LEFT An Amhara weaver at his
pit-loom.
RIGHT An Amhara painting
depicting all the stages in the
production of cotton cloth.

TOP AND ABOVE Muslim weavers
weaving cotton *shamma* shawls in
the city of Gondar.
TOP RIGHT, SECOND AND THIRD
RIGHT *Shamma* woven at Bahar Dar
on pit-looms.
BOTTOM RIGHT *Shamma* woven
in Sidamo province.

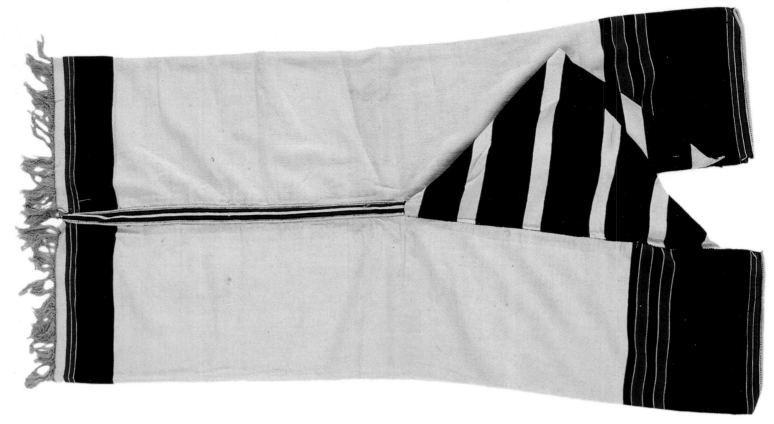

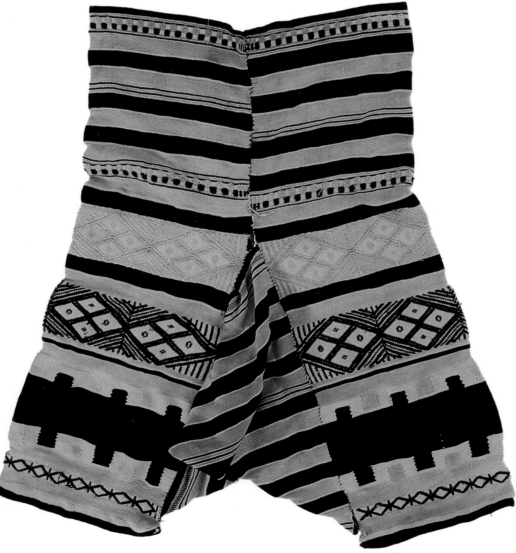

ABOVE Men's cotton trousers of the Dorze people of southern Ethiopia.
LEFT Men's trousers of the Dorze people of southern Ethiopia. Once reserved for the élite, they are now general ceremonial wear. The colours are symbolic: white and yellow meaning death, black rain and red the blood and meat of life.

OPPOSITE Men's trousers of the Dorze people of southern Ethiopia. At one time reserved for those who had killed in battle, they are now general ceremonial wear.

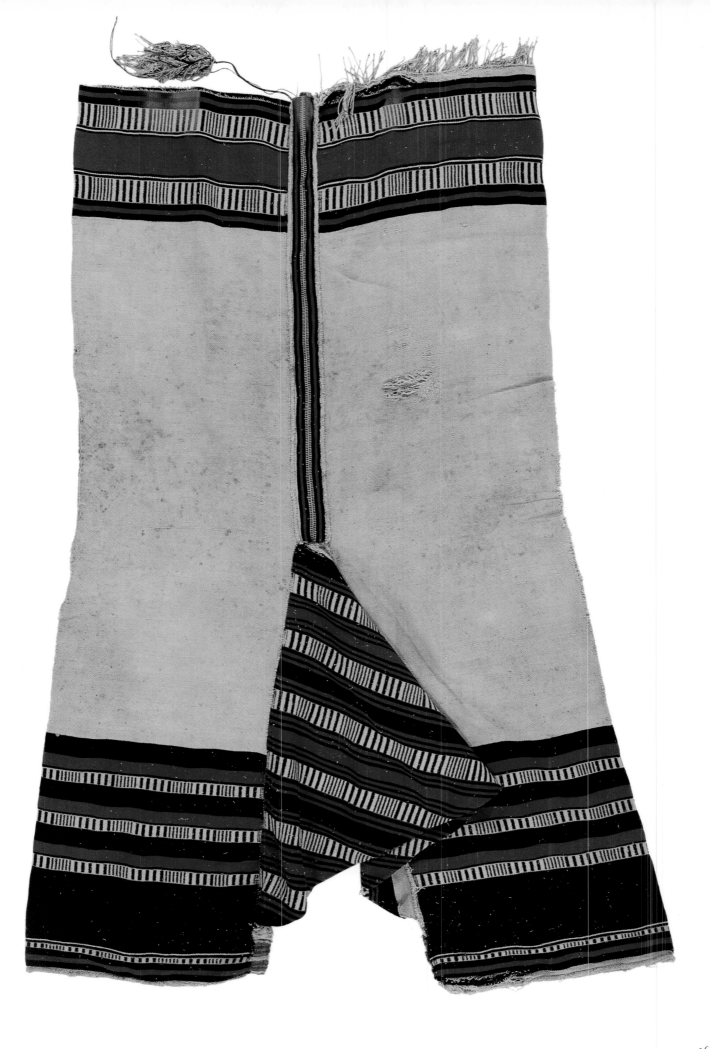

Ethiopian embroidery

There are two basic traditions of embroidery in Ethiopia. The first, associated with the Amhara and related peoples of the highlands, is steeped in the Coptic Christian tradition. The second, connected with the Muslim people of Harar, is a sophisticated urban style influenced by India and Arabia in its use of patterns and materials.

The Amhara *kemis* (chemise) is a long, open-necked shift with short, or often long, full sleeves. The cut varies from region to region within the Ethiopian highlands to such a degree that it is easy to distinguish between the styles of, say, the Amhara of Addis Ababa and a woman from Gondar or from Tigray. Whatever the region, *kemis* are traditionally made of handwoven undyed cotton and are embroidered at the neck, cuffs and hem. Depending on the region, the *kemis* are embellished with cotton embroidery or studded along the neck with small silver beads. This style of dress for women belongs to a Christian tradition. The *kemis* is worn with the *shamma* shawl, particularly on Sundays.

The Muslim style is completely different. Perhaps the most beautiful example belongs to the urban women of the ancient walled city of Harar. Marriage dresses are long, full smocks of indigo-dyed light cotton sewn up along a central longitudinal seam to form a V-shaped neckline. A piece of imported satin or damask of contrasting colour is sewn on, to cover the shoulders, neck and breast and upper back. All the edges of this applied fabric and the neckline are outlined with delicate restrained floral embroidery in satin stitch, which forms identical patterns on the inside of the dress. It is therefore possible to turn the dress inside out, a practice carried out at various stages in the marriage ceremony.

Underneath the dress women wear Jodphur trousers of Kutchi *mashru* (a striped warp-faced satin) imported from India. The cuffs of the trousers are embellished with a colourful locally made braid. The outfit is completed with a tie-dyed rayon or silk shawl – also from India – confirming the strong trading links that extend from Harar across the Indian Ocean.

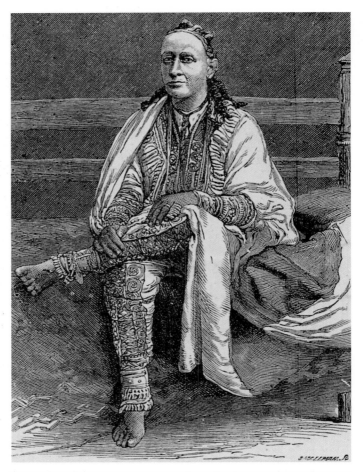

LEFT An Ethiopian highland woman's *kemis* of handspun and handwoven local cotton, Gondar district. The neckline and sleeves are embroidered in green cotton.
TOP AND ABOVE Panels of Amharic embroidery featuring the Coptic Christian cross.

OPPOSITE, CLOCKWISE FROM TOP LEFT
TOP LEFT Reversible wedding dress from Harar.
TOP RIGHT A Harar wedding dress, reversed. The satin panel serving as the yoke is imported from Asia.
BOTTOM RIGHT A young Harar bride.
BOTTOM LEFT Harar woman's trousers of Indian *mashru* fabric with braided silk trouser cuffs.

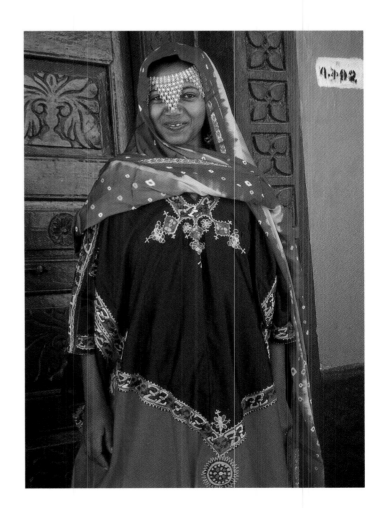

Leather, shell and beadwork

Throughout the Ethiopian highlands and down to the desert plain that stretches into Somalia and northern Kenya, the inhabitants wear not only cotton cloth but also skins and cured hides in the form of cloaks, aprons and baby carriers. As the whole area is lacking in natural resources, locally available animal skins are processed in order to supplement cotton clothes that have to be bought with very scarce monetary resources. The hides are tanned and then adorned with applied cowrie shells, glass beads or faceted lead or aluminium (made from Indian cooking pots) beads. Cowries come from the Indian Ocean (traditionally the Maldives). Their shape – reminiscent of a woman's vulva – denotes fertility and, as they were once used as small change in many of the countries bordering

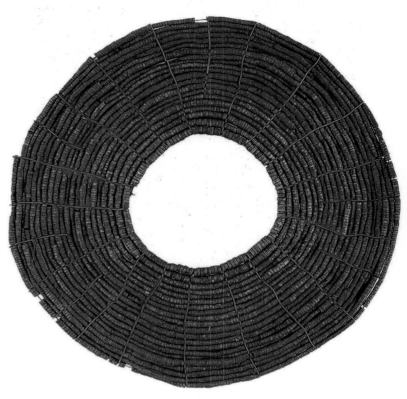

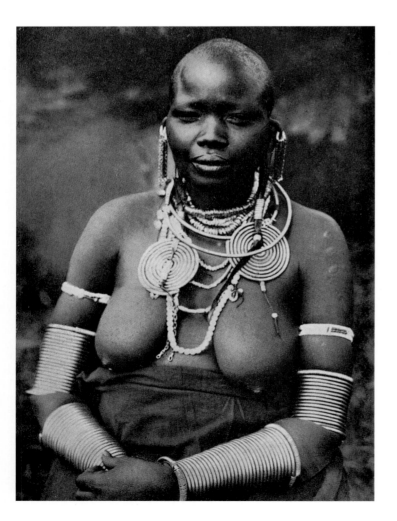

the Indian Ocean, they also denote wealth. The backs of the cowries are often ground down so that they are easier to sew on to the hide and will lie flat.

The skins of domestic animals, such as cows, camels or goats, or those of wild game, such as antelopes, are used. Any hair is singed off and the hide is then treated with tanning and softening agents, such as animal brains, which are rubbed in until the hide softens. It will be kept supple with regular applications of animal fats. Leather, which has a naturally integrated structure, can be cut without any danger of fraying.

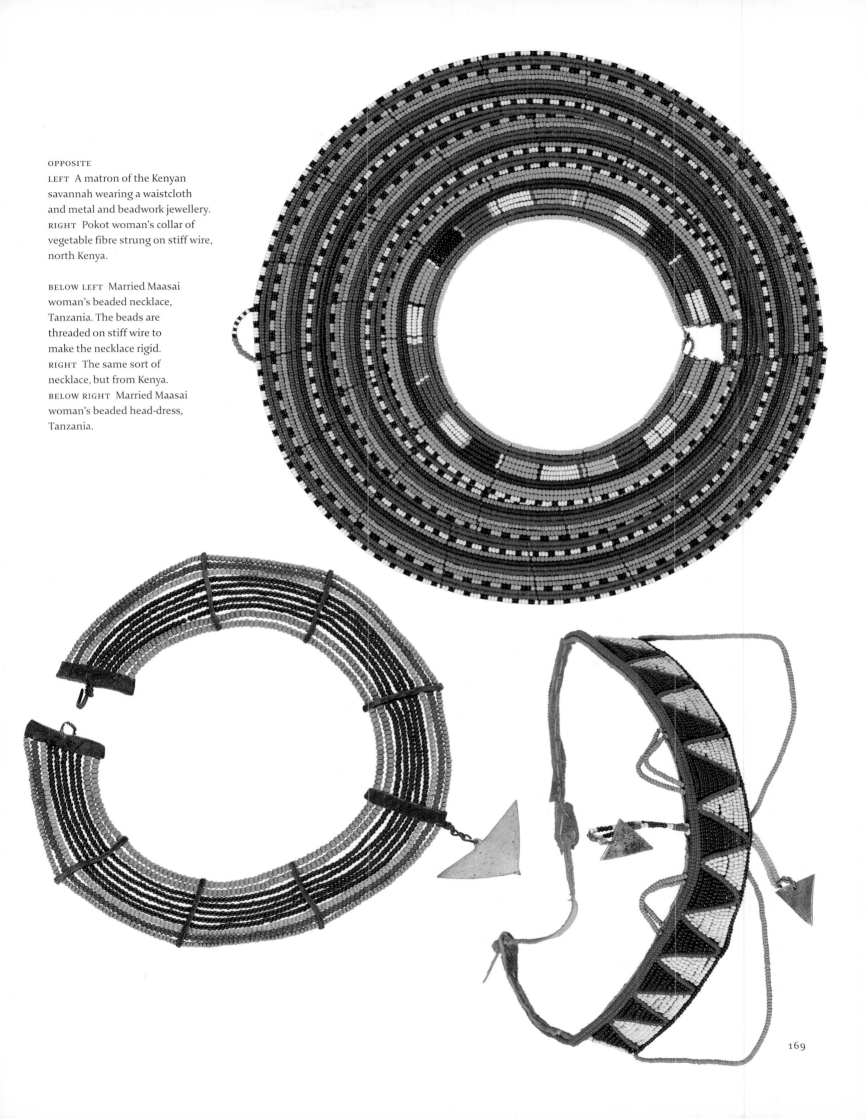

OPPOSITE
LEFT A matron of the Kenyan savannah wearing a waistcloth and metal and beadwork jewellery.
RIGHT Pokot woman's collar of vegetable fibre strung on stiff wire, north Kenya.

BELOW LEFT Married Maasai woman's beaded necklace, Tanzania. The beads are threaded on stiff wire to make the necklace rigid.
RIGHT The same sort of necklace, but from Kenya.
BELOW RIGHT Married Maasai woman's beaded head-dress, Tanzania.

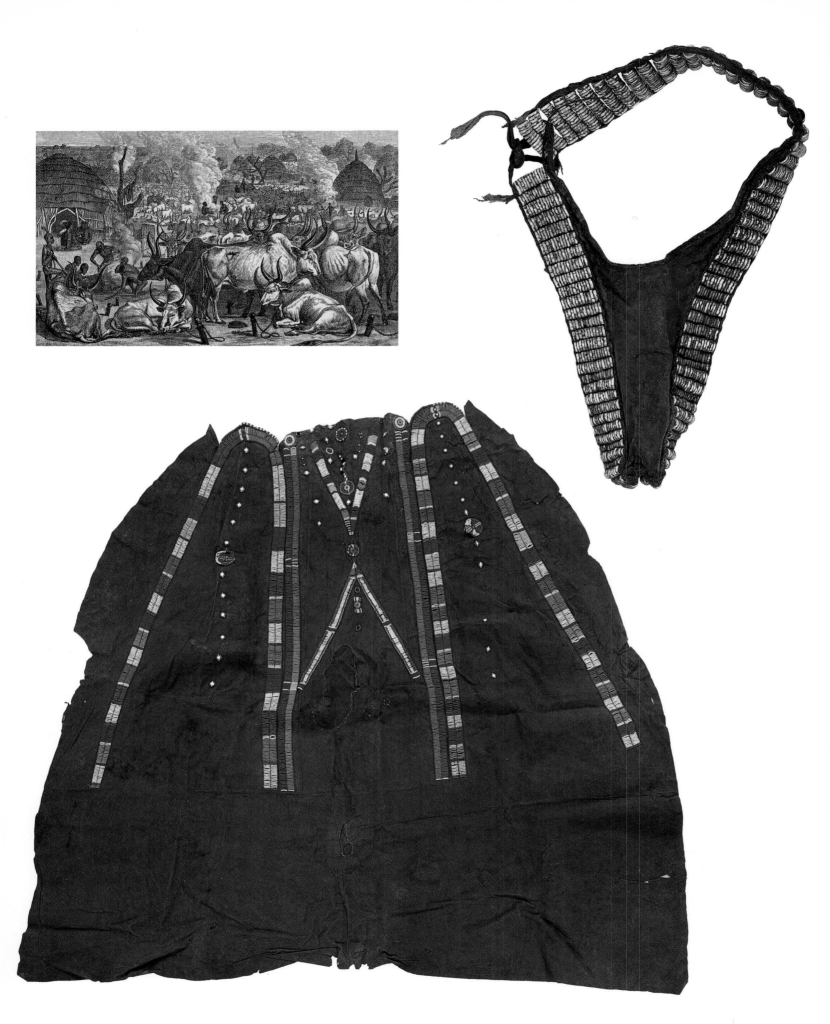

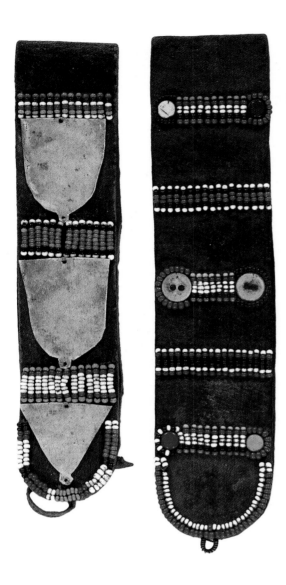
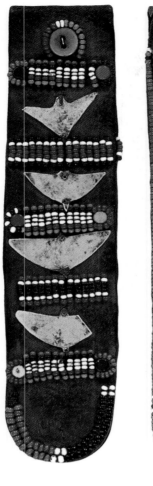
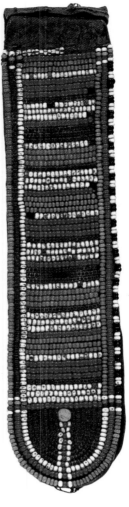

The Maasai are a cattle-raising people found in the Great Rift Valley of Kenya and Tanzania. Semi-nomadic pastoralists, they are renowned for wearing beadwork and applying ochre (red-brown mud mixed with animal fat or water) to their clothes and bodies.

Divided into ages, women, and particularly men, wear very different clothing and adornment depending on the age-set to which they belong. The clothing of both sexes consists mainly of treated (cow) skins and trade blankets. Traditional men's attire is a skin cloak, worn with a belt, necklet, brow band and armlets, some of which may be beaded. Men's dress becomes less ostentatious and showy with age.

Women's dress varies with the cycle of a woman's life. Girls wear a skin skirt, sometimes beaded, and a cloak. After marriage, a woman covers her breasts, either with a profusion of necklaces or with a leather cloak. A married woman's outfit is completed with a larger back skirt that sometimes covers a triangular or rectangular pubic apron. Both may be adorned with glass or metal beads.

Decorating leather with sewn beads is a reasonably recent (late 19th-century) invention. Beads were Dutch or Bohemian in origin. Today the Maasai of Tanzania have much more ornate designs than those of Kenya. Styles of beadwork and dress vary between the different regions of Maasai-land. The Ilkisongo of Tanzania prefer dark-red and dark-blue beads, while the Ilpurko of Kenya like orange and light blue. The togas of warriors are shorter amongst the Kenyan Maasai, who tend to wear more factory-made cloths than those of Tanzania, who, being more isolated, are more traditional in their dress.

Bark cloth of Uganda

Bark cloth was one of the first fabrics to be made in tropical Africa. It still has strong ritual importance amongst many of the peoples of Uganda. The numerous Baganda, who neighbour Lake Victoria, are noted for their copious production, which is used as shrouds and worn as traditional dress (known as *lusango*) at funerals and other 'cultural' occasions. The cloth is made by Baganda men, particularly around the town of Masaka, from the bark of the tropical fig *ficus natalenis*. A deep red known as *kimate* is the most desirable.

Bark can be stripped from the tree once a year and then regrows. At the bark-cloth-making village of Lusango, the bark was cut and scraped from the tree from just above the exposed roots to about 3 metres (10 feet) above. The tree trunk was about 1.80 metres (6 feet) in circumference. This bark was enough to make three cloths, which were sold locally. The bark is moistened and then beaten on a log of the same fig or another tree, known as *soga soga*, with heavy-headed ridged mallets of guava wood.

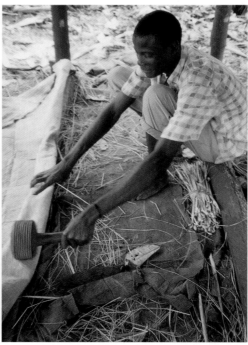

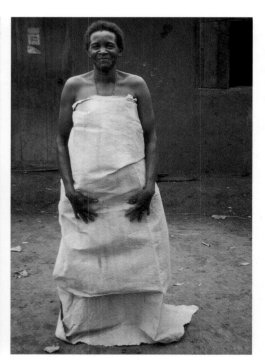

OPPOSITE

TOP Stencilled and embroidered bark cloth made by the Ganda people from the bark of a tropical fig tree by the shores of Lake Victoria.

BOTTOM LEFT Heavy-headed ridged mallets of guava wood used to beat bark into cloth.

BOTTOM CENTRE Using guava wood mallets to beat bark into cloth by Lake Victoria.

BOTTOM RIGHT A Ganda woman proudly wearing her *lusango* bark cloth in the village of Lusango.

LEFT AND ABOVE Ganda bark cloth made from a tropical fig. It has been torn during the beating process and has been patched.

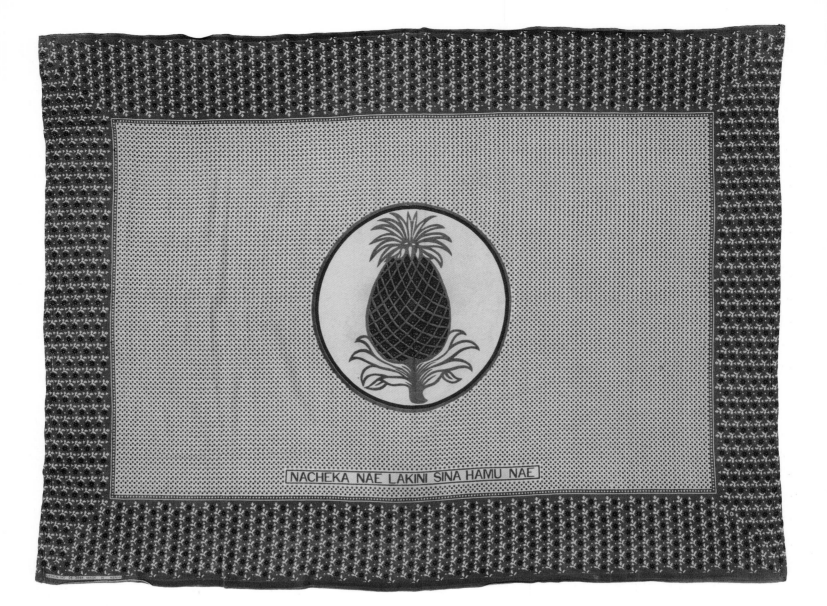

NACHEKA NAE LAKINI SINA HAMU NAE

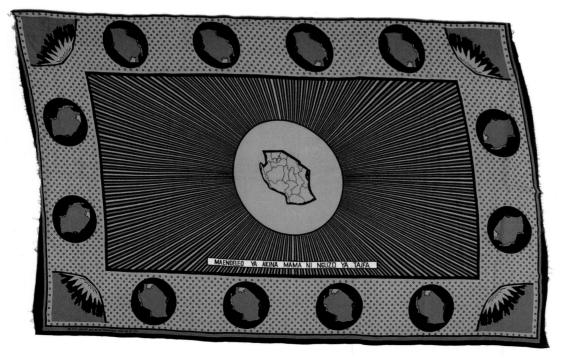

MAENDELEO YA AKINA MAMA NI NGUZO YA TAIFA

TOP AND LEFT Women's machine-printed, cotton *kanga* wraps from Kenya.

OPPOSITE Printed cotton *kitenge* woman's wrap from Tanzania. *Kitenges* are longer than *kangas* and entwine the body.

PAGE 176

TOP Tanzanian printed cotton *kitenge*.

BOTTOM Woman's machine-printed, cotton *kanga* wrap from Tanzania.

PAGE 177, CLOCKWISE FROM TOP LEFT

TOP LEFT Printed cotton *kitenge* from Kenya.

TOP RIGHT Swahili women in *kangas*.

CENTRE RIGHT A Swahili woman in a *kanga* having her hair done.

BOTTOM RIGHT A Somali woman in a striped *kikoi* cotton wrap.

BOTTOM LEFT Woman's machine-printed, cotton *kanga* wrap, Tanzania.

Kangas and *kikois*

With the exception of Ethiopia, textiles of East Africa have largely been imported. Any locally woven cotton fabric that was available on the Swahili coast was the product of looms brought in by Arabs. Cotton growing and processing is likely to have originated from the same source. In the interior of East Africa, on the savannah or in the hills, there is little need for much clothing. Skin or hides used to meet most local requirements. The pastoralists and farmers of these regions did not have a weaving tradition. Nevertheless, they readily bought textiles. With the opening up of the interior in the second half of the 19th century, mill-woven cloth and blankets from Europe and handwoven cloth from India and Arabia became available. Demand for cloth also increased as Christianity – with its insistence on modesty – spread.

The *kikoi* is a rectangle of cotton cloth, often with fringed ends, that is worn by rural men. Any pattern is woven rather than printed. *Kikois* are popular traditional dress for men of the Kikuyu and Maasai peoples. The classic Kikuyu *kikoi* is made up of two long, striped, handwoven pieces hand stitched together to form a large, wide garment.

Kangas, machine-printed cotton cloths worn in pairs known as *doti*, are the cloths most closely associated with Kenya and East Africa. Their origins are obscure – and lie either in Zanzibar or in Mombasa. There is no evidence that they were ever block printed by hand, so it must be assumed they were always machine printed. It is said that a fashion arose among Swahili women of cutting up lengths of imported European printed kerchiefs that came in blocks of six. They cut the block lengthways into two 3 × 1 kerchief lengths and wore one as a waist cloth and the other as a shawl. Arab and Indian merchants then had specially made cloths printed in mills in India and China. The first cloths, speckled on a dark ground, were called *kangas* as they resembled guinea fowl. *Kangas* have gone through many permutations over the years. Those from the 1970s, made in China, for instance, were of thicker cloth with bold uncluttered designs, whereas nowadays *kangas* are printed in India or locally on much thinner cotton and with comparatively fussy designs. However, they all share one common element – they are always embellished with a proverb in Kiswahili, examples of which are listed below. Every woman wearing a pair of *kangas* has a message to impart.

The proverbs on the various designs have many different messages: a spotted design is emblazoned with 'Good luck brings wealth'; a mango design sports 'Love is like a cough – it never goes away'; a map of the world suggests 'Even when we are separate, the memory will remain'. Bold *kangas* of the 1960 or 1970s were made in Japan or China, while current thinner ones are from India or local mills.

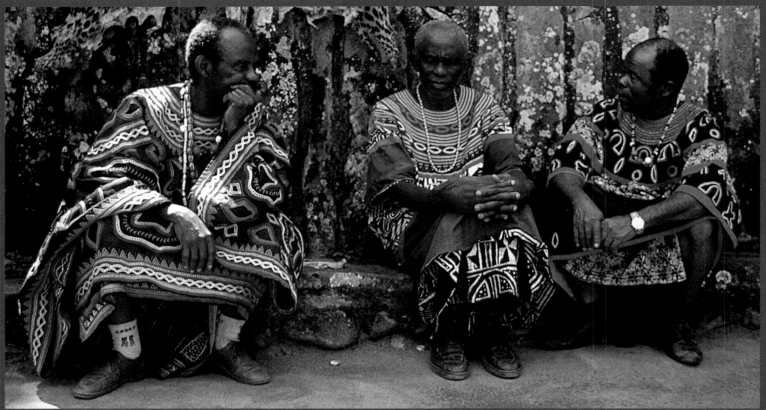

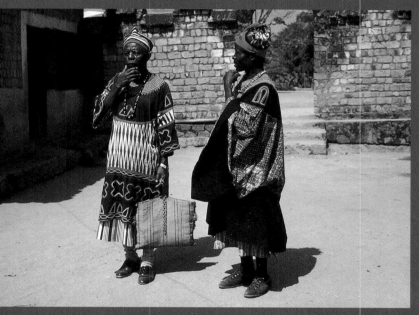

CENTRAL AFRICA

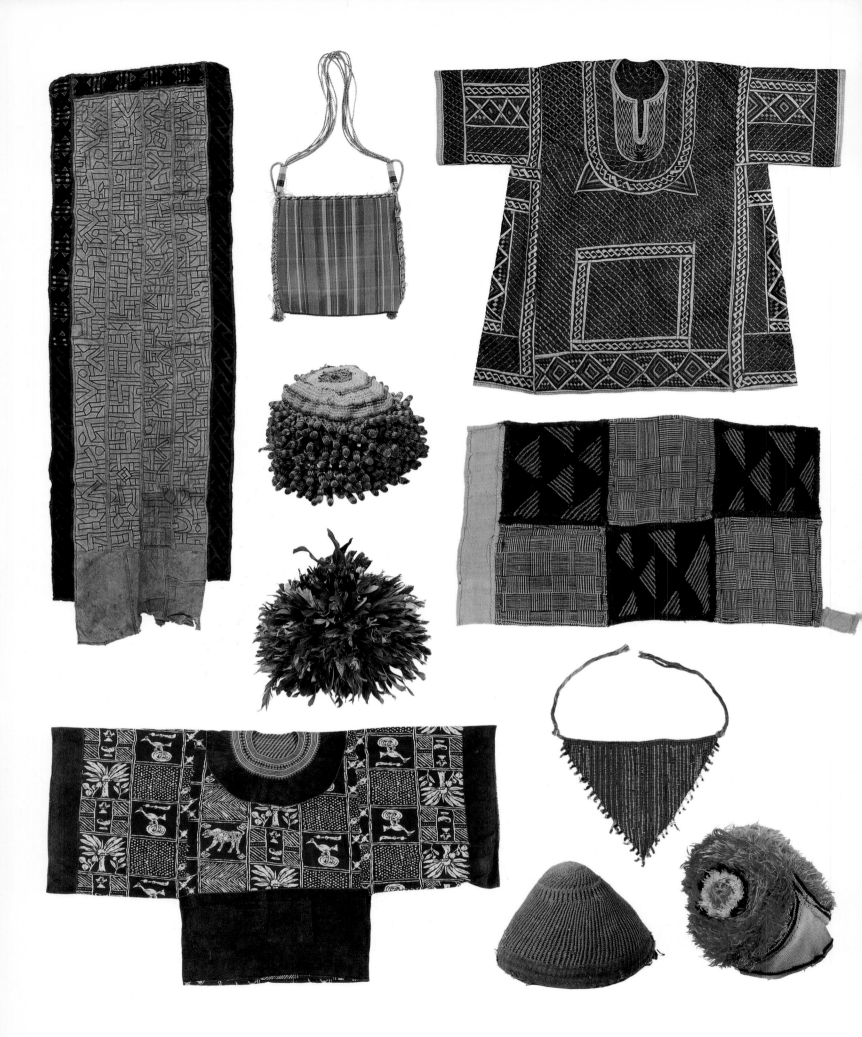

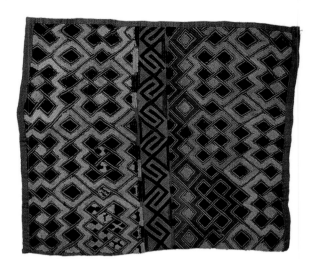

Introduction

CENTRAL AFRICA

Large areas of Central Africa are dominated by dense forests and, with a few notable exceptions, such as northern Cameroon and, in particular, southern Chad, there are no great cotton-growing areas.

What little clothing was needed in a very hot, humid climate was taken from the forests themselves. Bark breech-clouts for both sexes were made from the inner bark of tropical fig trees and, for those people with a weaving tradition, fibres from the abundant raphia palm were woven into skirts and wraps. Cameroon and the Congo in Central Africa have a tradition of vertical-loom weaving, which is undertaken by men, unlike in Nigeria.

The people of the Kuba tribal confederacy, based around the Kasai river in the southern Congo, are recognized as some of Africa's pre-eminent artists. Although they work in wood and metal, they also have a tradition of manufacturing cloth woven from the split younger leaves of the raphia palm. The Kuba, who have traditionally resisted the colonial trade in cotton cloth, have retained to this day great skill in making raphia cloth, weaving 'dance skirts', aprons and mats on a single-heddle loom set at 45 degrees to the vertical, under which the weaver sits.

Using appliqué, embroidery, cut-pile and resist-dyeing techniques, the Kuba have one of the largest textile repertoires in the whole of Africa. They have retained their impressive and varied textile tradition for two main reasons. First, the hierarchical nature of the sophisticated Kuba kingdom required a wide variety of traditional textiles to be produced for ceremonial use. Second, unlike other African societies, such as Nigeria, where raw materials were changed from homegrown and homespun to mill-spun and synthetic yet the same looms could still be used. In contrast, the Kuba raphia looms could not be adapted for weaving cotton or synthetic fibres.

Although the vertical loom exists in Gabon and Angola, those countries have no great textile traditions. Bark cloth is to be found wherever the Pygmies, those masters of forest dwelling, live. The Imbuti Pygmies of the Ituri rainforest of the north-eastern Congo make loincloths from the inner bark of the tropical fig trees that

they find in the forest. The outer bark of the young sapling is cut off. The inner bark is soaked in water for a few days or merely left to absorb moisture. When it is moist and pliable, it is placed over a hardwood log and beaten rhythmically until it expands (by as much as four times). The thin bark cloth produced in this way has strength lengthways but little widthways. The cloths are decorated with asymmetrical designs drawn with a stick, a vegetable fixative and charcoal.

Cameroon rivals the Congo in the diversity of textiles produced. Cotton is woven by men in the Muslim north in strips on double-heddle horizontal looms in the West African manner. In Cameroon, indigo dyeing is done in pits, again using a method almost identical to that of northern Nigeria.

It is in the grasslands of south-west Cameroon that there are textiles that differ markedly from those of its Nigerian neighbour. Although the Bamileke *ndop* stitched-resist cloth probably developed from the so-called *tivi* cloth from Wukari, Nigeria, the raphia weaving, embroidered gowns and crocheted, embroidered and feathered hats are all unique to Cameroon.

The use of natural dyes is still widespread. Indigo, which is widely grown, is used as a blue-dye stuff frequently in Cameroon, but much more sparingly further south. In the Congo, the Kuba exclusively employ vegetable and mineral dyes: camwood for red; brimstone tree (morinda) for yellow; mud, charcoal and various plants for black and brown; and clay (kaolin) for white.

Camwood, which is widely available in Central Africa, is used as both a medicine (it is rubbed on skin to treat ailments) and a dyestuff. Young trees give brown or yellow, older trees red. The best dyestuff is obtained from trees that grow on swampy land, where even the root will give a viable red. Camwood is grated into a powder and then boiled for approximately fifteen minutes before adding any fibre. By contrast, kola nut does not need to be heated and is therefore often used to introduce contrasting decorative details in Bamileke indigo-dyed *ndop* cloth.

Black is often obtained by using ferrous-bearing mud as a dye. A typical method is to dye raphia fibres black in western Cameroon. Leaves (containing tannin) from the *feseah* bush are boiled for about two hours with the raphia

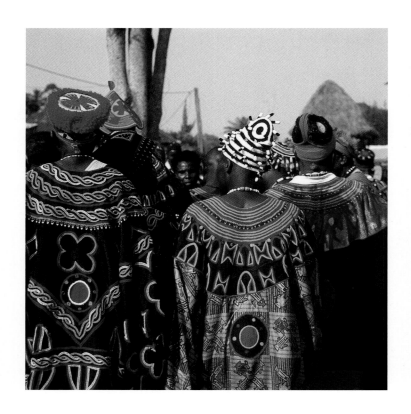

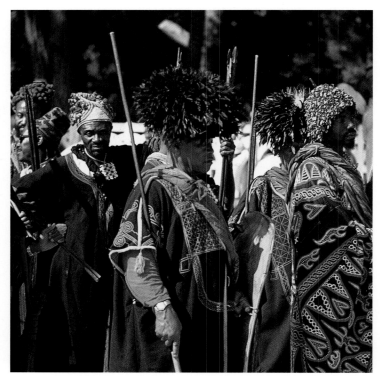

fibres, then drained and mixed with black clay from the river for about one hour. The raphia fibres are then given a thorough wash, dried in the sun and are at that stage ready to weave.

Many of the smaller countries of Central Africa have no great textile tradition. The countries to the north – Chad and Central African Republic – have horizontal looms, on which cotton strips are woven in a very similar manner to West African weaving. In Gabon, the Congo (Brazzaville) and Angola, raphia weaving takes place on upright looms and, in the more remote forested parts of those countries, bark cloth is made by such communities as the Pygmies.

The two most important textile-producing countries of Central Africa still have very vibrant textile traditions, whether weaving in cotton or raphia, dyeing in indigo, kola nut or camwood or embroidering in cotton, silk or raphia, without mentioning bead or shell work, which are still employed profusely. The hierarchical nature of the Kuba peoples and the inhabitants of the grasslands Cameroon, with their many different requirements for decorated cloth, will keep many textile craftspeople in business for years to come.

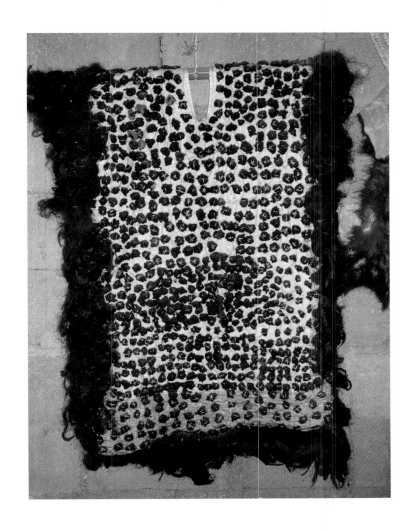

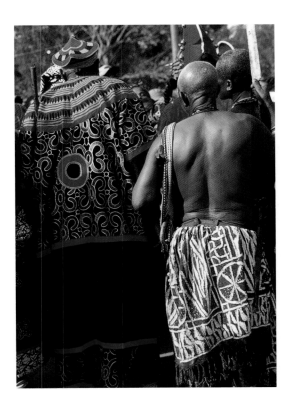

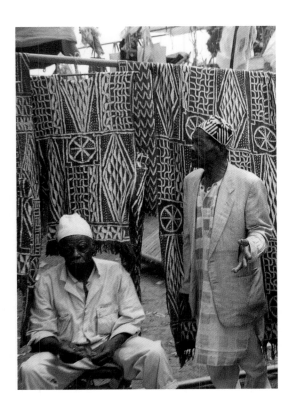

PAGE 181
Shoowa cut-pile raphia panel, Kasai river, the Congo.

OPPOSITE
LEFT Grasslands elders wearing embroidered smocks and a variety of festive hats, Cameroon.
RIGHT Elders at a ceremony in grasslands Cameroon. Those in the middle are wearing cockerel feather hats.

ABOVE Ceremonial Bamenda shirt embellished with tufts of human hair imbued with powerful magic.
FAR LEFT An elderly man wearing a *ndop* stitched-resist skirt, northern grasslands.
LEFT Selling *ndop* stitched-resist cloth at the fair in Banjoun, Cameroon.

183

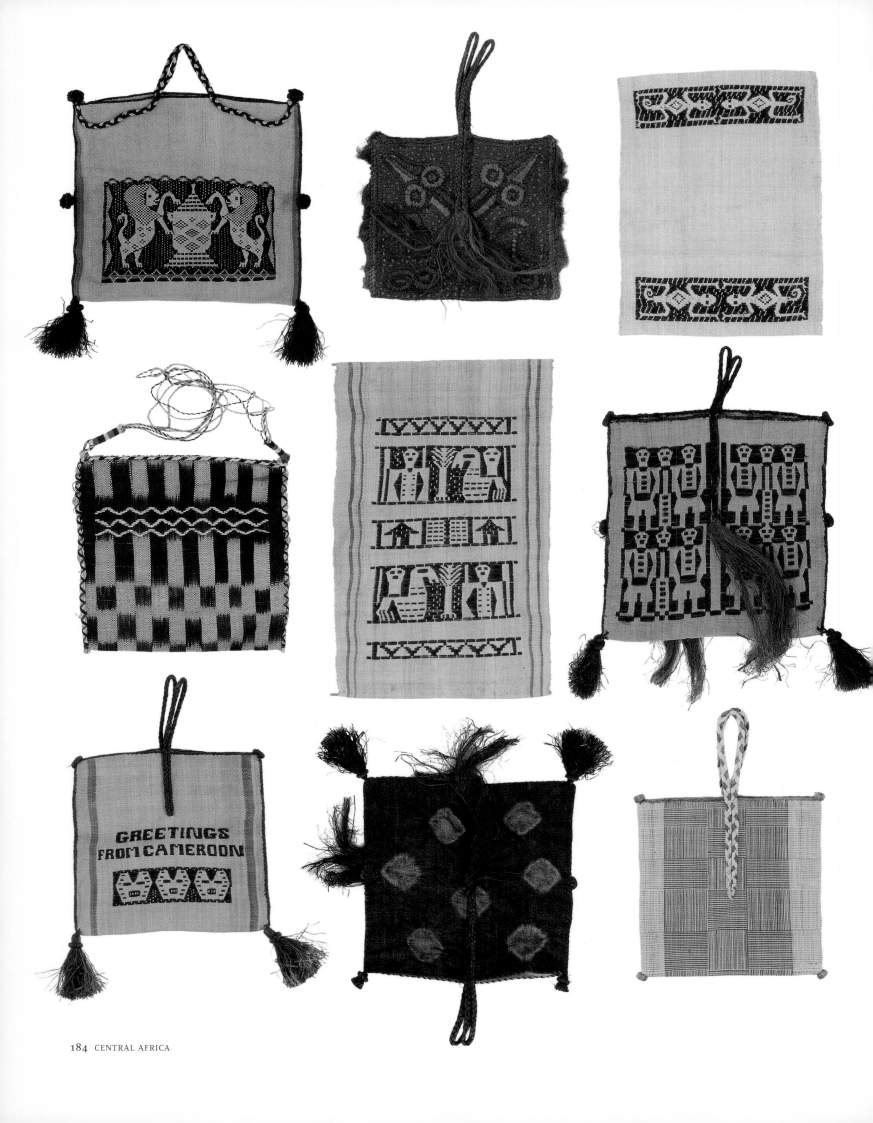

Cameroon raphia weaving

Raphia is probably the most important indigenous fibre used throughout Central Africa. Woven on vertical looms, it is the mainstay of the incredible textile repertoire of the Kuba confederacy in the Kasai river region of the Congo.

Raphia is a grassy fibre extracted from the leaves of a palm tree called *Raphia ruffia* or *R. taedigera* that grows abundantly in swampy land. Mature leaves can grow as long as 15 metres (50 feet), but only the young leaves about one metre (one yard) long are cut, pulled out and unfolded. If the palmlets (new shoots) are stripped out too often, the palm is damaged. The tip is bent back on itself a centimetre or so from the end, then sharply snapped between forefinger and thumb to separate the layers of leaf. The next stage involves stripping the upper epidermis before leaving it to be dried in the sun. The resulting fawn-coloured fibre can then be split with a knife, thumb, fingernail, the sharp edge of a shell or a special comb.

In Bamessing, western Cameroon, the flourishing raphia-weaving industry is mainly dedicated to the traditional shoulderbags worn in the region. Meta is another village that produces raphia bags in a slightly different style.

Freestanding Bamessing looms up to 2 metres (6½ feet) tall are mounted on a cross frame with all the parts made out of raphia wood, apart from the metal rods that act as 'breast' and 'warp' beam. The warps are raphia fibres knotted around the metal rods in such a way that the front and back warps form an equal number of threads. They create a weaver's cross, held in place by a shed stick placed above the single heddle, which is traditionally leashed to the back warps with raphia leashes (the leashes are now plastic unravelled from Chinese bags). The weaver sits on a stool in front of the loom, which is leaned as vertically as possible against a wall or tree. Raphia wefts are inserted by hand, without the use of a shuttle. They are never tied together; when the weft runs out, a new raphia weft is merely inserted halfway across the web. Wefts are beaten in with a wooden 'sword', which also helps to keep the shed open when inserting the weft. The front and back warps are woven together to form one fabric. Plain weave on this loom would take about four hours to complete.

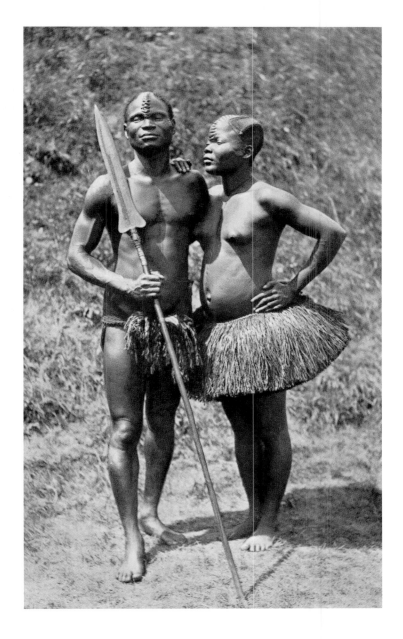

PAGE 184, CLOCKWISE FROM TOP LEFT
TOP LEFT Raphia bag with supplementary weft patterning, Bamessing, Cameroon.
TOP CENTRE Raphia bag, woven at Meta, embroidered with the double-headed serpent motif.
TOP RIGHT Raphia mat, woven on a vertical loom at Bamessing, Cameroon.
CENTRE RIGHT Raphia bag with supplementary weft patterning, used by a grasslands Fon, Bamessing, Cameroon.
BOTTOM RIGHT Raphia bag with basket weave patterning, woven on a vertical loom at Bamessing, Cameroon.

BOTTOM CENTRE Raphia bag with tie-dye patterning, Bamessing, Cameroon.
BOTTOM LEFT Raphia bag with supplementary weft patterning, Bamessing, Cameroon.
CENTRE LEFT Raphia bag with warp-ikat patterning, Bamessing, Cameroon.
CENTRE MIDDLE Raphia mat with supplementary weft patterning, Bamessing, Cameroon.

ABOVE A couple from the central Congo. She is wearing a skirt of grass fibre.

Ndop resist-dyed cloth of grasslands Cameroon

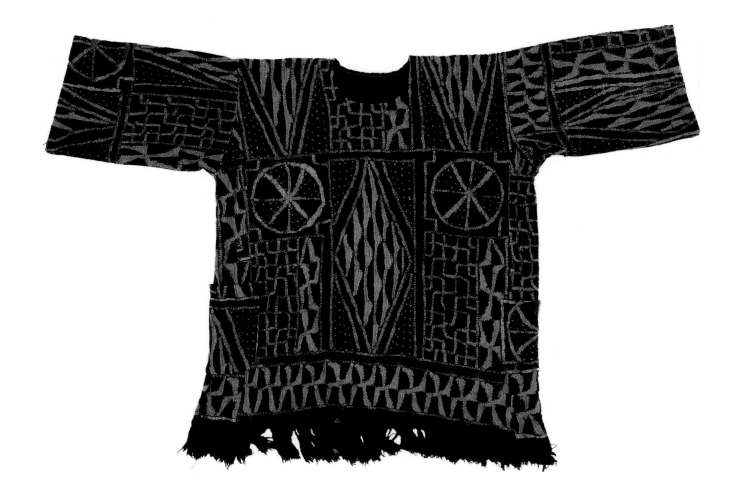

The famous resist-stitched, indigo-dyed cloth of the Bamileke of grasslands Cameroon is called *ndop* by Venice and Alastair Lamb. Though it is highly likely that it originated in Nigeria (in Bamenda, Cameroon, Nigerian *ndop* is known as *tivi*, after the eastern Nigerian Tiv people), it has been made for, and partially by, the Bamileke for many years. The Lambs identify the source of the Nigerian *ndop* as Wukari, but both Nigerian and Cameroonian *ndop* are in use. Often strips of both types of manufacture can be incorporated in the same cloth.

The base fabric of Bamileke *ndop* is stripwoven cotton cloth from the north of the country, around Garoua. This cloth is brought down to the Bamileke villages, around the cultural centre of Banjoun, where women will painstakingly stitch in the geometric resist designs in strong raphia thread, which will not break. The stitched cloth is then taken the many miles back up north to Garoua, where it is dyed blue

in the dye-pits. Traditionally, natural indigo was used, but it is now synthetic. The dyed cloth is transported back to the Bamileke, where women unpick the raphia stitches with a sharp knife or razor blade to reveal the pattern of white resist against a blue background. Care must be taken not to cut the cloth.

Bamileke patterns combine the tribal motifs used to decorate traditional housing with motifs adapted from 'Wukari' *ndop*. Nigerian *ndop* has a freer design and is characterized by patterns of interlocking swastikas, figurative patterns of humans, lizards, scorpions and even leopards, in contrast to the geometric forms found in Cameroon *ndop*.

Ndop has many traditional functions. Edged with red or carmine European baize, it makes up the twirling kilts of male dancers at mourning 'cry-dies'. Substantial, important old cloths are used as backdrops, mainly for ceremonies.

OPPOSITE Bamileke man's *ndop* shirt.

RIGHT *Ndop* from Nigeria with the leopard pattern.
BELOW LEFT Armed retainers of a Fon from the northern grasslands wearing a *ndop* skirt.
BELOW CENTRE An old Bamileke man wearing a *ndop* shirt and burled crocheted hat at Banjoun market.
BELOW RIGHT Two old Bamileke men selling *ndop* cloth at Banjoun market.

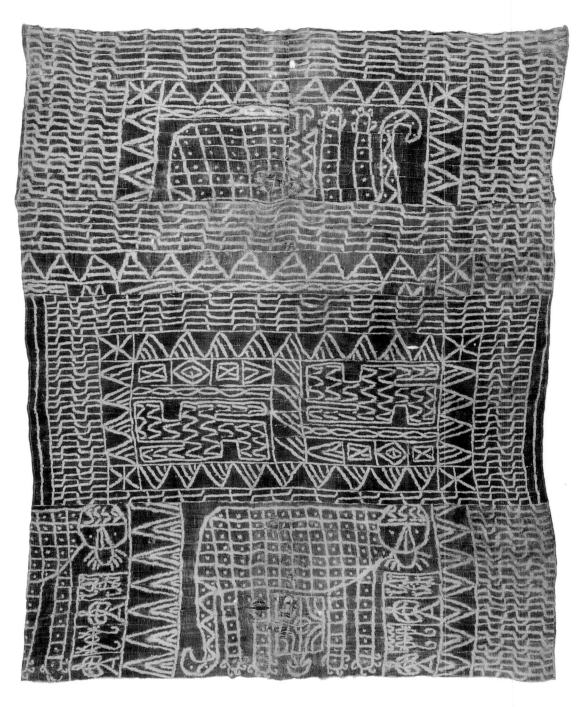

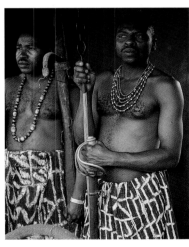

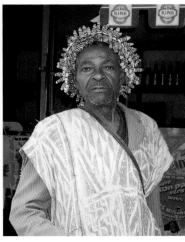

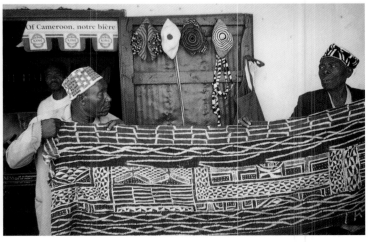

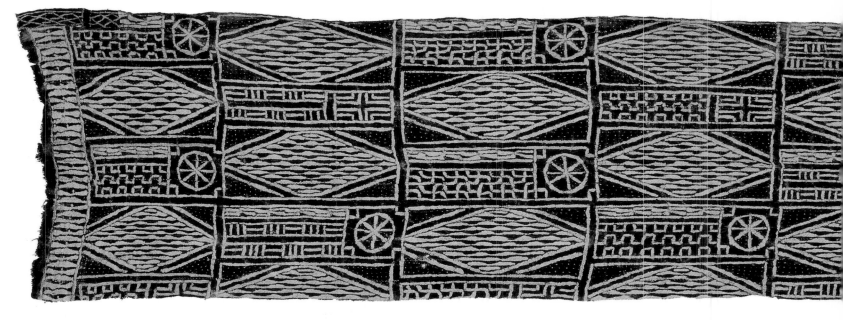

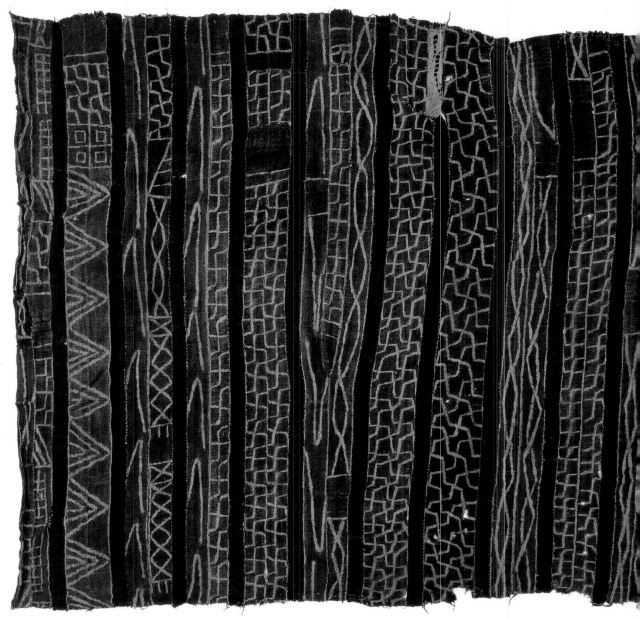

OPPOSITE
TOP A stitched cloth from near
Banjoun, Cameroon. The motifs
have been drawn out in mud and
stitched over with raphia thread.
CENTRE A partially stitched cloth
from near Banjoun, Cameroon.
The motifs have been drawn out
in mud and partially stitched over
with raphia thread.
BOTTOM *Ndop* cloth made by
men in Wukari, Nigeria, for export
to the Bamileke of Cameroon.

TOP Length of Bamileke *ndop* cloth
bought in Bafoussam market.
RIGHT *Ndop* cloth imported into
Cameroon from Wukari, Nigeria.

Kuba raphia weaving in the Congo

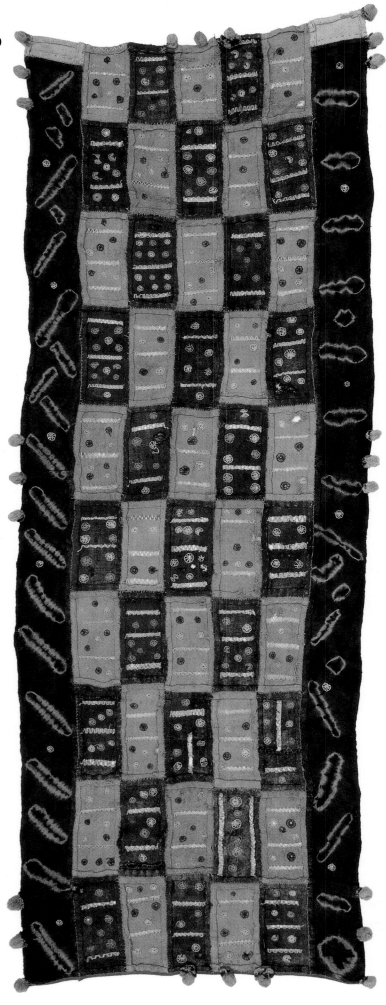

The Kuba tribal confederacy of the Kasai river area of the Congo are highly regarded for their raphia work, weaving 'dance skirts', aprons and mats on single-heddle looms. They make use of a wide range of textile techniques, including appliqué, embroidery, cut pile and resist dyeing.

To this day they retain a prolific raphia-weaving culture. Kuba men weave, while the women embroider and appliqué. One of the first uses of raphia cloth was as a light, portable, readily acceptable form of currency.

Men weave raphia cloth on a single-heddle overhead loom, set at an angle of about 45 degrees to the ground. The weaver sits in its shade and works above himself. Although such people as the Kongo of the coast once produced complex figured weaves on a similar loom, the Kuba restrict themselves to plain weave.

Because of the restricted length of the raphia fibres and because the Kuba employ no method for twisting lengths of fibre together to form a longer thread (as is done in Madagascar), Kuba men weave raphia cloth that is of a maximum dimension of one metre square (over ten square feet).

RIGHT Kuba woman's patchwork overskirt decorated with embroidery, eyelet stitching and drawn thread work. The rectangular patches are made of alternately dyed and undyed raphia.

OPPOSITE
TOP LEFT Kuba woman's patchwork overskirt with embroidery, eyelet stitching and drawn thread work.
TOP RIGHT Section of a Kuba woman's raphia skirt with drawn thread and needle-weaving details.
BELOW A Kuba raphia skirt from the Congo. The rectangular patchwork panels are decorated with embroidered lozenges punctuated with circles worked in eyelet stitch. The borders are decorated with tied-resist patterns.

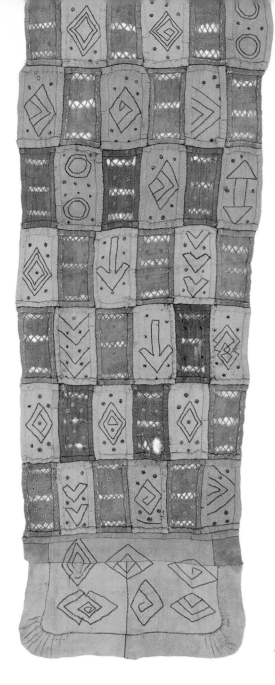

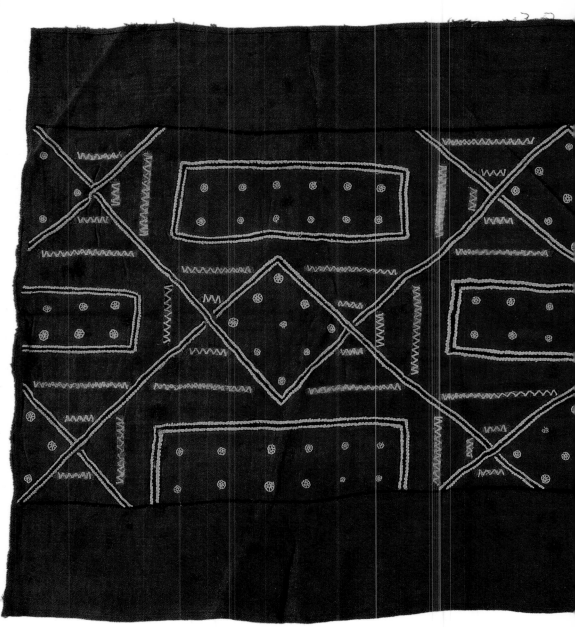

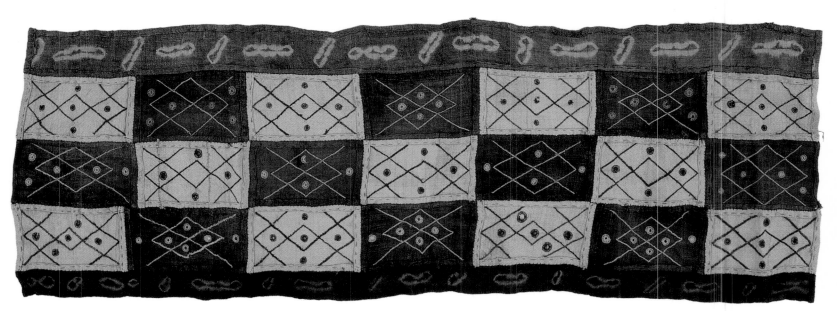

Kuba appliquéd and embroidered skirts

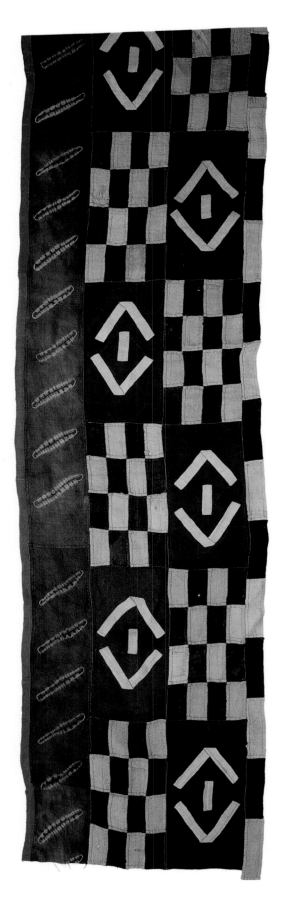

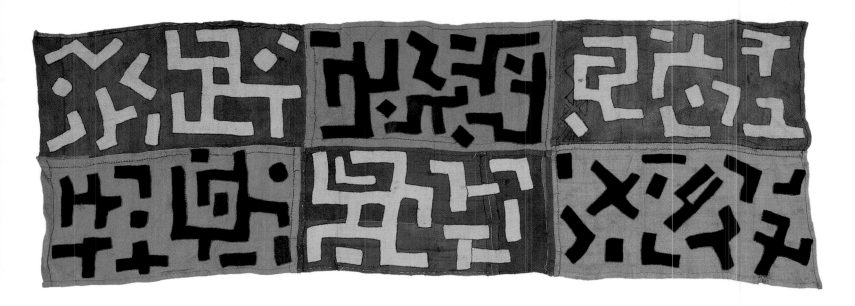

Raphia panels are commonly sewn together to form skirts using from four up to ten panels, less for an apron. The skirts are decorated in a variety of ways: by tie and dye, appliquéing, patchwork, drawn-thread work and with cowrie shells and bobbles. Details of cut-pile raphia embroidery were common.

Both men and women wear skirts, but the patterns differ for each sex. For instance, the skirts for the women of the Bushoong (the Kuba aristocracy) are embroidered in black-dyed raphia thread in complex patterns, whereas the Bushoong men wear skirts of a harlequin patchwork with small black-and-white rectangles.

Kuba patchwork involves squares or rectangles of raphia cloth being sewn in a way that is found in other parts of the world. What makes it unique is that the hems are not turned under, but face the surface of the fabric, giving it extra depth.

The Ngeende, another group belonging to the confederation, appliqué patches of raphia cloth in weird abstract shapes on to their skirts. A popular colour scheme is to combine camwood-dyed raphia patches with naturally coloured panels and vice versa.

Appliqué is used for not only decorative, but also utilitarian purposes. As a skirt made of freshly woven raphia panels is very stiff and uncomfortable, it has to be washed and pounded to make it supple. Unfortunately, raphia cloth is not very durable, so the pounding often results in holes in the cloth, which the decorative appliqué covers up.

Hemmed appliqué is the simplest form of appliqué. Motifs are simply cut out of raphia fabric and tacked on to the ground. Edges are then turned in and hemmed, leaving the ground raphia fabric visible between the applied pieces.

OPPOSITE LEFT Woman's appliquéd skirt, Ngeende branch of the Kuba people.
OPPOSITE RIGHT Man's patchwork, appliqué and resist-dyed skirt, Ngeende branch of the Kuba people.
TOP A patchwork and appliqué raphia-fibre dance skirt, Ngeende or Ngongo people.
RIGHT Woman's appliquéd skirt of the Bushoong Kuba people.
BELOW Reverse appliqué technique.

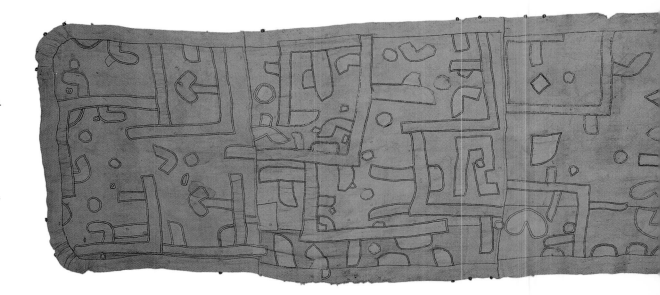

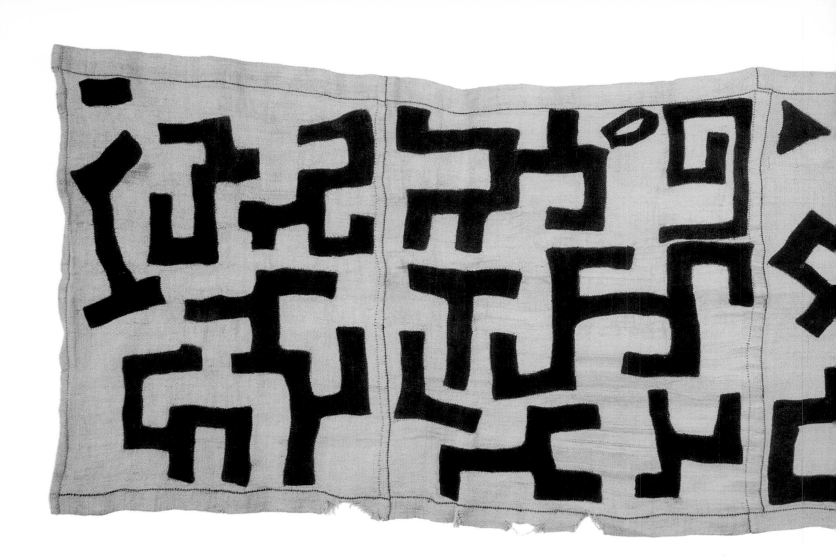

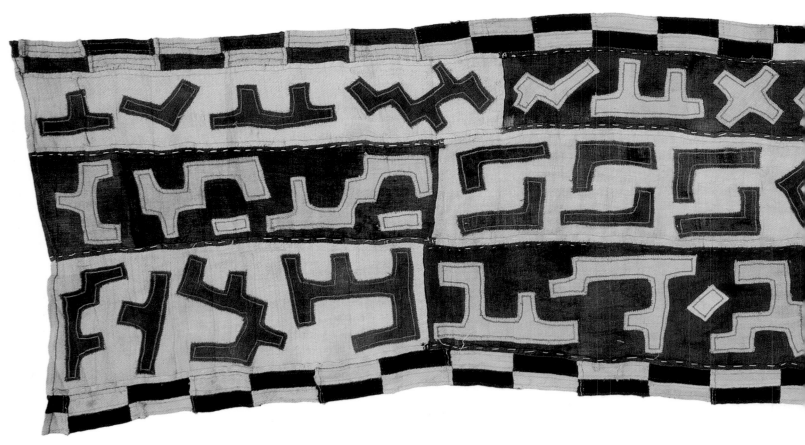

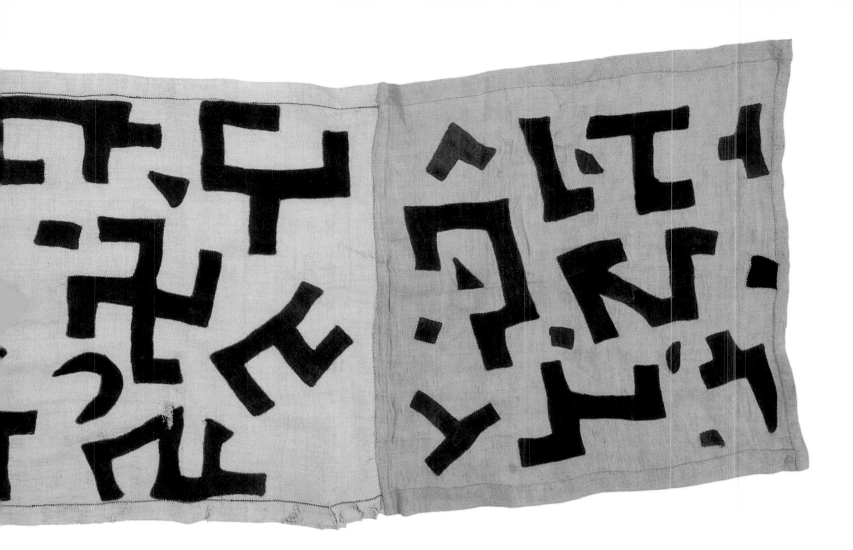

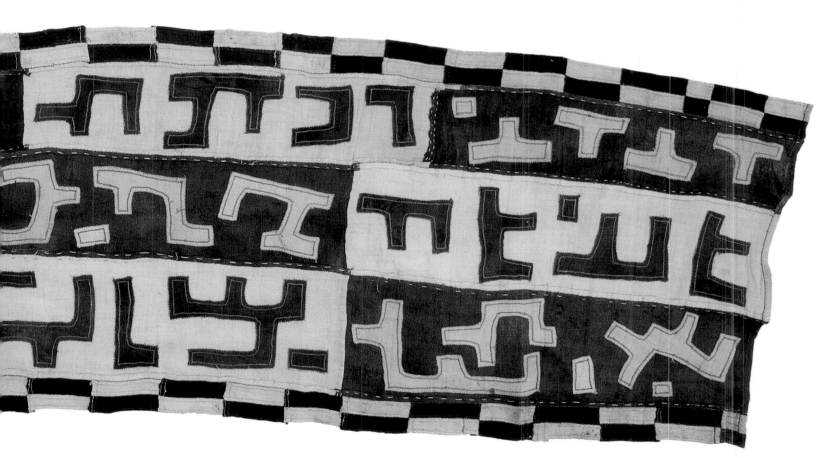

Shoowa cut-pile embroidery, the Congo

The Shoowa, a northern group of the Kuba, decorated their skirts with cut-pile details. In the early 20th century, Catholic nuns encouraged Shoowa women to use this technique more extensively; in addition to details on skirts, they sewed a large number of panels, usually square, which were used as dowry payments, shrouds, chair and floor coverings, and as symbols of wealth and status. Each geometric design – whether rectilinear, crosses and crotchets, chevrons or squares – is embroidered on a raphia panel and grows, almost organically, across the fabric. The cloths are named after what is considered as the dominant motif, for example, *Molambo* (Finger), *Bisha Koto* (Crocodile's Back), *Nyinga* (Smoke). One popular pattern is known as the 'Tyre' pattern, after the marks left in the sand by a colonial motorbike. The story, which may be apocryphal, goes that the Shoowa, to the surprise of the Belgian official, were much more interested in the tyre marks than in the motorbike that they had never seen before. Whatever the truth is, it has been calculated that the Shoowa use at least two-thirds of the known geometric patterns in their cut-pile embroidery. Their work is highly regarded outside the confines of their own region.

Nothing is drawn on the raphia panel (known as *mbol*) before stitching commences. All the patterns come from the imagination of the embroideress and can change as the work progresses. The voids between the cut-pile are first outlined in stem stitch with black or natural raphia thread and then filled in with cut-pile. Although there may be one dominant motif, which defines that part of the embroidery, it is likely that the motif will change as it spreads across the panel.

Cut-pile technique is similar to candlewicking. The embroideress softens the tips of raphia threads by gently chewing them and rolling them on her thigh. Then, using an iron needle, she pulls them through the surface of the fabric underneath a weft element. The tightness of the weave holds the thread in place without knotting. The thread, which is very fine, as the raphia fibres have been divided lengthways using a fine-toothed comb, is formed from several twisted fibres.

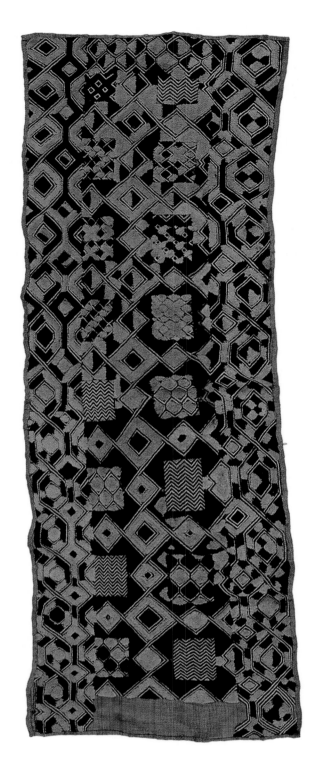

PAGES 194–95
TOP Woman's appliquéd skirt, Ngeende branch of the Kuba people.
BOTTOM Man's appliquéd skirt, Ngeende branch of the Kuba people.

ABOVE LEFT Cut-pile embroidery.
ABOVE RIGHT Shoowa cut-pile embroidered raphia overskirt, Kasai river, Congo.

OPPOSITE Shoowa, cut-pile embroidered raphia squares.

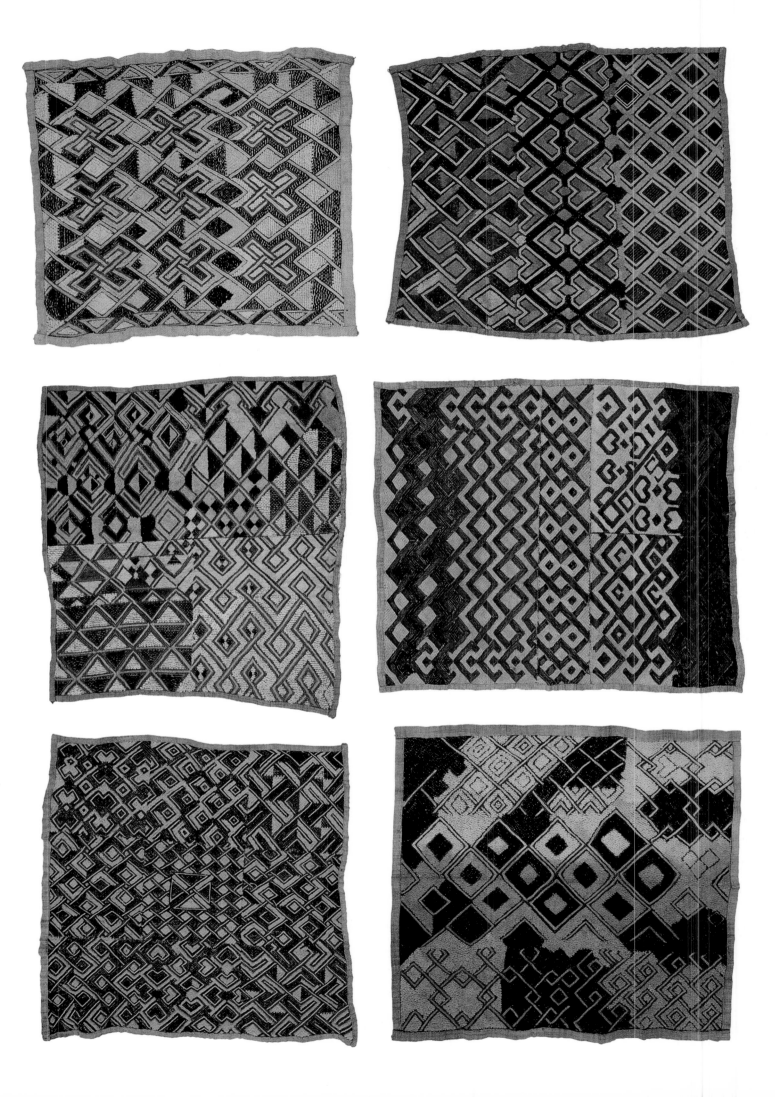

Tied and stitched-resist textiles of the Kuba, the Congo

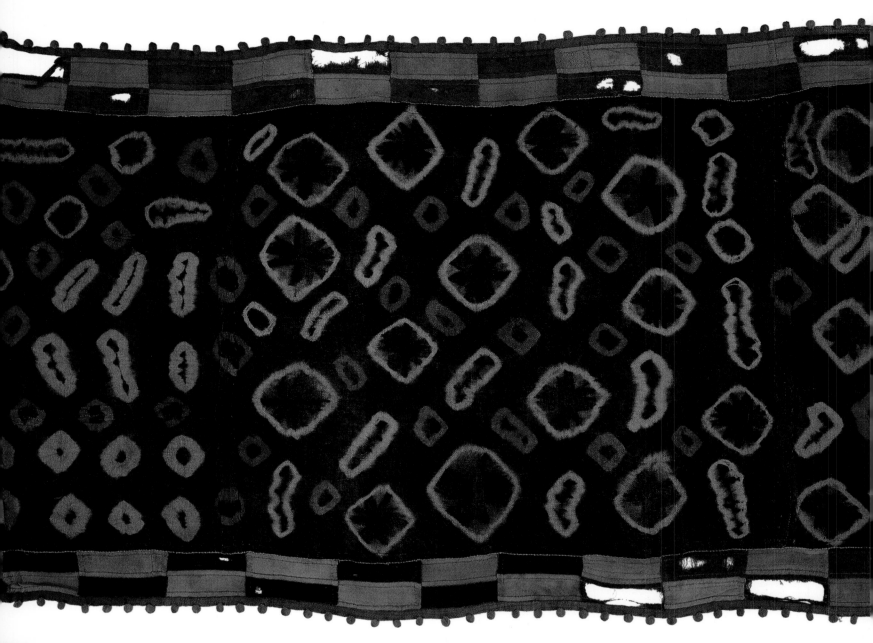

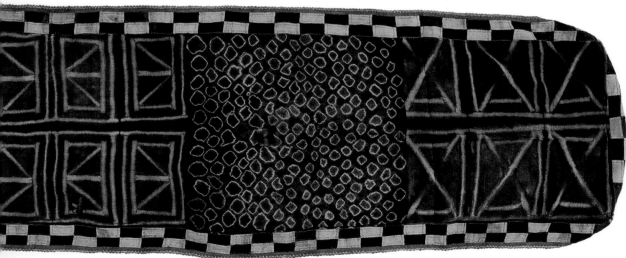

ABOVE Ngongo raphia skirt with tied-resist decoration, Kuba confederacy, Kasai river, the Congo. LEFT Ngongo man's raphia skirt with tied and stitched cane-resist decoration, Kuba confederacy, Kasai river, the Congo.

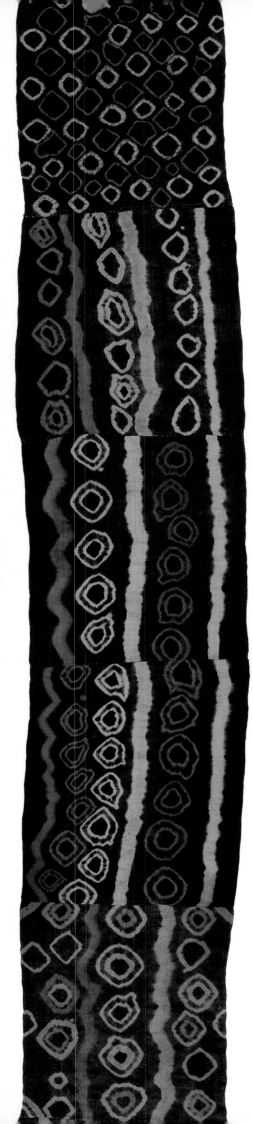

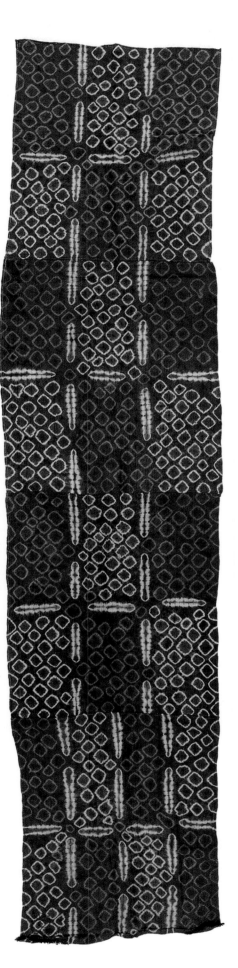

The Ngongo people of the Kuba confederacy decorate both men's and women's skirts and aprons with tie-dye and stitched resist, normally against a black ground, revealing resist patterns of circles and short wiggly lines in natural raphia colour. The Kumi Ngongo, the local royalty, work more complex patterns, using two or more dye-baths, usually variations on a red, black and brown colour scheme (camwood, brimstone tree, mud and charcoal). The Mapela combine small areas of tie and dye in a chequerboard with small black-dyed rectangles for men's skirts. The Ngongo and Ngeende clans wear skirts decorated by a form of clamp-resist.

Ngongo and Ngeende women fold raphia panels into eight to form a shallow cuboid. They then clamp them tightly in a criss-cross cane framework. After dip-dyeing, the cane clamps are taken off to reveal a cross-shaped resist pattern in natural raphia against a usually black ground. The areas that were in the centre of the clamped cuboid are much more lightly dyed than those on the outer faces. It is probably more common, however, just to stitch two cane strips placed on opposite faces of the cloth tightly together to form a resist. By repeating this over the cloth, patterns of rectangles and triangles are built up that are revealed in negative after dyeing in black and then snipping off the canes.

FAR LEFT Ngongo tie-dyed raphia dance skirt.
LEFT Ngongo or Ngeende tie-dyed raphia dance skirt.
OVERLEAF TOP Ngongo or Ngeende clamp resist-dyed skirt.
OVERLEAF BOTTOM Ngongo man's raphia skirt.

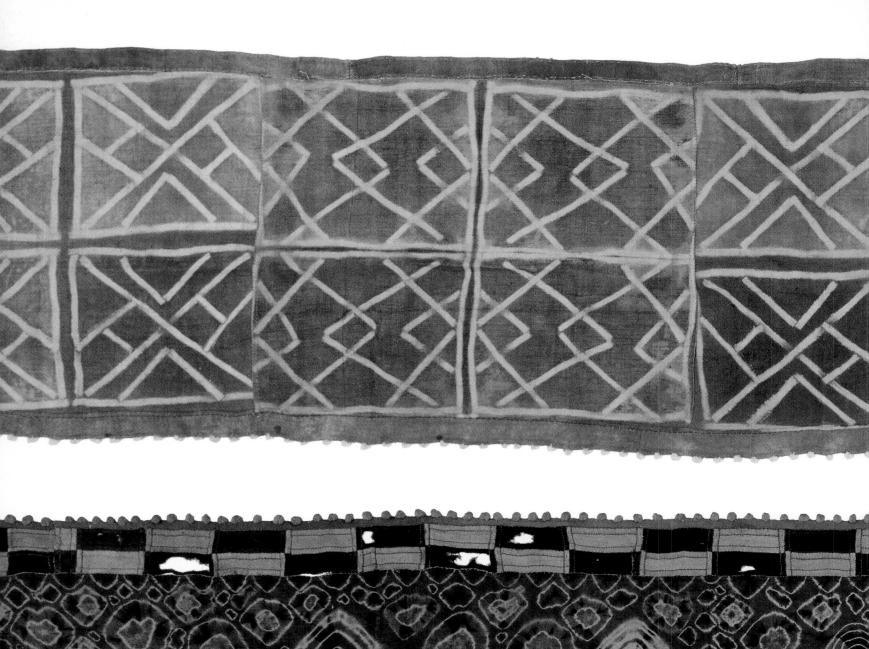

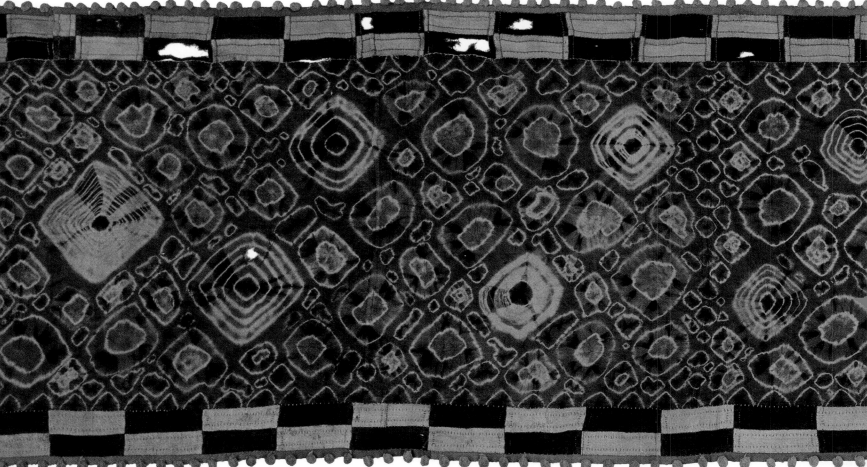

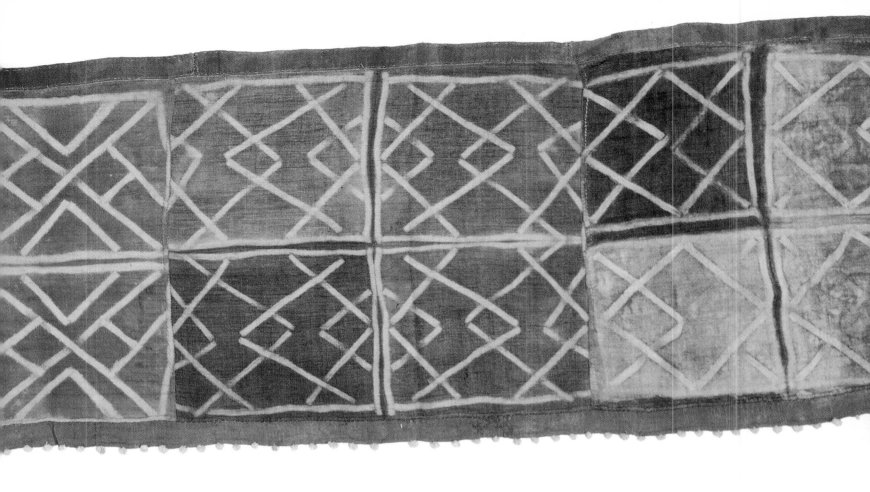

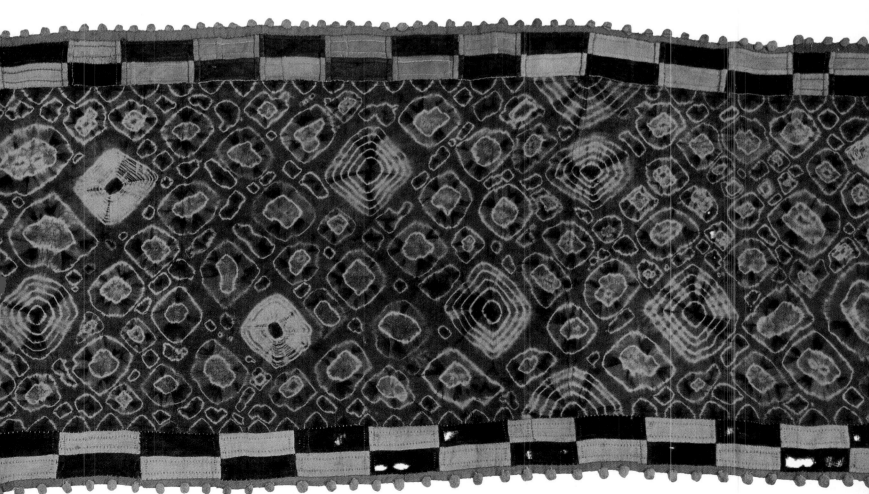

Pygmy and Kuba bark cloth, the Congo

The Pygmies, particularly the Imbuti of the Ituri rainforest of the north-eastern Congo, make loincloths from the inner bark of the tropical fig trees that abound in the forest.

The cloths, measuring approximately 15.25 × 45.75 (6 × 18 in.), are decorated with crude geometric and figurative designs drawn with a stick or a finger. Women prepare them anew for days of festive dancing, when they will tie them to their freshly oiled bodies with a palm twine belt. The painted bark-cloth flaps out provocatively behind as they dance. The same patterns on the bark cloth can be painted on the body.

The Itum clan of the Kuba occasionally use panels of painted bark cloth to decorate dance aprons and to create masquerade costumes for young boys at fertility festivals. Both items are painted with typical Kuba rectilinear motifs. The Bushoong make up overskirts with a central patchwork panel of black-and-white bark-cloth triangles surrounded on three sides by embroidered raphia panels. This particularly prestigious garment is often draped over bodies at funerals. Because of the frail nature of the bark cloth, it wears out before the embroidered borders. Consequently this type of overskirt is often found with much older embroidered panels.

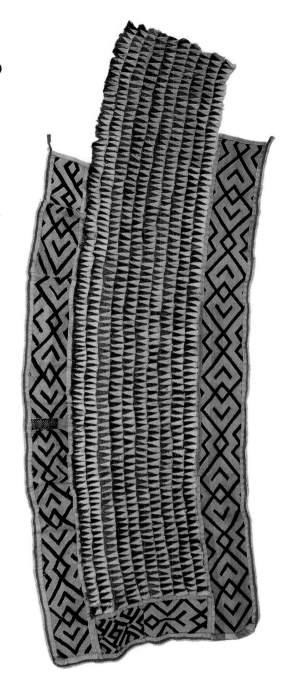

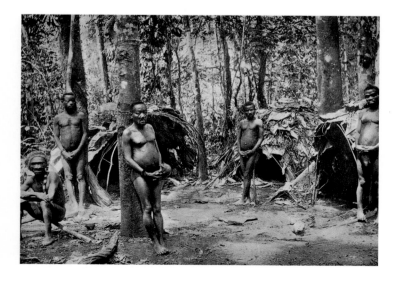

To make bark cloth, the moistened inner bark is hit rhythmically with beaters (often made of ivory) with a toothed face, rather like a European kitchen steak beater, until it expands widthways.

Pygmy women paint the designs of their loincloths with a stick for the linear elements or merely with a finger to daub areas of colour. For the former, a mixture of the juice of a fruit known as *kange, ebembe, ebimbele* or *tato* by different Pygmy groups and charcoal is drawn on. The juice acts as a fixative for the charcoal black. Any areas of colour will be made simply by daubing mud on with a finger.

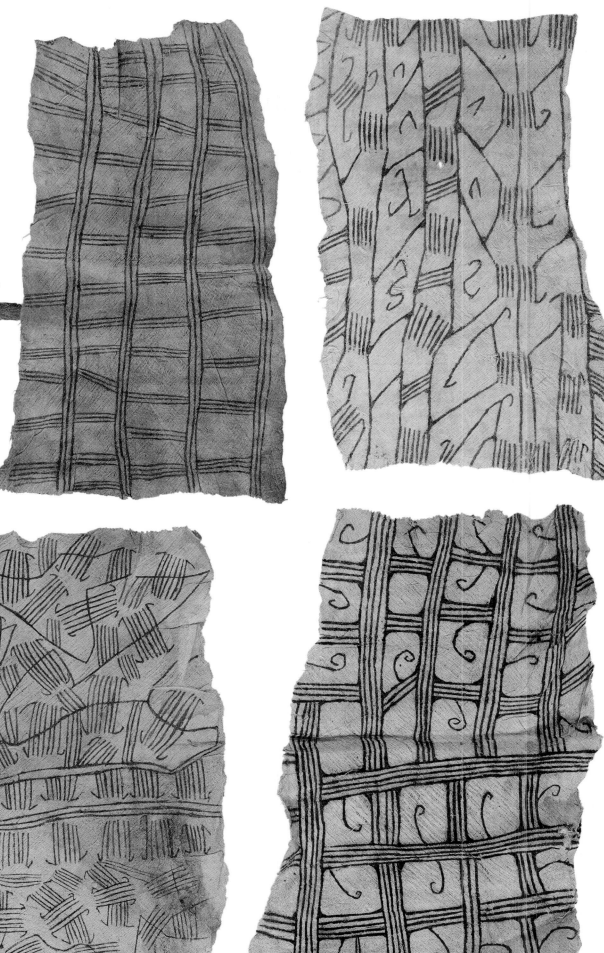

OPPOSITE

LEFT A Pygmy encampment in the north-eastern Congo.

RIGHT Overskirt of a harlequin patchwork of black-and-white triangles of bark cloth with an embroidered raphia border, Bushoong, Kuba confederation.

RIGHT Painted bark-cloth loincloths of Mbuti Pygmies of the rainforests of north-eastern Congo.

Bead and shell work of the Congo and Cameroon

Beads and shells are used all over Central Africa to make jewellery, to decorate masks and fetishes and to embellish ceremonial and masquerade costume.

The rich agricultural societies of western Cameroon have had access to European beads since the Portuguese set up trading centres on the coast over five hundred years ago. The chiefs of such people as the Bamileke and the Bamoun still adorn such prestigious items as thrones, drinking horns, palm-wine containers and ceremonial clothing with seed, bugle and coral beads, thereby enhancing their importance. As in Southern Africa, the *fons* or chiefs controlled access to the beads, which became more widespread as the years passed.

At present, beads in the grasslands Cameroon are used mainly to embellish the masquerade jackets and elephant masks of secret societies. Long white, red or dark-blue cylinder beads of Czech origin bought from Hausa traders are preferred for this purpose. Another group rich enough to use beads lavishly are the Kuba confederation of the Kasai river area of the Congo. The Kuba often mix seed and tubular beads in white, blue, red and green with cowrie shells from the Maldives in the Indian Ocean to decorate not only masks but also men's belts and little conical basketry hats.

The central section of the belt is decorated with the prestigious *imbol*, a type of guilloche knot in seed beads, while the cheaper cowrie shells – either lying flat or standing upright on one end – are sewn on to the rest of it. The highly decorative belts of royalty are made up wholly of white and coloured tubular beads in patterns of the *imbol* knot and other royal emblems. Beaded- and cowrie-adorned triangular pendants hang down from these belts. Cowrie shells are often sewn on to Kuba skirts, particularly to the drawn-thread embroidered skirts of the Itum people.

Rectangular aprons of woven beads and little triangular *cache-sexes* are worn by young women of the Kapsiki people (part of the group of the so-called Kirdi-mountaineers of north-western Cameroon, who were traditionally pagans).

The masquerade elephant masks and jackets are sewn on to indigo-dyed cotton backed with sisal in lazy or lane stitch, creating lanes of colour out of the beads. Each bead is sewn on perpendicularly to the direction of the lane.

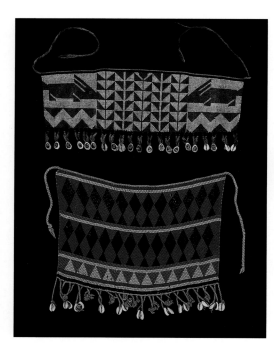

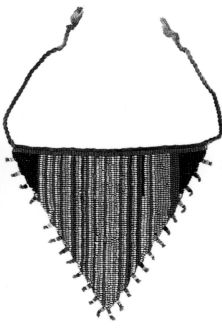

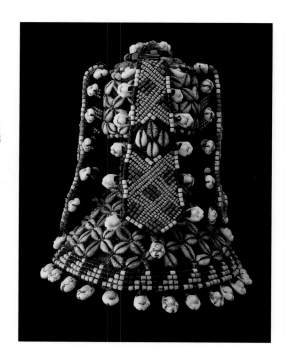

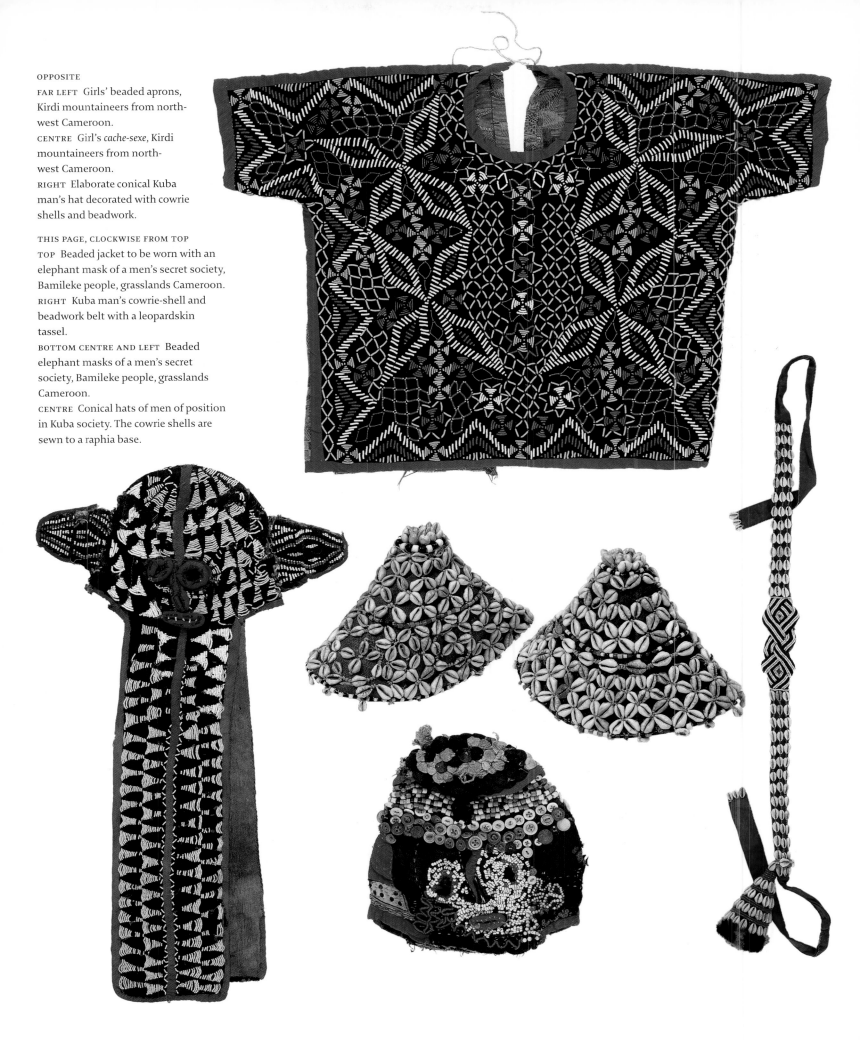

OPPOSITE

FAR LEFT Girls' beaded aprons, Kirdi mountaineers from north-west Cameroon.

CENTRE Girl's *cache-sexe*, Kirdi mountaineers from north-west Cameroon.

RIGHT Elaborate conical Kuba man's hat decorated with cowrie shells and beadwork.

THIS PAGE, CLOCKWISE FROM TOP

TOP Beaded jacket to be worn with an elephant mask of a men's secret society, Bamileke people, grasslands Cameroon.

RIGHT Kuba man's cowrie-shell and beadwork belt with a leopardskin tassel.

BOTTOM CENTRE AND LEFT Beaded elephant masks of a men's secret society, Bamileke people, grasslands Cameroon.

CENTRE Conical hats of men of position in Kuba society. The cowrie shells are sewn to a raphia base.

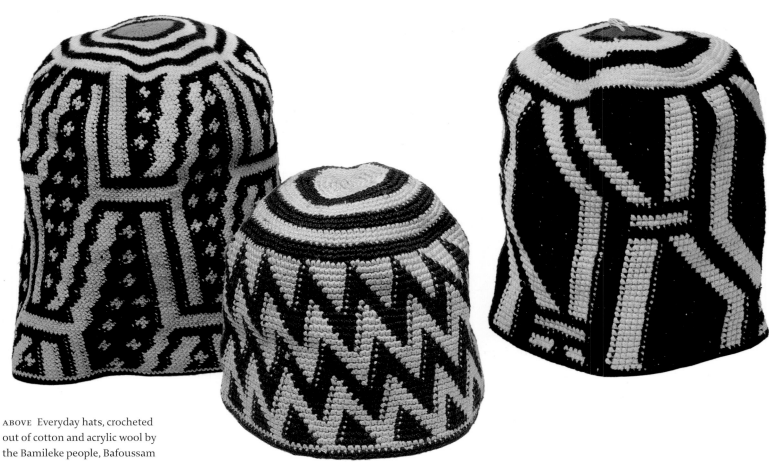

ABOVE Everyday hats, crocheted
out of cotton and acrylic wool by
the Bamileke people, Bafoussam
region, Cameroon.
BELOW Crocheted hats from the
northern grasslands, Cameroon.
They are worn by men of position
for ceremonial occasions.

Crocheted hats from Cameroon

Men in the grasslands Cameroon wear a wide variety of headgear for both everyday and ceremonial use, including feathered hats and caps with double flaps. However, by far the most common are those crocheted out of cotton, wool or acrylic.

Everyday crocheted hats tend to be worked in alternating blocks of blue or black and white, often with a red 'bull's-eye' spot at the very crown of the hat, which is worn high on the head. For ceremonial purposes, hats shaped like a Tibetan monk's cap, with long ties, often coming to waist level, are worn.

Most prestigious of all, because of their complexity, are those that resemble 'rasta' hair, with little crocheted burls, sometimes multi-coloured, sometimes stiffened with wooden inserts, sticking out all over the cap. This style is thought to evoke complex hairstyles that were once fashionable. These caps come in a variety of shapes – those of the Bamileke resemble a bonnet, those of the Bamenda a bishop's mitre.

The hats and the caps of the Tikar, Bamoun, Bamileke of the grasslands are all noteworthy. The headgear of the Bamoun and the Tikar, who have been influenced by the Muslim north, looks like Islamic turbans and fezzes. The oldest form of cap, made of crocheted cotton and decorated on either side with burls and tufts, may include panels of felt or other material. Caps are given such names as *ntcho* or *ntamp*, which is the flat-topped hat of crocheted wool worn by the Bamileke. It is crocheted by men using imported yarn stiffened by raphia.

Every piece of crochet is founded on a chain. First of all, a loop is pulled through a tied slip-loop with the hook. Then a succession of loops are taken through each other, one at a time, until the chain has reached the required length. In order to build a crocheted fabric and to add subsequent rows, a new sequence of loops has to be worked by hooking each one through the previous loop and through the previous row. Variations on the basic stitch include increasing the number of loops on the hook or linking them together.

BELOW LEFT Crocheted prestige hat with burls stiffened with wood, Bali, south-west Cameroon.
BELOW RIGHT Bamileke crocheted man's cap with soft, unstiffened burls.

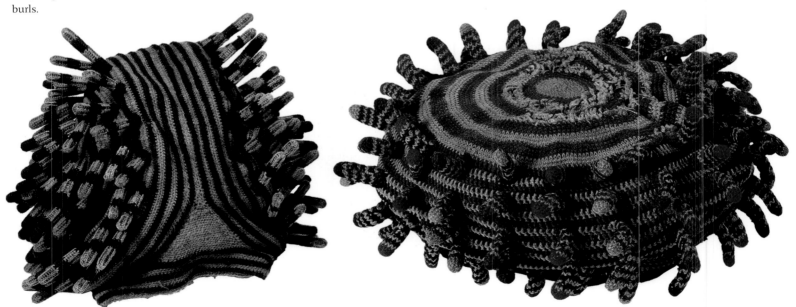

Feathered hats of Cameroon

In the grasslands Cameroon, basketwork or raphia-mesh caps adorned with wild bird feathers were worn by male dancers at funerals and other ceremonies. The red tail feathers of the African grey parrot were particularly chosen for this purpose, though dyed feathers were also considered acceptable and, in recent times, with the decline in numbers of wildlife, dyed cockerel feathers are the most frequently selected material. Bird feathers also embellish the brims of little pillbox caps. Again, in times past, wild-bird feathers would have been used, though nowadays chicken down is much more common.

The bird quills are pushed into the crown of a crocheted or basketry hat and sewn, or tied tight, with cotton or raphia thread. Those with a large spread of feathers are specially adapted to protect the feathers from being broken when carried. A loop, which is sewn inside the crown of the cap, can be tugged, when the cap is not being worn, to turn the cap inside out, bringing all the feathers together and protecting them with the inside-out cap (see illustration).

TOP AND CENTRE Crocheted men's caps trimmed with wild bird feathers, grasslands Cameroon. RIGHT Feathered hat turned inside out to protect the feathers from being broken when it is not in use.

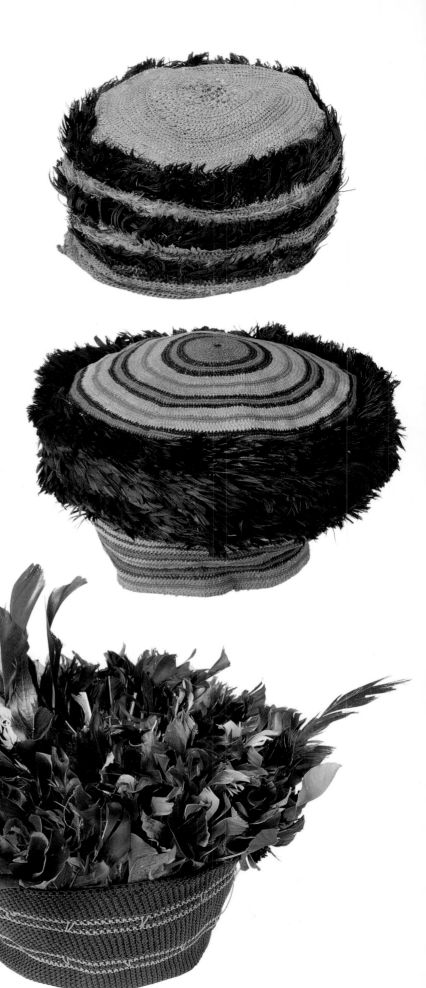

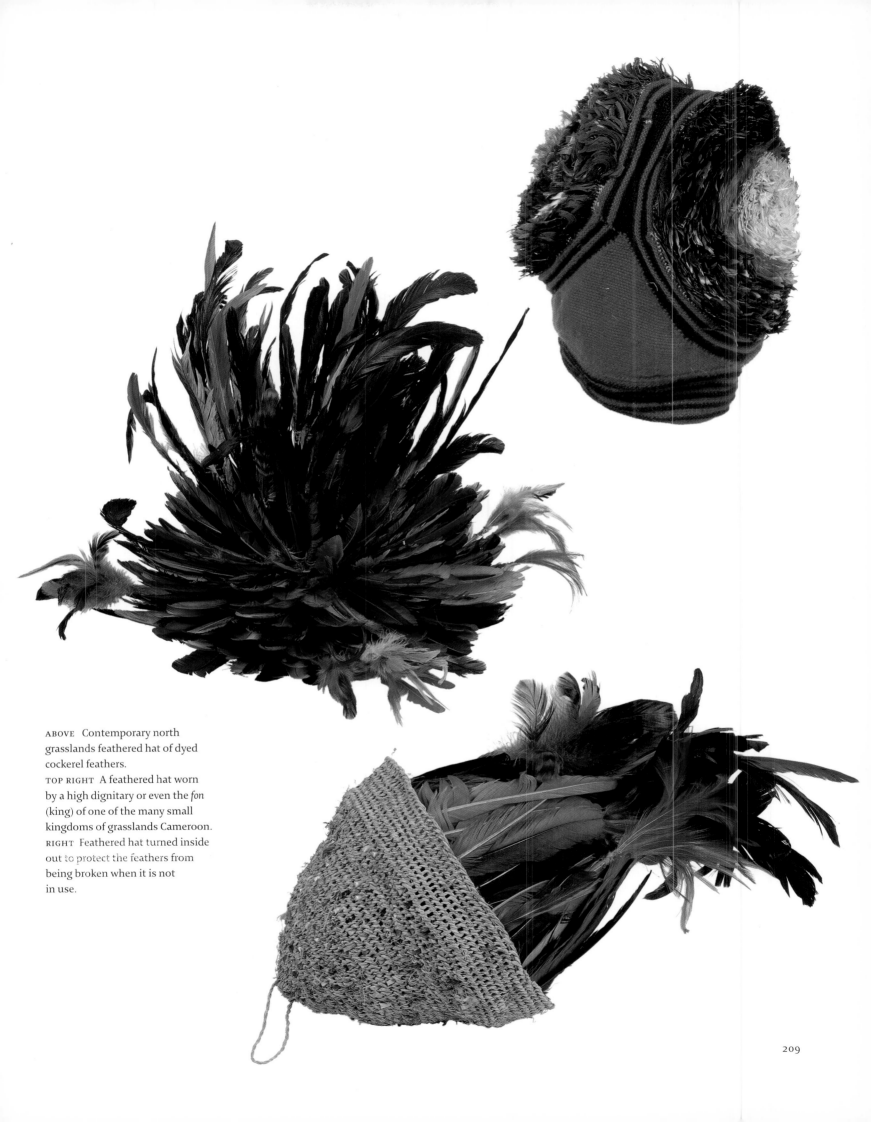

ABOVE Contemporary north grasslands feathered hat of dyed cockerel feathers.

TOP RIGHT A feathered hat worn by a high dignitary or even the *fon* (king) of one of the many small kingdoms of grasslands Cameroon.

RIGHT Feathered hat turned inside out to protect the feathers from being broken when it is not in use.

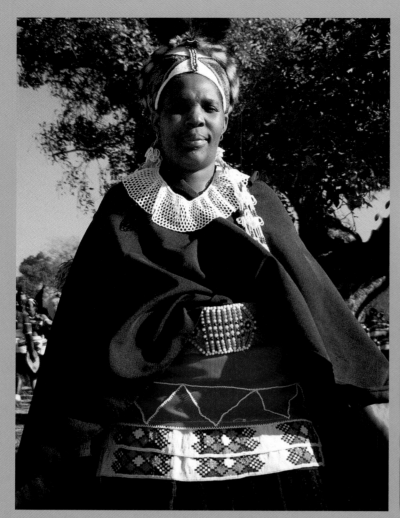
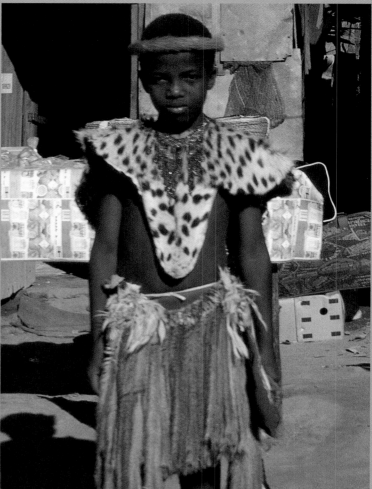
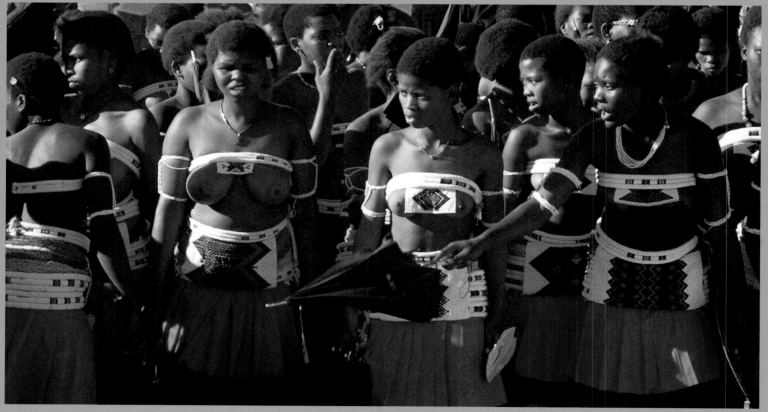

SOUTHERN AFRICA

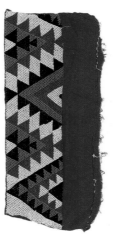

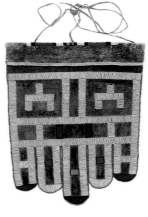

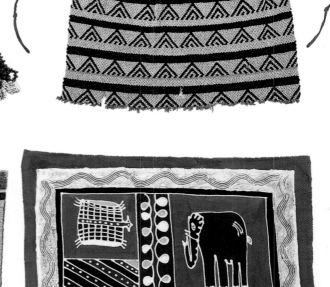

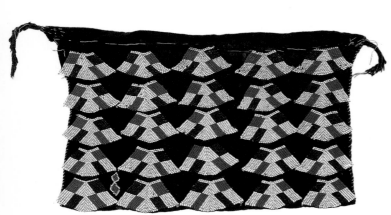

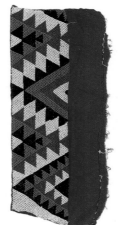

Introduction

SOUTHERN AFRICA

Textiles of Southern Africa vary widely. Apart from the island of Madagascar, with its different pattern of settlement, there was no strong weaving tradition. Until the early years of the 20th century, cotton cloth for ceremonial and everyday use was woven on single-heddle, ground looms in isolated areas of present-day Zambia, Zimbabwe and Malawi. Most Southern African clothing needs were satisfied with imported fabrics or skins and hides. What little weaving of cotton cloth on pit-looms there was of Arab origin along the southern Swahili coast died out more than one hundred years ago. However, there is evidence of weaving relatively simple cotton cloth on single-heddle looms up until the first decades of the 20th century among some groups, such as the Venda of northern Transvaal. Examples of such cloth have also been excavated on the site of Great Zimbabwe. The peoples of Southern Africa generally wore skins and hides or trade blankets bought from Europeans. Christian groups adopted Western dress completely or partially. Those furthest away from European settlement wore skirts, aprons and cloaks of hide or animal skin.

There had been a long tradition of sewing ostrich-shell discs on to these leather garments and of wearing ostrich-shell jewellery. As the 19th century progressed, there was a greater and greater influx of European seed beads, which were used – often with the encouragement of missionaries – to adorn leather garments and to make armlets, necklaces, anklets and pubic aprons. Each group – whether Xhosa, Sotho, Ndebele, Zulu, Tonga or even San (Bushmen) or Khoi (Hottentot) – developed their own distinctive style.

Young miners returning home from the gold mines of the Rand were given love necklaces by young women that contained a coded message of love. Beadwork was worn at initiation ceremonies for young men and women and formed an integral part of marriage costume. Though Christian groups sometimes disapproved of it, beadwork has, throughout the 19th and 20th centuries, come to be regarded as essential clothing and ornament of black South Africa.

Recent developments in Zimbabwe should also be mentioned. A form of batik has been created, using maize flour paste and chemical dyes, aimed at the tourist and export market. In the eastern part of Zimbabwe there is a long tradition of making sturdy, naturally coloured mats out of bark fibre.

The great island of Madagascar lies off the south-east coast of Africa. Separated from the mainland by the infamously rough and dangerous Mozambique channel, it was colonized by Malay-Polynesians in the first millennium rather than by peoples from the African mainland.

The peoples of the Malagasy highlands are of more or less pure Malay descent and they brought with them both weaving techniques and burial customs unknown in Africa. The Malay custom is to inter their dead in specially woven shrouds. This ritual is still practised by the Merina and Betsileo peoples of the Madagascar highlands, where these shrouds are known as *lamba mena* (literally, 'red cloth'). They bury not only the shrouds, but also all the traditional cloths belonging to the deceased, so that it is almost impossible to find examples of old cloths on the island at all.

A wide range of materials and techniques are employed in Madagascar. *Lamba* are woven in cotton, raphia, mulberry silk and any of the 13 known varieties of native wild silk. Some wool is even woven in isolated parts of the island.

The Sakalava wove raphia extensively and, within living memory, produced in certain villages very striking *lamba* decorated in warp ikat, in a manner reminiscent of eastern Indonesia. Raphia weaving today is concentrated in other parts of the island.

Cotton is woven all over the island, but the most prestigious material is silk. Like other materials, it is woven by most groups on a single-heddle loom set within a low, wooden, bed-like frame. *Bombyx mori* silk is in general reserved for special occasions, particularly for women.

The local wild silk, which is a speciality of certain villages in the central highlands, is preferred for shrouds, as it does not rot – an important factor for those groups who have the custom of second burials. This practice involves disinterring the body after a few years, cleaning the bones and then reburying them.

The most beautiful Malagasy silk weavings were the *lamba akotofahana*, those created for the Merina court and aristocracy on the ordinary Merina loom, with a single movable extra heddle for the additional patterns set in lengthwise stripes.

This type of weaving virtually disappeared with the end of the Merina monarchy in the late 19th century. It is now undergoing a revival with the help of Englishman Simon Peers and Merina master weaver Martin Rakotoarimana, who have adapted this brocading technique for the treadle loom.

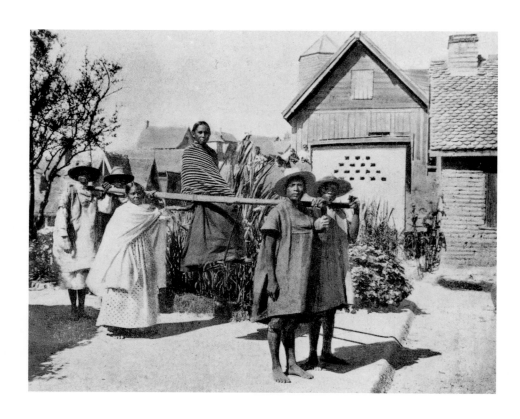

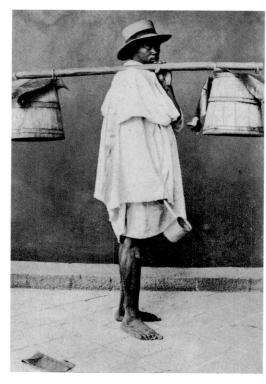

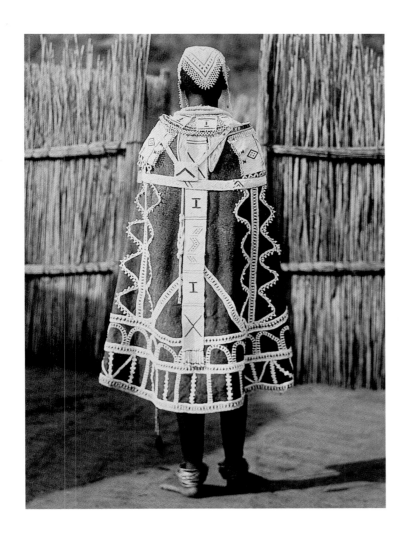

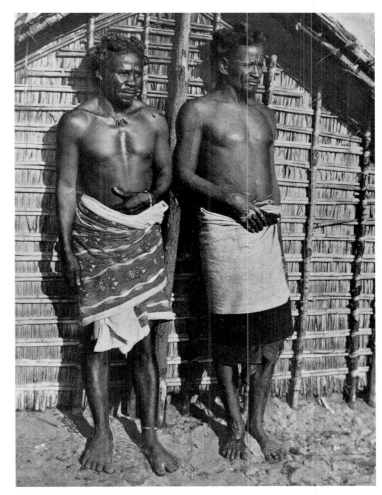

PAGE 213 Zulu woman's *isicholo* hat woven from ochre-dyed human hair and grass over a basketry frame.

OPPOSITE
LEFT Merina woman wearing a *lamba mena* cloth being carried in a litter in the highlands of Madagascar.
RIGHT Highland Merina farmer carrying his wares to market, Madagascar.

ABOVE LEFT Ndebele bride wearing a traditional beaded leather mantle, Potgietersrus, South Africa, 1923.
ABOVE RIGHT Sakalava men from north-western Madagascar.
RIGHT Highland woman weaving a *lamba mena* on a typical Malagasy single-heddle loom.

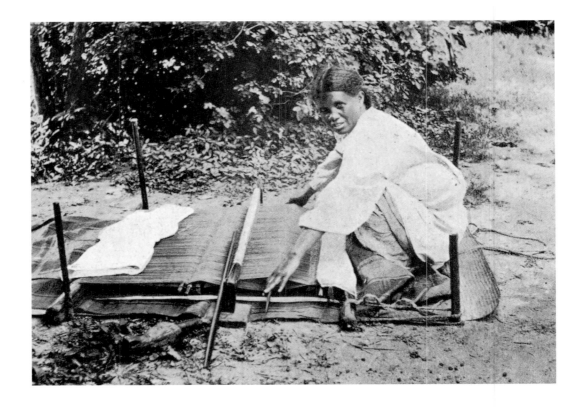

Zulu beadwork

Beadwork is a common decorative craft among the indigenous peoples of Southern Africa whose clothing needs, before the advent of the Europeans, were met by using the skins of wild animals. These skins were often decorated with discs of ostrich shell. Necklaces, aprons, belts and other items of decorative and ritual significance were often made from the same material. Traders and Christian missionaries introduced glass beads of European or Indian manufacture, along with such items as trade blankets. They encouraged the craft of beadwork, which soon became widespread among the tribes and developed into an astonishingly accomplished technique.

By the early 19th century, through the wars of their king, Shaka, the Zulu came to dominate large portions of South Africa. They have long been renowned for the complexity and richness of their beadwork. First brought by the Portuguese, and later by English-speaking traders and missionaries, imported beads were used as part of the bride price and as everyday as well as ceremonial wear. Although worn by both men and women, they were worked into collars, belts, aprons and love tokens by women. The Zulu kings established a strict royal monopoly on the import of beads, reserving certain beads for royal use or for those in royal favour. It is likely that beadwork techniques were developed in the royal household and were then disseminated among the wider population. With the British subjugation of Zulu power, the royal bead monopoly ceased, and, as white/black trade increased, regional styles and a preference for certain types of bead grew.

Beadwork is still common in rural Kwazulu (Zululand), for use both at home and abroad. It has declined or disappeared in those areas that have adopted Christianity, but remains popular in those that have not. Part of the courtship ritual of the Zulus involved teenage girls making beaded 'love letters', which were then given to young men. The arrangement and colouring of the beads was used to convey an allegorical message.

The Zulu employ many different techniques to create their beadwork, including netting and herringbone stitch, though by far the most common one is brick stitch. With this method, the beads are placed in staggered rows. As each new bead is threaded, the thread is passed under a loop of thread on the previous row and back through the bead. This looping gives Zulu beadwork its characteristic strength. The Zulus like motifs made up of lozenges, triangles and diagonal and horizontal lines.

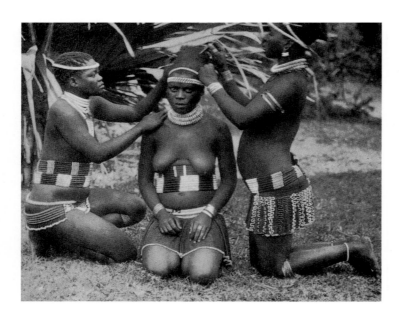

LEFT Adorning a Zulu girl's hair with red ochre. All the girls are wearing ornaments made of European trade beads.

OPPOSITE *Ucu* Zulu neck ornaments. An unmarried Zulu woman will make a beadwork necklace for her beloved.

PAGE 218
TOP LEFT AND CENTRE LEFT Two Zulu girls' beaded pubic aprons. BOTTOM LEFT Zulu beadwork neck ornament with a fringe of Job's tear seeds, from Nongoma, Kwazulu.

RIGHT Two Zulu beaded waistbands. They are made up of rolls of beadwork sewn together.

PAGE 219
TOP LEFT Early 20th-century Zulu beaded necklace for men or women. BOTTOM LEFT Early 20th-century Zulu woman's pubic apron worked in a chevron design in brick stitch. As a greater range of beads became available from white traders, designs became more complex. RIGHT Late 19th-century Zulu beaded necklace or waistband.

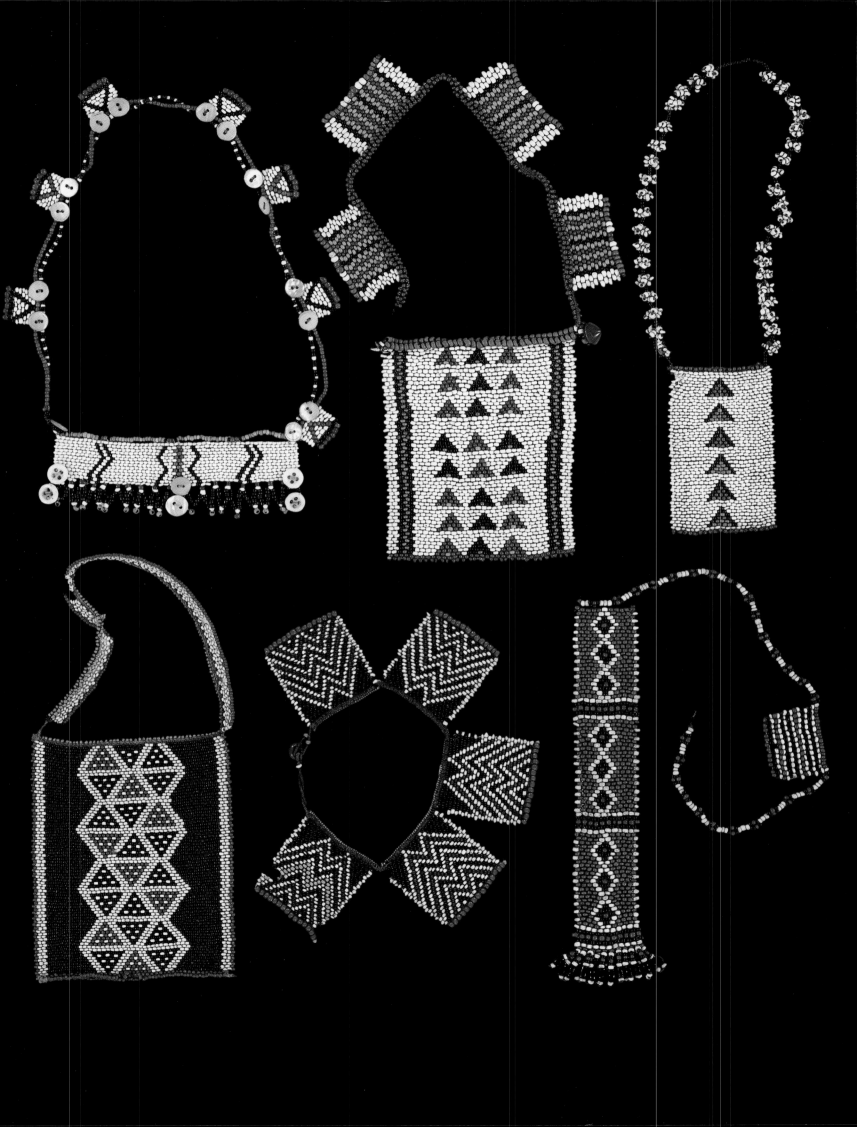

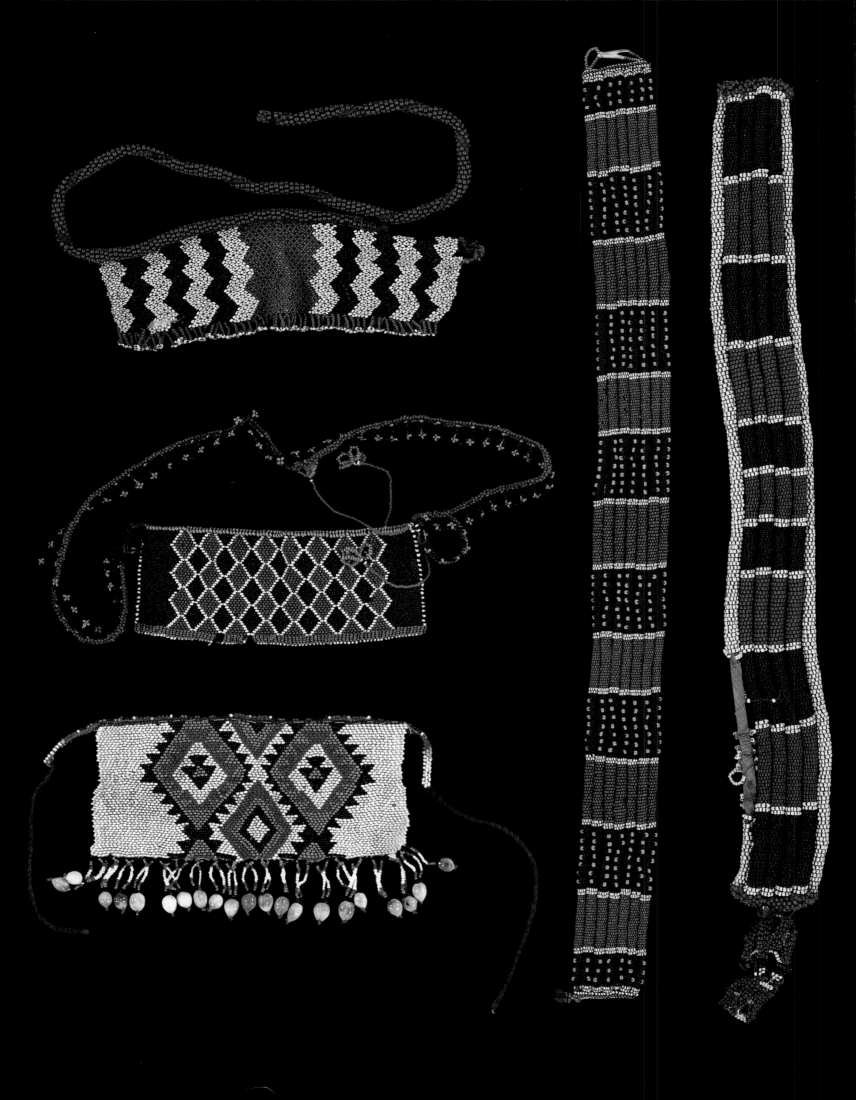

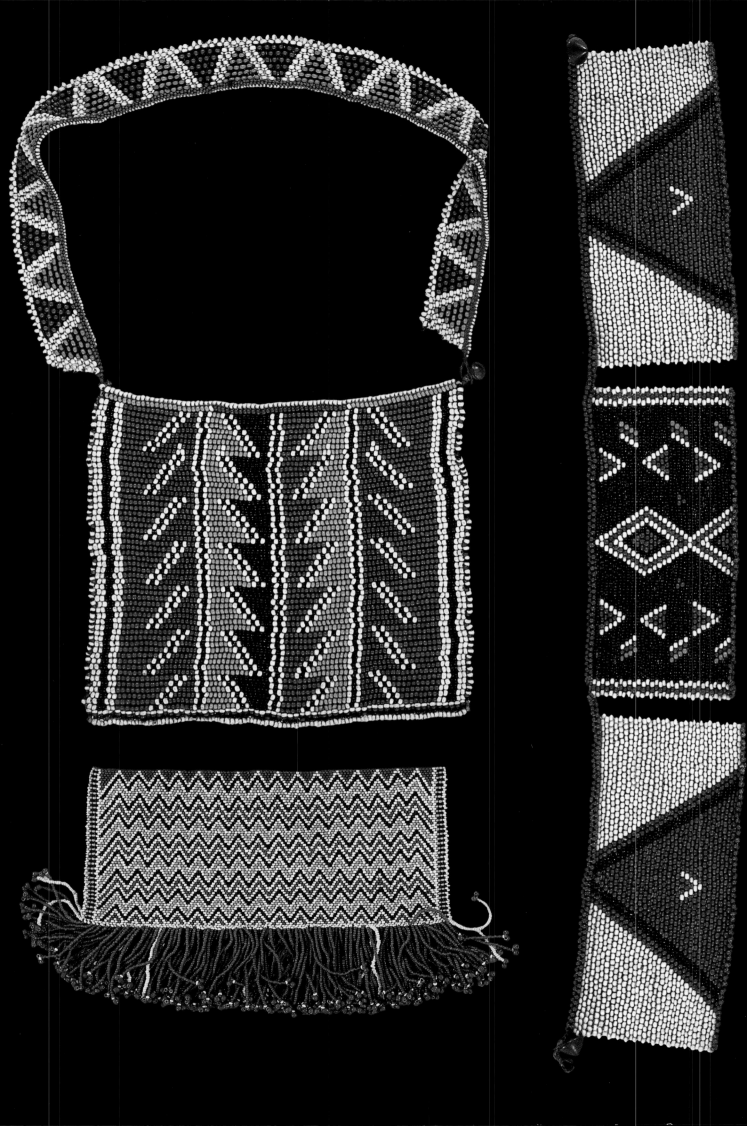

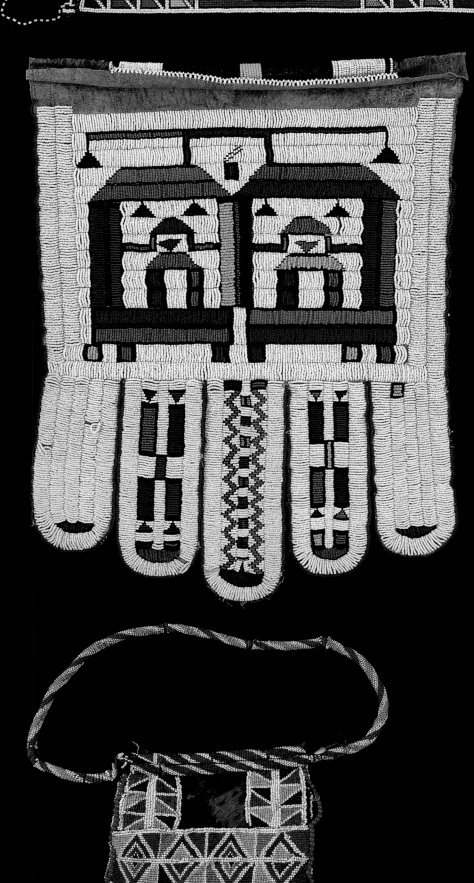
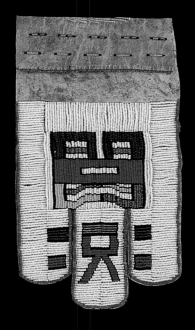
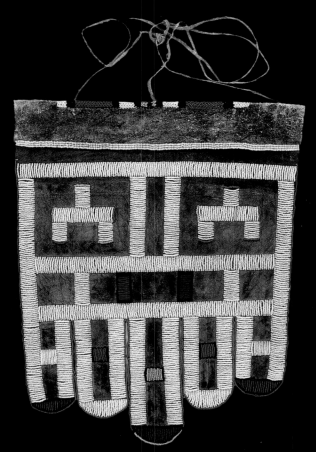

Ndebele beadwork

The Ndebele live in the old Transvaal of South Africa (not to be confused with the Ndebele of south-western Zimbabwe, who are a different group). The Ndebele broke away from the northern Nguni of the coast (later to become the Zulu) as long ago as the 17th century. Internecine warfare and external aggression later divided them. This section is concerned with the Ndebele group known as the Ndzundza Ndebele, who settled in the south of the old Transvaal. They were defeated by the Boers in 1883, their chiefs imprisoned, lands confiscated and their people virtually enslaved as indentured labour on Boer farms.

In a successful attempt to retain their cultural identity in such adverse circumstances, the Ndzunda Ndebele developed the arts of house painting and beadwork, using bold geometric patterns in both areas. Their beadwork also incorporates stylized images of flora and fauna and representations of the houses themselves.

Ndebele beadwork from the 19th century is mainly made up of closely worked white beads with only sparse coloured details. As the 20th century progressed, more and more coloured beads were used. In the 1960s a new range of European beads was adopted. By that decade there was a tourist market for the beadwork that encouraged bold new eye-catching designs.

Women carry out their beadwork not only during the quiet months of winter, but also whenever they have a spare moment at other times of the year. The family wealth is displayed by the number of bracelets, neckrings, or other items of jewellery – sometimes very large pieces – worn. Women will work Czech beads into capes, belts, aprons and even the edging of trade blankets. Green is a favourite colour.

At the end of a girl's initiation into womanhood, she is presented with an *isephephetu*, a stiff, beaded apron that symbolizes her change of status. On her marriage she dispenses with this apron, replacing it with the *umaphoto*, a large, beaded goatskin apron. At her wedding she will wear a dramatic beaded cape known as a *linaga* and, sometimes, a striped woollen 'Middleburg' blanket edged with broad bands of beadwork. Ndebele men seldom wear beadwork ornaments.

The Ndebele use several variations of herringbone stitch, particularly tubular herringbone, in their beadwork. In herringbone stitch the beads are set opposite each other in pairs at a 45-degree angle. The resulting beadwork patterns are linear and diagonal, with each seemingly straight line having a slightly zig-zag effect. Curvilinear patterns cannot be created. Herringbone stitch is restricted to the Ndebele and some Zulu groups.

OPPOSITE, CLOCKWISE FROM TOP
TOP Contemporary Ndebele beadwork belt. The imported seed beads are worked in herringbone stitch.
CENTRE RIGHT Miniature *ijogolo* beaded apron made in herringbone stitch on a goatskin base for the tourist market. Like much contemporary Ndebele beadwork, it depicts the AIDS ribbon.
BOTTOM RIGHT *Ijogolo* beaded apron of a married Ndebele woman with children. The imported seed beads are worked in herringbone stitch on a goatskin base.

BOTTOM LEFT Sotho woman's beaded apron worked in a protective pattern of triangles.
CENTRE LEFT *Ijogolo* beaded apron of a married Ndebele woman with children. The imported seed beads are worked in herringbone stitch on a goatskin base. The central motifs portray Ndebele houses and their inhabitants.

RIGHT Herringbone stitch used by the Ndebele forms solid blocks of beadwork.

Xhosa beadwork

Of all the Nguni-speaking peoples of Southern Africa, the group of peoples known as the Xhosa have been most affected by European settlement of their territory. Living in the Eastern Cape, they fought wars with, and lost land to, the incoming Europeans. They also traded with them at large fairs sanctioned by the British government. One of the main items of trade were glass beads from Venice, Bohemia or Holland. At one stage during the 19th century South Africa was the largest market for beads in the world.

Like the other indigenous peoples of Southern Africa, the Xhosa had a tradition of using ostrich-shell discs to decorate skins and hide and to make jewellery. It took little time, with some encouragement from the missionaries, to substitute beads for ostrich shells and to learn the requisite beadworking techniques. Christianity had a large influence on Xhosan life. A split emerged between the so-called 'School' and 'Red' Xhosa: the former, schooled at the English missions, adopted Christianity and a few Western ways; the latter, those who wore red ochre, clung to the traditional ways and beliefs. It is ironic that the ornaments that came to symbolize traditional dress in the 20th century were made by Xhosa women out of coloured glass beads obtained from trade with the Europeans.

The two main beadmaking branches of the Xhosa, the Thembu (Nelson Mandela's people) and the Mpondo, create very similar ornaments, but prefer different colours. The Mpondo like combinations of blue and white, while the Thembu prefer red. Beads are traditionally bought from local stores or trading posts, usually in strings, but sometimes as loose beads. Initially, before cotton thread became widely available, sinews or aloe fibre were used to string the beads. It was therefore important that the beads were even in size and had a large enough hole for the needle and the material on which the beads were threaded. Today's beads are much smaller and finer than the ones used by the Ndebele.

The Mfengu people should also be mentioned. The literal meaning of their name is 'those looking for work'. Reputed to be tribes dispersed by Shaka wars, they wear brown or yellow trade blankets with sewn white and black beads.

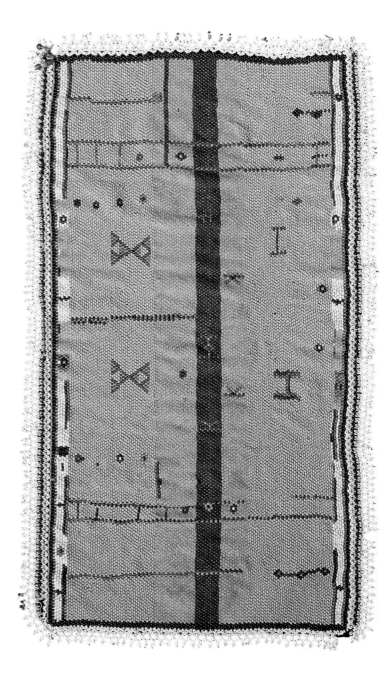

ABOVE Early 20th-century Xhosa beadwork panel from the Queenstown area, Ciskei.
OPPOSITE
LEFT Man's anklet, worn at important ceremonies and meetings. Each of a pair of anklets has a different design, but the designs themselves have remained much the same over the last one hundred years.
TOP Xhosa woman's beadwork apron.
BOTTOM Southern Sotho animal-skin apron of tooled leather with applied beadwork.

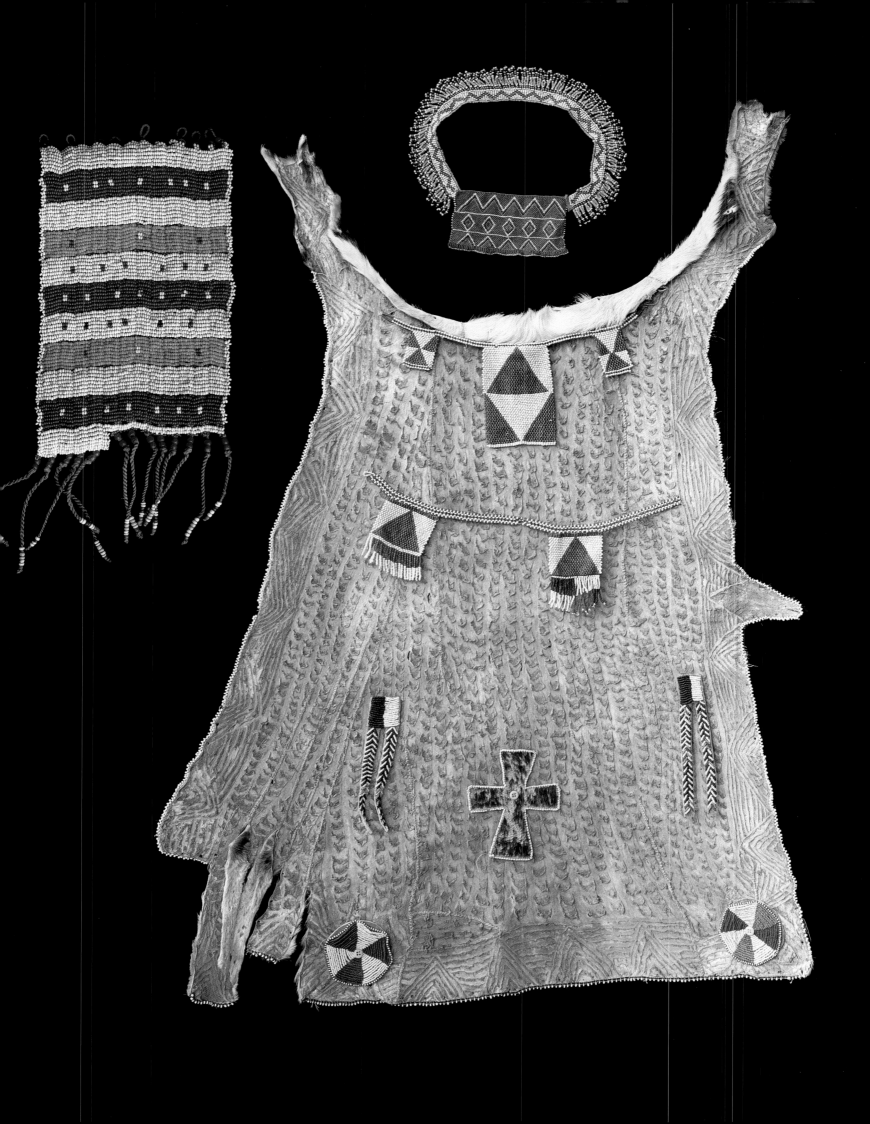

Madagascan raphia

The palm trees that produce raphia are native to Madagascar. Malagasy raphia textiles usually come in just one colour. However, in *Malagasy Textiles* (1989), John Mack states that in three villages in the highlands the Sakalava have been known to produce cloths decorated in warp ikat. Human figures and geometric devices were popular motifs.

Contemporary raphia weaving is now concentrated in the eastern part of the island. Ikat raphia warps are tied with resists then dyed. When the resists are untied, a pattern is revealed in the undyed area. A two-coloured patterned cloth can be created by weaving a warp-faced textile. More complex warp-ikat cloths involve more than one dye-bath and further tying and untying. This technique results in a colour scheme comprising the base colour, the colour of the dyes in which the threads have been soaked and a combination of colours where different dyes have been allowed to mix.

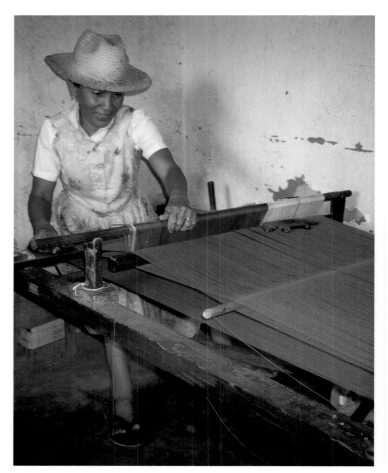

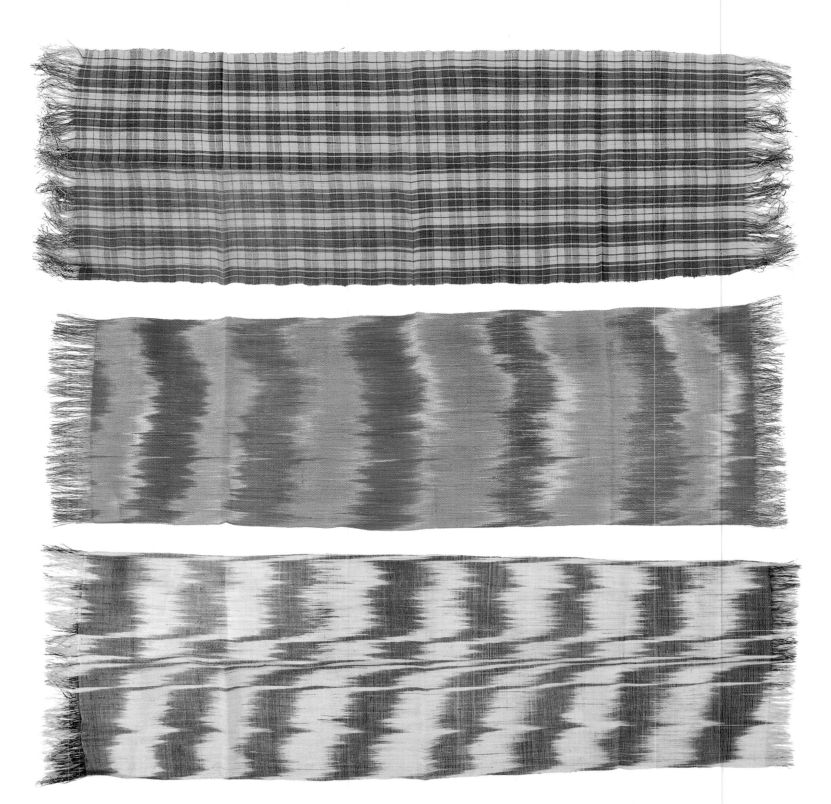

OPPOSITE

LEFT Raphia woman's wrap woven on the Betsimisaraka ground loom, eastern coastal region.

RIGHT Merina woman weaving on a single-heddle loom in the Madagascar highlands.

TOP Basket-weave raphia woman's wrap woven on the Betsimisaraka ground loom, eastern coastal region.

CENTRE AND BOTTOM Warp-ikat dyed raphia woman's wrap woven on the Betsimisaraka ground loom, eastern coastal region. The Sakalava of the north-west coast once specialized in the weaving of fine, figurative raphia warp ikats.

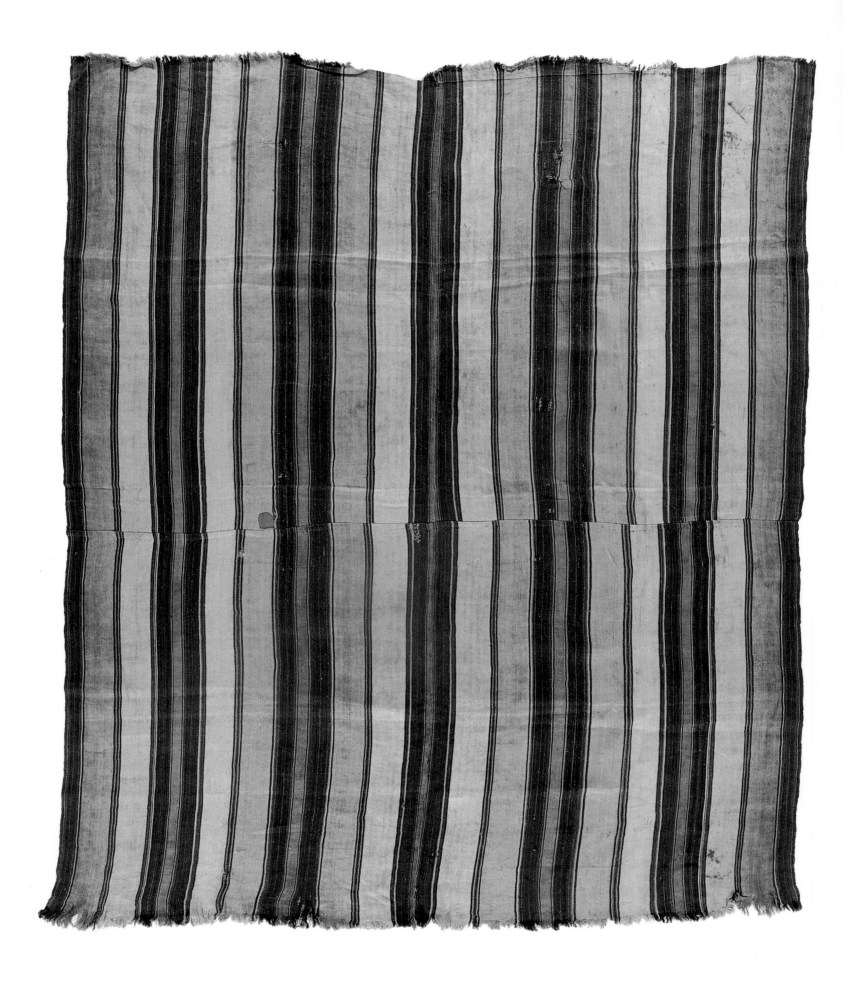

Madagascan silk

Lamba mena can be woven in cotton or local or imported mulberry silk. However, the preferred material is the local wild silk *landibe,* which has the crucial advantage of not rotting in the grave. As many Malagasy groups also practise the custom of second burials, this is an important consideration.

There are least thirteen different kinds of indigenous moth whose caterpillars spin cocoons (sometimes huge) that can be used for weaving.

Weavers of shrouds made out of *landibe* silk can be found in the village of Soatana, near Ambositra in the central highlands. The cocoons are gathered from a small tree called *Boroceras madagascariensis* in the nearby tapia forests. Women work together at their looms during the winter months when there is little to do on the land and when exhumation ceremonies are held. New *lamba mena* are then in demand for wrapping bones. Betsileo weavers were once so renowned that, in the 19th century, their weavings were used as currency. They were noted for their production of warp-striped cloth, with metal beads, to adorn the upper and lower borders.

When Madagascar went through the painful process of opening itself up to the rest of the world in the 19th century, one of the imports from Asia was the white mulberry tree, *Morus alba,* the only tree on which the *Bombyx mori,* the commercial silk moth, fed. The silk filament produced was much lighter and production per cocoon much greater than the indigenous *landibe* silk. Mulberry silk soon far exceeded *landibe*

in popularity for everything but shrouds. One interesting development was that the Merina aristocracy started to wear brocaded silks.

Betsileo women weave *landibe* on the typical Malagasy loom. Sitting inside the low, bed-like frame of the loom,the weaver stretches forward to operate the movable single heddle. The warps are wound continuously around the breast and warp beam and cross over to form the weaver's cross. The loom is a very simple construction of a sword beater and two shed sticks. The weaver pulls up the heddle to form the shed, passes the weft through on a wooden shuttle, then, letting go of the heddle, she makes countershed by tapping along where the warps cross with a little wooden spade-shaped beater to unloosen them. When countershed is made, the shuttle is passed through again. Natural dyes were obtained from the *nato* plant to give a red, *curcuma* a yellow and rice a white.

The most prestigious of the 19th-century mulberry cloths were the *lamba akotofahana* woven by Merina weavers. The brocaded areas were worked in vertical stripes, with plain weave strips interspersed between them. This work was carried out on the normal Merina loom. A supplementary, small heddle that was suspended above the main heddle was added and moved across the loom from patterned area to patterned area as the weaving progressed. Simon Peers, who has revived the weaving of these cloths, suggests that the technique was possibly introduced by the British, who brought over Assamese or Bengali weavers then in exile on Mauritius.

OPPOSITE Silk warp-striped *lamba,* probably Betsileo people from the region of Amblavao.

RIGHT Contemporary warp-striped silk *lamba* with supplementary weft details, woven by Merina weavers.

PAGES 228–29
TOP Early 20th-century silk Merina *lamba* with supplementary weft floral motifs also in silk.
BOTTOM Contemporary revival silk *lamba,* woven by Merina weavers.

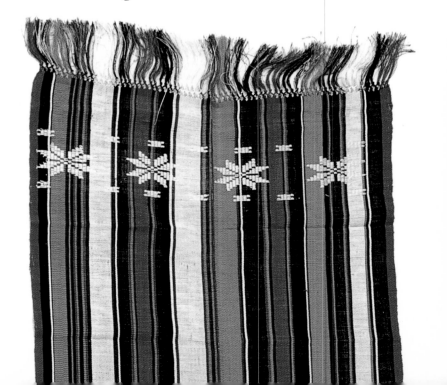

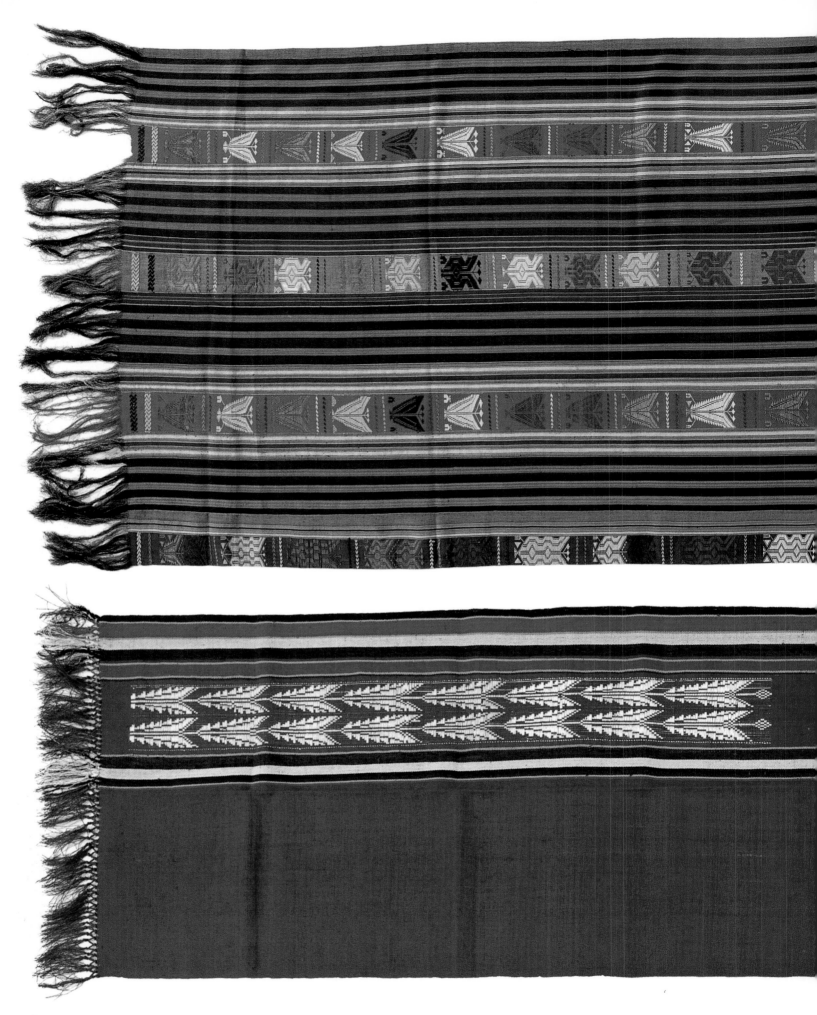

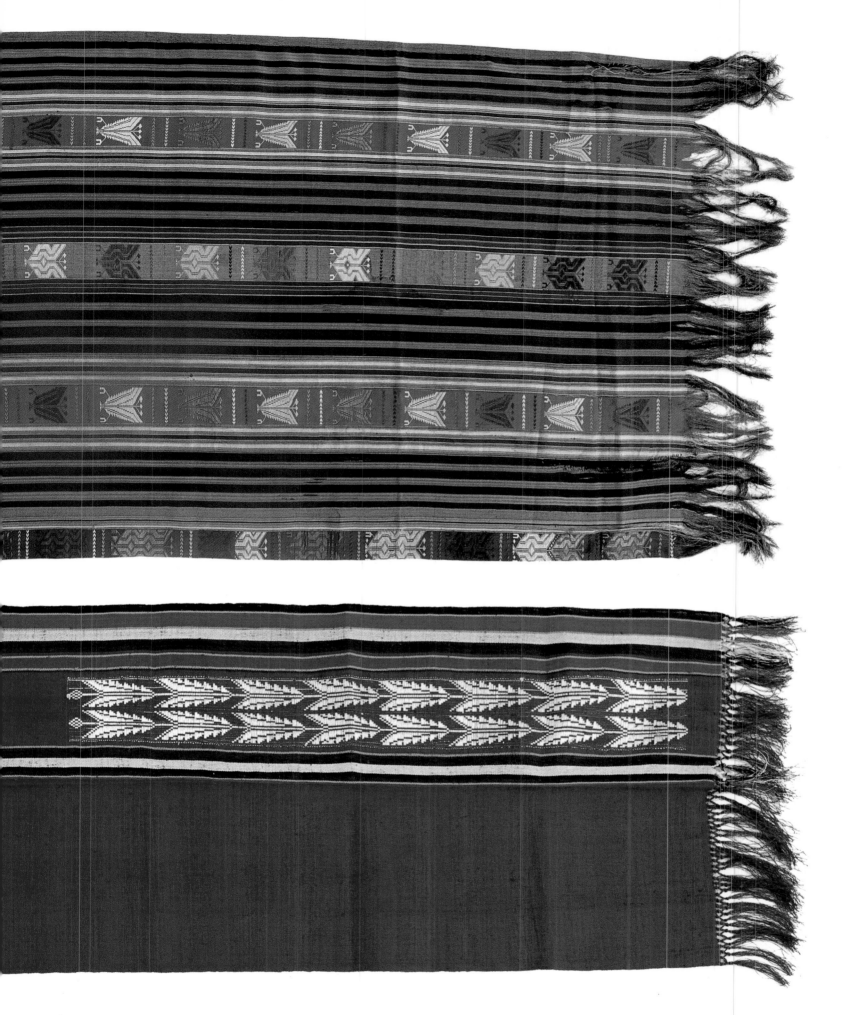

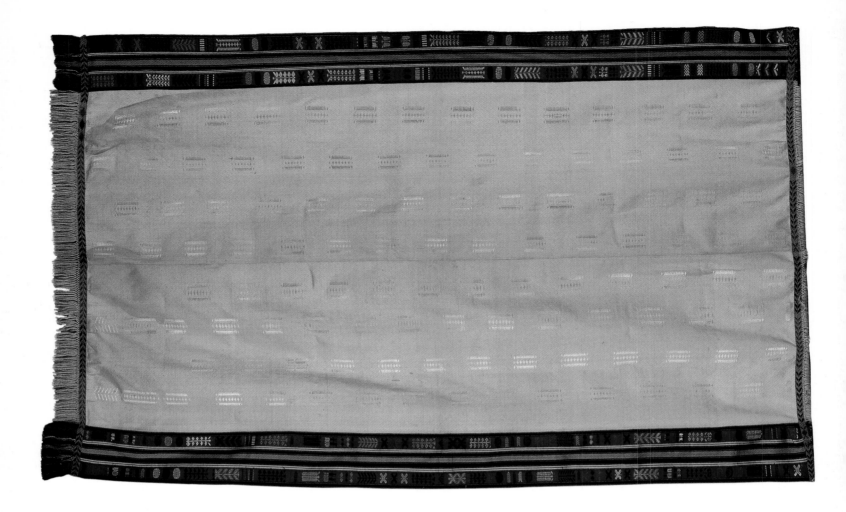

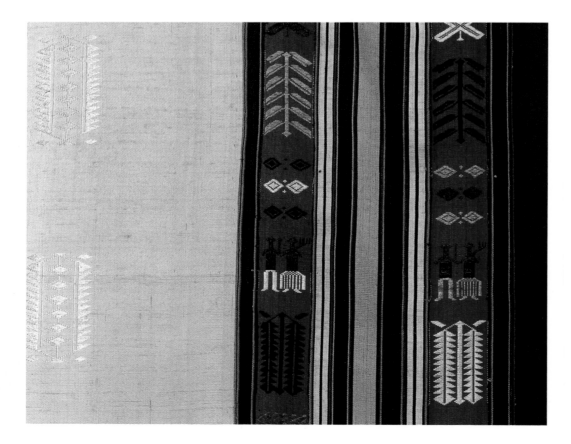

TOP Fine, late 19th-century *lamba akotofahana*, woven from mulberry silk, Merina people.

LEFT Detail of border of fine, late 19th-century *lamba akotofahana*, showing a married couple among flowers, worked in supplementary weft.

OPPOSITE Contemporary revival silk *lamba akotofahana*, woven by Merina weavers at the workshops of Simon Peers.

OPPOSITE INSET Sakalava men wearing *lamba mena*.

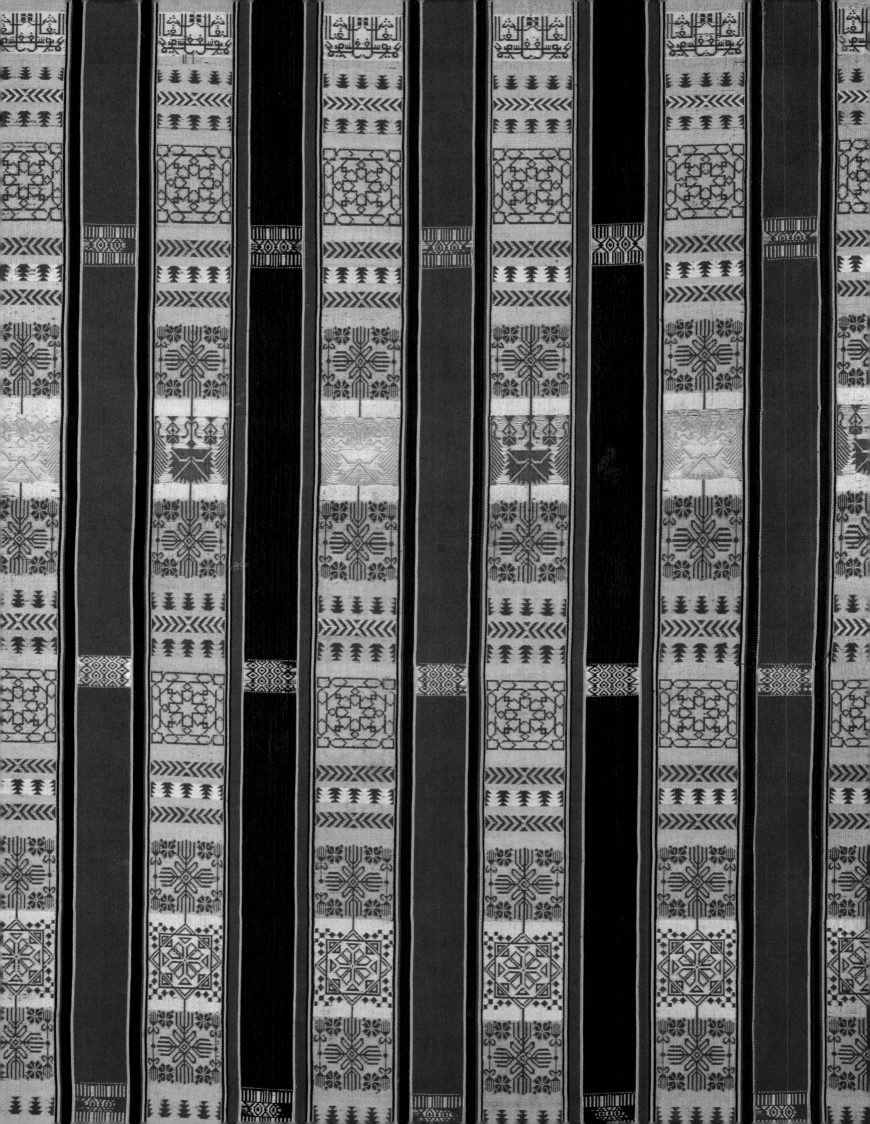

glossary

aba A robe of Arab origin

adanudo An intricately patterned cloth with weft float motifs made for wealthy Ewe chiefs and elders

adinkra cloth Fabric from Ghana covered in symbolic designs printed using stamps carved from calabash shell

adire alabere A Yoruba resist technique in which the dye is resisted using stitching

adire eleko A Yoruba method of dyeing in indigo in which a resist paste is painted or stencilled on to the fabric

adire oniko A Yoruba resist technique in which the dye is resisted with ties, usually of raphia

agbada Yoruba man's wide-sleeved gown (the Hausa term is *riga*)

akhnif 'Eye'-cloak woven by Chleuh Berbers, Morocco

Akwete Small town in south-eastern Nigeria famous for its women's vertical loom weaving

alaari Nigerian term for red silk (from Arabic *al-hareen*) originally imported from Tunisia

aso oke Yoruba high-status stripwoven cloth. The component strips are often decorated with weft-float work

axellal Kabyle woman's woollen wraparound garment

bakhnug One of three types of decorated shawl worn by women south of Gabes, Tunisia

bast Fibre obtained from the stems of certain herbaceous plants

batik The Javanese method of resist-dyeing using wax

bead netting A simple beadwork technique whereby three or five beads at a time are added all along a foundation row to create a further row. The process is repeated to build up a light fabric, typically patterned with lozenges and diagonals

blanket stitch A series of stitches are made around the raw edge of the cloth. By linking each stitch through the previous one the fabric is prevented from fraying

bogolanfini Mud-dyed ritual cloths of the Bamana and other ethnic groups of Mali

Bombyx mori The moth from which commercial silk originates

boubou Francophone term for a West African man's wide-sleeved gown

brick stitch A staggered beading stitch resulting in a stiff, firm fabric

Bushoong The aristocratic clan of the Kuba people, the Congo

buttonhole stitch This stitch is similar to blanket stitch, but much closer together. The hole is cut after the the stitching has been completed

calabash A gourd used for carrying liquids

cassava Starch derived from the tuberous root of tropical plants of the genus *Manihot*, which is also called manioc

clamp resist Resist dyeing method, whereby the resist is created by applying pressure to the cloth to be dyed through some kind of vice or clamp

Copt Egyptian Christian

couching Laid thread is attached to fabric with stitchery

countershed The shed that is the reverse of the natural shed

crotchet A doubly interlooped structure worked with a hook

cut-pile embroidery A form of embroidery practised by the Kuba of the Congo. Women stitch softened raphia fibres through the surface of raphia cloth and then trim them with a sharp blade

darning stitch Embroidery worked in rows of long stitches with tiny spaces between them

ddil Kabyle woman's decorative woollen cloak

double-heddle loom Used for weaving stripwoven cloth. The heddles are joined to each other by a cord and operated by foot pedals: in depressing one pedal the other is raised

drawloom A handloom capable of raising individual warps. It is therefore suitable for weaving complicated patterns

etu Yoruba term for Guinea-fowl pattern

faggoting Decorative embroidery technique for stitching two pieces of fabric together

farmla Sleeveless jacket worn by women and boys in the Maghreb

flij Strips woven out of sheep and goat wool on a ground loom belonging to a North African nomad woman. They are sewn together to make tents, coverings and cushions

Fon A people of Benin. Fon is also the title of one of the petty kings of grasslands Cameroon

Fulani Herders and farmers to be found all over the West African interior. Originally of Berber origin, they have intermarried with the locals for many generations. In Francophone Africa they are known as the Peul

gandura Woollen tapestry woven tunic of a boy from the Mzab region of Algeria

gara cloth Brightly coloured synthetically dyed cloth from the Guinea/Sierra Leone region

gentian violet A purple-coloured chemical used for medicinal purposes or as a dye stuff

gourgaf Low, rectangular embroidery frame of Turkish origin used in North Africa

haik Long length of cloth used as an outer garment or body wrap by Berber women

handira Moroccan Berber term for a *haik*

Hausa A Muslim people centred on northern Nigeria famous for their weaving and dyeing. They are found in other parts of West Africa, where they are noted as traders

heddle rod A rod with loops used on simple looms for making a shed opening

herringbone stitch (for beadwork) Beads are set and worked at a slight angle in pairs to form a solid fabric. This stitch is used extensively by the Ndebele and some Zulu groups

hiti Wall hanging for houses or tents, used especially in Morocco

hizam Belt or girdle removed at the wedding ceremony as they are believed to hinder conception. The lampas-weave *hizam*, woven at Fez and Tetouan, are justly famous

houli Tunisian Berber term for a *haik*

huronko A form of printing with vegetable dyes on cotton cloth from Sierra Leone

ikat The resist-dyeing process, in which designs are reserved in warp or weft yarns by tying off small bundles of threads with fibre resists to prevent the penetration of dye

OPPOSITE Algerian silk brocade woven on a Jacquard-type mechanized drawloom in the early 1900s.

Jacquard loom An automated system of raising heddles in a specific order using punched cards

jelabba North African robe

jelwa North African ceremony of the presentation of the bride

Kabyle Berber people of Algeria

kanga A rectangular printed cloth worn in East Africa, bought in pairs. One is worn around the waist, the other around the shoulders

katfiya General term for the small rectangular shawls worn around Gabes in Tunisia

kemis Embroidered, shirt-like smock worn by the Amhara or other Christian highland women of Ethiopia

kente **cloth** Ceremonial stripwoven cloth of the Ashanti people of Ghana

khaasa Woollen or wool and cotton blankets woven by the Fulani in the Niger Bend area

khlal Iron comb for beating in the weft on the North African Berber vertical loom

kikoi Plaid or striped patterned cloth

kilim Tapestry weave or a floor covering made in that technique

kitenge Woman's waist wrap made up of printed mill-cloth yardage

kola **nut** Nut from the *Cola nitida* tree. Though chewed as a mild narcotic, it gives a golden brown dye when it is crushed

Kuba A confederation of peoples centred around the Kasai river area in the Congo

lafun Cassava or cornstarch used as a resist medium by the Yoruba

lamba Untailored shawl found throughout Madagascar

lamba akotofahana Complex brocaded mulberry silk prestige cloth woven by the Merina in the 19th, and revived in the late-20th, century.

lamba mena Literally, 'red cloth'. The general term for a Malagasy *lamba*

lampas A complex weaving technique, probably of Byzantine origin, with two sets of warps and two sets of wefts. The designs appear in weft-faced satin weave

landibe One of the varieties of wild silk in Madagascar

lazy stitch or lane stitch Strands of beads sewn in parallel rows

ma'allema A teacher; in the context of this book, a teacher of embroidery

Maasai East African pastoralists

Maghreb (In Arabic literally, 'the West') North Africa, usually taken to exclude Egypt

mordant A metallic salt that combines chemically with the dyestuff to fix the dye permanently

mud cloth *see bogolanfini*

ndop Term for stitched-resist indigo-dyed cloth of Nigerian or Bamileke origin used for ceremonial purposes in the grasslands of Cameroon

ntshak Skirts with appliquéd raphia panels worn by the Bushoong and other Kuba peoples

ochre mud mixed with animal fat or water

Pano d'Obra Stripwoven trade cloths of Iberian inspiration, woven in Guinea or on the Cape Verde islands. As they were of a standard size and of fine quality, they were once used as currency

Peul *see* Fulani

pick One pass of the weft thread

pit-loom Double-heddle treadle loom with Asian antecedents, in which the weaver sits on the edge of a pit

qanat Screen

raphia Fibre derived from the dried new growth of raphia palm leaves

ras haml A woollen covering or eating cloth woven by nomads of the Tunisian and Libyan deserts. Made up of supplementary warp decorated strips

rayon A synthetic wood-based fibre

rda Woman's long wraparound robe woven at Mahdia and Djerba in Tunisia

Sahel The fertile central plain of Tunisia

satin stitch A long straight stitch that appears the same on both sides of the cloth

selvedge An edging that prevents cloth from unravelling

shamma White, handwoven cotton shawl worn by Ethiopian men and women

shed An opening between the warps, through which the weft can be passed while weaving

shed stick A stick threaded between the stretched out warps to create a shed

shot Weave showing different colours at different angles

single-heddle loom A simple loom whereby shed and countershed are made by manipulating a single heddle rod

'Spanish lace' Technique of weaving together groups of warps to create a pattern of holes

sprang A method of creating a fabric by manipulating only warp threads. No weft is introduced

stitched resist A resist is formed by stitching into the cloth, compressing it and pulling

the thread tight. The dye cannot penetrate it

stripwoven cloth Cloth made up by sewing narrow strips of cloth together, selvedge to selvedge. This type of cloth is to be found throughout West Africa

substantive dye A dye that does not need a mordant to make it permanent

Swahili People of mixed Arabic and Bantu origin living on the East African coast

sword (beater) A flat blade-like stick used with simple looms to beat in the weft

tajira Multi-coloured tie-dye shawl worn as a hair covering by Berber women in Tunisia

tapestry-weave Weaving technique using a discontinous weft to make different coloured blocks of pattern

tensifa Very long, narrow mirror cover, especially in Morocco

tibeb Coloured border of an Ethiopian *shamma* shawl

Tiraz Official factories in the Islamic world producing cloth or clothing for the ruler

turkudi Extremely narrow (about 1 in. or 2.5 cm) cotton strips woven by Hausa weavers

twill A weave in which each passage of the weft through the warps goes over two, under one, repeatedly

Ukura The term for pictorial indigo-dyed stitch-resist cloths made in northern Iboland for such organizations as the Leopard society of the Cross River area of Nigeria

warp The fixed lengthways elements stretching the length of the woven fabric

warp faced A weave in which the weft has been obscured by the warp threads and any pattern, most commonly longitudinal stripes, is carried by the warps

warp ikat The ikat resist-dyeing process is applied only to the warp threads to give them a pattern prior to weaving

wax resist *see* batik

weft The transverse elements of a woven fabric

weft faced A weave where the wefts are more densely packed than the warp or are of a heavier weight and so the warps threads are obscured and dominated by the wefts

weft float Supplementary weft that 'floats' freely across two or more warps before being reintegrated into the cloth

Wodaabe Nomadic Fulani (Peul) pastoralists

Yoruba Large ethnic group from south-west Nigeria

further reading

Adams, M., and Holdcraft, T. R., *Dida Woven Raffia Cloth from Côte d'Ivoire*, 1992

Adler, P., and Barnard, N., *African Majesty: The Textile Art of the Ashanti and Ewe*, 1993

—, *Asafo! African Flags of the Fante*, 1992

Arnoldi, M. J., and C. M. Kreamer, *Crowning Achievements: African Arts of Dressing the Head*, 1995

Baines, P., *Linen, Hand Spinning and Weaving*, 1989

Baker, P., *Islamic Textiles*, 1995

Balfour-Paul, J., *Indigo in the Arab World*, 1997

—, *Indigo*, 1998

Barbier, J. P. (ed.), *Art Pictural des Pygmées*, 1990

Barbour, J., and D. Simmonds (eds.), *Adire Cloth in Nigeria: The Preparation and Dyeing of Indigo Patterned Cloths Among the Yoruba*, 1971

Barnard, A., *Bushmen*, 1978

Barnes, R., *Indian Block -Printed Textiles in Egypt. The Newberry Collection in the Ashmolean Museum*, 1997

Bassani, E. (ed. M. Mcleod), *African Art and Artefacts in European Collections, 1400–1800*, 2000

Belkaid, L., *Algéroises Histoire d'un Costume méditerranéen*, 1998

Besancenot, J., *Costumes of Morocco*, 1990

Bosence, S., *Hand Block-Printing and Resist Dyeing*, 1985

Boser-Sarivaxévanis, R., *Aperçus sur la teinture à l'indigo en Afrique Occidentale*, 1969

—, *Les tissus de l'Afrique Occidentale*, 1972

Bühler, A., *Ikat, Batik, Plangi*, 1972

Burkett, M. E., *The Art of the Felt Maker*, 1979

Burnham, D. K., *A Textile Terminology, Warp and Weft*, 1981

Carey, M., *Beads and Beadwork of East and South Africa*, 1986

Clarke, D., *The Art of African Textiles*, 1997

—, *African Hats and Jewellery*, 1998

—, *Colours of Africa*, 2000

Collingwood, P., *The Techniques of Sprang*, 1974

—, *The Techniques of Tablet Weaving*, 1996

Coquet, M., *Textiles Africains*, 1998

Cornet, J., *Art Royal Kuba*, 1982

Courtney-Clarke, M., and G. Brooks, *Imazighen: The Vanishing Traditions of Berber Women*, 1996

Crabtree, C. and P., Stallebrass, *Beadwork: A World Guide*, 2002

Dixon, M., *The Wool Book*, 1979

Drewal, H., and J. Mason, *Beads, Body and Soul Art and Light in the Yoruba Universe*, 1998

Eicher, J. B., *Nigerian Handcrafted Textiles*, 1976

Emery, I., *The Primary Structure of Fabrics: An Illustrated Classification*, 1988

Etienne-Nugue, J., *Artisanats traditionnels en Afrique Noire – Benin*, 1984

Fage, J. D., *Introduction to the History of West Africa*, 1962

Fagg, W., *Yoruba Beadwork: Art of Nigeria*, 1980

Fakhry, A., *The Oases of Egypt (Siwa Oasis), Vol. 1*, 1982

Farris Thompson, R., and S. Bahuchet, *Pygmées?*, 1991

Fisher, A., *Africa Adorned*, 1984

Fitzgerald, D., *Zulu Bead Chain Techniques*, 1997

—, *More Zulu Beadwork*, 1999

Flint, B., *Tapis de Tissages*, 1974

Gargouri-Sethom, S., *Les Arts Populaires en Tunisie*, 1994

Gilfoy, P., *Patterns of Life – West African Strip-Weaving Traditions*, 1987

Gillow J., *Traditional Indonesian Textiles*, 1992

—, *African Painted and Printed Textiles*, 2000

—, and N. Barnard, *Traditional Indian Textiles*, 1991

—, and B. Sentance, *World Textiles*, 1999

Gittinger, M., *Master Dyers to the World*, 1982

Goitien, S. D., *Letters of Medieval Jewish Traders*, 1973

Golvin, L., *Les Tissages Décorés d'El Djem et de Djebeniana*, 1949

Graham-Stewart, M., and M. Stevenson (eds.), *South-East African Beadwork*, 2000

Hall, R., *Egyptian Textiles*, 1986

Hanby, J., and D. Bygott, *Kangas: 101 Uses*, 1992

Harris, J. (ed.), *5000 Years of Textiles*, 1993

Heathcote, D., *The Arts of the Hausa*, 1976

Hecht, A., *The Art of the Loom*, 1989

Horsfall, R. S., and L. G. Lawrie, *The Dyeing of Textile Fibres*, 1946

Hull, A., and J. Luczyc-Wyhowska, *Kilim: The Complete Guide*, 1993

Hultgren, M., and J. Zeidler, *A Taste for the Beautiful Zairian Art from the Hampton University Museum*, 1993

Hunt Kahlenberg, M. (ed.), *The Extraordinary in the Ordinary*, 1998

Hutchinson, J. B., *The Evolution of Gosspyium*, 1947

Idiens, D., and K. Ponting (eds.), *Textiles of Africa*, 1980

Issawi, C. (ed.), *An Economic History of the Middle East and North Africa*, 1982

Jacobsohn, M., *Himba Nomads of Namibia*, 1998

Jereb, J., *The Arts and Crafts of Morocco*, 1996

Kent, K., *Introducing West African Cloth*, 1971

Kreamer, C. M., and S. Fee (eds.), *Objects as Envoys: Cloth, Imagery and Diplomacy in Madagascar*, 2002

Kybalova, L., *Coptic Textiles*, 1967

Lamb, V., *West African Weaving*, 1975

—, and A., *Au Cameroun, Weaving, Tissage*, 1981

—, and A., *Sierra Leone Weaving*, 1984

—, and J. Holmes, *Nigerian Weaving*, 1980

Laoste-Chantréaux, G., *Mémoire de Kabylie*, 1994

Laporte, M., *Jeux de Trames en Algérie*, 1975

Larsen, J. L., A. Bühler and B. Solyom, *The Dyer's Art*, 1976

Last, J., and N. Donovan, *Ethiopian Costumes*, 2000

Lemaistre, J., and M.-F. Vivier (eds.), *De soie et d'or: broderies du maghreb*, 1996

Ling Roth, H., *Studies in Primitive Looms*, 1950

Mack, J., *Emil Torday and the Art of the Congo, 1900–1909*

—, *Malagasy Textiles*, 1989

— (ed.), *Africa – Arts and Cultures*, 2000

Magubane, P., *Vanishing Cultures of South Africa*, 1998

Mann, V., *Morocco Jews and Art in a Muslim Land*, 2000

Marcais, G., *Le costume musulman d'Alger*, 1918

Marzouk, M., *History of the Textile Industry in Alexandria*, 1955

Menzel, B., *Textilien Aus West Afrika*, 1972

Morrell, A., *Badla, Kamdani, or Mukesh – A Metal-work Embroidery Technique in India*, 2001

Morris, J., and E. Preston-Whyte, *Speaking with Beads: Zulu Arts from Southern Africa*, 1994

Nzita, R., *Peoples and Cultures of Uganda*, 1995

Paine, S., *Embroidered Textiles*, 1990

Phillips, T. (ed.), *Africa: The Art of a Continent*, 1995

Pickering, W., and R. S. Yohe, *Moroccan Carpets*, 1994

Picton, J., and J. Mack, *African Textiles*, 1995

— (ed.), *The Art of African Textiles: Technology, Tradition and Lurex*, 1995

Ponting, K. G., *A Dictionary of Dyes and Dyeing*, 1980

Powell, I., *Ndebele, A People and their Art*, 1995

Rainer, K., *Tasnacht*, 1999

Reswick, I., *Traditional Textiles of Tunisia and*

Related North African Weavings, 1985

Ricard, P., *Arts marocains*, 1918

—, *Les Métiers Manuels à Fes*, 'Hesperis', Vol. 4, 1925

—, and M. Kouadri *Le Batik Berbère*, 'Hesperis', Vol. 5, 1925

—, and M. Kouadri, *Procédés marocains de Teinture des Laines*, 1938

Rivers, V., *The Shining Cloth*, 1999

Rogers, C. (ed.), *Early Islamic Textiles*, 1983

Ross, D., *Wrapped in Pride, Ghanaian Kente and African American Identity*, 2002

Ryan, M. G., *The Complete Encyclopaedia of Stitchcraft*, 1981

Saitoti, T. O., and C. Beckwith, *Maasai*, 1983

Sandberg, G., *Indigo Textiles*, 1989

—, *The Red Dyes*, 1994

Saul, M., *Shells*, 1974

Schaedler, K.-F., *Weaving in Africa South of the Sahara*, 1987

Seiler-Baldinger, A., *Systematik der Textilen Techniken*, 1973

Sieber, R., *African Textiles and Decorative Arts*, 1972

Slavin, K. and J., *The Touareg*, 1973

Soubeyran, H. (ed.), *Lié Délié, La teinture a réservés, art traditional et contemporain*, 1983

Spring, C., *African Textiles*, 1989

—, *African Arms and Armour*, 1993

—, and J. Hudson, *North African Textiles*, 1995

—, and J. Hudson, *Silk in Africa*, 2002

Stanzer, W., *Berber – Tribal Carpets and Weavings from Morocco*, 1992

Stone, C., *The Embroideries of North Africa*, 1985

Storey, J., *The Thames and Hudson Manual of Textile Printing*, 1974

Thompson, D., *Coptic Textiles in the Brooklyn Museum*, 1971

Thurstan, T., *The Use Of Vegetable Dyes*, 1975

—, *Dye Plants and Dyeing – A Handbook*, 1973

Tournerie, P., *Colour and Dye Recipies of Ethiopia*, 1986

Tovey, J., *The Technique of Weaving*, 1975

Trowell, M., *African Design*, 1960

Vandenbroeck, P., *Azetta, L'art des femmes berbères*, 2000

Van der Stappen, X. (ed.), *Aethiopia – Peuples d' Ethiopie*, 1996

Vansina, J., *The People of Woot: A History of the Kuba Peoples*, 1978

Wace, A. J. B., *Victoria and Albert Museum Catalogue of Algerian Embroideries*, 1935

Wada, Y., M. Kellog Rice and J. Barton, *Shibori: The Inventive Art of Japanese Shaped Resist Dyeing*, 1983

museum collections

AUSTRALIA

Canberra Australian National Gallery, Lake Burley Griffin, Canberra City, A.C.T. (2600)

AUSTRIA

Vienna Museum für Völkerkunde, Neu Burg, A-1010, Vienna

BELGIUM

Antwerp Ethnology Museum, International Zeemanshuis, Falconrui 2, 2000 Antwerp

Brussels Musées Royaux d'Art et d'Histoire, 10 Parc du Cinquantenaire, 1040 Brussels

Tervuren Musée Royal de l'Afrique Centrale, Leuvensesteenweg, 13, 3080 Tervuren

CAMEROON

Yaoundé National Museum, Yaoundé

CANADA

Ottawa National Museum of Man, Victoria Memorial Museum Building, MacLeod at Metcalfe Streets, Ottawa, Ontario, KIA OM8

Toronto Royal Ontario Museum, 100 Queen's Park, Toronto, Ontario M5S 2C6

CONGO

Kinshasa Museum of Ethnology and Archaeology, Université National du Congo, B.P. 127, Kinshasa

CZECH REPUBLIC

Prague Náprstek Museum of Asian, African and American Cultures, Betlémské namé stí 1, 11000, Prague 1

DENMARK

Copenhagen National Museum of Denmark, Ny Vestergade 10, Copenhagen

EGYPT

Cairo Arabic Museum, Midal Babel-Hkalk, Cairo

FRANCE

Paris Musée de l'Homme, Muséum National d'Histoire Naturelle, Palais de Chaillot, 17 Place du Trocadéro, 75116 Paris

Musée National des Arts d'Afrique et d'Océanie, 293 Avenue Daumesnil, 75012 Paris

GERMANY

Berlin Museum für Völkerkunde, Arnimallee 23-27, D-1000 Berlin

Pergamonmuseum Staatliche Museen zu Berlin, Bodestrasse 1–3, 10178 Berlin

Cologne Rautenstrauch-Joest Museum, Ubierring 45, 50678 Cologne

Dresden Staatliches Museum für Völkerkunde, Palaisplatz, 01097 Dresden

Frankfurt-am Main Museum für Völkerkunde, Schaumainkai 29, 60594 Frankfurt-am Main

Stuttgart Linden-Museum, Hegelplatz 1, 70174 Stuttgart

GHANA

Accra Ghana National Museum, Barnes Road, P. O. Box 3343, Accra

ISRAEL

Jerusalem Sir Isaac and Lady Edith Wolfson Museum, Hechal Shlomo, 58 King George Street, 91073 Jerusalem

ITALY

Rome Luigi Pigorini Museum of Prehistory and Ethnography, Piazzale Guglielmo Marconi 14, 00144 Rome

JAPAN

Osaka National Museum of Ethnology (*Kokuritsu Minzokugaku Hakubutsukan*), 1–10 Senri Expo Park, Suita, Osaka

Museum of Textiles, 5–102 Tomobuchi-Cho, 1-Chome, Miyakojima-Ku, Osaka

MADAGASCAR
Tananarive Museum of Folklore, Parc de
Tsimbazaza, P. O. Box 434, Tananarive

MALI
Bamako National Museum of Mali, Rue de
Général Leclerc, P. O. Box 159, Bamako

NETHERLANDS
Amsterdam Tropenmuseum (Museum of the
Royal Tropical Institute), Linnaeusstraat 2, 1092
AD Amsterdam
Leiden National Museum of Ethnography,
Steenstraat 1, 2312 BS Leiden
Rotterdam Museum of Geography and
Ethnology, Willemskade 25, 3016 DM
Rotterdam

NIGERIA
Lagos Nigerian Museum, P. O. Box 12556, Lagos

PORTUGAL
Lisbon Museum of Overseas Ethnography,
Rua Portas de Santo Antao, 100 Lisbon

RUSSIA
St Petersburg Peter the Great Museum of
Anthropology and Ethnology, Universitetskaya
Nabrezhnaya 3, St Petersburg
Russian Museum of Ethnography, ul
Inzenernaya, 4–1, St Petersburg

SOUTH AFRICA
Cape Town South African Cultural History
Museum, 49 Adderley Street, P. O. Box 645,
Cape Town

SPAIN
Barcelona Museum of Ethnology, Pg Santa
Madrona 16*22, 08038 Barcelona
Madrid National Museum of Ethnology, Calle
Alfonso x11 68, 28014 Madrid

SWEDEN
Gothenburg Ethnographical Museum,
Norra Hamngatan 12, 41114 Gothenburg
Stockholm National Museum of Ethnography,
Djurgårdsbrunnsvägen 34, 10252 Stockholm

SWITZERLAND
Basel Museum für Völkerkunde,
Augustinergasse 2, 4001 Basel

Zurich Völkerkunde Museum der Universität,
Pelikanstrasse 40, 8001 Zurich

UNITED KINGDOM
Bristol Bristol City Museum and Art Gallery,
Queens Road, Bristol BS8 1RL
Cambridge University Museum of Archaeology
and Ethnology, Downing St, Cambridge CB2 3DZ
Edinburgh Royal Museum, Chambers Street,
Edinburgh EH1 1JF
Halifax Bankfield Museum, Ackroyd Park,
Boothtown Road, Halifax HX3 6HG
Leicester Leicestershire Museum and Art
Gallery, New Walk, Leicester LE2 OJJ
London British Museum, Great Russell St,
London WC18 3DG
Embroiderers' Guild, Apartment 41, Hampton
Court Palace, East Molesey, Surrey KT8 9AU
Horniman Museum, 100 London Road, Forest
Hill, London SE23 3PQ
Manchester The Whitworth Art Gallery,
University of Manchester, Oxford Road,
Manchester M15 6ER
Oxford Ashmolean Museum, Beaumont Street,
Oxford OX12PH
Pitt Rivers Museum, South Parks Road, Oxford
OX1 3PP

UNITED STATES OF AMERICA
Berkeley Lowie Museum of Anthropology,
Kroebber Hall, Bancroft Way, University of
California, Berkeley, CA 94720
Boston Museum of Fine Arts, 465 Huntingdon
Avenue, Boston MA 02115
Cambridge, Mass. Peabody Museum of
Archaeology and Ethnology, Harvard University,
11 Divinity Avenue, Cambridge, MA 02138
Chicago The Art Institute of Chicago, 111 S.
Michigan Avenue at Adams Street, Chicago,
IL 60603
Field Museum of Natural History, Roosevelt
Road at Lake Shore Drive, Chicago, IL 60605
Cincinnati Cincinnati Art Museum, Eden Park,
Cincinnati, OH 45202
Cleveland The Cleveland Museum of Art,
11150 East Boulevard, Cleveland, OH 44106
Denver The Denver Art Museum, 100 West
14th Avenue, Parkway, Denver, CO 80204
Detroit The Detroit Institute of Arts, 5200
Woodward Avenue, Detroit, MI 48202
Indianapolis The Indianapolis Museum of Art,
1200 West 38 Street, Indianapolis, IN 46208

La Jolla Mingei International Museum of Folk
Art, 4405 La Jolla, CA 92037
Los Angeles Los Angeles County Museum of
Art, 5905 Wilshire Boulevard, Los Angeles, CA
90036
UCLA Fowler Museum of Cultural History,
University of California, 405 Hilgard Avenue,
Los Angeles, CA 90095
Newark Newark Museum, 43–49 Washington
Street, Newark NJ 07101
New York City American Museum of Natural
History, 79th Street and Central Park West,
New York City, NY 10024
The Brooklyn Museum, 200 Eastern Parkway,
Brooklyn, New York City, NY 11238
Metropolitan Museum of Art, 1000 Fifth Avenue
at 82nd Street, New York City, NY 10028
Philadelphia Philadelphia Museum of Art,
26th Street and the Benjamin Franklin Parkway,
Philadelphia, PA 19130
Salem Peabody Essex Museum, East India
Square, Salem, MA 01970
San Francisco M. H. de Young Memorial
Museum, Golden Gate Park, San Francisco,
CA 94118
Santa Fe Museum of International Folk Art,
P. O. Box 2065 Santa Fe, New Mexico, NM 87504
Seattle Historic Costume and Textile Collec-
tions, University of Washington, Seattle, WA
98105
National Museum of Natural History, Seattle Art
Museum, Volunteer Park, Seattle, WA 98122
Washington, D.C. National Museum of African
Art, Smithsonian Institution, 950 Independence
Avenue SW, Washington, D.C. 20560
Textile Museum, 2320 S Street NW, Washington,
D.C. 20008

map

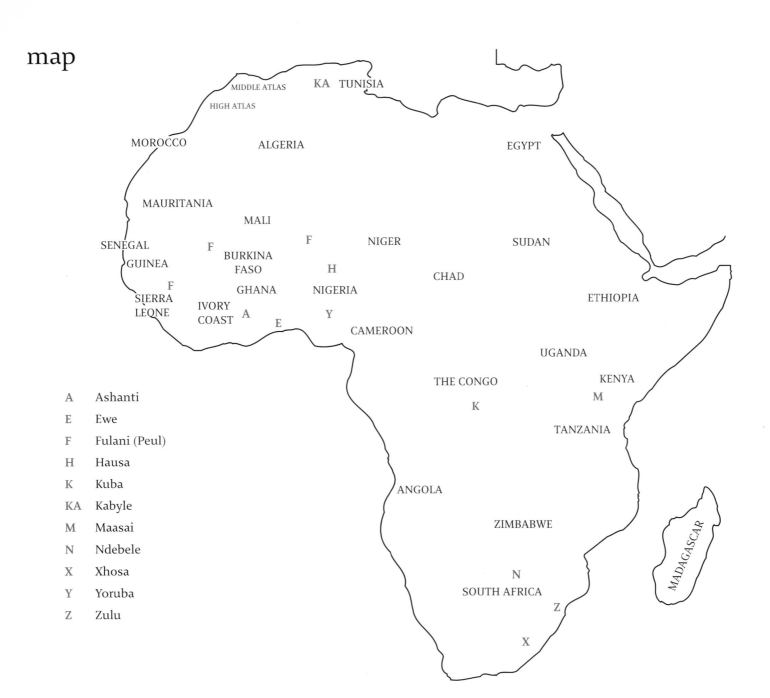

MIDDLE ATLAS
KA TUNISIA
HIGH ATLAS

MOROCCO
ALGERIA
EGYPT

MAURITANIA

MALI

SENEGAL
F
F
NIGER
SUDAN

GUINEA
BURKINA
FASO
H
CHAD

F
GHANA
NIGERIA
ETHIOPIA

SIERRA
LEONE
IVORY
COAST
A
Y
CAMEROON

E

UGANDA

THE CONGO
KENYA

K
M

TANZANIA

ANGOLA

ZIMBABWE

MADAGASCAR

N

SOUTH AFRICA

Z

X

A Ashanti

E Ewe

F Fulani (Peul)

H Hausa

K Kuba

KA Kabyle

M Maasai

N Ndebele

X Xhosa

Y Yoruba

Z Zulu

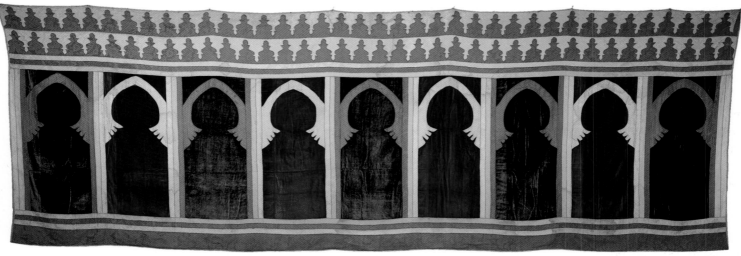

index

OPPOSITE *Hiti* appliquéd velvet
ceremonial hanging from Meknes
or Fez, Morocco.